Understanding the Business of Entertainment

Understanding the Business of Entertainment: The Legal and Business Essentials All Filmmakers Should Know is an indispensable guide to the business aspects of the entertainment industry, providing the information you need to break in and to succeed. Written in a clear and engaging tone, this book covers the essential topics in a thorough but reader-friendly manner and includes plenty of real-world examples that bring business and legal concepts to life. Whether you want to direct, produce, write, edit, photograph or act in movies, this book covers everything from how to find work in your chosen field to key provisions in employment agreements for creatives. If you want to make films independently, you'll find advice on where to look for financing, what kinds of deals might be made in the course of production and important information on insurance, releases and licenses.

Other topics covered include:

- Hollywood's growth and the current conglomerates that own most of the media
- How specific entertainment companies operate, including facts about particular studios and employee tasks
- How studios develop projects, manage production, seek out independent films and engage in marketing and distribution
- The kinds of revenues studios earn and how they account for these revenues
- How television networks and new media-delivery companies like Netflix operate, and where the digital revolution might take those who will one day work in the film and TV business

As an award-winning screenwriter and entertainment attorney, Gregory Bernstein gives us an inside look at the business of entertainment. He proves that knowing what is behind filmmaking is just as important as the film itself.

Gregory Bernstein has worked in the entertainment business for the past 33 years from both the business and creative sides—as an entertainment attorney, studio business affairs executive, WGA union senior executive, and award-winning screenwriter.

After graduating from the UCLA Law School in 1980, Bernstein practiced entertainment law for two years at O'Melveny & Myers, an international law firm. He then worked for six years as vice-president of business affairs at Columbia and Tri-Star Pictures, negotiating more than a hundred acting, directing, producing, writing, rights, financing and distribution agreements. Following his studio executive years, Bernstein enrolled in the film directing program at the American Film Institute where he earned an MFA degree. Since leaving AFI, he has received writing credit on three films: *The Conspirator*, which was released in 2011 and directed by Robert Redford, and for which he was awarded the Humanitas Prize; *Trial and Error*, which starred Charlize Theron, Michael Richards and Jeff Daniels; and *Call Me Claus*, which starred Whoopi Goldberg. He has also sold scripts to Disney and DreamWorks. In 2003, Bernstein took a sabbatical from writing and entered the Kennedy School of Government at Harvard University where he received a master's degree in public administration. Upon returning to Los Angeles, he served as the assistant executive director of the Writers Guild of America, West from 2004 until 2006. Since 2012, along with screenwriting, he has also taught film at Arizona State University.

Understanding the Business of Entertainment

*The Legal and Business Essentials
All Filmmakers Should Know*

Gregory Bernstein

Focal Press
Taylor & Francis Group

NEW YORK AND LONDON

First published 2015
by Focal Press
70 Blanchard Road, Suite 402, Burlington, MA 01803

and by Focal Press
2 Park Square, Milton Park, Abingdon, Oxon OX14 4RN

Focal Press is an imprint of the Taylor & Francis Group, an informa business

Notices
Knowledge and best practice in this field are constantly changing. As new research and experience broaden our understanding, changes in research methods, professional practices, or medical treatment may become necessary.

Practitioners and researchers must always rely on their own experience and knowledge in evaluating and using any information, methods, compounds, or experiments described herein. In using such information or methods they should be mindful of their own safety and the safety of others, including parties for whom they have a professional responsibility.

Product or corporate names may be trademarks or registered trademarks, and are used only for identification and explanation without intent to infringe.

Library of Congress Cataloging-in-Publication Data
A catalog record has been requested for this book

ISBN: 978-1-138-77643-2 (hbk)
ISBN: 978-1-138-77579-4 (pbk)
ISBN: 978-1-315-77313-1 (ebk)

Typeset in Berkeley
by Apex CoVantage, LLC

Printed and bound in the United States of America by Edwards Brothers Malloy on sustainably sourced paper.

To my wife, Sara, whose love and support has made everything possible.

To my daughter, Katherine, who every day proves that computer science, saxophones, fun and achievement really do go hand in hand.

To my mother, Pearl, who has always guided me forward and shown me the way.

Praise for *Understanding the Business of Entertainment*

vii

"Whether you're already in the business, or on the outside and looking in trying to make sense of the dizzying elements, this is an easy to read and comprehensive book from an expert who masterfully illuminates the fundamentals. As a screenwriter himself, Greg has now completed the task of weaving together the story of production as a business with the enabling elements that come before and after the cameras roll."

—**Jeffrey Ulin** *Author*, The Business of Media Distribution—Monetizing Film, TV and Video Content in an Online World

Contents

ix

Acknowledgments

There are many people to thank for their help, guidance and support. First and foremost, I must acknowledge the tremendous help I received from my wife Sara, whose writing and editorial skills far exceed mine. She read every word of this book several times and offered suggestions for improvement—and if that's not love, I don't know what is.

I also want to thank colleagues and friends who read various chapters and helped make them better with their insight, knowledge and editorial advice. To Miguel Valenti, Adam Colis, Greg Maday, Dana Lustig, Cliff Gardner, David Blau and my brother Peter, thank you all.

A special thanks goes to Jeff Ulin for his careful read of the entire text and for his comments, all of which proved to be so helpful.

I also owe a great deal to a large number of entertainment industry personnel who gave me information used in this book. You know who you are, and you have my tremendous thanks for all of your help.

I would never have written this book had I not been given the privilege of teaching film at Arizona State University. To Jake Pinholster and Miguel Valenti, to all of the faculty at ASU's School of Film, Dance and Theatre and to the students who inspire me every day, thank you all.

I owe a special debt of gratitude to the people who allowed me to interview them for this book—Cynthia Kanner, Mike Knobloch, Dana Lustig, Daniel Petrie, Jr., Michael Poryes, Hamilton Sterling and Maureen Tunney. On behalf of those who read this book and who benefit from what you say, thank you so much for your time and for the stories you tell.

And, finally, I want to thank everyone at Focal Press, and especially Emily McCloskey and Peter Linsley, for without their support and kindness, this book would not exist.

I have done my best to make sure all of the information in this book is accurate—however, if there are errors the fault is entirely mine.

Bound to Create

You are a creator.

Whatever your form of expression — photography, filmmaking, animation, games, audio, media communication, web design, or theatre — you simply want to create without limitation. Bound by nothing except your own creativity and determination.

Focal Press can help.

For over 75 years Focal has published books that support your creative goals. Our founder, Andor Kraszna-Krausz, established Focal in 1938 so you could have access to leading-edge expert knowledge, techniques, and tools that allow you to create without constraint. We strive to create exceptional, engaging, and practical content that helps you master your passion.

Focal Press and you.

Bound to create.

> We'd love to hear how we've helped you create. Share your experience:
>
> **www.focalpress.com/boundtocreate**

Focal Press
Taylor & Francis Group

Introduction

Back in the nineteenth century, when a handful of scientists were quietly discovering something they called electricity, the world's storytellers were doing pretty much what they had been doing for centuries. Talented people wrote plays or books or musical compositions, or entertained by telling stories at public gatherings. Entertainment was, for the most part, produced and consumed within narrow geographical boundaries. There was no television, no radio, no broadcasting of any kind. There were no movies, no DVDS, no records, no CDs, no internet, no computers.

There was no mass entertainment business.

At the dawn of the twentieth century, things rapidly changed. New technologies radically affected how content could be created and sent out into the world. A series of images could suddenly be filmed and projected, and the film industry was born. The record industry was also born thanks to the invention of mechanically reproduced sound. At precisely the same time, scientists were discovering that electromagnetic waves could transport sound over long distances, and so the birth of radio was fast approaching. Soon someone sitting in a radio studio in New York could entertain millions of people simultaneously across America; this was the stuff of fantasy for the previous century and the uncounted centuries before that.

These new forms of entertainment immediately attracted enormously creative people, geniuses like Charlie Chaplan and soon-to-be stars like John Barrymore and Gloria Swanson. But they also drew the interest of other people, business people, who loved entertainment but whose talents lay off-screen. These people could see there was money to be made doing what for them was new and exciting, and they had the tenacity, zeal and toughness to succeed. They would provide the financing and business infrastructure necessary to help creative people practice their art in return for a share of the profits. A *large* share of the profits.

The business infrastructure these people created eventually turned flickering images on a wall, or small images on a tube inside a box, into the

multi-billion-dollar global business we have today, with its tremendous social, cultural and political impact.

* * *

This book seeks to tell you about legal and business issues that govern the entertainment business. Though international aspects of the modern entertainment industry will be discussed, the book primarily adopts a United States perspective; the impact and nuances of other countries' business and legal practices are well beyond the scope of this volume. Furthermore, no single book could describe the business of entertainment with encyclopedic detail. Instead, the goal is to give you a working knowledge of important topics that people who want to work in the industry, or who already do, ought to know. If what's written here also encourages you to think, question and wonder about some of these subjects, so much the better.

The approach is to start with the widest possible focus and look at critical issues that impact the business, and then narrow our focus as we go along. We therefore start by looking at copyright law and First Amendment law. Nothing in America has had a more profound effect on the entertainment business then these laws, yet both were conceived long before anyone figured out how to make a movie or broadcast a TV show.

Interestingly, America's Founding Fathers included the notion of copyright in the U.S. Constitution. Why? Because they believed people should have an incentive to invent and create as this would benefit society as a whole. Today, copyright has become a complex group of laws that give creators, and sometimes the people who pay them, a number of exclusive ownership rights. Anyone who creates, produces or distributes entertainment ought to know copyright fundamentals.

Most books that discuss copyright either spend the entire volume doing so, and these books are usually meant for lawyers or law students, or else spend a small amount of time examining the topic in the most general terms. This book seeks a Goldilocks middle ground. The copyright discussion here can't possibly make you competent to handle copyright problems without an attorney, but it will give you a fundamental understanding of copyright's most important rules.

Next, we'll turn to copyright issues and business practices that apply to the music industry. Ask anyone who has put music into a film or TV project, and you'll hear this can be a complex and confounding task. I will try to make the rules and business practices understandable.

Another major copyright issue these days involves piracy, otherwise known as copyright infringement. This is an issue very much on the industry's collective mind. To those outside the business, pirating a show may seem like the digital equivalent of pilfering a grain of sand from the beach. To those working inside

the business, all that pilfering has led to lost jobs, lost revenue and many sleepless nights. We will therefore discuss the current legal precedents and impact of piracy, along with why people feel so free to pirate in the first place.

We'll next turn to the First Amendment. I think we can all agree that James Madison and his friends didn't have movies, television or radio in mind when they drafted the First Amendment's free speech provision. Porn and edgy lyrics and performers swearing on live TV were not high on their list of concerns. Nevertheless, modern courts have had to address these issues, and if you think courts have always said the First Amendment protects filmmakers, you're wrong. Indeed, for more than half of the twentieth century, the U.S. Supreme Court said the First Amendment did not protect movies at all. Though that's changed, there are still some things that writers, producers, directors, actors and studios can't say without legal repercussion, and so we'll discuss these issues as well.

With that legal background in mind, we'll narrow our focus and look at how the entertainment industry is organized. We'll specifically look at the growth of the modern entertainment business, examining its rise from the early twentieth century to the international media conglomerates that now create and own so much of the entertainment we consume.

Once again, laws and regulations have played a large part in the industry's growth, organization and current operations. We'll examine how government regulation of the business, as implemented by the Federal Communications Commission, has played an enormous role in creating the current shape of the entertainment industry.

From there we'll look at the media conglomerates themselves, examine which companies own what media assets, discuss the ever-expanding role of the internet in entertainment, and ask if our current media landscape is a good or not-so-good thing for society. We'll also discuss other organizations that impact the entertainment business, including entertainment unions and talent agencies.

We'll then narrow our focus again and look specifically at what film and TV companies do. For those readers who want to be filmmakers, I can assure you that understanding how these companies operate will ultimately help you practice your craft. I would never suggest you *must* think like a studio, but I will suggest it sometimes helps.

We'll primarily examine three major areas of studio operations, development, marketing and distribution, because these are the areas where important business decisions are made every day. Once production starts, the artists take over, but prior to production, and after it concludes, business concerns dominate what happens.

Next, we'll narrow our focus yet again, and discuss money and contracts. Artists and studios both want as much of the money pie as possible, and contracts are the mechanism by which the pie is apportioned. Therefore, we'll examine studio accounting and carefully look at standard contracts for writers, producers, directors and actors and for rights acquisition. We'll discuss what filmmakers normally get paid as well as other terms commonly negotiated in their deals. We'll also discuss the often confusing and elusive issue of gross and net profits. This entire discussion is supplemented by template contracts you can read online at [focalpress.com/cw/bernstein]. These templates are based on actual studio contracts and therefore reflect current industry standards. We'll then conclude this section by going over many previously discussed topics, including development, financing, distribution and contracts, in the context of independent filmmaking. Hopefully, this will give those of you interested in independent film a little more information at your fingertips.

The book concludes with a series of interviews in Chapter 14. These interviews are meant for film students and other non-industry professionals who might like to work in the entertainment business. Some of the people I interviewed are successful studio executives and some are successful filmmakers. Though one of the interviewees has been the showrunner of a hit TV series, none are famous in the traditional sense of the word. They are all "normal" people who found their way into the business. The goal here is to give you a sense of how they succeeded and what they do every day.

* * *

On a far more mundane note, one difficulty posed by writing this book has to do with word choice. For example, how does one succinctly refer to production or distribution companies that do similar things but in different media? For example, Warner Bros., NBC Television, the A&E cable channel and Netflix all produce, license and distribute content, but they are hardly the same kinds of companies doing exactly the same things. Warner Bros. is commonly referred to as a "studio," but the others are not, and NBC is commonly referred to as a "network," but the others are not. Some sharp-eyed readers who want words used with great precision might object if I refer to Netflix or NBC as a "studio" or "production company," because they're not precisely those things.

Often, this leaves a choice. Either I write with great specificity, delineating companies' differences each time the occasion requires it, or I use fairly generic terms meant to refer to these companies collectively. For the sake of brevity, I have opted for the latter. This means that, sometimes, when talking about media companies, I refer to them collectively as "studios" or "production companies," even if those terms do not truly fit one of the collective companies mentioned. Is Netflix really a "television" company? No, it's an internet company that now produces TV-like material. But, when discussing it collectively

with the networks and cable TV channels, I may refer to all of them as "television" companies, or "producers."

The same problem arises when discussing the artists who make entertainment. I therefore use the term "filmmaker" throughout this book to refer to anyone, be they writer, producer, actor, editor, cinematographer or other kind of artist, who helps create a film, television show, internet "TV show" or new media production.

Hopefully, the context will make the meaning of the words I choose clear, and I apologize in advance for the occasional lack of precision.

Then there is the issue of using masculine and feminine pronouns. I have opted not to use "him" or "his" when referring to a generic person, but instead to randomly switch between masculine and feminine pronouns.

Finally, two disclaimers: Though this book discusses various legal issues, it is neither my intention to practice law by writing this book nor my intention in any way whatsoever to provide legal advice to the reader on which the reader can rely. As I say throughout the book, readers facing entertainment legal issues must consult a licensed and knowledgeable attorney familiar with the issues faced by the reader. Also, though I occasionally discuss companies or other service providers in this book, I want to make clear that I do not endorse these entities or their services; my mention of a service provider or company cannot be relied upon by the reader as a legal basis for employing or otherwise doing business with that company or service provider.

SECTION 1
Law and Entertainment

We begin by examining the two most important areas of law that govern the entertainment industry—copyright and First Amendment law. Without both there would be no entertainment business as we know it.

Copyright gives creators and entertainment businesses exclusive ownership rights in the screenplays, books, films, TV shows, songs, games and other forms of entertainment they create. The First Amendment gives us all tremendous freedom to create just about anything we want, though not *everything* we want.

These two areas of law are the foundation on which the entertainment industry rests, and should be understood by all who work in this business.

CHAPTER 1
Copyright Law

INTRODUCTION

What is copyright? It's a set of laws that give authors of certain kinds of creative works the right to *exclusively* own and control their work for a period of time. Copyright actually gives authors several rights, and we'll discuss them later in this chapter, but for now what's important to know is that copyright gives authors and other creators the *sole* right to exploit the copyrighted work.

Any person or company that spends time and money creating something valuable wants to legally own that thing, whether what's created is a movie, video game, electric car or disposable diaper. As we'll see, copyright law grants ownership rights to only certain kinds of "things"—generally speaking, artistic and cultural works.

It's impossible to overemphasize the importance of copyright when it comes to the entertainment business. The fact is, copyright is the lifeblood of the entertainment industry. Its grant of *exclusive* ownership rights allows individual creators to have professional careers as authors of creative works, and it also allows entertainment companies to make billions of dollars annually from movies, television shows, video games, songs, plays and other forms of entertainment.

Without copyright, the entertainment business in all its forms would simply not exist, which means copyright law has had an incalculable impact on American society and culture.

IN THE BEGINNING

Back before the invention of the printing press, storytellers never had to worry about people stealing their work. For example, one of the world's first great storytellers, Homer, who probably lived sometime between 800 BC and 700 BC, almost certainly told his stories orally, and since the tape recorder wouldn't be invented for another 2,600 years, intellectual property theft was not high on his list of daily concerns. When the great Athenian playwright Sophocles (496–406 BC) actually did write the text of *Oedipus Rex*, he didn't have to worry about

unauthorized copying because only a handful of people could write, let alone read.

Fast-forward nearly two thousand years and nothing at all had changed. Authors such as Dante Alighieri (1265–1321), who wrote *The Divine Comedy*, and Geoffrey Chaucer (1343–1400), who wrote *The Canterbury Tales*, never worried about intellectual property theft as there was no way for people to effectively copy and distribute their work.

Then, around AD 1450, Johannes Gutenberg invented the printing press and book publishing was born. For the first time, an author's work could be copied with relative ease, and so for the first time writers and publishers had to worry about controlling the sale of what they created. Human nature being what it is, by the time Shakespeare's plays were first formally published in 1623, his publishers were already decrying "stolen and surreptitious" copies of the plays that were "maimed and deformed by the frauds of injurious imposters."[1]

Along with Hamlet and King Lear, intellectual property theft had arrived on stage.

At first, a handful of book publishers in England tried to prevent unauthorized copying by forming what was, in effect, a monopoly. Called the Stationers' Company, members of the group agreed not to copy a work published by a group member. England's government recognized the monopoly power of the Stationers' Company and officially sanctioned it to regulate the reproduction of books.[2] Much like the large entertainment conglomerates today, the Stationers' Company did everything it could to firmly control the production and distribution of published works.

By the late 1600s, however, the printers' imperious control had run its course; their ability to effectively censor what was published raised the hackles of the general public, and their greed and occasional abuse of authors' economic interests alienated the very people who supplied them with books in the first place.

Thus, the pendulum of control swung away from publishers and towards the authors themselves. In 1710, England's parliament passed what is known as the Statute of Anne, the first law that gave authors a governmentally recognized and enforceable copyright in their works. Under the law, authors owned the copyright to what they wrote for 14 years, during which time the author had the exclusive right to decide who could publish the work. The initial 14-year term could be renewed for an additional 14 years, after which time the work fell into the public domain,[3] and could then be copied by anyone.

Now jump forward another 77 years, to 1787, when the United States' Founding Fathers met in Philadelphia to draft the United States Constitution. A few years earlier England and its American colonies had engaged in a kerfuffle known as the American Revolution. The colonists had rid themselves of English control,

but that didn't mean the new American leaders turned their back on prevailing English law. Indeed, when the Founding Fathers met to write America's most cherished set of laws, the United States Constitution, they looked to English statutes with which they were familiar.

One of the legal notions the Founding Fathers chose to incorporate into the Constitution was copyright. The Constitution says, "Congress shall have the power to . . . promote the progress of science and useful arts, by securing for limited times to authors and inventors the exclusive right to their respective writings and discoveries."[4]

This Constitutional language has had a profound effect on copyright law in America. For one thing, from the very beginning, America's government has recognized that authors as well as other creative people should have a strong economic interest in the work they create. Giving authors and others the "exclusive" right to their work for a "limited time" means that they can control the exploitation of their work and thus reap whatever economic benefits the public chooses to bestow. The underlying public policy is clear: By providing this economic incentive the hope is that creative people will author new works, invent new products and make scientific discoveries, all of which benefit society as a whole.[5] If this economic incentive didn't exist, artistic people would have to find a different way to earn a living, which would severely restrict their ability to create, discover, and help advance society into the future.

The fact that the Founders gave *Congress* the power to secure copyright has also been vitally important. As you probably know, the United States has two distinct systems of law-making: The federal government can make federal laws under the powers granted it by the Constitution, and individual states can make laws, too. Thanks to the Constitution's "Supremacy Clause," federal law always takes precedence over state laws that are inconsistent with federal law.[6] Thus, by giving Congress the power to secure copyright, the Founders eliminated states from having a significant role in this process.[7] Therefore, people involved in entertainment need not generally concern themselves with 50 different state laws on the fundamental issues of copyright—they only have to understand the copyright laws passed by the United States Congress.

Congress has indeed exercised its Constitutional prerogative and passed various copyright laws from time to time. During the twentieth century, Congress passed two major overhauls of copyright law, in 1909 and then again in 1976. The 1976 Copyright Act,[8] though later amended and augmented due to issues raised by the digital revolution, is still the fundamental copyright law governing creative works. *Though the law was passed in 1976, by its terms it only applies to works created on or after January 1, 1978*; works created before January 1, 1978 are covered primarily (though not entirely) by the 1909 Act.[9]

Since the 1976 Copyright Act is the current governing law, we'll now turn to it and look at it carefully. Here are the principal questions we'll examine:

- What works qualify for copyright protection?
- What can't be copyrighted?
- When does copyright ownership begin, and what must an author do to officially obtain copyright?
- What specific rights do copyright owners receive?
- What happens when two or more people jointly create a copyrighted work?
- Who owns the copyright if someone pays you to create a work?
- How long does copyright last?
- What constitutes a violation of copyright, also known as copyright infringement?
- What defenses are there if someone claims you violated copyright?

WHAT WORKS QUALIFY FOR COPYRIGHT PROTECTION?

People can create a variety of different things, from scripts to medicine, from video games to light bulbs, from songs to atomic clocks and quantum computers. Copyright law only covers a certain portion of what people create.

Stated very generally, copyright covers artistic and cultural endeavors, while patent law, a wholly different and complicated subject, covers what can be broadly called inventions and the products derived from them.[10]

Since our focus is the entertainment industry, we'll concentrate on copyright. Section 102 of the 1976 Copyright Act generally tells us what kinds of works qualify for copyright protection. Here is the text of Section 102, and I have italicized the key words and terms that merit further discussion:

1. Copyright protection subsists, in accordance with this title, in *original works of authorship fixed in any tangible medium of expression*, now known or later developed, from which they can be perceived, reproduced, or otherwise communicated, either directly or with the aid of a machine or device. Works of authorship include the following categories:
 a. literary works;
 b. musical works, including any accompanying words;
 c. dramatic works, including any accompanying music;
 d. pantomimes and choreographic works;
 e. pictorial, graphic, and sculptural works;
 f. motion pictures and other audiovisual works;
 g. sound recordings; and
 h. architectural works.

2. In no case does copyright protection for an original work of authorship extend to any *idea*, procedure, process, system, method of operation, concept, principle, or discovery, regardless of the form in which it is described, explained, illustrated, or embodied in such work.

The first group of key words says that copyright subsists in "original works of authorship fixed in any tangible medium of expression." In other words, if you want your work to be protected by copyright, it must be an "original work of authorship fixed in any tangible medium of expression." So what does this mean?

Work of Authorship

Let's begin by looking at the term "work of authorship." To qualify for copyright, a work must be a "work of authorship." One might wonder what this term means, but fortunately we don't have to guess because the statute tells us. The statute says that "works of authorship" fall into a variety of categories, including "literary works," "musical works, including any accompanying words," "dramatic works, including any accompanying music," "motion pictures and other audiovisual works" and "sound recordings." These broad categories cover almost all forms of entertainment, from books and scripts that launch film and video projects ("literary works") to completed films, television shows, news broadcasts, new media productions and video games ("motion picture and other audiovisual works"), to musical soundtracks, songs and symphonies ("musical works, including any accompanying words"), to stage plays, musicals and operas ("dramatic works, including any accompanying music" and "choreographic works").

Original Works

To be eligible for copyright protection, the work must not only be a "work of authorship," it must be an "*original* work of authorship." This leads to the question, what does "original" mean? Though this might seem to be a fairly easy question to answer, in truth it's a bit complicated.

Before going any further, here's a question you may be asking yourself: Who gets to decide what "original" means? Since Congress wrote the law, doesn't Congress decide? Seems logical, but the answer is no, Congress doesn't decide. Our courts do. When disputes arise and copyright lawsuits are filed, it's our courts that look at Section 102 and interpret what Congress intended. Thus, judges' written opinions about copyright law, including Section 102, form the basis of our understanding of what "original" and other copyright terms actually mean.

So, when trying to determine what a word or term means, we have to turn to published court opinions to come to a conclusion. And when it comes to the

meaning of "original" in section 102, one thing courts make crystal clear is that for a work to be "original," *the author must not copy the work from any other source*. In other words, the work must be the product of the author's imagination. If the author copies the work from another source, then the work is not "original" and there can be no claim of copyright. Indeed, as we'll see later, if the author copies from another source, the author may be guilty of violating someone else's copyright.

Let's say you don't copy from someone else, but what you write just happens, rather miraculously and coincidentally, to copy another person's work? Sure, this isn't likely to happen, but authors frequently write works that are remarkably similar. So, the question is: If you write a work that is identical or extremely similar to a pre-existing work, can you still get copyright in your work? Theoretically, the legal answer is yes you can, so long as you didn't copy from any other source.[11]

So, "original" in Section 102 means you didn't copy someone else's work. Interestingly, courts have also said the word "original" has an additional, secondary meaning. I can highlight this additional meaning by asking some questions: What if I write out the alphabet, forwards and backwards, 200 times—can I claim copyright in my work? What if I write a play where a single character stands on a bare stage and simply utters the word "cat" over and over again for two straight hours—can I claim copyright to this? Or, what if I write the following poem, "One and one is two, I love you"—is this copyrightable? The answer in all three cases is almost certainly no, the work can't be copyrighted.

True, I didn't copy these works from any other source, and yet a court would undoubtedly rule they are not "original." That's because, to be original, courts say a work must have some measure of actual creativity to it. How much creativity? The answer is not much at all. The United States Supreme Court ruled in the case of *Feist v. Rural Telephone Company*,[12] that to be original, a work must possess:

> at least some minimal degree of creativity To be sure, the requisite level of creativity is extremely low; even a slight amount will suffice. The vast majority of works make the grade quite easily, as they possess some creative spark, 'no matter how crude, humble or obvious' it might be.[13]

Have you ever seen a Three Stooges short? If you have, you know the main characters spend much of their time hitting each other, poking their eyes out, clubbing each other in the head with hammers, anvils, axes and saws, saying "nyuk nyuk nyuk," and generally acting like three-year-old boys. Those scripts easily qualify for copyright, proving the point that not much real creativity is required (though I readily admit I love *The Three Stooges*).

The truth is, courts hesitate to rule on what is and what isn't creative. Judges are jurists, not novelists or film directors. They are not trained to judge the creative merits of a script or painting. So unless it's evident that no real attempt was made to be creative, courts are likely to find a work is original.

The question of whether a work is sufficiently creative to be considered "original" has sometimes been raised in connection with photography. For example, is a family photo a sufficiently creative work to be considered "original"? Section 102 says that works of authorship include "pictorial, graphic, and sculptural works," so what if I take a photograph of my family or the Mona Lisa with my iPhone, or what if I set up a movie camera in a stationary position and just let it roll—do these works have sufficient originality to merit copyright protection?

The answer, generally speaking, is yes. For example, in *Bridgeman Art Library v. Corel Corp.*,[14] the court had to determine whether exact photographic reproductions of art works qualified for copyright. The court said that they could, recognizing that:

> [t]here is little doubt that many photographs, probably the overwhelming majority, reflect at least the modest amount of originality required for copyright protection. 'Elements of originality . . . may include posing the subjects, lighting, angle, selection of film and camera, evoking the desired expression, and almost any other variant involved.'"[15]

Works Fixed in a Tangible Medium of Expression

Finally, to be eligible for copyright, an "original work of authorship" must be "fixed in any tangible medium of expression now known or later developed from which [the work] can be perceived, reproduced, or otherwise communicated either directly or with the aid of a machine or device." This simply means that the work must be written down on some tangible object such as paper, or recorded on audiotape or videotape, or on a DVD or CD, or stored in a hard drive or fixed by some other means.

So what if you improvise a comedy routine at open-mike night, or give a speech off the cuff to your local Rotary Club? In these cases what you say won't be protected by copyright since you didn't fix either of these works in a tangible medium of expression.

WHAT CAN'T BE COPYRIGHTED?

Interestingly, even if you fix your original work of authorship in a tangible medium of expression, not every aspect of your work may be protected by copyright. In other words, some component parts of your work may be unprotected and free for others to use.

The most difficult and important issue here has to do with *ideas*: Can you copyright a story idea? Can you copyright a story idea that underlies a finished screenplay, or a story idea you've written down but haven't yet developed into a screenplay? We'll also discuss whether you can copyright *facts* dramatized in a movie or TV show, whether you can copyright *titles*, and whether you can copyright *fictional characters* like James Bond or Mickey Mouse.

Ideas

If you pose the question, "Can ideas be copyrighted," the answer is easy: No, they can't. If you pose the question, "What is and what isn't an idea," the answer is unfortunately far more difficult to determine.

Section 102 of the 1976 Copyright Act says, "in no case does copyright protection for an original work of authorship extend to any idea." So, an idea never receives copyright protection. Not ever. A mere idea, even if written down, even if it serves as the foundation for a finished screenplay, can never in and of itself be a literary "work of authorship" deserving of copyright protection. You can write down your idea, you can develop it into an award-winning screenplay, you can fix it into a tangible medium of expression using concrete, superglue and the gigantic magnets at the Large Haydron Accelerator, and there will be no copyright protection. So, show your friend a great movie idea you've written down, and don't bother going to court if your now ex-friend steals it. There's nothing you can do about it because ideas can't be copyrighted; they are, as one court observed, "as free as air."[16]

Courts say that only the *expression* of an idea (and we'll examine what this means in a moment) is entitled to copyright protection.[17] In other words, only the *expression* of an idea can be an original work of authorship deserving of copyright. So write down a mere idea for a movie and you don't have a literary "work of authorship" capable of receiving copyright protection. Write down the *expression* of that idea and, presto, you have a literary "work of authorship" under Section 102 that can be copyrighted.

All of which leads to the obvious question: What constitutes a mere idea and what constitutes copyrightable expression of that idea? If you've guessed that the expression of an idea is a more elaborate, more detailed, more developed, more creative work than the idea itself, you're absolutely right. But where does one thing become the other? What's the formula to tell the difference between idea and expression? Surely the law would make so important a distinction easy to determine, right? Wrong.

Not even the great jurist Learned Hand (yes, that really was his name) could find a hard-and-fast rule to distinguish mere ideas from copyrightable expression. Decisions on these issues, he said, "must . . . inevitably be ad hoc."[18]

In *Nichols v. Universal Pictures*,[19] Judge Hand wrote the "abstractions test" as a guide:

> Upon any work, and especially upon a play, a great number of patterns of increasing generality will fit equally well, as more and more of the incident is left out. The last may perhaps be no more than the most general statement of what the play is about . . . but there is a point in this series of abstractions where they are no longer protected, since otherwise the playwright could prevent the use of his "ideas," to which, apart from their expression, his property is never extended. *Nobody has ever been able to fix that boundary, and nobody ever can*. (Emphasis added)[20]

Does that help you clearly understand what's an idea and what's copyrightable expression? I didn't think so. As Judge Hand indicates, there never has been and never will be an objective set of rules to distinguish ideas from expression.

There may not be an objective test, but that doesn't mean there's no basis for analysis. So, let's take Judge Hand's words to heart and look at patterns of generality and abstraction when it comes to stories; let's see if plain sense and reason can help distinguish mere ideas from copyrightable expression.

Let's say I have an idea for a movie. The idea is: At the risk of life and limb, our hero travels to search for something very valuable and important but in the end discovers something unexpected—some valuable truth about himself.

I would say this is the abstract statement of a mere story idea that can't be protected by copyright; in Judge Hand's words, it is "the most general statement of what the play is about." Think of all the movies that fit into this general pattern: *The Wizard of Oz*, *Star Wars*, *Raiders of the Lost Ark*, *Galaxy Quest* and *Inception* come to mind immediately. These are all entirely different movies, but the abstract idea of a quest leading to self-discovery lies in each of them.

Let's add a bit of detail and make the idea a little less general. What if I add that the hero will meet a group of friends along the way who will help and protect him? Yes, this may make our idea slightly less general, but I say what we have here is still extremely general, still a mere idea for a story, since thousands of stories include friends who help the hero.

Let's add some more detail. What if my hero travels to a strange and distant place during his quest? Have I now added enough detail for my story to cross over from idea to expression? I say no, I'm not even close, because this is still way too general and would apply equally to all of the movies I just listed.

Now, what if I swing the pendulum the other way and add a great deal of highly specific detail? What if I say that, in my story, the hero is a bored and restless Kansas farm girl who, thanks to a tornado, travels to a strange place, Oz, where

she meets some friends—the Scarecrow, Cowardly Lion and Tin Man—then tries desperately to get home, believing she has to get an evil witch's broomstick, but in the end learns she could always go home and that everything she ever needed or wanted was there with her family? Or, what if I say that, in my story, the hero is a young man living in a galaxy far, far away whose guardians are killed by the evil empire, so he moves throughout the galaxy in search of a princess kidnapped by the evil empire, meets some friends (the daring Han Solo, his Wookiee friend and two droids), ends up destroying the evil Death Star and in the end discovers he's destined to be a Jedi Knight . . . oh, and that the villain is actually his father.

The Wizard of Oz and *Star Wars*, though entirely different stories, are both rooted in the very same general ideas mentioned earlier. However, when sufficient specific inventive detail is added, we have clear expression of those ideas. And, in my opinion, that's really the key: specific invention. As Judge Hand said, it's easy to find similarities in different stories at abstract levels, but it's the specific invention—the unique product of the storyteller's imagination—that separates an idea from its expression and makes a work worthy of copyright.

It's important to understand why, as a matter of public policy, ideas should not be copyrightable. Let's take a different idea for a movie: "A man is in love with a woman, but so is another man, and this causes all sorts of problems between the three characters." If I could copyright this idea and legally own it, I would be able to prevent thousands of stories from being written, including *Casablanca*, *Broadcast News*, *Pirates of the Caribbean*, *Gone with the Wind*, *The Graduate*, and *The Hunger Games*. These are all entirely different movies, but they share the very general idea of a love triangle. What if I had the idea of writing a story about a ghost-like entity that terrorizes people in their homes? If I could copyright this idea, I could stop such films as *Poltergeist*, *Paranormal Activity*, *The Amityville Horror*, *Ghostbusters*, *The Sixth Sense* and so on.

Copyright is meant to better society by incentivizing people to create. However, if mere ideas could be copyrighted, then far too much creative work would be stopped cold. Not only would this result run afoul of the reasons for copyright, it would run afoul of our society's commitment to free speech, which we'll discuss in Chapter 5.

While the public policy behind these rules makes sense, authors are still left with a real problem: determining precisely how much specific invention is necessary to constitute expression of an idea. Sure, write a full-blown original script and you have expression; we'll all agree on that. But does that mean if you write 98 percent of the script you don't have expression? What about 75 percent? Or 50 percent? Or 25 percent? Or, what if you write a 10-page treatment or a 3-page outline—are these long enough to contain an idea's expression and therefore merit copyright protection?

This is important because authors want to share their stories with potential benefactors like producers and studios but don't want their stories stolen. So knowing where the line is between idea and expression is important.

Say I write a one-paragraph summary of a story and plan to show it to a producer— could that one paragraph be sufficiently original with sufficient specific invention to be considered expression? My guess is probably not. Say I want to show a producer a detailed 10-page treatment of a movie filled with specific invention—would that be considered expression, i.e., would that be a literary work of authorship and therefore protected by copyright? I would guess it certainly could be, depending on what you wrote. Can a one-page outline or a 3-page synopsis be protected? Hard to say.

I wish I could tell you exactly where the line is, but I can't. No one can. What I can say is the more you write, the more you specifically invent, the more defined your characters are, the more specific the plot details, the more your own originality is on the page, the better the odds your work will be considered expression and therefore protected.

PROTECTING IDEAS VIA CONTRACT LAW

So now maybe you're nervous about sharing what might be considered a mere idea. That's understandable. You should be aware, however, that while copyright law doesn't protect your ideas, contract law *may* protect them under certain circumstances.

Say you're a screenwriter and you think you have a wonderful idea for a film. Now let's say you don't want to write a lengthy treatment of your idea; in other words, you don't want to take the time to write something sufficiently detailed and expressive to be deserving of copyright protection. Say, instead, you just want to orally describe, or "pitch," your idea to a producer to try and generate interest. Since pitches are spoken and thus not fixed in a tangible medium of expression (unless you record your pitch or write it down word for word), pitches themselves can't be copyrighted. And, because pitches are usually very brief, even if you did write one down it may not be sufficiently expressive to be considered a literary work of authorship and thus copyrightable.

Still, pitches take place every day in the entertainment industry. The truth is, if you (or in the world of Hollywood, your agent) have a solid relationship with a potential business partner, say a producer or motion picture studio, the likelihood of someone stealing your idea is low.[21] But it does happen occasionally.[22] So what do you do—how can you protect your ideas when you pitch them?

In California, where most pitches take place, courts have ruled that when you reveal an idea to a potential business partner, that idea *can* be protected, not by federal copyright law but by California's state law of "implied contract."[23]

As you know, contracts describe the specific terms of an agreement bargained by two or more parties. Normally, if I go into a studio and pitch an idea to a producer and the producer wants to develop the idea into a movie, a contract will be written describing the terms of our bargain: I will get money to write the idea into a screenplay, and the producer will get a script she thinks can be made into a movie.

When someone steals an idea, however, obviously no contract has been negotiated and no payment made. Still, California courts can "find" a contract—an "implied contract"—even when one doesn't physically exist, and a court can demand that payment be made pursuant to that implied contract. However, for California courts to do this, it must be apparent that "the plaintiff . . . disclosed the work to the [potential buyer] for sale, and did so under circumstances from which it could be concluded that the [potential buyer] voluntarily accepted the disclosure knowing the conditions on which it was tendered and the reasonable value of the work."[24] In other words, the pitch must occur in a business setting where the person pitching is clearly trying to sell the idea to the listener and where both sides know payment will be required if the idea is eventually used by the listener.[25]

So let's say I'm playing golf with a Netflix executive. I'm standing on the beautiful fifteenth fairway of the Riviera Country Club when, just as my playing partner is about to swing, I blurt out an idea for a new Netflix series. What if the executive subsequently uses my idea without paying me? Answer: I'm out of luck, because there's no implied contract here; blurting out an unsolicited idea on the fifteenth fairway hardly sets up the expectation that the listener will have to pay for what was communicated. If it did, I could blurt out ideas all day long and put listeners in a terrible legal bind.

No, the circumstances of the pitch must demonstrate that the listener—the producer, director, studio executive or whoever—is obviously expected to pay for the idea if he uses it. Therefore, California courts have usually required that:

- Before someone submits an idea, that person must clearly condition the disclosure on the listener's agreement to pay for the idea if the listener uses it.
- The listener must know or should know the conditions on which the disclosure is being made before it's made.
- The listener must voluntarily accept the submission on the idea conveyor's terms and thereby impliedly agree to pay the idea conveyor.[26]

Some California courts have said that a specific request for money up front is not necessary—that the business circumstances alone surrounding the pitch can be used to prove that both parties knew payment would be required if the idea was subsequently used. *Being invited* into a producer's business office to pitch an idea would be evidence of such a business circumstance.[27]

Be aware that not all states follow California's rule, so knowledge of your state's law is essential if you want to protect your ideas. And be aware of this as well: To prevail on an implied contract claim, one must prove not only that both parties understood that payment was expected but also that the listener actually used the idea. Since so many ideas circulating in Hollywood are so similar, it's never easy to prove it was *your* idea that gave birth to a subsequent project. The producer can always argue he developed the idea from another source.

To summarize, ideas are not protected by copyright law and are free for everyone to use. Only the expression of ideas fixed in a tangible medium of expression receives copyright protection. Therefore, it's always best to develop your idea, be it a story or something else, so that it has sufficient detail, specificity and original invention to be considered expression protectable by copyright. Admittedly, the line between idea and expression is difficult to tell, but the more you develop your idea, the safer you are. When pitching ideas, it's always best to pitch to people you know and trust. In the absence of a good relationship with the person you're pitching to, make sure the discussion of your idea takes place in a business setting, preferably one where you've been invited to pitch and where both sides recognize that compensation will be required if the idea is subsequently used.[28]

Facts

James Cameron wrote and directed *Titanic*, a blockbuster movie based on a historical fact: the sinking of the great ocean liner Titanic. Does this mean no one can now make a movie about the disaster because the event itself has been copyrighted?

Section 102 of the 1976 Copyright Act is silent on whether facts are copyrightable. The courts, however, have been clear: *Facts cannot be copyrighted.* Facts are free for anyone to use, just like ideas. If someone could copyright facts, our ability to discuss and test important issues in the so-called marketplace of ideas would be drastically curtailed, which would surely run afoul of the First Amendment's free speech guarantees.

Therefore, you can't prevent others from writing about or dramatizing a fact simply because you did so first. For example, Steven Spielberg directed *Lincoln* from a screenplay by Tony Kushner. The film dramatized the last few months of President Lincoln's life and his push to get the 13th Amendment passed by Congress. Does the film prevent someone else from making a movie about the last months of Lincoln's life or his desire to pass the 13th Amendment? The answer is no. Nor does *Titanic* prevent others from making a movie about the Titanic's demise.[29]

What the authors of historical or biographical movies *can* prevent, however, is someone copying their *expression* of the facts. While both *Lincoln* and *Titanic*

are based on and dramatize historical fact, both films are replete with invented dialogue and scenes, suppositions based on fact, and the occasional inclusion of fictional characters. Movies are not documentaries, and so films based on real people and actual events usually take "artistic license" to make the storytelling more interesting. These storytelling inventions generally constitute the author's *expression* of the historical facts, and it is this expression that copyright law protects.[30] So, write about the Titanic if you wish—just don't include what James Cameron specifically invented: don't have a poor young man who wins a trip on the Titanic by winning a poker game, who stands at the bow of the ship and yells, "I'm king of the world," and who falls in love with a rich young women who's trapped in a loveless relationship whom we meet at the beginning of the story when she's an old woman.

Titles

You can't copyright a title of a book, movie, song, television show or video game. Titles simply don't have sufficient expression to be worthy of copyright protection. So don't bother registering your title with the United States Copyright Office, and don't think you have a copyright lawsuit if someone rips off your title.[31]

Fictional Characters

Movies, television shows and new media stories are usually told through the eyes of fictional characters. We know a movie, television show or new media work can be copyrighted,[32] but what about the fictional characters? Can a fictional character be copyrighted separate and apart from the stories that include them? For example, Ian Fleming created the character of James Bond, a cool, fearless British spy equally adept with a gun and a quip—a man licensed to kill bad guys who likes his martinis shaken not stirred and who all women find amazingly irresistible.

Is the character of James Bond by itself copyrightable, or only the stories incorporating the character? If the character can't be copyrighted, then anyone can use "James Bond" in a film, TV show or used car commercial.

Once again, Section 102 is silent on this issue. Unfortunately, in this case, court decisions are slightly more muddled. What court cases do demonstrate, however, is that fictional characters can transcend the mere "idea" of a character, such as the "crusty but benign boss" or a "femme fatale," or "nerdy guy" or "British spy," and become the "expression" of a character. When a fictional character makes the leap from mere idea to expression, then that character can be copyrighted.

One of the important early cases examining this issue, *Warner Brothers Pictures v. Columbia Broadcasting System*,[33] cast real doubt on whether a fictional character can be copyrighted. In that case the court said, "It is conceivable

that the character really constitutes the story being told, but if the character is only the chessman in the game of telling the story he is not within the area of the protection afforded by the copyright."[34] So, according to this court, unless a character and story are one and the same (which arguably is very rare), the character cannot be copyrighted.

Twenty-four years later, however, the same court ruled differently when the characters in question were Mickey Mouse and some of his Disney cartoon friends. In *Walt Disney Productions v. Air Pirates*,[35] Mickey, Minnie, Goofy and others Disney cartoon characters were, without Disney's permission, depicted in an underground comic book taking drugs, engaging in debauched sex and generally behaving in ways that didn't happen back then in the world of Disney . . . *ever*. So, Walt Disney Productions sued, claiming its cartoon characters were each protected by copyright and that those copyrights had been violated. Here, the court noted its previous ruling that characters created to serve a story are not entitled to copyright, but then said,

> When the author can add a visual image, however, the difficulty is reduced Put another way, while many literary characters may embody little more than an unprotected idea . . . a comic book character, which has physical as well as conceptual qualities, is more likely to contain some unique elements of expression.[36]

So, a cartoon or animated character, which has a precise physical appearance along with various anthropomorphic qualities, can transcend the "idea" of a character and become the "expression" of a character.

But can't a non-animated fictional character also be sufficiently detailed to transcend the idea of a character and become copyrightable expression? Doesn't the character of, say, James Bond transcend the broad "idea" of a suave British spy and become the protectable "expression" of a suave British spy? While it's impossible to predict what courts will do in all instances, I think it's likely many courts would now say a detailed, specific fictional character *can* be protected by copyright.[37]

For example, in *Burroughs v. MGM*,[38] the question was whether Tarzan, the fictional "ape-man" character created by author Edgar Rice Burroughs and depicted in many films, could be copyrighted. The court ruled that it could, saying:

> characters that are well-delineated in the Tarzan works of Edgar Rice Burroughs are protected from infringement by the copyright in the work itself The only issue remaining is whether any of the characters . . . were sufficiently delineated by the author to be copyrightable. It is beyond cavil that the character "Tarzan" is delineated in a sufficiently distinctive fashion to be copyrightable Tarzan is the ape-man. He is an individual closely in tune with his jungle

environment, able to communicate with animals yet able to experience human emotions. He is athletic, innocent, youthful, gentle and strong. He is Tarzan.[39]

In *Metro Goldwyn Meyer v. American Honda Co.*,[40] a court found that the character of James Bond *is* a "well delineated" character and thus protected by copyright.[41] Other courts have found that Rocky Balboa from the *Rocky* movies and the character of Godzilla are sufficiently well delineated to be copyrightable.[42]

WHEN DOES COPYRIGHT OWNERSHIP BEGIN, AND WHAT DO YOU HAVE TO DO TO SECURE COPYRIGHT OWNERSHIP?

Let's say you write an original screenplay and store it on your computer's hard drive. Under the terms of Section 102 of the 1976 Copyright Act, you have created an original work of authorship and fixed it in a tangible medium of expression. Therefore, your work is copyrightable. But what do you have to do, if anything, to legally acquire copyright ownership? Do you have to record your work with the United States Copyright Office, or write a copyright notice on your work using the © symbol, or pay money to a lawyer, or perform some bureaucratic, time-consuming task?

Fortunately, and perhaps amazingly, the answer is no. Indeed, this is one of the truly rare and wondrous times when the law actually makes something easy: *Once you have fixed your work of authorship in a tangible medium of expression, you instantly own the copyright.* You author it, you own it.

It used to be you could lose copyright protection if you published your work without a proper copyright notice, which included the © symbol or the word "copyright" plus the copyright owner's name and the date of publication. However, that requirement ended on March 1, 1989, when the United States signed the International Berne Convention for the Protection of Literary and Artistic Works (usually simplified to the "Berne Convention"). Thus, as of March 1, 1989, a copyright notice on published works was no longer necessary.[43]

Though the law now grants you instant ownership of the copyright, it is always wise to generate concrete proof that you are indeed the work's creator and therefore the true copyright owner. You not only want to create proof that you're the work's author, you also want to create proof of *when* you wrote the work.

Why is generating proof of when you wrote something so important? Because it's not uncommon that two people will write similar stories or songs or other types of work. It happens all the time. And when it happens, it's not unusual for one author to think the other must have copied from them. So if someone should ever accuse you of stealing their work, how wonderful it would be to prove that you wrote your work

before they wrote theirs—obviously, you could not have copied from something that didn't yet exist.

You can generate proof (a) that you wrote a work and (b) when you wrote it by registering your work with the United States Copyright Office. All you need to do is file the necessary documents and pay the required fee, which is currently $35 for online filing.[44] Additionally, registering your work with the United States Copyright Office is mandatory should you ever want to file a copyright infringement lawsuit.[45] If you register your work either within three months of its initial publication or within one month of learning that your copyright has been violated, you will also be entitled to substantially increased money damages should you win a copyright lawsuit.[46] And, if you register your work within five years of its initial publication, the registration certificate issued by the Copyright Office becomes prima facie evidence that you own the work and that the copyright is valid.[47]

Many screenwriters choose to register their scripts with the Writers Guild of America, West registry. While registering with the Guild does create proof of authorship and time of authorship, it does not provide the additional legal benefits granted to those who register with the Unites States Copyright Office. However, registering with the Guild is less expensive—$20 at the time of writing, and registration lasts five years.[48]

Always remember: You legally own the copyright to your work the instant you fix it in a tangible medium of expression—i.e. the minute you write it down. Registration is merely a means to create proof that you actually wrote it, when you wrote it, and offer you legal advantages should you ever want to file a copyright infringement lawsuit.

WHAT SPECIFIC RIGHTS DO COPYRIGHT OWNERS RECEIVE?

Okay, so you've written an original work of authorship and fixed it in a tangible medium of expression. Congratulations, you own the copyright to your work. But what exactly do you own? What rights does copyright give you?

Section 106 of the 1976 Copyright Act describes the specific, exclusive rights that copyright owners receive. Section 106 says:

> Subject to sections 107 through 122, the owner of copyright under this title has the exclusive rights to do and to authorize any of the following:
>
> (1) to reproduce the copyrighted work in copies or phonorecords;
> (2) to prepare derivative works based upon the copyrighted work;
> (3) to distribute copies or phonorecords of the copyrighted work to the public by sale or other transfer of ownership, or by rental, lease, or lending;

(4) in the case of literary, musical, dramatic, and choreographic works, pantomimes, and motion pictures and other audiovisual works, to perform the copyrighted work publicly;

(5) in the case of literary, musical, dramatic, and choreographic works, pantomimes, and pictorial, graphic, or sculptural works, including the individual images of a motion picture or other audiovisual work, to display the copyrighted work publicly; and

(6) in the case of sound recordings, to perform the copyrighted work publicly by mean of a digital audio transmission.

To be clear, these rights belong exclusively to the copyright owner, and if another person exploits any of these rights without the copyright owner's permission, that may constitute copyright infringement.

We need only very briefly discuss here the last two exclusive rights mentioned in Section 106. The fifth right mentioned gives copyright owners the right to physically display for others what they have created. This usually applies to works of fine art, such as a painting, sculpture or photograph. This right, then, has little application in the world of film, television and new media (though of course it does apply to film posters and the like). The sixth right concerns sound recordings and will be discussed in the next chapter. The first four exclusive rights, however, are vitally important, so let's turn to them now.

The Right to Reproduce

Section 106(1) gives copyright owners the exclusive right "to reproduce the copyrighted work in copies."[49] Reproduction simply means to copy a work in tangible form. If you quote out loud all the dialogue of a stage play to entertain an audience, you haven't violated the reproduction right because you didn't make any tangible copies (though you may have violated the author's exclusive performance right, which we'll discuss shortly).

Copying *all* of someone's work without permission, such as making an unauthorized copy of an entire film, clearly violates the reproduction right. The tough issue is when someone intentionally copies only a portion of the work. We'll talk about copyright infringement later; suffice it to say for now that if you steal a substantial portion of a copyrighted work and incorporate it into your own, a court may find you have violated the copyright owner's reproduction right.

The Right to Prepare Derivative Works

Section 106(2) grants the copyright owner the exclusive right "to prepare derivative works based upon a copyrighted work." A derivative work is one that's "derived" from an earlier work; think of it simply as an adaptation of a preexisting copyrighted work.[50]

The *Harry Potter* movies are adaptations of J.K. Rowling's wonderful copyrighted books and are therefore derivative works. Similarly, the movie *To Kill a Mockingbird* is a derivative work based on Harper Lee's book, and the filmed versions of *Pride and Prejudice* are derivative works based on Jane Austen's novel.

Movie and television shows can themselves breed derivative works. For example, *The Hangover* is an original movie based on a script by John Lucas and Scott Moore. *Hangover 2* and *Hangover 3*, however, are derivative works based on the preceding *Hangover* movies. The film *Get Smart* was a derivative work based on the very funny 1960s television series by the same name.

Here is a tricky but important point: A derivative work by definition adapts the copyrighted *expression* of the underlying work. Say I write a book about a young boy with magical powers who is then trained at school to use those powers. Have I necessarily created a Harry Potter derivative work? Absolutely not. I've merely copied an unprotected story idea—the idea of a boy possessing magical powers who goes to school to learn how to use them. But at some point I will cross the line into a Harry Potter derivative work when I start to copy the specific *expression* in J.K. Rowling's books; that is, when I start to include too much of what she specifically invented, such as the specific characters of Harry and his friends, Voldemort, Hogwarts and so on. Obviously, the *Harry Potter* movies, by design, copied a great deal of what Ms. Rowling invented and are thus clearly derivative works.

Why does Section 106 give the original author the exclusive right to make derivative works? Without this right, an author's original work, say a book, could be adapted into a lucrative film project by someone else, depriving the original author of the chance to benefit financially from what she created. Additionally, without this right, a less-than-ethical author could intentionally adapt a copyrighted work, use only a small but significant portion, and not violate the reproduction right. This means, without the derivative right, our unethical author would have stolen something but be free from legal consequence.

The bottom line here is this: Unless you or I have permission from the copyright owner, we can't write our own adaptation of a copyrighted work. It may happen in fan fiction all the time, but that doesn't mean, strictly speaking, copyrights aren't being violated.[51]

The Right to Distribute Copies

Section 106(3) grants the copyright owner the exclusive right "to distribute copies or phonorecords of the copyrighted work to the public by sale or other transfer of ownership, or by rental, lease, or lending." This seems pretty

straightforward. Once an author creates a work, only she can thereafter sell copies (or transfer ownership by some other means). However, once an author actually sells a copy of the work, the new owner is free to resell *that copy* without any restrictions whatsoever. In other words, the author controls the first sale of copies, but doesn't control the subsequent resale of those copies. Commonly referred to as the "first sale doctrine," this rule is described in Section 109 of the 1976 Copyright Act.

The reason for the first sale doctrine is simple: When the initial sale is made, the author receives fair compensation for the work. Therefore, the author's financial interest has been satisfied and the new owner is free to do as they please. The first sale doctrine allows, among other things, stores to resell or rent DVDs and individuals to sell their DVDs on Ebay.[52]

The Right to Perform Publicly

In the case of movies and other audiovisual works, as well as literary, musical, dramatic and choreographic works, Section 106(4) grants the author the exclusive right "to perform the work publicly." So let's ask: What does "perform" mean in this context, and what does it mean to perform a work "publicly"?

Section 101 of the 1976 Copyright Act says that "to perform" a work means:

> to recite, render, play, dance, or act it, either directly or by means of any device or process or, in the case of a motion picture or other audiovisual work, to show its images in any sequence or to make the sounds accompanying it audible.

In other words, when a movie is projected in a theater, it's performed; when a television show is broadcast on TV, or when you watch an episode of *House of Cards* on Netflix, it's performed; when a song is played on the radio or at your local baseball stadium between innings, it's performed.[53]

What does it mean to perform a work "publicly"? The 1976 Copyright Act attempts to define what a "public performance" is, but the language is somewhat vague,[54] and there are exemptions from the public performance rule.[55] For our purposes we can say that the overwhelming majority of film, television and internet showings and broadcasts are "public performances" because they are usually meant for public consumption and are indeed viewed by the general public. So, invite a few friends over to look at your DVD copy of *Godzilla vs. Space Godzilla* and we'll all agree this isn't a "public" performance but a private one. But show a movie to a few hundred paying customers in a movie theater or some other large hall, broadcast a show on television or over the internet, or play a song on the radio, and that's surely a public performance, which is the exclusive right of the copyright owner.

Licensing and Divisibility of Copyright

We now know that the author of a copyrighted work owns some extremely important exclusive rights, among them the right to copy the work, to sell copies, to perform the work publicly and to make derivative works. That's all wonderful, but think about the tremendous difficulties you'd face actually trying to exercise those rights by yourself. If you write a book, how are you actually going to make 40,000 copies of it? And how will you manage to sell it across America, or translate it into 25 different languages and sell it to people around the world? If you produce an independent film, how are you personally going to have it performed in movie theaters across America or, say, in Europe or Asia? How are you personally going to manufacture and sell DVDs or manage the technology of encoding and making the film available on the web? The truth is, neither you nor any one else, nor any single company for that matter, can do all these things.

So, authors of copyrighted works contract with other people and companies to copy, sell and perform their work, as well as make derivative works. For example, let's say you write a novel and want to sell it. Only you have the right to copy the book, only you have the right to sell those copies, and only you have the right to make derivative works. However, by contract, you can sell (or "license" as it's called in the entertainment business) the right to copy and distribute the book to Company "A." Or, should you so desire, you can license the right to copy the book to Company "A," the right to distribute the book to Company "B," and the right to make a film based on the book, i.e. to make a derivative work, to Company "C."

What I've just described gets at a very critical point that must be clearly understood: You can carve up, or divide, each of your exclusive copyright rights into as many discrete pieces as you want and, by contract, convey each piece to whomever you want. If you make an independent movie, you can, by contract, license the right to distribute the movie in America to Company "A," the right to distribute the movie in Mexico and Canada to Company "B," the right to distribute the movie in Europe to Company "C," the right to distribute the movie everywhere else in the world to Company "D," and the worldwide right to create and sell merchandise based on the film's characters to Company "E."

If you want, you can carve your exclusive rights into separate time periods; Company "A" might have the right to distribute your film for 10 years in England, Company "B" might have the right to distribute the film for 20 years in Germany, and Company "C" might have a 5-year merchandising right.

Or, you can carve up your rights on the basis of exclusivity. You might give Company "A" an exclusive license to distribute your book in Europe and companies "B" and "C" a nonexclusive license to distribute your book in North America.

In short, you can divide up your rights any way you want; the possibilities are limited only by one's imagination and the willingness of others to buy the specific rights you want to sell.

Why is divisibility of copyright so critical to authors and others in the entertainment business? Because companies around the world, be they in the business of copying works, distributing them, performing them or merchandising them, make money based on their own unique capabilities. Obviously, not every company in the world has the same strengths; not every company can best distribute a movie in Brazil or best perform a movie on television in Ireland or best figure out how to digitally compress a movie and make it available on the web. Nor can every company manufacture toys or records or know how best to market your work in America, or Asia, or South America.

By intelligently dividing up one's exclusive rights granted by copyright, the copyright owner can hope to give each separate piece to companies best situated to exploit them. This allows copyright owners to maximize the economic potential of their works and thus their own financial gain. Divisibility of copyright has therefore been critical to the enormous success of the entertainment business. It benefits the huge corporations that now control a large portion of the entertainment industry and, as we'll see in Chapter 13, it also benefits independent filmmakers trying to raise cash for their first productions.

I'll conclude this section with a bit of terminology. You noticed I used the word "license" above. In the entertainment business, contracts that transfer a portion of one's copyright in return for payment are called "licenses." They may be called licenses, but they are simply contracts, nothing more, nothing less. So, negotiate an agreement with company "A" to distribute your movie in return for a percentage of the profits or with company "B" to publicly perform your song for a set fee, and you've negotiated a copyright "license." The author, or copyright owner, is the "licensor" and the other party, the buyer, is the "licensee." So next time you're eating in Beverly Hills and you hear someone say, "Hey, Joe, I just licensed my movie's distribution rights to Netflix," you'll know what they're talking about.

JOINT WORKS

We know who owns the copyright if one person authors a work—obviously, the author owns the copyright.[56] But who owns the copyright when two or more people work together to create a copyrighted work?

The copyright issues surrounding collaboration and so-called "joint works" can raise problems for people, especially people just starting out who choose to partner with someone. A person who works on a project with a partner may

believe that, by virtue of the partnership alone, both partners are legal co-owners of a work when in fact the law gives sole legal ownership to just one partner. Or, a partner may believe that, by virtue of her singular effort, she should solely own a work when in fact, under the law, ownership is actually shared with her partner. So let's see if we can untangle these issues.

Section 101 of the 1976 Copyright Act defines a "joint work" as "a work prepared by two or more authors *with the intention* that their contributions be merged into inseparable or interdependent parts of a unitary whole" (emphasis added). Stated a little less formally, a joint work is where each collaborator knows and intends that her work output will be merged to form one complete work. A composer and lyricist know and intend that their efforts will form one single work, a song. Screenwriting partners each know and intend that their efforts will form one complete work, a screenplay. Each of these is an example of a joint work.[57]

If you plan to work with a partner to create a copyrighted work, there is a potential problem you need to understand. We know that mere ideas are not copyrightable, only the expression of ideas. So what happens when one collaborator contributes an idea and the other collaborator contributes all of the expression of that idea? To put this in more concrete terms, what if I go to a writing partner with a great idea for a movie and my partner actually writes the script? Do we jointly own the copyright or just the person who actually wrote the script? What if after communicating my idea I meet with my partner repeatedly, going over what she's written, and offering my thoughts, suggestions, ideas and encouragement?

There would seem to be some disagreement among courts as to how these sorts of cases should be resolved.[58] The majority view, however, appears to be that each collaborator *must contribute actual expression of ideas* in order for the work to be a joint work.[59] In other words, each screenwriting partner or each member of a songwriting team must write copyrightable expression to claim joint ownership. So, where one person supplies only ideas and encouragement and the other does the actual writing, most courts will say only the actual writer owns the copyright.

So, if you're the "idea person," what do you do? Good ideas are important, but copyright law offers you no protection. Copyright, however, can be sold or otherwise transferred by contract.[60] So, if one partner supplies only ideas and suggestions, and the other partner actually writes the work, these partners can contract with each other to share copyright. Alternatively, the partners can agree that one will be the writer and the other will be the producer, in which case the producer will have to option the rights to the script from the writer (see Chapter 12 for a discussion of optioning rights).

Let's say two people do co-author a joint work—what exactly does each person own? Section 201(a) of the 1976 Copyright Act simply says, "The authors of

a joint work are co-owners of copyright in the work." What this means is that each collaborator shares *equally* in all revenue earned from the copyright.

But what if one collaborator does a lot of work and the other not so much? What if one collaborator's work creates 75 percent of the copyrightable expression and another collaborator creates 25 percent? Do these collaborators share equally all revenues generated by the copyright, or are the revenues split 75/25? The answer is that they share equally regardless of the proportionate size of their contribution.

We discussed that copyright generates revenues when the various rights granted to copyright owners (the right to copy, sell, perform publicly, make derivative works and display) are commercially exploited. But must collaborators of a joint work agree on *how* to exploit their copyright? Can one joint owner go off and negotiate a license agreement without the knowledge or consent of the other? In America the answer is yes when one party grants a *nonexclusive* license. If, however, one party wants to grant an exclusive license, all joint owners will probably have to agree, otherwise the courts will likely treat the conveyance as a nonexclusive grant.[61] If, for example, one collaborator wants to give company "A" the exclusive right to distribute the joint work in America, the other collaborator(s) will almost certainly have to agree before an exclusive license can actually be transferred. However, if one collaborator wants to give company "A" the *nonexclusive* right to distribute in America, the collaborator can do this unilaterally.[62] In all cases, however, revenues generated from *all* licenses are split equally among the joint authors.[63]

WORK FOR HIRE

The entertainment industry routinely employs people to create copyrighted works. Every day, production companies hire people to write scripts, compose music and direct movies and television shows.

The question becomes, who owns the copyright when someone is hired to create the work? If a studio hires me to write a screenplay, do I own the screenplay's copyright or does the studio that's paying me? Should the creator always own the copyright because it's their creation, or should the employer that pays for the work own the copyright because they made the work possible?

When someone is hired to work on a film or other kind of audiovisual entertainment, the rules are easy to understand: *Whoever pays usually owns the copyright.* This is called the "work for hire" rule.

Section 101 of the 1976 Copyright Act defines the term "work for hire" as:

(1) a work prepared by an employee within the scope of his or her employment; or
(2) a work specially ordered or commissioned . . . as a part of a motion picture or other audiovisual work . . . if the parties expressly agree in a written instrument signed by them that the work shall be considered a work made for hire.[64]

Why the two different definitions? The answer lies in the specifics of labor law, which fortunately for you are beyond the scope of this book.[65] All you really need to know is that subsection (2) is the one that applies to most creative people working in the entertainment business. Therefore, in the world of entertainment, a "work for hire" is usually one specially "ordered or commissioned" as part of a film or other audiovisual work, where the parties expressly agree in a signed contract that the work shall be considered a work for hire. A script can be a work for hire. So, too, can a musical score or video game or even a finished film.

Section 201(b) of the 1976 Copyright Act grants the entire copyright to the person or company that pays for the work.[66] So, if Paramount Pictures pays someone to write a script, Paramount Pictures will own the copyright, provided the contract with the writer expressly says that the work shall be considered a work for hire.

My wife and I have been hired many times to write screenplays. Guess what language always turns up in our contracts? In every one, without fail, there is a clause identifying our screenplay as a work for hire. (Studio lawyers never miss this one if they want to keep their jobs.) If you want to be a producer some day and hire writers and other creative people, odds are you'll include this language in your contracts, too, because you'll want to own the copyright.

Is the work for hire rule just and defensible? Some creative people think not. They would say simply because someone pays for a creative work doesn't mean they should legally be deemed its "author" and own every facet of it. Defenders of the work-for-hire rule will argue that the rule is absolutely justified because it furthers the fundamental reason for copyright, which is to promote creative work by providing financial incentives. They will say if a company pays to have creative work done, it's the company that's promoting the creative work, taking all of the financial risk, and therefore fully deserving of copyright's financial rewards.

HOW LONG DOES COPYRIGHT LAST?

If you are a copyright owner, how long will your copyright last? Does it last forever or only for a limited time?

Before going any further, you need to understand an extremely important concept—that of the "public domain." We've previously outlined that certain kinds of things, such as ideas and facts, can't be copyrighted. Ideas and facts are free for anyone to use. This means they are in the "public domain." *Anything in the public domain is completely unprotected and available for anyone to adapt or otherwise incorporate into their work, free of charge, free from the law, free from anything and everything.*

There are many works, such as Shakespeare's plays, that never had copyright protection because they're simply too old. There are other works that may have had copyright protection but lost it. The most likely reason for losing copyright protection is that the work's term of copyright (a subject we're about to discuss) expired. Margery Williams first published *The Velveteen Rabbit* in 1922. The book was copyrighted. However, the book's term of copyright has now expired. This means the book is no longer covered by copyright and is therefore now in the public domain. And this means anyone is free to use the book in any way that they want.

So, remember: Ideas and facts are always in the public domain and free for anyone to use. Copyrighted works fall into the public domain when their term of copyright ends.

This raises the question, how long does copyright last?

Recall that the Statute of Anne gave authors a 14-year exclusive right to publish their work, which could be renewed once for an additional 14 years. This general notion was adopted in the United States, and when Congress wrote the 1909 Copyright Act it gave copyright owners an initial 28-year term of copyright, which could be renewed once for an additional 28-year term.[67] Thus, a published or registered work authored under the 1909 act could ostensibly enjoy copyright protection for a total of 56 years and only then go into the public domain.

The 1976 Copyright Act, along with some ensuing amendments, lengthened the duration of copyright for works written under the 1976 act as well as those written under the 1909 act. Suffice it to say, the result can be a bit confusing. I will do my best to simplify.

Under the 1976 act, which you'll recall actually took effect on January 1, 1978, copyright begins when an original work of authorship is fixed in a tangible medium of expression and lasts for the duration of the author's life plus an additional 70 years.[68] So, any work authored after January 1, 1978 is protected by copyright for the author's life plus 70 years. If you write a copyrighted work tomorrow, your copyright will last for your lifetime plus another 70 years. Obviously, since you'll be in heaven during the final 70 years of the copyright, it will be your heirs, or whoever you choose to transfer your copyright to via will or contract, who will reap the financial benefits of the copyright's final 70 years.

What if it's a joint work? Then copyright lasts 70 years after the last joint author passes away.[69]

What if it's a work for hire? A work for hire's copyright lasts either 95 years from the work's initial publication or 120 years from the work's creation, whichever comes first.[70]

What about works authored before January 1, 1978? Under the 1909 act, as mentioned, published or registered works used to have copyright for a maximum of 56 years (28 years plus one renewal term of 28 years), but I also mentioned that the 1976 act changed things. Rather than take you through the nuances of succeeding copyright laws and amendments, here's the bottom line: Works written in 1922 or before 1922 are now in the public domain and free for all to use; their term of copyright has expired. Almost all works written from 1923 through January 1, 1978 are protected by copyright for 95 years.[71] So, for example, the novel *Gone with the Wind* was first published in 1936. The book is now protected by copyright for 95 years and will go into the public domain at the end of 2031. Mickey Mouse first appeared on the scene in 1928, so Mickey is now slated to enter the public domain at the end of 2023.[72] Kahlil Gibran published *The Prophet* in 1923. Like any other copyrighted work initially published in America in 1923, it will enter the public domain in 2018.

What if you make a movie (or other work) based on something in the public domain—can you copyright your new work? If I make a film based on *Hamlet*, which is clearly in the public domain, can I copyright my movie? I'd be using Shakespeare's characters, his story and his dialogue. The question will be, *have I also contributed enough new original copyrightable expression to deserve copyright in my movie?* In the case of a film the answer is undoubtedly yes, if for no other reason than how I've chosen to photograph the production will constitute original expression worthy of copyright protection. Many people who have made their version of *Hamlet*—or any other work in the public domain—have changed lines or scenes, added material, or modernized the work in some manner. All of these changes may constitute original expression. *And it's only the new, original expression that copyright will protect.* You can't stop others from making their versions of *Hamlet* since the play itself is in the public domain and free for all to use; you can stop others from using the *original expression* you created in your version.

COPYRIGHT INFRINGEMENT

People in the entertainment business have been known to file lawsuits from time to time based on copyright. After all, copyright is what allows you to earn money from your creative work, and people sometimes think someone is earning what should be *their* money by violating, or infringing, *their* copyright. Given that digital piracy is now a fact of life, copyright infringement is high on the entertainment industry's list of concerns. But outright piracy is not the only way copyrights may be infringed; infringement can occur in subtler, less publicized ways as well.

So what exactly does it mean to infringe someone's copyright? In the strictly legal sense, this is easy to answer. Section 501(A) of the 1976 Copyright Act says, "anyone who violates any of the exclusive rights of the copyright owner as provided by sections 106 through 122 . . . is an infringer" This means, for example, that if you exercise without permission the copyright owner's right to reproduce her work, or to create a derivative work, or to distribute the work, or to perform or display it, then you have infringed the copyright and can be held liable in court.

That's not difficult to understand. And, often, it's not difficult to prove infringement. For example, if someone performs your work without permission, there will be witnesses to say it happened. That's an easy case to win in court. If someone sells a copyrighted work they don't own or writes a derivative work without permission, these can also be easy cases to prove.

What can be extremely difficult to prove, however, is whether or not the reproduction right has been infringed. We'll focus on this issue not only because it poses problems, but also because it's the most frequently alleged type of infringement.

Think for a moment what it actually means to "reproduce" someone's work. Does it mean you have to copy *all* of it? Or have you "reproduced" it if you copy just part of it? Have I copied if I intentionally reproduce 90 percent of someone's work? How about 50 percent? How about if I intentionally copy 1 percent? What if I put everything into my own words but take every story point, every characterization and every nuance of someone else's work?

If someone intentionally copies an entire work without permission, that's a clear violation of the reproduction right. For example, we can all agree (I hope) that copying a movie without permission and watching it on your computer violates the reproduction right as it's currently written. I recognize some people believe that anything on the internet can be copied free of charge, or that copyright law as it's currently written is outdated. While attitudes towards copyright may be changing,[73] there's no question, as of now, that copyright law forbids the unlicensed reproduction of an entire copyrighted work, such as a movie.

Even if you copy verbatim just a small portion of someone else's work, you can be held liable. In *Harper & Row, Publishers, Inc. v. Nation Enterprises*,[74] a magazine quoted verbatim 300 words from an unpublished 200,000-word memoir written by ex-president Gerald Ford. Though the case turned heavily on a different issue, the court noted that copying 300 words verbatim out of 200,000 was enough to violate the reproduction right.

Where things get messy is when someone doesn't copy verbatim but allegedly takes a significant chunk of someone else's original expression by creating something very similar. Remember, ideas can't be protected by copyright, only the expression of those ideas. So what if someone allegedly steals the expression, but doesn't do so verbatim?

To put it more concretely, what happens if someone writes a script that's very similar to yours?

This is an especially tough issue to dissect because, recall, someone can theoretically create a work that's like yours and still be okay if the author didn't actually *copy*. Copyright law therefore anticipates that very similar works may coexist peacefully. On the other hand, in the real world, authors may *not* coexist peacefully when their works are similar—there are often angry feelings and the sudden appearance of lawyers.

Unfortunately, getting at the truth in these situations is very difficult. There are really two issues that need to be resolved here: First, there is the question of proving or disproving whether someone actually copied or whether they came up with the work entirely on their own. Second, if someone did actually copy, how much copying is too much and constitutes infringement?

Let's start with the issue of proving actual copying. What evidence would you use to prove someone actually copied from you when the copying isn't verbatim? Most people who steal are not dumb enough to write in their diary: "Dear Diary, today I copied my favorite movie and ripped them off so I can be unjustly rewarded." No, people who peek into copyrighted works and steal from them are no more likely to come clean than students who peek into their neighbor's final exam. Each thief can say, "Hey, I didn't peek, I came up with it on my own." And, unless they've left an incriminating diary entry or bragged about it to friends or somehow been caught in the act, there's usually no concrete way to prove they didn't come up with it on their own.

Generally, all that the courts can do in these situations is engage in an educated guessing game by analyzing circumstantial evidence to determine whether someone relied on their own imagination or intentionally copied.

What kinds of circumstantial evidence do courts look at? Generally two kinds: "access" and "substantial similarity."[75] When taken together, these two concepts are used to determine whether copying in fact took place and if too much of a pre-existing work was copied.

Access

"Access" requires a court to determine if the supposed copier had the *opportunity* to view the underlying work. If Person "A" accuses you of intentionally copying his work, but Person "A's" work is unpublished and sitting on his desk halfway around the globe, that's easy—there's simply no way you had access to his work and you could never have seen it. But what if Person "A's" work, a book, *was* published and a few hundred copies were in local bookstores when Person "B" wrote a very similar story that was made into a movie? Person "B" swears on a stack of bibles he didn't copy anything. Person "A" is sure he did. In this actual case, the court found no proof of access because a few hundred

copies in bookstores created only a "bare possibility" that Person "B" had actually seen the book.[76] In short, the court needed more circumstantial evidence to rule that the alleged infringer had viewed the author's book.[77]

But what if the first work has been widely distributed and is really famous? It may be you've never seen the *Iron Man* movies, but try convincing a court you didn't have access to them. This becomes a trickier issue, however, where the underlying work wasn't extremely popular or was popular a long time ago. Still, a court found that George Harrison, a member of the Beatles, had access to *He's So Fine,* a song that had been popular eight years before Harrison wrote a melodically similar song, *My Sweet Lord.*[78] In a different case involving songs, a court found access when one song was popular in 1964 and the alleged infringing song was composed twenty-five years later in 1989.[79]

What about this situation, which happens frequently: Writer "A" gives her script to an agent, producer, production company or studio, and the script is rejected. Then, some time later, Writer "B," who is affiliated with the same agent, or producer, or production company or studio, writes a script very similar to Writer "A's"? Writer "A" is very likely to believe that someone slipped her script to Writer "B," who then copied from it.

The cases involving this issue have turned on each case's specific facts—some found there was access in these sorts of instances[80] and some didn't.[81] There are no rigid guidelines I can give you, other than this: Generally speaking, if *all* a plaintiff can prove is that a company received her work—usually referred to as "bare corporate receipt"—that will be insufficient to prove access. Something more must be demonstrated, a greater nexus between company personnel and the artist who allegedly copied the underlying work.[82] Still, for producers who read thousands of scripts, there is always the lurking problem that, one day, they will produce a project that's substantially similar to a previously submitted screenplay. Indeed, the threat of copyright infringement lawsuits based on access to lots of scripts has caused many in the industry to read scripts submitted only by people they know and trust.

Substantial Similarity

Proving access, however, is just the first requirement to prove that illegal copying occurred. The second requirement is to prove that the two works are "substantially similar."

So what does this mean? Certainly, if an infringer changes just one word in a script we'd all agree that such a cute attempt to evade liability would fail; our friend Judge Learned Hand said that the reproduction right "cannot be limited literally to the text, else a plagiarist would escape by immaterial variation."[83] So, changing some of the text won't insulate the copier from liability. But what if someone doesn't copy any of a script's specific text but copies the characters

and the plot? When does such an alleged infringing work become "substantially similar" to the pre-existing work? What ironclad, concrete definitional guidelines have the courts given us? The word "none" comes to mind.

That may be a bit harsh, I suppose. Courts do say that the substantial similarities must involve copyrightable expression rather than non-copyrightable ideas, facts or public domain material. That's fine, but as we've seen before, the line between unprotected ideas and protected expression is very hard to find.

Indeed, so many films are really very similar. What can be a fun game for film buffs but an infuriating game for litigants is to search for similarities between two different stories. Finding similarities is often extremely easy. For example, at the purely structural level, literally thousands of films are similar: (a) during the first 10 minutes or so, we meet the protagonist in his current setting; (b) around the 10-minute mark, something happens to alter his life; (c) the protagonist then waffles about whether to chart a new course; (d) eventually the protagonist changes his life and pursues a goal he didn't have when the film started; (e) the protagonist has the help of friends but is also pursued by a dangerous villain; (f) as time goes on, the danger increases and it looks like our hero will fail; (g) but then the protagonist devises a clever escape, defeats the villain and saves the day. Can one writer claim copyright infringement if another's script is structured like this? Certainly not. Arguably, the vast majority of all scripts are structured generally like this and any court would find this structure part of the "idea" of a screenplay rather than its expression.[84]

Often, strong similarities are found in the conceit of different stories. For example, in 1998, two films were released that both involved deadly asteroids hurtling towards Earth: *Deep Impact* and *Armageddon*. Both films included astronauts trying to stop the asteroids and protect Earth. Was there a copyright violation here? Not even close. The idea of an asteroid hitting Earth is way too general, a mere idea. But what about the fact that both movies involved astronauts going into space to try and stop the asteroid? Here, the very premise of these movies, an approaching asteroid, basically necessitated these similar story points; either astronauts go into space or no one does anything and Earth is destroyed, which would make for a depressing movie.

Courts recognize that story ideas generate scenes that naturally result from the story's setting or situation. The term used for such scenes is "scene à faire,"[85] and courts will not find copyright infringement based on similarities in such scenes. For example, in *Walker v. Time Life Films, Inc.*,[86] a book author argued that his book and an allegedly infringing film both "begin with the murder of a black and a white policeman with a handgun at close range; both depict cockfights, drunks, stripped cars, prostitutes and rats; both feature as central characters third-or fourth-generation Irish policemen who live in Queens and frequently drink; both show disgruntled, demoralized police officers and unsuccessful foot chases of fleeing criminals."[87] The court ruled,

however, that this did not constitute copyright infringement because these similarities would appear in any "realistic" story about police work in New York City. Stated another way, these similarities flowed from the stories' settings and situation and were therefore deemed part of the overall story idea.

Although "substantial similarity" is a horribly murky and ill-defined term, I think it's fair to say that courts require a great deal of similarity to find infringement. Some courts will refuse to find "substantial similarity" where differences exist between two works' themes, or total concept and feel, or plot, or mood, or characterizations, or sequence of events and pace, or a combination of these elements.[88]

At the end of the day, a cynic might argue that courts do whatever they think is just given the circumstances, and then rationalize their decisions by finding ways to make them fit into prevailing law. This isn't hard for courts to do when the prevailing law, such as the law of infringement, has no clear boundaries. Given it's impossible to say where substantial similarity begins and ends, my best advice is: Don't ever copy, keep organized records of what you've read and when you've authored your works, and when in doubt seek an attorney's advice.

Striking Similarity

Before leaving the subject of infringement, it's important to note another doctrine some courts have adopted. These courts say works can go beyond having "substantial similarity" and instead have "striking similarity." What constitutes "striking similarity" is no more clearly defined than what constitutes "substantial similarity," though obviously you need a whole big heaping helping of similarity for something to be "strikingly similar."[89] Still, even if something is "strikingly similar" to something else, you still need to prove the alleged infringer had access to the other work. Or do you? Some courts are prepared to say that where two works are so strikingly similar as to defy all probability, then you don't even have to prove access—you can presume it along with copyright infringement.[90]

Hmm. We've said all along that someone can write a work identical to a preexisting work *if* they didn't copy. But now we're saying that if what you write is "strikingly similar" to something else, you may be *presumed* to have had access and presumed to have illegally copied.

This is not only entirely inconsistent, it's a bit unnerving. If you're a writer, what do you think is more likely to happen in your lifetime—winning the lottery, getting hit by lightning, or accidentally writing something that's "striking similar" to something else? I may be neurotic, but I'll go with the latter.

I'll conclude our infringement discussion with this thought: Writers or producers may wonder whether they should look at a previous work they think may be

substantially similar to a project they're pursuing. On the one hand, if you look at the previous work, you've accessed it. On the other hand, if you don't look, a court may infer access if the previous work was widely distributed or if what you create is strikingly similar. Speaking only for myself, I always want to be certain that what I'm doing is not too similar to a pre-existing work, so I'll usually take a look. If my project seems too similar, I'll simply drop it and go on to the next.

FAIR USE

We'll finish our discussion of copyright by briefly discussing another vitally important but frustratingly murky set of rules called Fair Use. All filmmakers, studio executives and agents should have a basic understanding of what Fair Use means. *Don't, however, let a little knowledge be a dangerous thing; this is one area where you absolutely can't play amateur lawyer. When dealing with Fair Use issues, expert advice from legal counsel is a must.*

Fair Use is a defense people can use when they have infringed someone else's copyright. In other words, thanks to Fair Use, someone may infringe someone else's copyright with impunity.

Jon Stewart is a good example of someone who relies on Fair Use. Almost every night on his satirical television show, Stewart mocks the cable news channels by playing real news clips. News broadcasts are copyrighted, and therefore the copyright owners have the exclusive right to publicly perform these broadcasts. But Stewart routinely broadcasts—that is, publicly performs—real news clips from CNN, or Fox News, or MSNBC, and I can assure you he does so without permission. Documentarians also often include copyrighted footage in their films without permission; educators copy protected material and give it to students; comedians may parody a song by changing its lyrics thus creating a derivative work, and so on. All of the above can happen with impunity thanks to Fair Use.

Why create copyright laws granting authors exclusive rights and then allow certain people to legally infringe them? Because the law is trying as best it can to balance two very different and competing societal interests. On the one hand, our Founding Fathers believed society benefits when creative people are incentivized to create new works; on the other hand, the Founding Fathers believed that society benefits from free speech and the free flow of ideas. Copyright stifles speech. It gives authors a monopoly over their expression for a long time. Give copyright owners too much power, and too much discussion will be removed from the public dialogue. That's the main reason why ideas can't be copyrighted. On the other hand, give copyright owners too little power and the incentive to create will be unacceptably diminished. So, Congress and the courts have tried to create a balance between the interests promoted by both copyright and free speech. Fair Use is one mechanism to maintain this balance.[91]

Fair Use is included in Section 107 of the 1976 Copyright Act, which says in part:

> Notwithstanding the provisions of sections 106 and 106A, the fair use of a copyrighted work . . . for purposes such as criticism, comment, news reporting, teaching scholarship, or research, is not an infringement of copyright. In determining whether the use made of a work in any particular case is a fair use the factors to be considered shall include:
>
> (1) the purpose and character of the use, including whether such use is of a commercial nature or is for nonprofit educational purposes;
> (2) the nature of the copyrighted work;
> (3) the amount and substantiality of the portion used in relation to the copyrighted work as a whole; and
> (4) the effect of the use upon the potential market for or value of the copyrighted work.

As you can see, the statute gives us four factors to consider when determining whether the unauthorized use of a pre-existing work is or isn't a Fair Use.[92] You might ask, just *how* does one consider and weigh these factors? Do all four factors have to weigh in favor of Fair Use for a court to rule the use is okay? The answer is no. What if three factors weigh in favor of Fair Use and one factor weighs against; does Fair Use win three to one? What if three factors *slightly* weigh in favor and one *really* weighs against?

The fact is, the statute says absolutely nothing whatsoever about what to do with these factors other than to "consider" them. There's no guidance at all. Not surprisingly, this means Fair Use decisions by courts have been hard to predict, sometimes contradictory, and no doubt maddening to the people affected by them.[93]

Let's examine each of the four factors.

Fair Use Factor #1: The Purpose and Character of the Use

The first factor says that, when determining if a use is a Fair Use, one examines "the purpose and character of the use, including whether such use is of a commercial nature or is for nonprofit educational purposes."

Taken as a whole, the factor asks that we look at *why* someone used a copyrighted work and to decide if the reasons are acceptable. This means we need to know what reasons *are* acceptable. Given that Fair Use is meant to balance free speech interests against the copyright owner's economic interests, perhaps we must assess if an alleged Fair Use has a strong free speech component. In other words, does the alleged Fair Use represent the kind of speech the First Amendment was designed to promote and protect?

Say I take a beautiful copyrighted image you created and put it on toilet paper I manufacture because I think it will promote sales. That doesn't feel like the

kind of "speech" the First Amendment was really meant to protect. So the question becomes, are there some types of speech that are more "free speechy" than others?

Here, Congress does offer some guidance. Section 107 lists six categories of speech that weigh in favor of Fair Use: "criticism, comment, news reporting, teaching (including multiple copies for classroom use), scholarship, or research."[94] One professor has noted that these categories (and perhaps others you can think of) involve speech "in which the social, political and cultural benefits of the use will outweigh any consequent losses to the copyright proprietor."[95] In other words, these uses promote the free flow of political, social and cultural ideas, allowing us to sometimes ignore the personal financial interests of the copyright owner.

These six uses also suggest a slightly more subtle way to look at this subject. When someone uses a copyrighted work for criticism, comment, news reporting, teaching, scholarship or research, he is usually using the work for a *different reason* than the author did, and usually appealing to a very different economic market. Importantly, if the Fair Use work appeals to an economic market different from that of the original work, then it's unlikely the Fair Use work will harm the value of the original work's copyright (which is the fourth Fair Use factor mentioned in Section 107).

For example, say a documentarian makes a film about how child stars sometimes become troubled adults. To help make this point, the documentarian includes in her film a copyrighted clip of a sitcom featuring one of those child stars. The TV network originally produced the show to entertain the audience (and, of course, to make money). The documentarian used the clip to help make her point about the perils of fame. These are very different purposes and appeal to different audiences.

Say a satirist uses news clips to mock the excesses of cable news. Again, why did the news channel put on its news broadcast? To inform its viewers. Why did the satirist use clips from the broadcast? To comment on the accuracy or competency of the news network.

Courts often refer to these different kinds of uses as "transformative." As mentioned, a transformative use generally appeals to a different economic market than the pre-existing work, which means the economic market for the underlying work is left unhurt.[96]

Indeed, you're likely just mooching off the original author's ingenuity if you use a copyrighted work for an identical purpose. For example, I might write a book that's made up entirely of quotes from the TV series *Downton Abbey* and call my book *The Wit and Wisdom of Lord Grantham and the Residents of Downton Abbey*, but if all I'm doing is making a buck by copying the work of the show's writer, I'm in for a long day in court.[97] Or how about this real case where a television station in Los Angeles was sued after it broadcast copyrighted footage of

a riot. A freelance reporter had shot the copyrighted footage and sold it to a competing news outlet, which aired it. The television station copied and aired the same footage believing it could do so since it was engaged in news reporting. A court ruled otherwise, saying this was not a Fair Use because there was no transformative purpose involved here; the television station used the copyrighted footage for precisely the same reason as the first news outlet, to inform.

Take a copyrighted work and use it for a different purpose, however, one that adds to the free flow of ideas, and you will be in better shape under the law. However, will someone always be okay if they use a copyrighted work for a transformative purpose? *Absolutely not*. Just because someone is engaged in criticism, comment, news reporting, teaching, scholarship, research or some similar type of activity doesn't mean the use will always be a Fair Use. Remember that this first factor is only one of four to be considered when determining whether something is a Fair Use. All four factors have to be weighed.

One last comment regarding the first factor: Recall that we must consider "the purpose and character of the use, *including whether such use is of a commercial nature or is for nonprofit educational purposes*." Is a use more likely to be a Fair Use if there is a nonprofit educational purpose involved? Absolutely. Are you then guaranteed to be okay? Absolutely not. It's just a factor to be considered. Conversely, what if the use is in connection with a profit-making venture— does that mean Fair Use is always out of the question? Not at all. Every satirical show on television, every newspaper, every documentary film seeks to earn a profit. So trying to make a buck won't kill your opportunity to use the Fair Use defense. Like everything else, it's just a factor to be considered.

Fair Use Factor #2: The Nature of the Copyrighted Work

The second factor mentioned in Section 107 tells us to look at "the nature of the copyrighted work." Since Congress chose to include this as a factor to be weighed, we can presume Congress believed that not all works' "natures" are the same. But what "nature" are we supposed to look at?

The U.S. Supreme Court tried to clarify by saying this "factor calls for recognition that some works are closer to the core of intended copyright protection than others."[98] The Court went on to say that works closer to the "core" are more deserving of copyright protection and thus Fair Use may be more difficult to establish.[99]

Okay, so we're in search of "the core of intended copyright protection." Perhaps we can find it by looking at what copyright is meant to do, which is to protect and promote creativity. So maybe the "core" is located in the vicinity of true creativity.[100] Maybe this means that a Pulitzer prize-winning novel is "closer to the core" than a finger painting completed in 30 seconds by a drunk guzzling two-buck chuck. At least one author believes that this rule "affords the greatest

degree of protection to highly creative works, and the least to works that are factual or practical in nature."[101] Like Fair Use analysis in general, this factor is maddeningly fuzzy and highly subjective.

Fair Use Factor #3: The Amount and Substantiality of the Portion Used

The third factor mentioned in Section 107 tells us to look at "the amount and substantiality of the portion used in relation to the copyrighted work as a whole." This factor is a bit easier to comprehend. If you take too much of the underlying work you may be trading too heavily on its notoriety, thus diminishing your supposed transformative purpose while potentially impacting the value of the underlying work's copyright. Fewer people may buy an author's novel if I copy four-fifths of it in my literary criticism book. Or, say I make a 90-minute documentary about Michael Jackson's life and include a full hour of copyrighted concert footage featuring Jackson. Am I not in this case just recycling that concert footage, trying to make some money off it under the guise of a documentary, and also threatening that footage's market value?

I think it's safe to say that people who intend to use a pre-existing work for a transformational purpose should use as little of the pre-existing work as possible to make their transformative point.

Remember the case of the underground comic book where Mickey and Minnie were depicted doing very un-Disney like things? The satirists claimed they were mocking the pristine and wholesome world of Disney. Normally that would be a fine transformative use, but the court said that by drawing the cartoon characters precisely as Disney did, the satirists took more of Disney's work than was necessary to conjure up the image of Mickey and his friends.[102] In other words, the satirists could have drawn a mouse that put you in mind of Mickey to help make the satirical point, but a mouse that nevertheless differed from Mickey.[103] So, people relying on Fair Use should always take as little of the underlying work as possible if they must take any at all.

Fair Use Factor #4: The Effect on the Market Value of the Underlying Work

The fourth factor to be weighed is "the effect of the use upon the potential market for or value of the copyrighted work." If an alleged Fair Use harms the value of an author's copyright, then a court might not find the use is fair. Indeed, the U.S. Supreme Court said this factor is "undoubtedly the single most important element of fair use."[104]

Those, then, are the factors to be weighed. Because the law is so murky, people thinking of relying on Fair Use might wonder if they should first ask permission of the copyright owner to use a portion of the work. Maybe the copyright

owner says "Okay" and all worry about being sued goes away. But what if the copyright owner says "No" and you go ahead anyway—are you somehow disadvantaged because you asked and were turned down? The U.S. Supreme Court answered this question by saying no, you're not legally disadvantaged by asking.[105] So go ahead and ask if you want, but my suggestion is always first ask a lawyer. If you're contemplating infringing someone else's copyright, it's absolutely essential to seek legal counsel's advice.

NOTES

1 Amanda Mabillard, "Shakespeare in Print," *Shakespeare Online*, Aug. 20, 2004, last accessed on July 18, 2014, http://www.shakespeare-online.com/biography/shakespeareinprint.html.
2 For those who want to know more, read the Licensing Act of 1662.
3 The term "public domain" is discussed on page 34.
4 Article 1, Section 8.
5 See, e.g., *Sony Corp. of America v. Universal City Studios, Inc.*, 464 U.S. 417, 429 (1984) ("[Copyright] is intended to motivate the creative activity of authors and inventors by the provision of a special reward, and to allow the public access to the products of their genius after the limited period of exclusive control has expired").
6 Article 6, Clause 2 says, "This Constitution, and the Laws of the United States which shall be made in pursuance thereof; and all treaties made, or which shall be made, under the authority of the United States, shall be the supreme law of the land; and the judges in every state shall be bound thereby, anything in the constitution or laws of any state to the contrary notwithstanding." See *McCulloch v. Maryland*, 17 U.S. 316 (1819).
7 It is true that states are free to legislate on issues not covered by federal copyright law. For example, copyright law requires a work of authorship to be fixed in a tangible medium of expression to be eligible for copyright. Under what's called "common law," states can protect certain works that are not fixed in a tangible medium of expression. See Melville Nimmer and David Nimmer, *Nimmer on Copyright* (Matthew Bender & Co., Inc. 2014), Section 2.02, 2-20. The issue of state laws, however, is beyond the scope of this book.
8 The 1976 Copyright Act is codified in Title 17 of the United States Code.
9 Certain provisions of the 1976 Act, such as how long copyright lasts, do affect works created prior to January 1, 1978. The issue of length of copyright is examined on pages 33–5.
10 Section 101 of Title 35 of the United States Code states that patents are available to, "Whoever invents or discovers any new and useful process, machine, manufacture, or composition of matter, or any new and useful improvement thereof, may obtain a patent therefor, subject to the conditions and requirements of this title."
11 See *Airframe Sys., Inc. v. L-3 Communications Corp.*, 658 F.3d 100, 106 (1st Cir. 2011); Melville Nimmer and David Nimmer, *Nimmer on Copyright* (Matthew Bender & Co., Inc. 2014), Section 13.01[B], 13-10. As we saw when discussing copyright infringement (see pages 35–41), if you write something identical or strikingly similar to a pre-existing work, a court might assume you did illegally copy it even if, in fact, you didn't. For example, if you wrote a script that word for word copied the screenplay of *Inception*, you would surely have an impossible time convincing a skeptical court you actually came up with it on your own. Still, there is the theoretical possibility that two identical or almost identical works could each receive copyright.
12 499 U.S. 340 (1991).
13 The *Feist* court ruled that an alphabetical listing of names, towns and telephone numbers in a telephone book was not sufficiently original, i.e. creative, to receive copyright protection.

14 36 F. Supp. 2d 191 (S.D.N.Y. 1999).

15 *Id.* at 196–197.

16 *Desney v. Wilder*, 46 Cal.2d 715, 731 (1956).

17 See, e.g., *Eldred v. Ashcroft*, 537 U.S. 186 (2003).

18 *Peter Pan Fabrics, Inc. v. Martin Weiner Corp.*, 274 F.2d 487 (2nd Cir. 1960).

19 45 F.2d 119 (2nd Cir. 1930).

20 *Id.* at 121.

21 Richard Walter, current Chairman of UCLA's Screenwriting program, seriously doubts idea theft is a frequent occurrence. See http://richardwalter.com/2013/08/ideas-are-commonly-stolen-another-hollywood-hoax/.

22 See *Buchwald v. Paramount Pictures Corp.*, 13 U.S.P.Q.2d (BNA) 1497 (L.A. Super. Ct. 1990) (Phase 1), *later proceeding* 90 L.A. Daily J. App. Rep. 14482, December 26, 1990 (L.A. Super. Ct. December 21, 1990) (Phase 2).

23 *Montz v. Pilgrim Films & Television Inc.*, No. 08–56954, 2011 WL 1663119 (C.A.9 (Cal.)), (9th Cir. May 4, 2011) (7-4 Decision); *Grosso v. Miramax Film Corp.*, 383 F.3d 965 (9th Cir. 2004); *Desny v. Wilder*, 46 Cal.2d 715 (1956). There are other potential claims a plaintiff could make besides breach of implied contract when an idea is stolen. See Melville Nimmer and David Nimmer, *Nimmer on Copyright* (Matthew Bender & Co., Inc. 2014), Section 19D.04[A], 19D-41.

24 *Grosso v. Miramax Film Corp.*, 383 F.3d 965 (9th Cir. 2004). Compare this with the case of *Faris v. Enberg*, 97 Cal App. 3d 309 (1979), where the plaintiff approached a famous sportscaster to serve as emcee on a possible TV quiz show. When the sportscaster subsequently served as emcee on a similar game show, the plaintiff sued. The court found no liability, saying that, in this case, the plaintiff never tried to *sell* the sportscaster anything. Instead, the game show format was presented to see if the sportscaster would be willing to go into business with the plaintiff. See Melville Nimmer and David Nimmer, *Nimmer on Copyright* (Matthew Bender & Co., Inc. 2014), Section 19D.05[A][2][a][i], 19D-50.

25 See, e.g., *Faris v. Enberg*, 97 Cal. App. 3d 309 (1979).

26 See *Mann v. Columbia Pictures*, 128 Cal. App. 3d. 628, 646–647 n.6 (1982).

27 See *Gunther-Wahl Productions, Inc. v. Mattel, Inc.*, 104 Cal. App. 4th 27 (2002); Melville Nimmer and David Nimmer, *Nimmer on Copyright* (Matthew Bender & Co., Inc. 2014), Section 19D.05[A][2][a][ii], 19D-52-55.

28 On the flip side, scripts that are sent to agents, producers or studios unsolicited can pose legal problems for those who receive them. See page 38.

29 It's worth noting that James Cameron's film was hardly the first about the Titanic. Previous films about the disaster included *Titanic*, *A Night to Remember*, *The Unsinkable Molly Brown* and *Raise the Titanic*.

30 See *De Acosta v. Brown*, 146 F.2d 408 (2nd Cir.1944) (fictionalized elements in screenplay about Clara Barton were protected by copyright); *Miller v. Universal City Studios, Inc.*, 650 F.2d 1365, 1369 (5th Cir.1981) ("since facts do not owe their origin to any individual, they may not be copyrighted and are part of the public domain available to every person"); *Narell v. Freeman*, 872 F.2d 907, 910–11 (9th Cir.1989) ("Historical facts and theories may be copied, as long as the defendant does not 'bodily appropriate' the expression of the plaintiff"). See also *Feist Publications v. Rural Telephone Service Co.*, 499 U.S. 340 (1991).

31 It is true that the Motion Picture Association of America ("MPAA") maintains a Title Registration Bureau. This is a voluntary program in which the major studios participate. Each studio can register a title with the Bureau and, once registered, the other studios agree not to use that title. As mentioned, however, this is a voluntary program and not a function of copyright law. Additionally, the law of Trademark and Unfair Competition may be used to protect titles but this is beyond the scope of this book.

32 See Section 102(a)(6) of the 1976 Copyright Act.

33 216 F.2d 945 (9th Cir. 1954).

34 *Warner Brothers Pictures v. Columbia Broadcasting System*, 216 F.2d 945, 950 (9th Cir. 1954).

35 581 F.2d 751 (1978).

36 *Walt Disney Productions v. Air Pirates*, 581 F.2d 751, 755 (9th Cir 1978).

37 In his landmark *Nichols v. Universal* decision, Judge Learned Hand discussed whether characters can be copyrighted independently from the plot itself: "Nor need we hold that the same may not be true as to the characters, quite independently of the 'plot' proper, though, as far as we know, such a case has never arisen. If Twelfth Night were copyrighted, it is quite possible that a second comer might so closely imitate Sir Toby Belch or Malvolio as to infringe, but it would not be enough that for one of his characters he cast a riotous knight who kept wassail to the discomfort of the household, or a vain and foppish steward who became amorous of his mistress. These would be no more than Shakespeare's 'ideas' in the play, as little capable of monopoly as Einstein's Doctrine of Relativity, or Darwin's theory of the Origin of Species. It follows that the less developed the characters, the less they can be copy-righted; that is the penalty an author must bear for marking them too indistinctly." *Nichols v. Universal*, 45 F.2d 119, 121 (2nd Cir. 1930).

38 519 F. Supp. 388 (SDNY 1981), affirmed 683 F.2d 610 (2nd Cir. 1982).

39 *Id.* at 391.

40 900 F. Supp. 1287 (C.D. CA 1995).

41 It should be noted that the court said, "James Bond is a copyrightable character under either the . . . 'story being told' test or the . . . 'character delineation' test." *Id.* at 1296.

42 See *Anderson v. Stallone*, 11 USPQ2d 1161 (C.D. Cal. 1989) (Rocky copyrightable); *Toho Co. v. William Morrow & Co.*, 33 F. Supp. 2d 1206 (C.D. Cal. 1998) (Godzilla copyrightable).

43 Including the traditional copyright notice still can be helpful, however, should you ever end up in a lawsuit. Including the copyright notice prevents a defendant from mitigating damages by claiming he innocently infringed the copyright. See sections 401(d) and 402(d) of the 1976 Copyright Act.

44 Here is a link to the United States Copyright Office's FAQ page: http://www.copyright. gov/help/faq/faq-register.html.

45 Section 411(a) of the 1976 Copyright Act states that, except for certain specific circumstances mentioned in the statute, "no civil action for infringement of the copyright in any United States work shall be instituted until preregistration or registration of the copyright claim has been made in accordance with this title."

46 See Section 412 of the 1976 Copyright Act.

47 See Section 410(c) of the 1976 Copyright Act.

48 You can visit the Writers Guild of America, West's information page about its registration program here: http://www.wgawregistry.org/webrss/regdetails.html.

49 There are a few exceptions that allow third parties to copy a work without the copyright owner's permission. Some of these exceptions include a library's right to make copies under certain circumstances (Section 108), the right to purposefully imitate a pre-existing sound recording Section (114(b)), and the right under certain circumstances to copy the music and lyrics of a previously recorded and distributed song (Section 115).

50 Section 101 of the 1976 Copyright Act defines "derivative work" as: "A work based upon one or more preexisting works, such as a translation, musical arrangement, dramatization, fictionalization, motion picture version, sound recording, art reproduction, abridgment, condensation, or any other form in which a work may be recast, transformed, or adapted. A work consisting of editorial revisions, annotations, elaborations, or other modifications which, as a whole, represent an original work of authorship, is a 'derivative work.'"

51 Some may think fan fiction authors are completely inoculated from copyright liability because they don't usually benefit financially from their adaptations. This simply is not true. Someone can still violate copyright even if he or she never makes a dime off of the infringing activity. Having said that, it's certainly true some authors have embraced fan fiction for a variety of reasons and don't file infringement lawsuits even though they theoretically could.

52 Why then can't buyers of a digital copy of a movie resell that copy to others? If you pay for a film from iTunes and download it, why can't you resell your digital copy to someone else? Because you're not just selling the copy, you're reproducing it as well.

53 During the summer of 2014, the Supreme Court had to decide whether a private company, Aereo, Inc., infringed the public performance right when, through the use of antennas, it retransmitted free, over the air copyrighted television broadcasts to its subscribers so those subscribers could see those broadcasts on internet-enabled devices. The Supreme Court decided that such retransmission of freely received over-the-air broadcasts did constitute a public performance. See *American Broadcast Companies v. Aereo, Inc.*, which you can read here: http://www.supremecourt.gov/opinions/13pdf/13-461_l537.pdf.

54 Section 101 of the 1976 Copyright Act says: "To perform or display a work 'publicly' means: (1) to perform or display it at a place open to the public or at any place where a substantial number of persons outside of a normal circle of a family and its social acquaintances is gathered; or (2) to transmit or otherwise communicate a performance or display of the work to a place specified by clause (1) or to the public, by means of any device or process, whether the members of the public capable of receiving the performance or display receive it in the same place or in separate places and at the same time or at different times."

55 For example, Sections 110(1) and (2) give classroom teachers, under certain circumstances, the right to perform copyrighted works for the benefit of their students' education.

56 Section 201(a) of the 1976 Copyright Act says: "Copyright in a work protected under this title vests initially in the author or authors of the work."

57 Note that it's not even necessary for one collaborator to know who the other collaborator is, or to ever meet with this person or even to communicate with them. All that's required for a joint work is that each collaborator knows and intends that their work will be merged with someone else's work to form one complete project. See *Edward B. Marks Music Corp. v. Jerry Vogel Music Co.*, 140 F.2d 266 (2nd Cir. 1944). However, where Author "A" writes a work without knowledge of or intention that it will be merged with Author "B's" subsequent work, then the resulting merged work will not be considered to be a joint work. Rather, the resulting work will likely be considered a derivative work of Author "A's" initial work. See *Batiste v. Island Records Inc.*, 179 F.3d 217, 222 n.7 (5th Cir. 1999).

58 See Roger Schechter and John Thomas, *Principles of Copyright Law* (West 2010), Kindle ed., location 3060–3135.

59 See, e.g., *Erickson v. Trinity Theater*, 13 F.3d 1061 (7th Cir. 1994); *Childress v. Taylor*, 945 F.2d 500 (2nd Cir. 1991).

60 See Section 201(D)(1) of the 1976 Copyright Act.

61 See Melville Nimmer and David Nimmer, *Nimmer on Copyright* (Matthew Bender & Co., Inc. 2014), Section 6.10[A][2], 6-36 et seq.

62 *Id.*

63 *Id.* at Section 6.12[A], 6-49–6-50.1

64 I have edited out some of the text of Section 101's work-for-hire definition because the additional text does not directly relate to entertainment industry issues. For the record, here is Section 101's definition in its entirety: "A 'work made for hire' is (1) a work prepared by an employee within the scope of his or her employment; or (2) a work specially ordered or commissioned for use as a contribution to a collective work, as a part of a motion picture or other audiovisual work, as a translation, as a supplementary work, as a compilation, as an instructional text, as a test, as answer material for a test, or as an atlas, if the parties expressly agree in a written instrument signed by them that the work shall be considered a work made for hire. For the purpose of the foregoing sentence, a 'supplementary work' is a work prepared for publication as a secondary adjunct to a work by another author for the purpose of introducing, concluding, illustrating, explaining, revising, commenting upon, or assisting in the use of the other work, such as forewords, afterwords, pictorial illustrations, maps, charts,

tables, editorial notes, musical arrangements, answer material for tests, bibliographies, appendixes, and indexes, and an 'instructional text' is a literary, pictorial, or graphic work prepared for publication and with the purpose of use in systematic instructional activities."

65 For the curious, the first subsection deals with people who are "employees" under prevailing labor law and the second subsection, the one that applies to most creative people in the entertainment industry, deals with people who are "independent contractors" under labor law. Screenwriters, directors, editors, cinematographers and other creative people are almost always employed as "independent contractors." For a brief explanation of the differences between an "employee" and "independent contractor," see "Independent Contractor (Self-Employed) or Employee," *IRS*, last accessed on July 8, 2014, http://www.irs.gov/Businesses/Small-Businesses-&-Self-Employed/Independent-Contractor-Self-Employed-or-Employee.

66 Section 201(b) specifically says, "In the case of a work made for hire, the employer or other person for whom the work was prepared is considered the author for purposes of this title, and, unless the parties have expressly agreed otherwise in a written instrument signed by them, owns all of the rights comprised in the copyright."

67 See Section 24 of the 1909 act. Note that in the 1909 act the term of copyright generally did not begin upon fixation of a work of authorship in a tangible medium of expression as it does in the 1976 act. Instead, the term of copyright generally began on initial publication or registration of the work. See sections 9 and 12 of the 1909 act.

68 See Section 302(a) of the 1976 Copyright Act. Also, all copyright interests actually expire at the end of the calendar year when the expiration would otherwise occur. See Section 305.

69 See Section 302(b) of the 1976 Copyright Act.

70 See Section 302(c) of the 1976 Copyright Act, which also covers anonymous works and pseudonymous works.

71 There can be exceptions to the 95-year period, however. As mentioned, works written under the 1909 act received copyright in a two-step process—initially for 28 years, and then, if the owner properly renewed the copyright, for another 28 years. It's the "if" that causes problems. *If* copyright was renewed properly, then any such work now has copyright protection for 95 years; if the copyright wasn't renewed as required, then the work may have fallen into the public domain long ago. Also, certain works written before January 1, 1978 might never have been published, which can also affect the current term of copyright. See http://www.copyright.gov/circs/circ15a.pdf.

72 Some have argued that Congress previously extended the term of copyright at the behest, among others, of the Walt Disney Company. It's been noted that these extensions were not so surprisingly enacted shortly before Mickey Mouse was about to lose copyright protection. See., e.g., Steve Shlackman, "How Mickey Mouse Keeps Changing Copyright Law," *Art Law Journal*, February 15, 2014, last accessed on July 8, 2014, http://artlawjournal.com/mickey-mouse-keeps-changing-copyright-law/; Timothy Lee, "15 years ago, Congress kept Mickey Mouse out of the public domain. Will they do it again?," *The Washington Post*, October 25, 2013, last accessed on July 8, 2014, http://www.washingtonpost.com/blogs/the-switch/wp/2013/10/25/15-years-ago-congress-kept-mickey-mouse-out-of-the-public-domain-will-they-do-it-again/. We'll see what happens as 2023 approaches.

73 See Chapter 3, footnote 24.

74 471 U.S. 539 (1985).

75 See, e.g., *Beal v. Paramount Pictures Corporation*, 20 F.3d 454 (11th Cir. 1994) (". . . courts have developed methods by which copying can be proven indirectly The plaintiff is first required to show that the defendant had access to the plaintiff's work; second, the plaintiff must show that the defendant's work is substantially similar to the plaintiff's protected expression"); *Ferguson v. National Broadcasting Company*, 584 F.2d 111, 113 (5th Cir. 1978) ("Since there is seldom direct evidence of 'copying,' the plaintiff

generally proves this element by showing that the person who composed the defendant's work had access to the copyrighted work and that the defendant's work is substantially similar to the plaintiff's"). These days, courts and authors often say that, first, a plaintiff must prove access and "probative similarity," which means similarity that's sufficient to raise an inference that copying occurred. If these hurdles are met, next a court must determine if the alleged offending work is substantially similar to the protectable elements of the underlying work. See *Muller v. Twentieth Century Fox Film Corp.*, 794 F. Supp. 2d 429, 439-440 (S.D.N.Y. 2011).

76 *Jason v. Fonda*, 526 F. Supp 774 (C.D. Cal. 1981).

77 See *Rice v. Fox Broadcasting Co.*, 148 F. Supp. 1029 (C.D. Cal 2001) (distribution of 17,000 videotape copies sufficient to raise a legitimate question of whether access had occurred).

78 Though the court didn't believe Harrison intentionally copied *He's So Fine*, it did determine (divine?) that he copied "unconsciously." Since the court found Harrison had access to the earlier song, and since the songs were deemed substantially similar, the court ruled Harrison infringed the *He's So Fine* copyright. See *Bright Tunes Music Corp. v. Harrisongs Music*, 420 F. Supp 177 (SDNY 1976), affirmed *ABKCO Music, Inc. v. Harrisongs Music*, 722 F.2d 988 (2nd Cir. 1983).

79 See *Three Boys Music v. Bolton*, 212 F.3d 477 (9th Cir. 2000). In this case, Michael Bolton, who composed the infringing song, was a teenager in 1964, however the court found access because it surmised teenagers listen to the radio and thus Bolton probably heard the song in question.

80 See, e.g., *Moore v. Columbia Pictures Industries, Inc.*, 972 F.2d (8th Cir. 1992). There the court noted that establishing a "bare possibility" of access is insufficient, but rather the plaintiff must establish a "reasonable possibility" of access. The court also said a "reasonable possibility of access" can be established under the "corporate receipt doctrine," which it defined as: "If the defendant is a corporation, the fact that one employee of the corporation has possession of a plaintiff's work should warrant a finding that another employee . . . had access to plaintiff's work, where by reason of physical propinquity between the employees the latter has the opportunity to view the work in the possession of the former." *Id.* at 924, quoting Melville Nimmer and David Nimmer, *Nimmer on Copyright* (Matthew Bender & Co., Inc. 2014), Section 13.02[A]. The court also explained that "we believe that the corporate receipt doctrine applies where there is a "relationship linking the intermediary and the alleged copier," even though the purported copier is not an employee of the intermediary. *Id.*, quoting *Meta-Film Assoc., Inc. v. MCA, Inc.*, 586 F Supp. 1346, 1357 (C.D. Cal. 1984). In this case the court found that giving a performer's demonstration tapes to a corporate executive could constitute access where that executive's boss, who sat near her, suggested to different performers that they create a song, which, the plaintiff alleged, turned out substantially similar to the performer's song. See also *Bouchart v. Baltimore Ravens, Inc.*, 241 F.3d 350 (4th Cir. 2001); *Brainard v. Vassar*, 625 F. Supp. 2d 608 (M.D. Tenn. 2009); Melville Nimmer and David Nimmer, *Nimmer on Copyright* (Matthew Bender & Co., Inc. 2014), Section 13.02[A], 13-15–13-37.

81 See, e.g., *Jones v. Blige*, 558 F.3d 485 (6th Cir. 2009) ("bare corporate receipt" by an executive in one department of entertainment corporation didn't prove access where there was no evidence that the supposed infringing parties even knew that executive or received the underlying work); *Muller v. Twentieth Century Fox Film Corp.*, 794 F. Supp. 429 (S.D.N.Y. 2011) (submission of script to film company did not prove access where there was no evidence that another screenwriter who wrote the allegedly infringing screenplay actually ever saw the script); *Dimmie v. Carey*, 88 F. Supp. 2d 142 (S.D.N.Y. 2000) (where unsolicited song was mailed to defendant record company and plaintiff never even received an acknowledgement of receipt from the record company, such bare corporate receipt, in the absence of any other evidence or striking similarity, was insufficient to prove access); Melville Nimmer and David

Nimmer, *Nimmer on Copyright* (Matthew Bender & Co., Inc. 2014), Section 13.02[A], 13-15–13-37.

82 See, e.g., *Muller v. Twentieth Century Fox Film Corp.*, 794 F. Supp. 2d 429, 442–43 (S.D.N.Y. 2011). See also the other cases cited in footnotes 76 and 77 above.

83 *Nichols v. Universal*, 45 F.2d 119, 121 (2nd Cir. 1930).

84 See Chris Vogler, *The Writer's Journey*, 3rd ed. (Michael Wiese Production 2007).

85 Scene à faire is a French term meaning "scene that must be done."

86 784 F.2d 44 (2nd Cir. 1986).

87 *Id.* at 50.

88 See, e.g., *Beal v. Paramount Pictures Corp.*, 20 F.3d 454 (11th Cir. 1994) ("In evaluating claims of substantial similarity, courts have examined different aspects of the work in question. The district court specifically enumerated plot, mood, characterization, pace, and setting as relevant factors Beal contends that the district court erred in finding insufficient similarities in these aspects. We will examine each aspect independently, adding sequence of events, which Beal argues is also relevant"); *Denker v. Uhry*, 820 F. Supp. 722 (S.D.N.Y. 1992) (*Driving Miss Daisy* ruled non-infringing of previous work where the "theme" of the two works was expressed differently, the "total concept and feel" of the two works differed, and where supposed plot similarities were not deemed significant). One court did find substantial similarity between the movie *Jaws* and a subsequently produced film called *Great White*. There, the court noted a large number of very specific plot and character similarities. See *Universal City Studio v. Film Ventures International*, 543 F Supp. 1134 (C.D. Cal. 1982). See also Paul C. Weiler and Gary Myers, *Entertainment, Media and the Law: Text, Cases, and Problems*, 4th ed., pages 343–347 (West 2011).

89 The authoritative copyright text, *Nimmer on Copyright*, defines "striking similarity" as similarity that "preclude[s] the possibility that the [alleged copier] arrived at the same result . . . as a matter of logic, the only explanation for the similarities between the two works must be 'copying rather than . . . coincidence, independent creation, or prior common source.'" Melville Nimmer and David Nimmer, *Nimmer on Copyright* (Matthew Bender & Co., Inc. 2014), Section 13.02[B], 13-31, quoting *Bernal v. Paradigm Talent & Lit. Agency*, 788 F. Supp. 2d. 1043, 1052 (C.D. Cal. 2010). See also *Selle v. Gibb*, 741 F.2d. 896 (7th Cir. 1984)) ("an inference of access may still be established circumstantially by proof of similarity which is so striking that the possibilities of independent creation, coincidence and prior common source are, as a practical matter, precluded. If the plaintiff presents evidence of striking similarity sufficient to raise an inference of access, then copying is presumably proved simultaneously").

90 See *Gaste v. Kaiserman*, 863 F.2d 1061 (2nd Cir. 1988) (access requirement can be satisfied where there is "striking similarity" between the two works); *Ferguson v. National Broadcasting Co.*, 584 F.2d 111, 113 (5th Cir. 1978) ("If the two works are so strikingly similar as to preclude the possibility of independent creation, 'copying' may be proved without a showing of access").

91 See *Golan v. Holder*, 181 L. Ed. 2d 835 (2012); *Iowa State University Research Foundation, Inc., v. American Broadcasting*, 621 F.2d 57 (2nd Cir. 1980).

92 Note that the statute says these four factors "shall" be included in any such determination, which suggests these four factors must be considered but other factors may also be considered as well. See Roger Schechter and John Thomas, *Principles of Copyright Law* (West 2010), Kindle ed., location 8185.

93 In *Campbell v. Acuff-Rose Music, Inc.*, 510 U.S. 569 (1994), Justice Souter, writing for a majority of the Court, said that Section 107 "calls for a case-by-case analysis" and provides only "general guidance." *Id.* at 577.

94 Section 107 says, "Notwithstanding the provisions of section 106 and 106A the fair use of a copyrighted Work . . . for purposes *such as* criticism, comment, news reporting, teaching scholarship, or research, is not an infringement of copyright" (emphasis added). The words "such as" clearly imply that these are not the only categories that might qualify for Fair Use.

95 See Roger Schechter and John Thomas, *Principles of Copyright Law* (West 2010), Kindle ed., location 8237.

96 See *Campbell v. Acuff-Rose Music, Inc.*, 510 U.S. 569, 591 (1994) ("when . . . the second use is transformative, market substitution is at least less certain, and market harm may not be so readily inferred"). This case dealt with the band 2-Live Crew's parody version of Roy Orbison's classic song, "Pretty Woman." To be funny, parodies often closely copy the underlying work, which can quickly lead to copyright litigation. In this case, the court noted that a parody may not diminish the value of the parodied work because the parody itself is so different and appeals to a different audience.

97 See *Castle Rock Entertainment v. Carol Publishing Group*, 150 F.3d 132 (2nd Cir. 1998) (trivia quiz book about *Seinfeld* TV show found to violate copyright and not be a Fair Use where the purpose of the book was to entertain by using copyrighted material taken from the show). See also *Warner Bros. Entertainment Inc. v. RDR Books*, 575 F. Supp. 2d 513 (S.D.N.Y. 2008) (though the court ruled an unauthorized reference guide to the *Harry Potter* books could be a transformative use under Fair Use law, the court ultimately found the unauthorized work in question was not a Fair Use because its purpose was not entirely transformative and too much of J.K. Rowling's original expression was taken).

98 *Campbell v. Acuff-Rose Music, Inc.*, 510 U.S. 569, 586 (1994).

99 *Id.*

100 See. e.g., *Harper & Row v. Nation Enterprises*, 471 U.S. 539, 563 (1985) (where the court identified factual works as being farther away from the "core"; the court said, "The law generally recognizes a greater need to disseminate factual works than works of fiction or fantasy").

101 See Roger Schechter and John Thomas, *Principles of Copyright Law* (West 2010), Kindle ed., location 8385.

102 *Walt Disney Productions v. Air Pirates*, 581 F.2d 751 (1978).

103 It has been noted that parody, such as happened in the *Air Pirates* case, poses especially difficult Fair Use questions. Roger Schechter and John Thomas in their excellent book, *Principles of Copyright Law* (West 2010), write that "Courts have struggled for decades with the place of parody under the fair use doctrine. At least two aspects of parody have made it especially troubling. First, a parodist must necessarily borrow considerable amounts from the work being mocked. Without such extensive borrowing, the target of the parody will be obscure and the humor will be lost. Of course extensive borrowing has usually resulted in a denial of the fair use defense. Second, because parody is critical of the original work, the author of the underlying work is highly unlikely to grant permission to the parodist, and is likely to litigate with vigor when the parody appears on the market." *Id.* at location 8971-72. See *Campbell v. Acuff-Rose Music, Inc.*, 510 U.S. 569 (1994), where the band 2-Live Crew landed in court when it recorded a parody version of Roy Orbison's classic song, "Pretty Woman." The Supreme Court ruled this was a Fair Use, noting that a parody, even one that takes a great deal of the underlying work, may not diminish the value of the parodied work because the parody version may appeal to a different audience.

104 *Harper & Row v. Nation Enterprises*, 471 U.S. 539, 566 (1985).

105 *Campbell v. Acuff-Rose Music, Inc.*, 510 U.S. 569, 585 n.18 (1994) ("being denied permission to use a work does not weigh against a finding of fair use").

CHAPTER 2
Music Copyright

INTRODUCTION

The ability to experience music radically changed during the early part of the twentieth century. First, the phonograph was introduced at the start of the century,[1] next came commercial radio in 1920,[2] and then sound was added to films in 1926–1927.[3] By the middle of the twentieth century, music seemingly came from everywhere—from restaurants, bars, stores, baseball parks, elevators, cars and television sets. The twenty-first century has added iPhones and gas station pumps to the list. Not surprisingly, over the years, both the law and business practice adapted to accommodate this explosive new market.

From the inception of the sound era, musical works have been protected by copyright. The 1909 Copyright Act covered musical works,[4] and Section 102 of the 1976 Copyright Act identifies "musical works, including any accompanying words" as works of authorship eligible for copyright.[5]

Most of the general copyright rules we've discussed apply to musical works. For example, to receive copyright, a musical work must be original and fixed in a tangible medium of expression. The term of copyright is the same for musical works as for everything else, and rules regarding joint works apply equally as well.

Music, however, does create its own unique legal and business issues. We'll look here at broad issues that people who either work or want to work in the entertainment industry need to know.

Before going forward, I want to make a fundamental point about music copyright. As we'll discuss, copyright law at first only covered what a composer and lyricist authored and fixed in a tangible medium of expression. What they fixed was, and still is, a blueprint for a musical piece or song that a person or band or orchestra can read and perform. For many years, when music or a song was recorded, copyright continued to protect *just the notated music and lyrics, and not the sound recording.* It wasn't until 1972 that Congress permitted the actual sound recording of songs and musical compositions to be separately copyrighted.

Music copyright can be confusing, but if you bear in mind there are two very different kinds of musical copyrights—one for the underlying composition and one for the actual sound recording—this will hopefully make things a bit easier to understand.

MUSIC AND COPYRIGHT LAW

During music's tremendous commercial growth in the twentieth century, Congress made several changes to copyright law to accommodate the special interests of various parties involved in the music business. Most of these changes addressed either highly technical issues or the concerns of a relatively few people, and these changes don't need to be discussed here.[6] Congress did, however, make two very important changes to copyright law that you should understand. One change created the "compulsory mechanical license" and the other created the just-mentioned sound recording copyright.

Compulsory Mechanical License

As we've discussed, copyright owners control five exclusive rights in their work—the right to reproduce, to make derivative works, to distribute, to perform publicly, and to display. Under certain circumstances, however, copyright owners of musical works do *not* control all of these rights. More specifically, owners of musical copyrights sometimes don't fully control the right to copy their own work. In these cases, other people can copy their work and distribute those copies *without* permission of the copyright owner.

To be clear, we're talking here about copying only the underlying musical piece and, where applicable, lyrics; we're not talking about copying an actual sound recording. Why might Congress allow a third party to copy someone's music and lyrics without permission? Because when Congress wrote the 1909 Copyright Act, Congress couldn't help but notice that significant changes were brewing in the world of music reproduction. Lawmakers could clearly see that the ability to mechanically reproduce sound had arrived on the scene. Player pianos that used manufactured piano rolls enabled people to mechanically reproduce a musical work, as did gramophones, which were the early versions of record players.[7]

Though music reproduction was still a nascent business, Congress understood its commercial potential and worried that composers and music companies would monopolize the music business.[8] To prevent this from happening, Congress, in the 1909 Copyright Act, gave third parties certain rights to reproduce and distribute a musical work without the composer's permission.[9]

This right became known as a "compulsory mechanical license." That's because the new law gave third parties the right to *compel* music authors to grant them a license to reproduce their previous published music and sell copies of the

reproduction. It was called a "mechanical license" because, when the law was written, music was reproduced only on machines—gramophones, for example.

The practical, real-world effect of the compulsory mechanical license was to give third parties the right to "cover" songs and orchestral music without asking for permission from the composer and lyricist. It's worth repeating: A compulsory mechanical license compels the song's copyright owner to allow reproduction of the music and lyrics, but not the *actual sound recording* of the song. The compulsory mechanical license thus enables third parties to hire their own singer and musicians and recording engineers, to record the song, and then to distribute that new recorded version to the public.[10]

To date, the Beatles' song "Yesterday" is widely considered to be the most covered song in history, with over 3,000 separate renditions.[11] Assuming the Beatles had neither the time nor the inclination to approve 3,000 separate license requests (one per day would take nine years to process), the people who recorded their version of the song without the Beatles' permission have the compulsory mechanical license to thank.

Not that the Beatles didn't get something out of it. While people can compel composers and songwriters to grant a mechanical license, they do have to pay royalties to the copyright owner. The current royalty structure is discussed in Section 115 of the 1976 Copyright Act. The royalty is based on how many copies of the cover version are distributed.[12] For example, if an artist covers a song on a record and 100,000 copies of the record are distributed, then the royalty would be based on 100,000 copies. At the time of writing, the compulsory mechanical license royalty is 9.10 cents per copy for songs five minutes or less in length, and 1.75 cents per minute or a fraction thereof per copy for songs longer than five minutes.[13] Thus, if an artist covers a three-minute song using a compulsory mechanical license and the artist distributes 100,000 copies of their version,[14] then the artist covering the song must pay the author 100,000 × 9.1 cents, which equals $9,100.

It is important to know that Section 115 restricts the use of compulsory mechanical licenses in several ways. These limitations include:

- Music is *not* subject to a compulsory license and may not be covered *unless and until* it has already been recorded at the author's behest and distributed to the public-at-large.[15] This means the author gets first crack at recording and selling the musical work to the public before anyone can cover it.
- A person may obtain a compulsory license only if his primary purpose in making the cover version is to sell it to the public for private use.[16]
- *You can't receive a compulsory license if you want to use your cover version in a film, DVD or any other format that includes visual elements*; you can only cover a song if the cover version will solely be distributed in an audio-only

format.[17] This means people who want to use pre-existing music or songs in movies, TV shows, video games or other audiovisual works must get explicit permission from the copyright owner in the form of a "synch license." This is discussed later in the chapter.

- The cover version can't change the music's basic melody or fundamental character.[18]
- Some music is *never* subject to the compulsory mechanical license. Section 115 says a compulsory mechanical license is only available to cover "nondramatic" musical works.[19] Therefore, "dramatic" musical works are *not* subject to the license. What's a dramatic work? It's a musical work that's part of telling a dramatic story, such as a work in a musical play or opera.[20] So, if you want to copy a song from your favorite musical, you can't compel the composer to grant you a license—you have to ask for one. Second, you can't receive a compulsory mechanical license to cover musical works written specifically for movie soundtracks or any other audiovisual work.[21] Thus, a film's musical score is not subject to a compulsory mechanical license.

Sound Recordings

For the past hundred years or so, musical pieces have generally been written so they can be recorded. Despite this two-step process, copyright law has traditionally deemed only the composer and (where applicable) the lyricist to be the work's authors. In general, therefore, these people, and *only* these people, have received copyright to a musical work, along with the exclusive rights that comes with copyright ownership.

Prior to the 1970s, there was no copyright protection whatsoever for the *actual recording* of a musical work. If you think about it, this may strike you as odd. As previously mentioned, notated music, much like a screenplay, generally serves as a blueprint for a future work. In the case of screenplays, however, that future work—a movie—has always been entitled to copyright protection, separate and apart from the underlying screenplay. Yet, this has not always been the case with sound recordings. Maybe this was so because, for centuries, musical compositions were designed for musicians whose performance literally vanished into thin air, so perhaps Congress was slow to extend copyright protection to anyone other than the work's authors. Regardless of the reason, Congress did not include sound recordings as a "work of authorship" eligible for copyright until 1972.[22]

Interestingly, a primitive form of music piracy served as an impetus for Congress to act. Back in the 1960s and early 1970s, pirates began bootlegging master recordings.[23] A "master recording," or "master," is simply the final version of a music recording; it's the "master" you hear when you listen to a song on the radio or on a record.

Donald Passman, in his book *All You Need to Know About the Music Business*, points out how pirates sometimes used bootlegged masters prior to 1972. Say back then you were somewhat less than scrupulous (or far less than scrupulous) and wanted to make money by selling a bootlegged master of a song on a record *you* distributed. How could you do it within the strict letter of the law? First, get a compulsory mechanical license so you could legally copy the song on your record. Next, "cover" the song by using the bootlegged master. What would stop you from doing this? Answer: nothing. Since there was no copyright in the master sound recoding, it was unprotected. So, without having to pay for your own recording session, voilà, you "covered" the song by using the original master.[24]

The sound recording copyright Congress created in 1972 put an end to this rather unsavory practice; by extending copyright protection to sound recordings, pirates could no longer copy a master recording with impunity.

Congress, however, did not see fit to grant sound recordings *all* of the rights granted to other works of authorship. There are two major differences. The first deals with the exclusive performance right. While songwriters (and authors of every other work of authorship for that matter) have the exclusive right to control all public performances of their work, owners of sound recordings have only a very limited right to do so.[25] Their public performance right is restricted solely to "digital audio transmissions"[26]—that is, transmissions in a digital format as opposed to transmissions that go over airwaves or by any other means.[27]

What is the practical effect of this omission? Say you write a hit song and a radio station or baseball stadium owner wants to play it. Playing the song over the radio or before 40,000 people sitting in a baseball stadium constitutes a "public performance" of the song. Therefore, to publicly play the song, the radio station or ballpark must receive permission from you, the author of the song, in the form of a public performance license. Permission will likely be granted only if a satisfactory royalty is paid.

Songwriters and composers can make a fortune from these performance royalties,[28] but not owners of the sound recording copyright. When the master version of the song is played over broadcast radio or at the baseball stadium or at a mall, as may be done thousands of times a day worldwide, the owner of the sound recording copyright receives nothing.[29]

The other major difference between a sound recording copyright and every other copyright has to do with the reproduction right. Recall that someone can be deemed to have illegally reproduced another person's copyrighted work if the infringer had access to the copyrighted work and the infringer's work is substantially similar. While it's true that the sound recording copyright prevents someone from copying the actual master recording, it's perfectly okay under current

law for a third party to intentionally mimic the sound of the master recording when making a cover version. In other words, there will be no legal liability if your recording is substantially similar or even strikingly similar to the original version as long as you used your own ingenuity when making the cover version and didn't physically copy the master.[30]

Ownership of Sound Recordings

Just who owns a sound recording copyright? This is often a much easier question to ask than to answer, which can pose terrible problems for filmmakers who want to use pre-existing music in their films, TV shows, internet productions or commercials.

First let's ask, who *should* own the sound recording copyright? If copyright is meant to benefit authors, then who "authors" the sound recording? Certainly, the band members or musicians are responsible for the sound. So is a singer in the case of songs. Arguably, so is the record producer who is ultimately responsible for the sound recording. How about the sound mixer or whoever assists the sound mixer? Good question. Could be.

It's safe to say most sound recordings are joint works[31] of authorship with several people sharing the copyright. Oftentimes, these collaborators will come to an agreement amongst themselves regarding who owns the sound recording copyright. But when they don't agree, things can get messy, especially for filmmakers who want to license master recordings for use in a production. Where bands have split up, or where people involved in a sound recording can't agree on who owns what, it can be extremely difficult to license the master recording.

But wait—thanks to the work-for-hire rule, don't we usually know who owns a sound recording? Isn't it the party that pays for the sound recording? Indeed, when a company or person does pay for the recording, then yes, the paying entity usually does own the sound recording copyright. But on *what basis* they own it is arguably a bit vague.

Certainly, record companies that routinely pay for sound recordings will argue they own the sound recording copyright as a work for hire. But, as we'll see shortly, this may not be the case, and even the recording companies aren't sure about it. So, to cover their bases, most record companies or other paying entities do something clever in their contracts with recording artists. First they say that the sound recording is a work for hire. However, they often add contractual language that says if ever the recording is judged *not* to be a work for hire, which means the recording artists would have owned the copyright from the get-go, those recording artists agree in the contract to transfer the copyright to the recording company. In other words, if a court ever decides the

recording isn't a work for hire, the record company owns the copyright anyway because, by contract, the artists have already transferred their copyright to the company.[32]

You'd think it would be pretty easy to look at copyright law and determine if sound recordings can be a work for hire. Yet, when it comes to sound recordings, the people who drafted the work-for-hire statute gave us a big glaring hole to contemplate. Section 101 of the 1976 Copyright Act defines a work for hire as:

> (1) a work prepared by an employee within the scope of his or her employment; or (2) a work specially ordered or commissioned for use as a contribution to a collective work, as a part of a motion picture or other audiovisual work, as a translation, as a supplementary work, as a compilation, as an instructional text, as a test, as answer material for a test, or as an atlas.

Clause (1) deals with works prepared by employees within the scope of their employment. It may sometimes be that people who make sound recordings do so as employees of the paying entity. When this is the case, then, yes, a sound recording can be a work for hire.

Usually, however, the people creating the sound—band members, musicians, a singer—are not, in the legal sense, "employees" of the record label or the paying entity. Instead they are what the law calls "independent contractors"[33] and therefore clause (1) doesn't apply to them at all. So, we have to look at clause (2), which says a work can only be a work for hire if it's

> commissioned for use as a contribution to a collective work, as a part of a motion picture or other audiovisual work, as a translation, as a supplementary work, as a compilation, as an instructional text, as a test, as answer material for a test, or as an atlas.

What you don't see in this list is anything directly referring to sound recordings. Sure, per clause (2), if a sound recording is made in connection with a movie or other audiovisual work, then the recording can be a work for hire.[34] But what about a song meant to be distributed on a record or as a digital download? If the song is part of an album, can you say that it's used as either a "contribution to a collective work" or a "compilation"?[35] People have argued over this, with many believing that, on its face, clause (2) denies work-for-hire status to sound recordings produced for records.[36]

Still, if whoever pays for a sound recording is going to end up owning the copyright anyway—either as a work for hire or through a clever contractual transfer of copyright ownership—why bother analyzing the nuances of the work-for-hire issue? Why should anyone care on what basis the paying entity owns the sound recording copyright? Here's why: There's a big

difference if the paying entity owns the copyright by virtue of a contractual transfer rather than as a work for hire. The big difference is, because of the 1976 Copyright Act, transfers of copyright that occurred on January 1, 1978 or thereafter can be terminated after 35 years, which means the sound recording artist(s) might eventually recover the copyright should they so desire.[37]

A musical artist who signed a recording contract in 1978 did so, at the time of writing, 36 years ago. Some recording artists who were popular in the late 1970s and early 1980s may think (a) the sound recording I made isn't legally a work for hire, (b) therefore the paying entity owns the copyright, if at all, by virtue of a contractual transfer I agreed to in my contract, (c) more than 35 years have passed (or will soon pass) since the transfer was made, and (d) I want my sound recording copyright back.

Ultimately, courts will have to decide whether or not sound recordings can be works for hire or not.[38]

Sampling and Mash-Ups

Sampling and mash-ups offer a good opportunity to summarize mechanical license and sound recording copyright laws. Given that musical artists these days like to sample music, the question is, do they have to pay for the works they sample? The answer is yes, because courts have ruled that sampling without permission violates copyright law. For example, in *Bridgeport Music, Inc., et al. v. Dimension Films et al.*,[39] the court found sampling a five-second guitar riff violated copyright. In another case, *Grand Upright Music Limited v. Warner Bros. Records, Inc.*,[40] the defendants claimed sampling was acceptable without obtaining a license because so many people in the music industry did it. The court responded by saying, "the defendants . . . would have this court believe that stealing is rampant in the music business and, for that reason, their conduct here should be excused." The court's response to this argument was "Thou shall not steal."

Thus, if a master recording is sampled without permission, two copyrights are violated: The copyright in the song, owned by the composer and lyricist, and the sound recording copyright. Therefore, where an artist wants to sample, they need to strike a deal with both the songwriter(s) and the sound recording copyright owner(s).

Why must a deal be made with the songwriter? Can't a compulsory mechanical license be used to give someone the right to sample the song? The answer is no because, as mentioned above, a compulsory mechanical license forbids changing the music's basic melody or fundamental character.[41] Samples and mash-ups, however, place the musical work in a different context and therefore do change its fundamental character.

MUSIC PUBLISHING

Legal issues have distinctly influenced the way business is conducted in the music industry. Certain business practices have evolved over time that are important to understand. One of these practices involves the role of music publishers.

Imagine it's 1964 and you're either John Lennon or Paul McCartney—the Beatles' principal songwriters and therefore the owners of those songs.[42] Both were in their early twenties, neither went to college, and neither was prepared to handle the business demands their success created. Suddenly, they were international superstars and everyone wanted a piece of them and their music.

If you were Lennon or McCartney, how could you possibly manage all of the business demands and opportunities? How could you personally manage getting all of your songs on radio stations across the world, or publishing the songs as sheet music in dozens of different languages, or managing concert dates, or licensing your music when licenses were required, or making record deals and collecting all the royalties owed to you? How could two twenty-something people handle all this? Obviously they couldn't.

Of course, the Beatles' success was unprecedented, but the fact is that all songwriters and composers throughout most of the sound era have needed help promoting their work and managing business affairs. So music companies formed to handle these matters. These companies, known as "music publishers," take artists' music, promote it, make record deals, attempt to have the records played on radio stations or in public places, entice artists to sing or cover their clients' songs, cajole film producers to use the songs in movies, and collect all payable royalties.

Don't be confused by the name "music publisher." These companies don't "publish" music in the traditional sense of the word. Instead, think of them as agents who exploit their clients' musical works by promoting them, granting licenses and collecting fees.

Given that music publishers routinely grant copyright licenses to third parties, one of two things must happen: Either (a) every time the publisher wants to grant a license, the publisher has to call the composer and/or lyricist and eventually work out a deal, or (b) the author of the musical work has to transfer the copyright to the publisher so the publisher doesn't have to pick up the phone every time a deal is in the offing, but instead can act unilaterally.

Which option do you think prevailed? If you said the copyright is transferred to the music publisher, you're right.

To be clear, music publishers usually *own the copyright* to whatever song or musical work they promote. That's what music publishers have generally

demanded from composers and lyricists as a precondition for their help. In return, the music publisher uses its business connections and clout to exploit the song commercially. As a general rule of thumb, the publisher keeps 50 percent of the revenues generated (called the "publisher's share") and the work's author keeps 50 percent (called the "author's share").

I mention this because, as discussed earlier, if someone wants to use a pre-existing song in a film or other audiovisual work, a compulsory mechanical license is unavailable.[43] Therefore, movie, television, video game and commercial producers who want to use a song must specifically ask for and receive what's called a "synch" license. More often than not, this request will be made to a music publisher, because a publisher usually owns the song's copyright.

Thanks to the damage done by music piracy over the past two decades, many music publishers have gone out of business. At the time of writing, four large music publishers remain: EMI, Sony/ATV, Universal and Warner/Chappell. So, if you want to use a well-known song in your production, there's a good chance one of these four companies owns the copyright.

Ironically, the internet, which has taken so much from the music industry thanks to piracy, has given a tiny bit back by allowing artists to manage their own affairs more easily. Some new artists now self-publish their works, using the internet to market and distribute them, thus permitting the artists to maintain control of the copyright. Because some artists do self-publish, it may be one day you'll end up talking directly to a musical work's author if you need a copyright license.

LICENSES

Filmmakers often approach copyright owners seeking licenses to use a musical work in a variety of different ways. The following are the licenses most frequently sought.

Synch License

A "synch license" permits someone to use a pre-existing song or other musical work in a film or any other kind of audiovisual production. It's called a "synch" license because, in the pre-digital era, a music track was physically synched up with the film's negative so the music played at precisely the right moments.

A synch license can cost anything from next to nothing to hundreds of thousands of dollars, depending on the popularity of the song and whether or not the song will be used prominently, such as in a film's main titles or in advertising for

the production. Assuming a music publisher owns the copyright to the work, the music publisher will generally receive 50 percent of all synch license fees and the author will receive 50 percent.

Bear in mind that a synch license only allows someone to copy, distribute and perform the song's music and lyrics in the production; it does *not* allow you to use the master sound recording. If a producer wants to use the master, the producer will need to negotiate both a synch license and a sound recording license, which often means negotiating with two different parties. If, however, the producer is prepared to create her own version of the song for use in the production—in other words, to pay for a cover version of the song—then only a synch license will be necessary.

Also, note that a synch license or a sound recording license doesn't necessarily grant permission to use the song in the DVD version of the film, or any other subsequent version for that matter. In short, one must carefully negotiate in what media formats and for how long the song or the master recording may be used.

Performance License

Composers and songwriters exclusively own the right to publicly perform their work.[44] Therefore, a "performance license" must be obtained by anyone who wants to publicly perform the song. Radio broadcasts, live concert performances and recorded airings at ballparks and shopping malls are all examples of public performances.

Given the seemingly limitless number of venues that publicly perform music, copyright owners cannot possibly manage all of the public performance licensing transactions. So copyright owners have transferred control of their public performance right to third parties known as "performing rights societies." These outfits can license a single song or, under what's called a "blanket" license, every song they control. The largest performing rights societies are the American Society of Composers, Authors and Publishers ("ASCAP"), Broadcast Music, Inc. ("BMI") and the Society of European Stage Authors and Composers ("SESAC"). These three organizations control the performance rights to an enormous catalogue of songs and other musical works.

ASCAP, BMI and SESAC not only sell performance licenses to those that want them but also collect the required royalties. Given that musical works are performed countless times a day around the globe, one can legitimately ask how organizations like ASCAP and BMI keep tabs on how many times a song or piece of music has been publicly performed. Certainly the internet makes it much easier for those that perform songs, such as radio stations and public venues, to keep accurate accounts of when a song is played.

Moreover, those accounts can be instantly transmitted to companies like ASCAP. Beyond this, the performing rights societies routinely sample how often a song or piece of music is played on the radio or TV or in public venues during a discreet period of time, and then from this information the societies extrapolate how often the musical work is played over longer stretches of time. It's on this latter estimation that the performing rights societies pay members their royalties.[45]

To say that performance royalties constitute a lucrative business is an understatement; ASCAP said it distributed $827 million to its members in 2012.[46]

Grand Rights

When someone wants to use a pre-existing song or musical work in a stage play, musical stage play or opera, a "grand rights" license must be negotiated with the copyright owner, which as we've discussed is usually a music publisher. As with any license, generally half of the royalties paid for the license will go to the music publisher and half will go to the work's author.

NOTES

1 Trevor L. Cass, "A Short History of the Gramophone," *The Museum of Technology*, last accessed on June 18, 2014, http://www.museumoftechnology.org.uk/stories/grams.html.
2 See "KDKA begins to broadcast, 1920," on the PBS website, last accessed on June 18, 2014, http://www.pbs.org/wgbh/aso/databank/entries/dt20ra.html.
3 Dion Hanson, "The History of Sound in the Cinema," *Cinema Technology Magazine*, July/August 1998, last accessed on June 18, 2014, http://www.cinematechnologymagazine.com/pdf/dion%20sound.pdf.
4 See, e.g., Section 1(e) of the 1909 act.
5 17 U.S.C 102(a)(2).
6 Just by way of example, restaurant owners pushed for changes in copyright law allowing them to broadcast music in restaurants without having to pay performance royalties to authors. The restaurant owners succeeded, because Section 110(5)(b) of the 1976 Copyright Act, as amended by the Sonny Bono Copyright Term Extension Act, now says that restaurant owners whose restaurant is less than 3,750 square feet can broadcast a song in restaurants via radio transmission without having to pay a performance royalty.
7 See Howard Abrams, "Copyright's First Compulsory License," *Santa Clara Computer & High Technology Law Journal*, vol. 26, no. 2, pages 219–220, last accessed on June 18, 2014, http://digitalcommons.law.scu.edu/cgi/viewcontent.cgi?article=1499&context=chtlj.
8 *Id.* It's also worth remembering that, in the first decade of the twentieth century, Teddy Roosevelt and his strong anti-monopoly views dominated the political landscape. Perhaps it's not surprising, then, that when Congress drafted the 1909 Copyright Act, it sought to make sure the new commercial market for music reproduction didn't solely fall into the hands of the people who wrote and published music.
9 See Section 1(e) of the 1909 act, which says: "whenever the owner of a musical copyright has used or permitted or knowingly acquiesced in the use of the copyrighted work upon parts of instruments serving to reproduce mechanically the musical work, any other

person may make similar use of the copyrighted work upon the payment to the copyright proprietor of a royalty."

10 While Section 115 permits artists to cover a song without permission of the copyright owner, the artist is not entitled to any copyright in their cover version. In other words, an artist covering a song can't obtain a copyright in their version as a derivative work. See Section 115(a)(2).

11 See http://www.songfacts.com/detail.php?id=82.

12 See Section 115(c)(2).

13 See "Mechanical License Royalty Rates," *U.S. Copyright Office*, last accessed on June 18, 2014, http://www.copyright.gov/carp/m200a.pdf.

14 These hypothetical 100,000 copies could be sold as part of full-length records, or as singles, or as digital downloads, or any combination thereof.

15 See Section 115(a)(1) of the 1976 Copyright Act. Note that the law now deems distribution to include sales via digital downloads.

16 See Section 115(a)(1) of the 1976 Copyright Act. The U.S. Copyright Office says that non-private uses include use in "background music systems, jukeboxes, broadcasting, or any other public use." See "Circular 73, Compulsory License for Making and Distributing Phonorecords," *U.S. Copyright Office*, page 2, last accessed on June 18, 2014, http://www.copyright.gov/circs/circ73.pdf.

17 Since one can only get a compulsory mechanical license to distribute cover versions on phonorecords, and since phonorecords are defined as objects that convey "sounds," an object that conveys more than just sounds, such as a DVD, is not a phonorecord, thus making the compulsory mechanical license unavailable.

18 Section 115(a)(2) of the 1976 Copyright Act states, "A compulsory license includes the privilege of making a musical arrangement of the work to the extent necessary to conform it to the style or manner of interpretation of the performance involved, but the arrangement shall not change the basic melody or fundamental character of the work, and shall not be subject to protection as a derivative work under this title, except with the express consent of the copyright owner."

19 Section 115(a).

20 See Donald S. Passman, *All You Need to Know About the Music Business*, Kindle ed. (Rosetta Books 2010), location 3757.

21 Section 115 says that the compulsory mechanical license can only be obtained where the new version of the song will be distributed in "phonorecords." Phonorecords is clearly a "word" only a lawyer could love, but for the record, Section 101 of the Copyright Act defines "phonorecord" as "material objects in which sounds, other than those accompanying a motion picture or other audiovisual work, are fixed by any method now known or later developed, and from which the sounds can be perceived, reproduced, or otherwise communicated, either directly or with the aid of a machine or device." Therefore, by definition, a phonorecord can't include a film or TV show soundtrack. Since one can only get a compulsory mechanical license to distribute cover versions on phonorecords, and since phonorecords don't include motion picture soundtracks, one can't get a compulsory mechanical license to copy a soundtrack or other musical work accompanying a film or other audiovisual work.

22 See Section 102(a)(7) of the 1976 Copyright Act; see also "Copyright Registration for Sound Recordings," *U.S. Copyright Office*, last accessed on June 18, 2014, http://www.copyright.gov/circs/circ56.pdf, footnote 1.

23 Yes, long before our digital era, people were hard at work pirating music. Back then, people were quite cheeky about it, too—they sometimes issued bootlegged recordings with a skull and crossbones logo on the record. See Donald S. Passman, *All You Need to Know About the Music Business*, Kindle ed. (Rosetta Books 2010), location 5734.

24 *Id.* at location 5722.

25 See Section 106(6) of the 1976 Copyright Act and Section 114 of the 1976 Copyright Act.

26 *Id*. The "digital audio transmission right" was added to copyright law by the 1995 Digital Performance Right in Sound Recording Act. The 1998 Digital Millennium Copyright Act further modified the digital audio transmission right. The law gets byzantine and confusing; fortunately, while the specifics of the law necessarily concern digital transmitters, they need not concern us.

27 But there's even an exception to this rule—a terrestrial radio station that broadcasts digitally in HD does not have to pay any royalties unless it simulcasts its transmission by streaming it over the internet, and if it does simulcast the broadcast, then it only pays royalties on the streaming portion of the broadcast. See Donald S. Passman, *All You Need to Know About the Music Business*, 7th ed. (Rosetta Books 2010), location 5454.

28 Just to emphasize the point, songwriters earn the performance royalty, not the members of the band that performed the song. In any band, it's the songwriting member(s) who can get rich from performance or mechanical license royalties, because they own the copyright to the songs. Other members of the band are not by law entitled to any share of this money. Other band members would likely have an interest in the *sound recording* copyright, though this is a far less lucrative copyright than the author's copyright.

29 One obvious question to ask is, why were sound recordings given a significantly diminished performance right? The cynical though no doubt truthful answer has to do with lobbyists. Lobbyists for terrestrial radio stations and public venues fought hard against having to pay a sound recording royalty. Why didn't digital radio stations also rise up to defeat this law? Probably because when the digital audio transmission right was added to copyright law in 1995, the internet was still embryonic and its early adopters didn't have the clout to defeat the law. For what it's worth, terrestrial radio stations have argued that their airplay of records is a boon to sales. The argument goes that band members who likely earn a percentage of sales revenues should be happy for the airplay without receiving a sound recording royalty. So far, Congress has agreed.

30 See Section 114(b) of the 1976 Copyright Act.

31 For a discussion of "joint works," see pages 30–2.

32 David Nimmer and Peter S. Menell, "Sound Recordings, Works for Hire, and the Termination-of-Transfers Time Bomb," 49 *J. Copyright Soc'y U.S.A.* (2001), pages 387, 396.

33 See the following IRS publication for an explanation of the differences between "employees" and "independent contractors": http://www.irs.gov/Businesses/Small-Businesses-&-Self-Employed/Independent-Contractor-Self-Employed-or-Employee.

34 See *Lulirama Ltd., Inc. v. Axcess Broad. Servs., Inc.*, 128 F.3d 872, 882 (5th Cir. 1997) (court ruled sound recordings of musical jingles were not a work for hire when it was not apparent the jingles would be used in audiovisual works); *Staggers v. Real Authentic Sound*, 77 F. Supp. 2d 57 (D.D.C. 1999) (court noted that sound recordings were not included in Section 101, Clause 2).

35 Record companies will certainly argue that a song on an album is part of a "collective" work. See Donald S. Passman, *All You Need to Know About the Music Business*, Kindle ed. (Rosetta Books 2010), location 3757.

36 See, e.g., Devon Spencer, "Sound Recordings in 2013: A Legal Brief," *Music Business Journal* (Berklee College of Music), November 2011, last accessed on June 18, 2014, http://www.thembj.org/2011/11/sound-recording-in-2013-a-legal-brief/.

37 See Section 203 of the 1976 Copyright Act.

38 See Caz McChrystal, "Avoiding the Copyright War of 2013," *Music Business Journal* (Berklee College of Music), July 2009, last accessed on July 15, 2014, http://www.thembj.org/2009/07/avoiding-the-copyright-war-of-2013-master-reversals-looming/.

39 383 F.3rd 390 (6th Cir. 2004).

40 780 F. Supp. 182 (S.D.N.Y. 1991).

41 See Section 115(a)(2) of the 1976 Copyright Act.

42 They owned the music and lyrics, not the sound recording.

43 Recall that these licenses are only available if you distribute a song solely in an audio-only format.

44 Recall that, except for digital audio transmissions, sound recording copyright owners do not own or control the performance right.

45 See Donald S. Passman, *All You Need to Know About the Music Business*, Kindle ed. (Rosetta Books 2010), location 4170 et seq.

46 See "Public Performance Right for Sound Recordings," *Future of Music Coalition*, November 5, 2013, last accessed on June 18, 2014, http://futureofmusic.org/article/fact-sheet/public-performance-right-sound-recordings.

CHAPTER 3
Copyright and Piracy

INTRODUCTION

To those who tell you voting doesn't matter, that one vote can't change any-thing, you tell them about *Sony Corp. of America v. Universal City Studios,*[1] com-monly known as the *Betamax* case. Back in 1984, the U.S. Supreme Court had to decide if commercially sold videotape recorders violated copyright law. By a 5-4 vote, the court ruled that these machines, which consumers used to copy movies and TV shows off their television sets, did not run foul of copyright.

One can argue that this one-vote decision dramatically changed America. Had that one vote gone the other way, modern devices that can download and copy media, such as DVRs and iPods, might still be only figments of some tech geek's imagination. Your laptop computer, iPhone, tablet, PlayStation and Xbox might be unable to download or play previously recorded films and TV shows, and there might never have been DVDs.

Fortunately for the entertainment business, the digital era came unimpeded. In fact, entertainment companies have made a fortune since the introduction of the Betamax recorder and all the subsequent media playing and recording devices. DVD sales alone amounted to nearly $22 billion in 2004,[2] and though revenues suffered a significant drop-off between 2004 and 2012, the sales of physical discs and digital copies alone still rang up $18.2 billion in 2012[3] and $18.3 billion in 2013.[4]

The amusing irony here is that the studios hated videotape recorders when they were commercially introduced back in the mid-1970s and sought to ban them. Indeed, the *Betamax* case began when Universal Pictures and Walt Dis-ney Productions filed suit against Sony in an attempt to rid the world of these machines. Why did the studios sue? For one thing, executives simply disliked ceding the ability to copy their product to someone else. For another, they wor-ried about viewers skipping commercials, which could lead to a loss of advertis-ing revenue, or saving tapes and then not watching future reruns of the show or movie. Some insightful executives worried about the industry losing significant revenues thanks to people copying movies and TV shows rather than buying them on videotape, a market that would soon become highly lucrative.

So the studios went to court, and their eventual legal defeat turned out to be one of the best things that ever happened to the industry. At the time, few executives could foresee the great technological opportunities that were coming their way. With all the benefits, however, came problems, and none more threatening than piracy.

Significant piracy issues began to confound the industry just fifteen years after the *Betamax* decision, bringing a slew of new digitally based copyright cases to the courtroom. We'll examine a few of these digital piracy cases, but first let's go back to the dawn of home taping and examine *Sony Corp. of America v. Universal City Studios.*

THE *BETAMAX* CASE

The printing press was the first great technology that enabled people to easily copy someone else's work. It took hundreds of years for much to change in the world of copying, but the last five decades have more than made up for the centuries of peace and quiet. From Xerox machines, to videotape recorders, to DVD burners and internet file-sharing programs, each new advance has made our lives better by making copying easier. At the same time, however, these new technologies have posed legal problems—often copyright issues—for courts to decide. Perhaps no decision was more important than the U.S. Supreme Court's ruling in the *Betamax* case.

When introduced to the marketplace, videotape recorders[5] were very expensive and somewhat slow to capture the public's passion. Importantly, by 1984, when the Supreme Court decided the *Betamax* case, only 20 percent of American households had a videotape recorder.[6] Costing several hundred dollars or more, these machines allowed users to tape a program from their television set, even if they weren't watching it. I will never forget buying my first recorder in 1980 and hooking it up. Such joy! At the time it seemed a miracle that I could study to take the horrid bar exam and set a machine to record an L.A. Lakers' basketball game.

I may have been excited, but the studios that were having their content copied were not. So they sued.

Stop and think about it for a moment. These machines allowed people like me to copy an entire TV show or movie. But don't copyright owners control the exclusive right to reproduce their work? Doesn't Section 106(1) of the Copyright Act give this right *only* to authors? You bet it does. Therefore, a third party who wants to copy a work needs permission—a license—from the copyright owner. If the third party has no license but copies anyway, that's infringement, unless the third party can claim the copying is a Fair Use.

Back then, when I was copying Lakers' broadcasts, I certainly had no license to copy anything, nor did anyone else using these machines (and I can assure you

few of us had any clue what Fair Use meant). So wasn't this really a clear-cut case of copyright infringement? Because all these shows were being copied in their entirety without permission, didn't the studios have to win this case?

No doubt that's what the studios thought. So how could they possibly lose 5-4?

You may be thinking the studios lost because they sued Sony, but Sony was not the party actually doing the copying—buyers of the machine were doing the copying. It's a good point, but under prevailing court decisions, a party like Sony could be held liable for "contributory infringement" if that party significantly induced or assisted others to violate copyright. And wasn't that exactly what Sony was doing, assisting people like me to violate copyright? That was the primary purpose of Sony's machine, wasn't it?

The Supreme Court ruled otherwise. Yes, the court said, Sony's Betamax machine could be used to infringe copyright. The court also said, however, there could be no finding of contributory infringement if Sony's Betamax machine was capable of a "substantial non-infringing use." In other words, the court said if a manufacturer sells a machine that can be used to violate copyright but can also be used for something substantial that doesn't infringe copyright, then the manufacturer may be off the hook. So the court had to see if Sony's videotape machine was capable of a substantial non-infringing use.[7]

The court found one and, as you may have guessed, it did so by bringing Fair Use into its analysis. The court noted that one of the primary functions of videotape machines was to permit users to watch a show hours after it had been aired—say, when the user came home from work (sound familiar?). The court referred to this, appropriately enough, as "time-shifting." The question for the court became, was "time-shifting" for the user's convenience a Fair Use?

If one resorts to a Fair Use analysis, as the Supreme Court did, one must examine the four-prong Fair Use test we previously discussed. As you know, this involves analyzing the nature and character of the purported Fair Use, how much of the underlying work was copied (in this case, usually all), and to what extent the purported Fair Use injured the value of the underlying copyright.[8]

Interestingly, the five-member Supreme Court majority didn't discuss how much of each work was being copied via time-shifting. This omission did not go unnoticed in Justice Blackmun's dissent:

> The third statutory factor—"the amount and substantiality of the portion used"—is even more devastating to the Court's interpretation. It is undisputed that virtually all [videotape recorder] owners record entire works . . . , thereby creating an exact substitute for the copyrighted original. Fair use is intended to allow individuals engaged in productive uses to copy small portions of original works that will facilitate their own productive

endeavors. Time-shifting bears no resemblance to such activity, and the complete duplication that it involves might alone be sufficient to preclude a finding of fair use. It is little wonder that the Court has chosen to ignore this statutory factor.[9]

Instead, the majority opinion focused on two prongs of the Fair Use test—the nature of the use, and whether the use injured the underlying copyright. The court's majority ruled that time-shifting was a Fair Use because (1) the nature of the use was primarily noncommercial, and (2) the use did not injure the value of the underlying copyright. Because of this finding, the court ruled the Beta-max was capable of a "substantial non-infringing use." Given this, Sony and its machine were off the copyright hook.

One can only wonder what might have happened had the case come along a few years later. Back in 1984, the home video market was still quite small. The Blockbuster chain of video stores hadn't even opened; the first Blockbuster store opened for business in 1985, and it was only after that that the home video market grew rapidly. Indeed, by the early 1990s, there were more than 1,000 Blockbuster stores and more than two-thirds of American homes had a video-tape recorder.[10] If there had been a Blockbuster store on every corner when the case was decided, renting and selling to lots of people the very movies that were being recorded, the Supreme Court may have believed that home-taping did injure the value of copyrights.

On the other hand, had the court ruled in the studios' favor, what would have happened to all those offending machines? There were several million in circulation by 1984. Would the police start conducting systematic searches of peoples' homes to determine what mom and dad and junior were taping? This hardly seemed likely, so some people believed the Supreme Court had no choice but to rule in Sony's favor. No one knows what the justices privately thought about all this; what we do know is that the court, by one vote, gave home taping the stamp of approval, paving the way for DVRs and so many other media-playing devices we now take for granted. The technological flood-gates were about to open.

NAPSTER AND GROKSTER

Fifteen years later, the entertainment industry had a far more serious copying problem to confront. If the studios were concerned about videotape recorders, they were downright apoplectic about peer-to-peer file-sharing technology.

In the mid-1990s, a decade after the *Betamax* decision, the internet began its exponential growth. By the late 1990s, some very bright, creative people figured out that internet users, no matter where they lived, could share digital media files on a massive scale if only they all used the same software. Sites like Napster provided that software. In Napster's case, the idea was to enable users to share

MP3 files; that is, to make copies of songs by downloading them using Napster's peer-to-peer network, centralized servers and searchable index.

As far as young people were concerned, it was a fantastic idea. By February 2001, Napster had more than 60 million users.[11] In that month alone, a total of 2.5 billion songs were swapped on the site,[12] thanks to people spending more than a combined 6 billion minutes of their lives on Napster.[13] For those keeping score at home, that's the equivalent of over 11,400 years of human life.

Of course, what some called massive file sharing, others called massive copyright infringement. Therefore, it's hardly surprising it took only months for Napster to be sued by such disparate parties as the band Mettalica, rapper Dr. Dre, and the Recording Industry Association of America.

Relying on the *Betamax* case, Napster argued that its technology was capable of a substantial non-infringing use. Perhaps this was so, but the *Napster* court didn't care, because it found an important distinction between the *Betamax* and *Napster* cases. The *Napster* court observed that, in the *Betamax* case, the U.S. Supreme Court said:

> if liability "is to be imposed on [Sony and other manufacturers] in this case, it must rest on the fact that *they have sold equipment with constructive knowledge of the fact that their customers may use that equipment to make unauthorized copies* of copyrighted material." . . . The *Sony* Court declined to impute the requisite level of knowledge where the defendants made and sold equipment capable of both infringing and "substantial noninfringing uses." (Original emphasis)[14]

In other words, if a court believes a company should have known it was assisting infringement, the court can impute such knowledge, called "constructive knowledge," to the company. The *Betamax* court was unwilling to impute to Sony constructive knowledge that its customers were violating copyright. This was because Sony had no way of knowing what Betamax users were doing at any given moment and no ability to control those users, *and* because the machines could be used for a substantial non-infringing use. This combination of mitigating factors got Sony off the hook.

The *Napster* court, however, had no problem imputing constructive knowledge of infringement to Napster. This was because Napster *controlled* all traffic through its servers. It had the power to know precisely what was happening on its site and, unlike Sony, Napster could have stopped all infringing transactions, but didn't. Therefore, Napster was ultimately forced to shut down.[15]

At about the same time Napster was having its plug pulled, the website Grokster was just starting up. This was another peer-to-peer media file-sharing site, but the denizens of Grokster learned a thing or two from Napster's demise. Grokster's founders reasoned that if Napster ran afoul of the law because it used centralized servers that gave Napster control over the offending transactions, Grokster would

rid itself of all control. Ignorance would be Grokster's bliss, and only the end-users' computers would manage file sharing, which included exchanges of songs, TV shows and movies.

When the inevitable lawsuits came and the case found its way to the U.S. Supreme Court in *MGM Studios, Inc. v. Grokster, Ltd.*,[16] Grokster made two main arguments. First, as mentioned, it claimed that it had no knowledge of or control over what its users were doing. As a technical matter, this was entirely true; Grokster had no way to know who was sharing what at any given moment. Yet, for anyone whose head wasn't buried in the sand, it was very clear what was going on. People used Grokster for the same reason they used Napster, to share digital files of copyrighted material on a massive scale. A statistical analysis, admittedly performed by a studio-commissioned statistician but nevertheless cited by the court, showed that 90 percent of the material available to Grokster's user's was protected by copyright. This should come as a shock to no one.

Grokster's second argument was that, even assuming the statistician's numbers were correct, certainly some of the material being swapped was in the public domain. No doubt this was true, too. Therefore, Grokster argued, its software was capable of a substantial non-infringing use, just like Sony's Betamax machine.

The fact is, Grokster had Sony's cocktail of mitigating factors—no knowledge, no control, and the ability to perform a substantial non-infringing use. That's why Grokster won in lower court decisions.[17]

The U.S. Supreme Court, however, reversed and ruled against Grokster. Ultimately, the Supreme Court never faced the issue of whether or not Grokster's software could be used for a substantial non-infringing use. It never determined what mix of infringing and non-infringing uses rendered a product legal or illegal. Instead, the court found Groskter liable for contributory infringement because the evidence showed Grokster actively wanted and intended its users to infringe copyright—that its whole business model was knowingly predicated on copyright infringement. In essence, unlike Sony in the *Betamax* case, the Supreme Court found Grokster to be a bad actor that actively wanted illegal conduct to occur.

So, where are we today? What issues might future entrepreneurs consider when contemplating a new technology? Certainly no one can define with confidence what a "substantial non-infringing use" means. No one can say where the line is drawn between an acceptable and unacceptable business model, or whether an acceptable business model created with innocent intentions could be misconstrued someday. As is often the case, the law is vague.

We do know some things. We do know that if evidence demonstrates a website's creators actively want their site to assist or enable copyright infringement, they can be held liable for contributory infringement. This is true even

if, as in *Grokster*, the creators have no control over each transaction. Conversely, where a website's functionality can be used to actually control what transactions take place, then the website's owners may be liable if they don't prevent copyright infringement from occurring. All of which brings us to YouTube.

YOUTUBE AND THE DIGITAL MILLENNIUM COPYRIGHT ACT

YouTube is a fantastic website that hosts a whole lot of copyright infringement. As you know, copyright owners have the exclusive right to copy and distribute their work, yet non-copyright owners routinely upload, that is copy and distribute, protected material to YouTube. YouTube knows this just as well as you and I do. There's also no question, however, that YouTube is capable of substantial non-infringing uses; indeed, it hosts countless non-infringing videos.

In 2007, Viacom, which owns Paramount Pictures, CBS and several cable channels, sued YouTube, which was by then owned by Google. Viacom alleged that its various companies' copyrighted material appeared in tens of thousands of separate videos hosted by YouTube, videos that were viewed more than 1.5 billion times.[18] That's potentially a lot of ad dollars going into YouTube's pocket, and Viacom alleged that YouTube possessed the kind of improper intentions that sank Grokster. Indeed, Viacom claimed that YouTube "has built an infringement driven business by exploiting the popularity of [Viacom's] copyrighted works and the works of other copyright owners."[19]

YouTube's defense relied on a key provision of the Digital Millennium Copyright Act ("DMCA"). By way of background, the DMCA was passed in 1998 and drafted to bring America into compliance with two different World Intellectual Property Organization ("WIPO") treaties. Much of the act creates significant criminal penalties for those who circumvent various copyright protection technologies[20] incorporated into copyrighted works, such as DVDs.[21]

YouTube, however, relied on a different part of the DMCA. When Congress wrote the act, it recognized that countless websites allowed people to upload content. Congress further understood that some of that uploaded content might infringe copyright. This would leave Internet service providers (ISPs) and websites that were understandably unaware of the uploaded content potentially liable for copyright infringement. So, the ISPs asked Congress for protection, believing the threat of endless copyright lawsuits would seriously damage their business.

Congress obliged by passing what is now Section 512 of the Copyright Act. This section protects web businesses from liability if they institute a mechanism for people to register a copyright complaint and, once a legitimate complaint is received, if the offending material is removed from the website.

YouTube created just such a procedure and relied on this to defend itself. Essentially YouTube said, What else could it possibly do? YouTube justifiably claimed that, in the absence of a formal complaint, it had no way of knowing whether copyrighted material on its website was uploaded with or without the copyright owner's permission. Given that a hundred hours of videos are uploaded to YouTube *every minute*,[22] the website is arguably way beyond effective self-policing. Therefore, YouTube said, it can only rely on notices received from copyright owners and then act to remove the offending material.

How would you rule in this case? Here we have a website that (a) hosts a whole lot of copyright infringement, (b) knows it hosts a whole lot of copyright infringement, (c) makes a lot of money off people viewing both offending and non-offending material, (d) can't know whether any particular piece of protected content was uploaded with or without the copyright owner's permission, (d) hosts so much content that it can never be effectively policed, (e) like Napster, has the capability to block offending content, and (f) follows the legal procedure, Section 512, that Congress enacted.

In 2010, a federal district court ruled in favor of YouTube. Viacom appealed. The parties then reached a settlement in March 2014, the terms of which were not disclosed. What can be said is that (a) since the inception of the lawsuit, YouTube has become an enormous player in the entertainment industry, and (b) sometimes it's better to work with a heavyweight than fight it. Thus, after seven years of litigation, a joint Google-Viacom press release said, "This settlement reflects the growing collaborative dialogue between our two companies on important opportunities, and we look forward to working more closely together."[23]

Of course, this leaves copyright owners who do not want their content uploaded with a problem: How do you scan a website for your protected content when the website may have more videos than the ocean has drops of water? Regardless, that's the world we have today. Ultimately, people, and perhaps the law, will have to adjust to changing times.

MORALITY AND DIGITAL PIRACY

Given the copyright issues posed by the internet, one might surmise the web will keep lawyers busy for eternity. Except times may be changing. Attitudes towards copyright are changing.[24] The sheer scope of the problem is seemingly beyond management, which leads many to think copyright law must inevitably change.

Having said this, there is a moral and financial component to copyright infringement that is undeniably real and disturbing. Granted, pirating a song or TV show off the web may be a venial sin and not a mortal one. However, despite the fact that infringers can be fined or jailed[25]—despite the fact that illegal

downloading is a form of theft—people pirate all the time. A 2013 report called "Sizing the Piracy Universe" claimed that 432 million unique internet users worldwide explicitly sought copyrighted content in January 2013, and that 13.9 billion page views were recorded that month on websites devoted to piracy, an increase of about 10 percent over the previous 15 months.[26]

While some people may truly believe everything on the web can be legally copied, most know otherwise. When I have really pressed admitted pirates (which, for a start, includes a whole lot of people in college) to explain or justify the morality of their actions, I think most have a somewhat difficult time. They know, on a moral level, that it's stealing, but the people I talk to most often rationalize what they do by arguing it's akin to stealing a piece of bubble-gum from the world's richest store. They say they pirate because media owners are greedy, the asking price for media is way too high, and the piracy merely deprives enormous corporations of a tiny drop in their ocean of unending profits.

People can try to rationalize all day long why stealing a piece of entertainment they can't afford is *morally* different from stealing a car they can't afford. Notwithstanding the underlying ethical similarities and despite all the rationalizations I've heard, no doubt people steal entertainment rather than Ferraris because, with entertainment, they don't think they're going to get caught.

What people may not know is that all this stealing hurts more than just megacorporations. It significantly hurts the not-so-rich as well. The music industry has been terribly damaged by piracy, leading to the loss of thousands of jobs—jobs held by ordinary people just trying to get by. Indeed, a 2007 study found that music piracy had by then cost more than 70,000 jobs and 2.7 billion dollars in lost annual wages.[27] A similar 2006 study focused on the film business concluded that piracy had cost more than 141,000 jobs and up to $5.5 billion in lost annual wages.[28] Even if these studies are only remotely accurate, that's still a lot of people who lost work, salaries, health benefits and pensions just because so many felt entitled to save a few dollars and watch or listen to whatever they wanted for free.

I am aware that there's an argument that piracy actually helps on occasion. The argument goes that piracy helps by widely distributing a show or song among people who might never buy it anyway, thus the piracy doesn't really injure the bottom line but does create a helpful buzz for the work. None other than Jeffrey Bewkes, CEO of Time Warner, gave support to this argument. When asked how he felt that HBO's *Game of Thrones* was apparently the most pirated show on television, Bewkes reportedly said the piracy and the buzz it created "was better than an Emmy." Why? Because it led to increased HBO subscriptions.[29]

Those who think piracy is an overrated concern will also note that a recent MPAA report claims the 2013 worldwide box office was up from the previous year by 4 percent, and up 1 percent in the United States and Canada. The total

worldwide box office stood at just over $35 billion,[30] hardly a number, some will say, that seems indicative of an industry being "destroyed" by piracy.

Certainly, in recent years, media industries have begun to adapt to the reality of digital file sharing. Bands, for example, now routinely give away music, hoping to entice people to buy concert tickets where some real money can be made. Meanwhile, iTunes and its à-la-carte pricing scheme has pushed down prices to the point where many are willing to buy music rather than steal it. As for movies, they remain more difficult to pirate off the web; downloading a hi-def 120-minute film remains a lot more problematic than copying a three-minute song. And if people want to see a movie *right now*, companies like Netflix, Amazon, Hulu and iTunes make this possible via streaming.

With the recent rapid growth of sites like Netflix, plus the fact that more than 70 percent of American households now have broadband access,[31] perhaps the ready availability of films will reduce the incentive to pirate. Not that the MPAA has slowed its anti-piracy efforts. For example, since search engines are often used to find pirated material, the MPAA recently announced that Google in 2013 removed over 200 million links to pirated material, a 400 percent increase over the 50 million links removed the previous year.[32]

No doubt piracy will continue. Media giants will therefore continue their efforts to curb piracy, all the while considering new cost and distribution schemes designed to lessen its impact. For its part, the U.S. Congress had begun the process of reviewing copyright law, which could lead to significant changes in coming years.

As for the individuals who pirate, it may be the lost jobs, lost health care and lost pensions are simply too great an abstraction to change their behavior. Of course, should the pirates end up working in the entertainment business and their paycheck starts to suffer or their job is threatened, their moral compass may suddenly point in a different direction.

NOTES

1 464 U.S. 417 (1984).
2 See Mike Snider, "Home Video Sales Slide; More Opt for Blu-Ray Players," *USA Today*, May 3, 2011, last accessed on July 14, 2014, http://usatoday30.usatoday.com/tech/news/2011-05-02-dvd-movie-sales-continue-slide_n.htm.
3 Ben Fritz, "Home Video Revenue Stops Falling," *Los Angeles Times*, January 8, 2013, last accessed on June 18, 2014, http://articles.latimes.com/2013/jan/08/entertainment/la-et-ct-home-video-revenue-no-longer-falling-20130107.
4 Mike Snider, "Streaming Video Subscriptions Drive Industry Rise," *USA Today*, January 13, 2014, last accessed on June 18, 2014, http://www.usatoday.com/story/tech/personal/2014/01/13/home-entertainment-sales-rise-2013/4456151/.
5 Back then there were two different types of videotape recorders; one used Sony's Betamax format and others used what was called the VHS format.
6 "TV Basics," *TVB*, page 2, last accessed on June 18, 2014, http://www.tvb.org/media/file/TV_Basics.pdf.

7 464 U.S. 417, 442 (1984).

8 The Fair Use test also requires analysis of the nature of the work itself, but the court did not raise this issue in its decision.

9 464 U.S. at 497.

10 "October 19, 1985: First Blockbuster Store Opens," *History*, last accessed on June 18, 2014, http://www.history.com/this-day-in-history/first-blockbuster-store-opens; http://www.tvb.org/media/file/TV_Basics.pdf.

11 "March 6, 2001: The Death Spiral of Napster Begins," *History*, last accessed on June 18, 2014, http://www.history.com/this-day-in-history/the-death-spiral-of-napster-begins.

12 Richard A. Spinello, "Beyond Copyright: A Moral Investigation of Intellectual Property Protection in Cyberspace," in *The Impact of the Internet on our Moral Lives*, Robert Cavalier, ed. (State University of New York Press 2005), page 31.

13 "Global Napster Usage Plummets, But New File-Sharing Alternatives Gaining Ground, Reports Jupiter Media Metrix," *Comscore*, July 20, 2001, last accessed on June 18, 2014, http://web.archive.org/web/20080413104420/http://www.comscore.com/press/release.asp?id=249.

14 239 F.3d 1004, 1020 (9th Cir. 2001).

15 After its initial shutdown, and then some subsequent legal and business transactions, the Napster name and logo was bought by Best Buy, which eventually negotiated to merge Napster with the music website Rhapsody.

16 545 U.S. 913 (2005).

17 *MGM v. Grokster*, 380 F.3d 1154 (9th Cir. 2004).

18 See Viacom complaint against YouTube, page 3, which you can read here (last accessed on June 18, 2014): http://wendy.seltzer.org/media/ViacomYouTubeComplaint3-12-07.pdf.

19 *Id.* at page 13.

20 These technologies are commonly referred to as "digital rights management" or DRM.

21 See 17 U.S. Code Section 1201, 1204.

22 YouTube publishes this and other statistics here (last accessed on June 18, 2014): http://www.youtube.com/yt/press/statistics.html.

23 Jonathan Stempel, "Google, Viacom Settle Landmark YouTube Lawsuit," *Reuters*, March 18, 2014, last accessed on June 18, 2014, http://www.reuters.com/article/2014/03/18/us-google-viacom-lawsuit-idUSBREA2H11220140318.

24 Certainly organizations like Creative Commons reflect a change in attitude about copyright. For those who don't know, Creative Commons makes it easy for creators to issue licenses that permit third parties to use their work in defined ways. Creative Commons licenses, for example, may permit someone to use a work only for noncommercial purposes, or prohibit someone from making a derivative work. Sites like Flickr.com and deviantART.com permit users to apply a Creative Commons copyright when they upload an image. Google also allows you to search for works tagged with Creative Commons licenses. You can visit the Creative Commons website here: http://creativecommons.org.

25 See 18 U.S. Code Section 2319.

26 See David Price, "Sizing the Piracy Universe," *NetNames Envisional*, September 2013, page 3, last accessed on June 18, 2014, http://copyrightalliance.org/sites/default/files/2013-netnames-piracy.pdf.

27 Stephen E. Siwek, "The True Cost of Sound Recording Piracy to the U.S. Economy," *The Institute for Policy Innovation*, August 21, 2007, last accessed on June 18, 2014, http://www.ipi.org/ipi_issues/detail/the-true-cost-of-sound-recording-piracy-to-the-us-economy.

28 Stephen E. Siwek, "The True Cost of Motion Picture Piracy to the U.S. Economy," *The Institute for Policy Innovation*, September 2006, page i, last accessed on June 18, 2014, http://www.ipi.org/docLib/20120117_CostOfPiracy.pdf.

29 Todd Spangler, "Time Warner's Bewkes: Piracy of HBO 'Game of Thrones' is 'Better than an Emmy,'" *Variety*, August 7, 2013, last accessed on June 18, 2014, http://variety.com/2013/digital/news/time-warners-bewkes-piracy-of-hbo-game-of-thrones-is-better-than-an-emmy-1200575271/.

30 "Theatrical Market Statistics 2013," *MPAA*, page 2, last accessed on June 18, 2014, http://www.mpaa.org/wp-content/uploads/2014/03/MPAA-Theatrical-Market-Statistics-2013_032514-v2.pdf.

31 Emil Protalinsky, "Over 70% of U.S. households now have broadband Internet access, with cable powering over 50% of the market," *TNW Blog*, December 9, 2013, last accessed on June 18, 2014, http://thenextweb.com/insider/2013/12/09/70-us-households-now-broadband-internet-access-cable-powering-50-market/.

32 "Search Engines Must Help Curb Piracy," *MPAA*, November 14, 2013, last accessed on June 18, 2014, http://www.mpaa.org/search-engines-must-help-curb-piracy/.

CHAPTER 4
International Copyright

THE BERNE CONVENTION

Back in 1873 there was a scientific exhibition in Vienna, Austria, called the International Exhibition of Inventions. People from around the world were invited to participate in what amounted to a kind of world's fair of science. Some inventors, however, refused to attend because they feared people would steal their inventions and exploit them in their home countries. Yes, intellectual property theft was alive and well in the nineteenth century, and so, not surprisingly, people began to think about the need for an international system of protection.

Only 13 years later, in 1886, a system of international copyright protection emerged with the initial implementation of the Berne Convention for the Protection of Literary and Artistic Works. Now commonly referred to as the Berne Convention, this pact among nations created international recognition and enforcement of a broad set of copyright principles. As of this writing, 167 countries have signed the Berne Convention, which is administered by the World Intellectual Property Organization (WIPO). The United States, a latecomer to signing the Convention, finally did so in 1989.

The Convention essentially does two things: First, it requires each signatory country to provide via its own laws certain fundamental copyright protections. Any country can offer its citizens more protections than are included in the Convention, but countries may not offer less. The fundamental protections which each country must observe include the following: Copyright begins when a work is first fixed in a tangible medium of expression; formal registration is not required for someone to be a copyright owner; and copyright ownership must last no less than the life of the author plus 50 years, though in the case of filmed works the convention permits protection to last 50 years from initial distribution of the work.[1] Additionally, the Convention requires that copyright owners in each signatory nation receive certain exclusive rights. Generally speaking, these rights include:

- the right to translate the work;
- the right to make reproductions;

- the right to publicly perform filmed works, musical works, or dramatic works that include music, such as plays and operas;
- the right to make adaptations;
- the right to recite written works in public.

The Convention also includes the notion of Fair Use and permits nations to allow citizens to freely exercise a copyright owner's exclusive rights under certain circumstances.[2]

In 1994, another international agreement, the Agreement on Trade-Related Aspects of Intellectual Property Rights (TRIPS), reaffirmed the Berne Convention's copyright requirements but also amended them. For example, the TRIPS agreement makes clear that computer programs and databases are literary works eligible for copyright protection, and it allows member nations to offer copyright protection lasting only 50 years in some circumstances.[3]

Along with mandating fundamental copyright protections in each member nation, the Berne Convention's other main purpose is to protect authors when their works are exploited in another country. The fundamental rule is this: A signatory country must extend to an author from another country the same copyright protection it gives its own citizens. Thus, if I'm an American citizen and I first publish my work in America but the work is thereafter exploited in Germany (which is a signatory to the Convention), the German government must give me the same copyright protection it gives to its own citizens. Similarly, the American government will enforce American copyright law to protect a German author whose work is subsequently exploited in the United States.

Copyright law still varies from nation to nation, but the Berne Convention has created a worldwide baseline of protection and offers authors some comfort when their work is exploited in other countries.

MORAL RIGHTS

American copyright law is fundamentally rooted in economics. Copyright gives authors various exclusive rights so they can benefit financially from their work. As we've seen, in certain circumstances, the law gives the same rights to employers who pay for works to be created. The notion is that economic incentives lead to good work that benefits us all.

This is a perfectly reasonable paradigm for the protection of authors' works. But it's not the only one. European countries like France and Germany have long recognized that an artist's attachment to her work extends beyond economic interests and includes something more personal. These countries have therefore extended to authors certain personal or "moral" rights that last even after the author has transferred ownership of their work to others. The Berne Convention

expressly includes some of these more personal rights, which ostensibly member nations are required to observe. The Convention says:

> Independently of the author's economic rights, and even after the transfer of the said rights, the author shall have the right to claim authorship of the work and to object to any distortion, mutilation or other modification of, or other derogatory action in relation to, the said work, which would be prejudicial to his honor or reputation.[4]

No doubt there are many screenwriters in Hollywood who believe their scripts have been "distorted" or "mutilated" or "modified" in a manner prejudicial to the writer's "honor or reputation." While I say this with some intended humor, the fact is that authors who transfer copyright to studios generally have no say in what happens to the work once it's left their hands. On a personal note, I can recall how my father was furious when a musical piece he wrote as a work-for-hire was licensed to a political candidate he didn't support, yet there was nothing he could do about it.

This raises the question: If America has signed the Berne Convention, and the Convention requires adoption of these moral rights, must not these rights then exist in America? In 1988, when Congress considered the Berne Convention, Congress said these rights did already exist here. Indeed, the Congress stated quite unequivocally that America was in full compliance with the Convention's moral rights requirements thanks to a legislative cocktail of federal and state laws:

> Protection is provided under existing U.S. law for the [moral] rights of authors This existing U.S. law includes various provisions of the Copyright Act and Lanham Act, various state statutes, and common law principles such as libel, defamation, misrepresentation, and unfair competition, which have been applied by courts to redress authors' invocation of the right to claim authorship or the right to object to distortion U.S. [moral rights] obligations under Article 6bis [are therefore satisfied] and . . . no further rights or interests shall be recognized or created[5]

Still, despite Congress' 1988 assertion that U.S. law covered moral rights, in 1990 Congress passed the Visual Artists Rights Act (VARA), which expressly includes a moral rights provision. The law says the author of a work of visual art, which includes paintings, drawings, prints, sculptures and still photographs, has various rights *whether or not he remains the copyright owner.* Among these rights are:

> the right to claim authorship of that work . . . to prevent the use of his or her name as the author of the work . . . in the event of a distortion, mutilation, or other modification of the work which would be prejudicial to his or her honor or reputation . . . [and] to prevent any

intentional distortion, mutilation, or other modification of that work which would be prejudicial to his or her honor or reputation[6]

One might reasonably ask why, if U.S. law already covered the topic of moral rights as Congress asserted in 1988, Congress felt compelled just two years later to add it to VARA, and why did Congress apply these rights only to works of visual art? I can't give you a good answer to either question.[7]

As you may gather, America does not have a tradition of extending personal moral rights to authors. Yes, there are unquestionably safeguards in various laws designed to protect authors from those who would misappropriate their work for financial gain. Still, America has never really embraced the notion of an author's moral, creative rights as other countries have. In the legal sense, we see creative works as property, as economic assets, and not as intensely personal extensions of the author himself. Arguably, VARA was a start in a different direction, but also an apparent end, since nothing has happened in the intervening 24 years.

NOTES

1 See Berne Convention, Article 7, Section 2.
2 See Berne Convention, Article 10.
3 The World Trade Organization administers the TRIPS agreement. You can read more about the agreement here: http://www.wto.org/english/tratop_e/trips_e/intel2_e.html
4 See Berne Convention, Article 6bis(1).
5 See the Senate Report on the Berne Convention Implementation Act of 1988, which can be found in 1988 U.S. Code, Congressional and Administrative News 3706, 3714-15.
6 See the 1976 Copyright Act, Section 106(A).
7 You may wonder whether the visual artist or the employer maintains the moral rights described above if an artwork is considered a work-for-hire. The answer is neither, because VARA specifically excludes all works-for-hire from its protection. See the 1976 Copyright Act, Section 106(A)(c)(3).

CHAPTER 5
First Amendment Law

INTRODUCTION

There would be no entertainment business as we now know it in America without the First Amendment. The Amendment itself is very brief:

> Congress shall make no law respecting an establishment of religion, or prohibiting the free exercise thereof; or abridging the freedom of speech, or of the press; or the right of the people peaceably to assemble, and to petition the Government for a redress of grievances.

Though every word has great meaning and import, the words that have the most consequence for the entertainment industry are: "Congress shall make no law . . . abridging the freedom of speech, or of the press." That's it. These 14 words have had an incalculable impact on American politics, society and culture. They have given us the right to speak freely in ways that, historically, most governments would never tolerate, and they have allowed the modern entertainment business, undreamt of when the words were written, to flourish.

Of course it's not only the words themselves that have had this impact—it's the way these words have been interpreted by U.S. courts. Our courts have to rule on the meaning of these words in the context of specific legal cases. Does the First Amendment's free speech guarantee allow government to pass laws that punish obscenity? Does it permit government to censor speech on television? Does it permit us to say anything we want about private citizens or public figures, even if what we say is false and harmful? These are the kinds of First Amendment issues courts must decide.

Here's another issue: What's the meaning of the two words written in the Amendment that I've emphasized in the following: "Congress shall make *no law* . . . abridging the freedom of speech"? Does this really mean Congress is forbidden from passing *any* laws curtailing speech? Does "no law" really mean *no* law? If it did, then no law could be passed prohibiting people from blocking a road during rush hour so they can give a speech about the pros and cons of the designated hitter rule in baseball.[1]

Not surprisingly, the U.S. Supreme Court has said that, despite the "no law" words used in the First Amendment, government can pass some laws that curtail speech.[2] Not many, but some. For example, you can't hold a protest rally whenever and wherever you want in public,[3] you most definitely can't publish child pornography, and there are some other speech-related activities our current laws prohibit.

Some of these prohibitions, few though they may be, impact the work of entertainers, and so they are the focus of this chapter. More specifically, we'll look at:

- Speech: Is entertainment "speech"?
- Obscenity and indecency: Does the First Amendment allow government to prosecute someone for creating or distributing material that's obscene, or for broadcasting material that's "indecent"?
- Violence: Can producers, writers and others who create violent entertainment be held accountable if someone watches that entertainment and then commits a violent act?
- Self-censorship: To what extent does the entertainment business censor itself?
- Libel: Can media companies be held accountable if false statements about someone (which are, after all, speech) appear in books or entertainment productions?
- Invasion of Privacy: Can media companies be held accountable if productions invade the privacy of others?

Let's begin by asking a very important question. We know that the First Amendment broadly protects speech. But is entertainment "speech," or is it something else?

ENTERTAINMENT AND "SPEECH"

Is a movie "speech"? Is a reality TV show "speech"? Is a video game "speech"? Are these things covered by the First Amendment's free speech guarantees? If so, then they are broadly protected and subject to only the very few speech limitations allowed by the Supreme Court. If, however, they aren't "speech," then all bets are off and government can pass just about any law it wants to censor them.

I think most people reading this book will assume a movie or TV show or video game is "speech" protected by the First Amendment. But just pause for a moment and ask yourself *why*? Why, for example, should a slasher movie be considered "speech"?[4] Is protecting a chainsaw-wielding lunatic wearing a hockey mask what our Founding Fathers had in mind when they wrote the First Amendment? Since they had no idea what a movie was, they certainly weren't trying to protect every on-screen serial killer from governmental interference when they gave us free speech. And would anyone argue that the total amount of truly erudite, informative and enlightening speech included in some reality

TV shows is approximately zero? Can't you claim that most entertainment is really just a business commodity like spark plugs and soap—something to be sold for profit and unworthy of First Amendment protection?

In the first half of the twentieth century, the U.S. Supreme Court did *not* consider films to be "speech" protected by the First Amendment. In *Mutual Film Corporation v. Industrial Commission of Ohio*,[5] a case decided in 1915, the Supreme Court was asked to stop film censorship by Ohio's government. Back then, Ohio had a film censorship board that had to approve any film before it could be shown publicly.[6] People who showed films without the censorship board's approval were subject to arrest.

Ohio's constitution, however, had a provision very similar to the U.S. Constitution's First Amendment and so film owners asked the U.S. Supreme Court to rule that Ohio's free speech guarantee prevented censorship. Instead, by unanimous vote, the Supreme Court refused to stop the censorship.

The Supreme Court declined to stop censorship of movies. But why? Didn't Ohio's free speech guarantee protect movies from some moralizing government bureaucrat? No, the Supreme Court said, it didn't, because films aren't "speech." Instead, the court said, "The exhibition of moving pictures is a business, pure and simple, originated and conducted for profit . . . [and] not to be regarded by the Ohio Constitution, we think, as part of the press of the country, or as organs of public opinion." The court added that films "may be used for evil" and that "a prurient interest may be excited and appealed to." For these reasons the court removed films from the First Amendment's free speech protections.

It was not until 1952, in *Burstyn v. Wilson*,[7] that the Supreme Court reversed itself and declared films to be "speech" protected by the First Amendment. The court brushed aside the argument that entertainment companies are businesses, saying:

> It is urged that motion pictures do not fall within the First Amendment's aegis because their production, distribution, and exhibition is a large-scale business conducted for private profit. We cannot agree. That books, newspapers, and magazines are published and sold for profit does not prevent them from being a form of expression whose liberty is safeguarded by the First Amendment. We fail to see why operation for profit should have any different effect in the case of motion pictures.[8]

The court also said that movies deserve First Amendment protection because:

> It cannot be doubted that motion pictures are a significant medium for the communication of ideas. They may affect public attitudes and behavior in a variety of ways . . . the importance of motion pictures as an organ of public opinion is not lessened by the fact that they are designed to entertain as well as to inform.[9]

Today, it is beyond question that most types of entertainment are "speech." For example, in *Brown v. Entertainment Merchants Association*,[10] the U.S. Supreme Court examined whether violent video games are "speech." California had passed a law banning the sale or rental of violent games to minors, a significant act of government censorship. The court struck down the ban as unconstitutional, saying,

> The Free Speech Clause exists principally to protect discourse on public matters, but we have long recognized that it is difficult to distinguish politics from entertainment, and dangerous to try. "Everyone is familiar with instances of propaganda through fiction. What is one man's amusement, teaches another's doctrine." . . . Like the protected books, plays, and movies that preceded them, video games communicate ideas—and even social messages— through many familiar literary devices (such as characters, dialogue, plot, and music) and through features distinctive to the medium (such as the player's interaction with the virtual world). That suffices to confer First Amendment protection. Under our Constitution, "esthetic and moral judgments about art and literature . . . are for the individual to make, not for the Government to decree, even with the mandate or approval of a majority."[11]

Thus, books, plays, movies, television shows, video games, songs, new media productions and other forms of entertainment are now unquestionably "speech" protected by the First Amendment. Given this, government's ability to censor or regulate entertainment is limited, which has allowed people who create entertainment to say pretty much anything they want. But not everything. The limitations that do exist will occupy the rest of this chapter.

OBSCENITY

Films, television shows, video games and the like may generally be "speech," but that doesn't mean everything depicted in a film, television show or video game is *necessarily* "speech." Just because you can film something doesn't mean that what you are filming is "speech."

The Supreme Court has ruled obscenity isn't "speech," which means the First Amendment doesn't protect it. This being so, the government is free to enforce criminal laws punishing people who create and traffic in obscene films and other materials.

What is it that makes something legally obscene? The U.S. Supreme Court, in *Miller v. California*,[12] a case decided in 1973, described the following three-pronged test to determine if something is obscene:

> (a) whether the average person, applying contemporary community standards, would find that the work, taken as a whole, appeals to

the prurient interest, (b) whether the work depicts or describes, in a patently offensive way, sexual conduct specifically defined by the applicable state law; and (c) whether the work, taken as a whole, lacks serious literary, artistic, political, or scientific value.[13]

I'll simply make four quick observations and move on. First, note that the use of the word "and" before the third prong of the test means that all three prongs must be satisfied to find a work obscene.

Second, the definition of obscenity requires that something appeal to the prurient interest and *only* to the prurient interest. Thus, by definition, a gruesome depiction of non-sexual violence or cruelty cannot in America be legally obscene.[14]

Third, the test asks us to consider whether an average person applying "contemporary community standards" would find the work appeals to the prurient interest. This means that what may be judged to appeal to the prurient interest in "Community A" may not be so judged in "Community B." In other words, theoretically, a person in "Community A" might go to jail for publishing something X-rated, while a person living in "Community B" would be free to play golf. This begs the question, what constitutes a "community" these days? One can imagine that long ago, when America was a more rural, isolated place, specific communities were quite clearly defined. But today, when we're all connected to the internet, where does one "community" end and another begin?[15]

Finally, some may wonder about all the sexually explicit material available on the web. Is some of this material legally obscene? Could be. I think it's fair to say that internet pornography appeals to the prurient interest and, in many cases, lacks serious artistic value. The second prong of the Miller test, however, requires that material be "patently offensive," and perhaps here things get a little difficult. Certainly pornography is patently offensive to many people, but obviously not to everybody given how much of it is consumed by Americans. It is interesting that there have been relatively few obscenity convictions in recent years, though they do occur from time to time.[16] One can speculate on why this is so, but the fact remains that the Miller test continues to be the law of the land, arguably giving local prosecutors the freedom to prosecute if they should so desire.

INDECENT SPEECH

So, obscenity isn't "speech" for First Amendment purposes. Because it isn't speech, we have no First Amendment right to create, distribute or consume it. We do, however, have a First Amendment right to create, distribute and consume speech that *is* protected by the First Amendment.

This leads to the following interesting problem: Say I'm a comedian or a radio personality, and I tell a joke on TV or radio and use the word "fuck," or "shit," or some other four-letter word? Or what about when Bono, lead singer of U2,

said, "This is fucking brilliant" when he accepted a Grammy award on live network television?

Under the Miller test, none of this would be obscene. You can't really say that a single word appeals to the prurient interest, or that it's patently offensive nowadays. All such language, therefore, is "speech" covered by the First Amendment and thus arguably free for everyone to say and hear. And yet, this language would undoubtedly raise the hackles of some people watching television, as well as the hackles of some community leaders who would say this kind of language is offensive to many and harmful to children.

So, the problem becomes, what to do with speech that the First Amendment covers, that certainly adults have every right to hear, but which can nevertheless offend many and be inappropriate for children?

Obviously, if I tell a dirty joke in a nightclub before a group of paying customers, the government would be hard pressed to say anyone suffered. But, as we'll see in a moment, *where the potentially offensive speech comes into one's home via TV or radio free of charge,*[17] that's a different story.

A bit of history will help here. The issue of indecent language traveling across the airwaves arose in the aftermath of the 1960s when television and radio broadcast standards began to loosen. During the 1970s, TV and radio programs occasionally came under fire for what some thought was risqué content. For example, the groundbreaking television show *All in the Family,* which premiered in 1971, dealt openly with such taboo subjects as racism, bigotry, homosexuality, atheism, impotence, abortion and sexual harassment.

Remember, this was before both cable and satellite television and before the internet and video games, when broadcast television and radio came freely into Americans' homes and was the principal means of in-home entertainment. Among the huge audience tuning in nightly were people easily outraged, and also children. So, as standards regarding on-screen language and content relaxed, certain viewers and officials whose sensibilities were affronted pushed back.

This nascent culture war engaged both politicians and social leaders, and became fodder for young comedians who had little patience with America's moralists. George Carlin was such a comedian. A wry observer of American culture, Carlin wrote a comedy routine in the early 1970s called "Filthy Words." The routine described what Carlin called the seven dirty words you can't say on television. Needless to say, this routine was not performed on television but before standup audiences where Carlin analyzed the seven words in great and lavish detail.[18] One of those performances was recorded, and on one afternoon in 1973, a New York radio station aired that recording. Among the listeners were a man and his young son. The man subsequently complained to the Federal Communications Commission (FCC) about his son's suddenly enlarged vocabulary.

The Carlin radio broadcast reached the U.S. Supreme Court in a case called *Federal Communications Commission v. Pacifica.*[19] The issue was whether the government, under existing law enforced by the FCC, could forbid "any obscene, indecent, or profane language by means of radio [and television] communications," and fine or imprison broadcasters that violated this rule.[20] The FCC believed that the broadcast Carlin routine did violate this rule because it was indecent and profane, and that sanctions could therefore be levied against the broadcaster.

Ultimately, in a narrow 5-4 vote, the U.S. Supreme Court said the government could regulate, that is censor, what the Supreme Court called "indecent speech" broadcast over the airwaves. "Indecent speech" includes discussion of sexual or excretory activities or organs in patently offensive ways as measured by contemporary community standards.

Just to reiterate, no one argued that the Carlin routine was obscene. Though filled with coarse language, it was still "speech" under the First Amendment and adults had every right to hear it. Indeed, there's no doubt the *Pacifica* court would have protected this speech were only adults in the audience. The court said the government's power to regulate "indecent speech" depended on the context in which the speech occurred, and the court took pains to say the Carlin broadcast occurred in the afternoon when children were likely to hear it. Thus, the court suggested the broadcast of indecent speech might be okay at certain times of day when children likely weren't listening.

The *Pacifica* rule is still the law of the land. Patently offensive speech regarding "sexual or excretory activities or organs" may not be broadcast by television and radio stations you don't have to pay to receive; that is, broadcast by (a) network TV or local, independent free television stations, which anyone can receive free of charge with a simple antenna, and (b) free radio. The FCC's right to censor indecent speech on channels requiring cable or satellite receivers is very much in doubt and is not likely permitted.[21] That's because people pay for cable or satellite TV to come into their home and therefore have, the reasoning goes, the unfettered right to see and hear indecent speech all day long if they want to.

In the aftermath of Bono's spontaneous F-bomb at the Grammys in 2003, and Janet Jackson's famous "wardrobe malfunction" during the Super Bowl half-time show in 2004,[22] the FCC increased potential fines for broadcasters who transmit indecent speech, including what the FCC now calls "fleeting expletives."[23] As of this writing, the FCC imposes its ban only when children might be in the audience, which is deemed to be between 6 a.m. and 10 p.m.[24]

THE INTERNET AND INDECENT SPEECH

What about the internet and indecent speech? When the *Pacifica* ruling was announced in 1978, the internet was just a gleam in a few computer scientists' eyes. But, by the mid-1990s, the internet was alive, readily available to children,

and growing exponentially, with much of that growth rooted in sexual content. So, in 1996, Congress passed and President Clinton signed the Communications Decency Act.[25] This act made it a federal crime to transmit "indecent" speech over the internet, which was defined as "any comment, request, suggestion, proposal, image or other communication that, in context, depicts or describes in terms patently offensive as measured by contemporary community standards, sexual or excretory activities or organs."

When the issue reached the U.S. Supreme Court, the court declined to follow its *Pacifica* ruling and instead struck down the Communications Decency Act in *Reno v. American Civil Liberties Union*.[26] Why did the Supreme Court refuse to uphold legislation that criminalized indecent speech on the internet? The court laid out several reasons: First, television's indecency ban wasn't a 24-hour-a-day ban as would be the case under the proposed act. Second, unlike TV and radio, the internet can only come into one's home if one pays for it. Third, television had a long history of regulation, which the internet did not. Fourth, every adult in America generally has the right to consume indecent speech, so to ban it entirely from the internet would be to censor a great deal of content adults are permitted to see and hear.

Having been rebuked by the Supreme Court, Congress then passed the Child Online Protection Act.[27] This act didn't ban all indecent content but tried more narrowly to restrict the transmission of sexual content to children by commercial websites. Opponents of the law, however, argued this act would also inevitably cause the removal of content from the web that adults are allowed to see. This meant, so the argument went, the law impermissibly curtailed speech in an overly broad way.[28] As of the time of writing, the Child Online Protection Act has been the subject of extensive litigation and has never gone into effect,[29] which means currently there is no government censorship of indecent speech on the web.

VIOLENCE IN ENTERTAINMENT

If you're texting while driving down the street and you run into someone, we'll all agree you're liable for what you've done. You acted negligently and caused injury, and it's your responsibility to pay for the damages. What if you're texting, you drive carelessly, and a car swerves to avoid you and runs into a third party? Should you be liable for the third party's injury? Courts would certainly say yes, because your negligence directly led to a reasonably foreseeable injury.[30]

That's the key when it comes to negligence law—did you directly cause the injury, and was the injury reasonably foreseeable?

I think a lot of people who object to highly graphic film violence believe it's reasonably foreseeable that on-screen violence, especially violence that seems glorified, will have ill effects on some members of the audience. And really,

broadly speaking, there's no doubt that's true. While we can debate whether watching violence has a negative effect on the average person, there's no doubt psychologically disturbed members of the audience may see a film and then, one day, use it as a template for their criminal acts.

So the question becomes, can filmmakers be held legally responsible for the criminal acts of others who copy what they see on a screen? Is a specific person's criminal act after seeing a movie reasonably foreseeable to the filmmakers? And how does the First Amendment's free speech protections impact these cases? Given that violent films are neither obscene nor indecent under current law,[31] can the government somehow regulate and punish an entirely new category of speech—"violent" speech?

The most important ruling regarding the government's right to punish violent speech was announced in *Brandenburg v. Ohio*.[32] In that 1969 case, the state of Ohio tried to punish a Ku Klux Klan member who told a crowd, "If our President, our Congress, our Supreme Court continues to suppress the White Caucasian race, it's possible that there might have to be some revengeance [sic] taken."[33] Despite the speaker's obvious issues with the English language, the state believed he had violated a law that prohibited anyone from advocating violence to effect political change. In *Brandenburg*, the U.S. Supreme Court overturned the conviction and declared the state law unconstitutional. The court said mere advocacy of violence *in a general way* is protected speech and cannot be punished by the state. What is unprotected under the First Amendment, and what can therefore be criminalized, is *"advocacy [that] is directed to inciting or producing imminent lawless action and is likely to incite or produce such action."*[34]

So, the First Amendment does *not* protect speech that is (a) designed to incite imminent lawless action, and (b) likely to produce imminent lawless action.[35] Only in this situation, said the court, is the possibility of physical harm sufficiently real to permit censorship and prosecution.

As mentioned, the *Brandenburg* case involved someone seeking political change. The case had nothing to do with violence in entertainment. Nevertheless, courts dealing with alleged entertainment-inspired violence have frequently relied on *Brandenburg* when deciding cases. Therefore, complaining parties who allege that a film or song inspired someone to commit a violent act must prove that the artists and entertainment companies involved *intended* to incite *imminent* lawless action that was *likely* to occur.

So how do complaining parties prove this? The answer is, they can't really. You can't say that the director and producers of *Natural Born Killers*, which 14 actual murderers say inspired them to kill,[36] *intended* audience members to immediately commit violence, or that such criminal acts were *likely* to immediately occur.[37] Nor can you say that people who perform songs that discuss killing police officers or committing suicide *intend* audience members to immediately commit these acts.[38]

Since violent speech in entertainment generally doesn't meet the *Brandenburg* test, the First Amendment has protected this speech. And perhaps this is not altogether surprising. The fact is, the law has always been reticent to attribute a person's criminal behavior to the non-criminal behavior of someone else; traditionally, the law requires criminals to bear sole responsibility for what they do. Placing responsibility for a crime on the media would be, under the law, to diminish the traditional responsibility placed solely on the criminal.[39] Moreover, though one might foresee that a deranged person could be influenced by violent media, producers can't possible foresee just *who* will be, so when someone does commit a copycat crime there's simply no way to say the producer could foresee that this particular person would commit this particular act. Nor did the producer intend him to.

It is also a fact that the overwhelming majority of audience members do not commit crimes after seeing violent films or listening to graphic songs. How can something that has no criminal effect on so many be declared the legal cause of the criminal acts of so few? And how do you prove that a movie or song *caused* someone's antisocial behavior. Surely, many factors are involved when someone behaves criminally, and so is it fair, under the law, to single out what may be just one of them?

Finally, there is a slippery slope issue. If the media is to be held accountable for the criminal behavior of others, where do you draw the line? What crimes or other forms of behavior can the media be held responsible for? If someone sees a cartoon where a character is hit on the head with a one-ton anvil and then two days later the viewer drops an anvil on some unfortunate passer-by, should the cartoon maker be responsible? Where do you draw the line?

For these reasons, Supreme Court decisions have left the media with great freedom to create and distribute violent media. And yet, for many, there is the nagging worry that surely all this violence can't be healthy. A 2007 FCC report said the average American has, by the age of 18, watched more than 10,000 hours of television and seen 15,000 acts of murder and 200,000 total acts of violence.[40] One has to wonder at the impact of all this. As of now, however, only this can be said with confidence: Ultimately, only smaller audiences, and not the law, will cause media producers to forego graphic violence.

VOLUNTARY CENSORSHIP

As we have discussed, government's ability to censor entertainment is very limited. However, the entertainment industry has long understood that court decisions, even in an area as hallowed as the First Amendment, can be fragile things. A wave of public opinion can always wash over public officials, pushing them to act, and though judges are generally meant to be immune from day-to-day political concerns, it's entirely conceivable that some aren't. Given that profits

are at stake, the entertainment business has historically been loath to push its luck and the government too far. Indeed, since the early 1900s, the industry has chosen to censor itself to stave off potential interference.[41]

Let's be clear: This is not censorship mandated by the First Amendment or any law passed by government. This is censorship the industry voluntarily imposes on itself to placate public officials and the public at-large.

The need to placate government officials began long ago, about the same time people realized that "moving pictures" might actually amount to something. Recall that, in the 1915 *Mutual Film Corporation* case, the Supreme Court said films could be used for "evil." Well, what could possibly have given the Supreme Court that idea, back in the silent film era? What could people possibly have been filming in 1915 that could raise the hackles of a respectable judge or God-fearing state legislator? Take a guess. If you guessed sex, you're right.[42]

We may want to think of film as art, but it's also commerce, and even in the 1910s filmmakers knew what some audiences wanted. And this, of course, shocked a whole lot of people, some of them government officials and church leaders who were very willing to stomp on this burgeoning new form of entertainment.[43]

So, by the 1920s, the entertainment industry was considering voluntary censorship to try and ward off the threat of greater government regulation. Hollywood executives tapped Will Hays, a Presbyterian church leader and former postmaster general in the Harding administration to make sure the industry remained untouched by politicians and moralists. The mechanism for this was the "Hays Code," a set of voluntary rules that Hollywood in 1930 agreed to censor itself by.

For anyone alive between 1930 and the late 1960s when the Hays Code was discarded, the following is just a partial list of things that were not supposed to be in films:

- "pointed profanity," which included the words "God," "Lord," "Jesus," "Christ" (unless used reverently in connection with religious ceremonies), "Hell," "damn,"[44] "Gawd," and every other profane and vulgar expression however it may be spelled;
- any licentious or suggestive nudity—in fact or in silhouette; and any lecherous or licentious notice thereof by other characters in the picture;
- the illegal traffic in drugs;
- any inference of sex perversion;
- white slavery;
- miscegenation;
- sex hygiene and venereal diseases;
- scenes of actual childbirth;
- ridicule of the clergy.

Among the items requiring "special care" were sympathy for criminals, sedition, prostitution, "first-night scenes," surgical operations, the use of drugs, and "excessive or lustful kissing."[45]

The Hays Office enforced the code by screening, scrutinizing and censoring films slated for public exhibition. If a film didn't follow the Hays Code rules, then the film didn't receive the Hays Office's stamp of approval, which up until the 1950s killed the film's chance to be exhibited.

When I was growing up in the 1960s, husband and wife Rob and Laura Petrie, characters in television's marvelous *Dick Van Dyke Show*, still slept in separate beds. But the sexual revolution underway in the 1960s, as well as competition from foreign films where both married and unmarried people slept (and did more than sleep) in the same bed, put pressure on Hollywood to discard the Hays Code. So did the advent of television a decade earlier and the resulting steep decline in movie attendance.[46] As early as 1953, Hollywood studios desperate for box office hits began to incrementally defy the voluntary code and release films that didn't receive the Hays Office stamp of approval.[47]

By the mid-1960s, the Motion Picture Association of America (MPAA) had a new leader, Jack Valenti. Mr. Valenti had been a close advisor to President Johnson and had therefore been dealing with the world's great issues. Now, he had a different sort of problem—as the new head of the MPAA, he had to negotiate whether the word "screw" and the term "hump the hostess" could be included in the upcoming film version of *Who's Afraid of Virginia Woolf*. In one of the world's great triumphs of compromise, Mr. Valenti tossed the word "screw" but kept "hump the hostess."[48]

Valenti quickly understood three things: First, this was a stupid discussion for grown people to be having. Second, times and mores had definitely changed. And third, Hollywood's need to insulate itself from government interference still existed. So Valenti worked to rid Hollywood of the outdated, moralizing Hays Code and instituted instead the MPAA ratings system.[49]

We still have the MPAA ratings system today (though it has changed slightly over the years).[50] The "G," "PG," "PG-13," "R" and "NC-17" codes are now very much a part of our entertainment culture. According to the MPAA's website:

> [T]he current movie rating system was born out of the simple notion that the movie industry wouldn't approve or disapprove what audiences should see, but instead would focus on "freeing the screen" and educating parents to help them make movie-going decisions for their family.[51]

Of course, the MPAA ratings code does to some extent "disapprove" of what some audiences should see. Children under 17 can't see an "R"-rated movie without a parent or guardian at their side, and no one 17 or under can see a film rated NC-17.[52] That being said, this current form of self-censorship has generally served to keep critics at bay.

Certainly not everyone is thrilled with the system. Some argue that it permits young people to see gruesomely violent films that have become more commonplace[53] and which, critics say, are far more unhealthy than seeing some sexual content in films that often receive more restrictive ratings. Others believe the ratings system allows young people to see too much sexual content.[54] Occasionally, the system has angered filmmakers by giving their films restrictive ratings. For example, the makers of *The Tillman Story*, a documentary about football star Pat Tillman who joined the military and was killed by friendly fire in Iraq, were upset their film received an "R" rating. The rating was based solely on soldiers' realistic use of profanity in the film. The filmmakers argued, to no avail, that the "R" rating would unjustly limit young people from seeing a film they ought to be able to watch.[55]

Regardless of the system's shortcomings, the television, music and video game industries have adopted similar ratings codes designed to help parents guide their children's entertainment choices. Whether parents routinely use these codes, whether young people routinely evade them, and whether they do any good will always be up for discussion. For our purposes, we'll simply say that voluntary self-censorship has been a prolonged undertaking of the entertainment business, one designed to prevent far more serious governmental interference. Whether or not one likes the ratings codes, it's probably fair to say they've done their job and helped keep the government off the industry's metaphorical back.

We've discussed obscenity, indecent speech and violent speech, which all affect society at large. We'll now examine very different kinds of speech that can also get filmmakers into legal trouble. These kinds of speech, however, usually injure only one specific person at a time.

LIBEL AND SLANDER

Here are some words that are neither obscene nor indecent: "Joan is a prostitute who sells drugs and cavorts with terrorists." Can I get in trouble for saying those non-obscene, non-indecent words, or does the First Amendment protect me? Well, if those words are true and Joan is/does all of these things, then I have nothing to worry about. But if those words aren't true, then I better hope I have a very large bank account when Joan sues because the First Amendment probably won't protect me.

Television shows, books, articles, newspapers, blogs, documentaries and other forms of entertainment frequently address the lives of real people, often the rich and famous, and sometimes ordinary people trying to live quietly next door. When *untrue* things are said about a person by the entertainment or news media, and those untrue things *harm that person's reputation*, then the First Amendment's free speech guarantee is greatly diminished and the law can punish the speaker.

As with copyright, the law here can be subjective and difficult to interpret. Unlike copyright, however, these laws are not passed by Congress—they are passed by each state's legislature. Although there is great similarity between states' laws, there are also some differences. So, the following discussion is meant merely to give you a very basic understanding of what the general law is and hopefully to raise red flags for those who might be contemplating a risky production. As with any legal issue, I urge you to seek legal counsel's advice if you feel you may be venturing into unsafe waters.

Let's begin by identifying some terms. A "defamatory" statement is a *false statement that harms the reputation of another person in the community*.[56]

If I announce to a stadium filled with people that you're a thief, and you aren't, I have uttered a false statement that hurts your reputation. Thus, my statement is "defamatory" and I have "defamed" you.

"Libel" happens when the defamatory statement is *published* in some way. "Published" in this case means more than just written in a book or newspaper—it means fixed in any medium of expression, such as a blog, film, television show or news broadcast. "Slander" means the defamatory statement is *spoken*.[57]

While there are some other minor legal differences between libel and slander, these differences need not concern us; for our purposes, think of libel and slander as exactly the same apart from the former being published and the latter spoken.

To be found guilty of libel or slander, someone must generally do all of the following:

- Publish (in the case of libel) or speak (in the case of slander) a statement about a person who is clearly identified in the statement.
- The person who is identified must generally be alive. In other words, the customary rule is *you cannot libel or slander the dead*. This means, as far as the laws of libel and slander are concerned, you can almost always say any false, terrible thing you want to about a dead person.[58] You'll have to answer to your conscience, but not the law.
- The statement about the living identified person must be false. Thus, *truth is always a defense to a claim of libel or slander*.
- The statement must be read or seen or heard by at least one person other than the speaker/publisher and the "victim" (i.e. there is no libel or slander if the false statement is made *only* to the "victim").
- The false statement must harm the person's reputation in the community.

Tabloid news reporting and fictionalized dramatizations of actual events are where these issues most frequently pop up in the world of entertainment. Newspapers and tabloids may rush to print something salacious about someone and get the story wrong, triggering a lawsuit.[59] Or a fictionalized telling of an actual event, such as in a docudrama or feature film, can falsely distort the character of a real-life person and lead to a libel lawsuit.[60]

With respect to fictionalized accounts of true stories, great care must be taken to ensure that no fictionalized scenes, dialogue or even images[61] present a defamatory portrayal of a living person.[62] Even if you change a real person's name in your production to try and hide their true identity, you can still libel them if at least one person in the audience can reasonably recognize who you're actually portraying.[63]

Public Figures

As we all know, entertainment often focuses on the lives of real people. Especially famous people. Whether it's through news reporting, news commentary, docudramas or other forms of storytelling, we like to pry into the lives of the rich and famous. We seemingly can't get enough of them. Which leads to the question, when it comes to libel and slander, are public figures treated differently than ordinary people? Are they fair game in ways that private citizens are not?

When you look at how politicians are often accused of everything in the book, it quickly becomes obvious they are treated differently. Take President Obama—political opponents have labeled him a communist, a socialist, a Nazi, anti-American, not a real American, and an anti-American Kenyan socialist Nazi. Let us presume that, in actuality, none of this is true. Notwithstanding the fact that President Obama is very unlikely to sue, could he? Should public officials be able to sue when someone says something defamatory about them? Or should the First Amendment's free speech guarantee permit us to say anything we want about political figures or other famous people, whether true or not?

The U.S. Supreme Court has recognized that you and I do have greater freedom to be wrong when speaking about public figures than when speaking about private citizens. After all, most public figures (though not all) actively seek the limelight, seek its privileges, become of real interest to the public, and thus must be willing to endure the spotlight to a greater degree than a private person.

In *New York Times v. Sullivan*,[64] the Supreme Court ruled just how much the spotlight affects public officials. The court said that public officials can only prove a case of libel or slander if they prove by clear and convincing evidence[65] that the defamatory statement was made with "actual malice." What does "actual malice" mean? It means that whoever made the defamatory statement must have either known the statement was false or made the statement with "reckless disregard of whether it was false or not."[66] In other words, while you can be successfully sued if you negligently make a mistake and say something false and harmful about a private person, when it comes to public officials you have to either *know* you were wrong or *acted recklessly* when you made the offending statement.

New York Times v. Sullivan's actual malice rule applied to public officials. However, in *Curtis Publishing Co. v. Butts*,[67] the actual malice standard was applied to "public figures" as well. Thus, a "public figure," such as a prominent movie star, must also prove that someone either knew a statement was false or acted in reckless disregard of the truth when they made the offending statement.

All of the above raises many issues that must be carefully examined by anyone concerned about libel. I'll mention just a few of these issues here to give you a sense of what people must think about when producing entertainment. If you want to learn more, you can look at the footnotes for some additional guidance, though a thorough discussion of these issues requires a rigorous legal text and legal counsel should be sought if you're contemplating something even remotely risky.

One question that frequently arises is just who is a "public figure"? We'll all agree a famous movie star is a public figure, but what about a private person suddenly thrust into the spotlight by, say, a spontaneous heroic act or by becoming a publicized crime victim. Must such "ordinary" people more readily endure false statements about them thanks to the actual malice rule simply because they were unintentionally made famous? Or, what about the spouse or child of a public figure—is that person also a public figure? And if someone becomes a public figure, are they necessarily a public figure for all time and with respect to all forms of commentary, or can they be temporarily a public figure and only with respect to a certain issue? The Supreme Court in *Gertz v. Robert Welch Inc.*[68] generally addressed the very broad issue of public figure status;[69] careful reference must be made to this case and other legal precedents if problems in any entertainment production arise.

Just as importantly, what does it mean to act in "reckless disregard" of the truth? Have I acted in reckless disregard if I publish a negative story about someone told to me by an informant and it turns out the informant was wrong? To what extent must I independently verify what an informant tells me?[70] And what if I repeat a defamatory statement first made by someone else?[71]

Also, think about docudramas and movies based on true stories involving public figures. Writers always fictionalize events, scenes and dialogue to make a story as interesting as possible. If the filmmakers are knowingly fictionalizing, then certainly where public figures are involved the filmmakers *know* what they're saying is not the literal truth. Some minor fictionalization may not trigger libel liability, but fictionalizations that are deemed defamatory can land people in hot water.[72]

And what if I publish an unflattering opinion about someone? Can I get sued for this? Historically speaking, a mere opinion has not been considered libel or slander.[73] But, under certain circumstances, an opinion can reasonably be interpreted as a thinly veiled assertion of an untrue fact, and when that's the case, courts have found liability. You can't necessarily say, "In my opinion, Jones is a

thief" and be fine under the law just because you used the words "in my opin-ion."[74] Or if I make an obvious unflattering joke about someone, as comedians often do—can I get into trouble for that?[75]

These are just some of the issues that need to be carefully examined where someone starts to say, publish or depict something potentially defamatory about a living person. So, if you ever find yourself concerned about these issues, do seek legal advice.

INVASION OF PRIVACY

Can you say something that's not obscene, not indecent, *and absolutely true,* and still get in trouble with the law?

You might think the First Amendment protects all true statements, but it doesn't.

As some in the entertainment world have learned the hard way, true statements made in the course of news or entertainment productions *can* subject people to legal liability. This can happen if the true statements invade someone's privacy.

Courts and scholars have long recognized that you and I have a right to privacy.[76] The law generally recognizes four different ways privacy can be invaded: "intrusion," "public disclosure of private facts," "false light," and "misappropriation of one's name and likeness." As with defamation, you gen-erally can't invade the privacy of a dead person.[77] Also like defamation, inva-sion of privacy laws are passed by each state and therefore laws will differ from state to state.

With that said, let's briefly examine the four different types of invasion of pri-vacy usually recognized by state law.

Intrusion

Intrusion is the most obvious form of invasion of privacy. This happens when people in search of information, usually members of the news media, physically violate a person's reasonable zone of privacy.[78] In a sense, this form of invasion of privacy is akin to trespass. If you're in the bathroom of your house and a news-man barges through your bathroom door with a camera, and if any footage is then aired, that would most definitely be "intrusion." Trespassing on people's private property to get information or footage,[79] using surreptitious recording devices,[80] and generally making an ungodly nuisance of yourself by constantly violating someone's personal space,[81] can all be intrusion if the nature of the intru-sion would be offensive to a reasonable person.

Where intrusion gets a bit more interesting is when someone is out in public but otherwise behaving privately. For example, if a movie star is standing nude on her balcony and can be seen by people who are legally entitled to be where they are, is she "out in public" or reasonably in her zone of privacy? Say I'm

standing on the street where I'm allowed to be, 500 yards away from her, with a camera that has a lens the size of a tractor trailer, and I take a picture of her. Can I publish that picture, or would that be intrusion?[82]

What about private citizens who are out in public? Are they fair game for the prying lens of the media? When it comes to *newspapers*, the answer is generally yes. If you're having an illicit affair and you and your paramour are sitting on a park bench and a photo of you ends up on the front page of the newspaper, this would not be intrusion because newspapers are generally free to publish what they record in public places.[83] However, would a movie or TV crew be equally free to shoot private people out in public? Should entertainment productions have the same right to photograph and air footage of private people as newspapers? We'll discuss this very shortly.

Public Disclosure of Private Facts

You don't need to trespass on someone's physical zone of privacy to be liable for invasion of privacy. You can invade someone's privacy by publicly disclosing private facts about them. To constitute this form of invasion of privacy, the disclosure must be (a) highly offensive to a reasonable person, and (b) not newsworthy, which means the disclosure is not of legitimate concern to the public.

As you might imagine, these sorts of disclosures generally concern information that is highly embarrassing. If you blog or make a film about the very private sexual peccadilloes of your best friend, then (a) your best friend will no longer be your best friend, and (b) he can sue you for invasion of privacy. Your friend's private sexual behavior is of no newsworthy value to the general public, and its disclosure would likely be deemed to be highly offensive by a jury.

Public disclosure of private facts most frequently occurs in media stories concerning crime victims or the dalliances of celebrities. As with other legal issues we've discussed, states' laws and interpretations differ and thus do not lend themselves to quick and easy summaries. However, it is worth making one observation: Where the embarrassing fact disclosed has been previously revealed in an open government proceeding or can be found in the public record, such as publicly available criminal records, then usually there will not be liability for disclosure.[84]

False Light

The false light version of invasion of privacy is a bit like defamation. It's similar because it requires communication of a false statement. Unlike defamation, however, the false statement need not harm someone's reputation—it must simply cause emotional distress and be the kind of false statement an average person would find highly offensive.

In *Time Inc. v. Hill*,[85] the U.S. Supreme Court ruled that a complaining party must prove "actual malice" when a media outlet is accused of a false light invasion

of privacy. Thus, just like defamation suits brought by public figures, proof is required that the media outlet either knew the statement was false or acted in reckless disregard of the truth. Of course, when a story about real people includes fictional scenes and dialogue, as in a docudrama or many movies, one would think the actual malice test could be met if the fictionalization led to a false light allegation. Therefore, people who make and distribute fictionalized stories about real people have to be extremely careful to avoid both a false light invasion of privacy and defamation lawsuit.

Misappropriation of Someone's Name or Likeness

This form of invasion of privacy occurs when someone uses another person's name or likeness without permission for commercial reasons or for some other exploitive purpose. Thus, misappropriation would occur if someone snaps a person's picture and uses it without permission to advertise, endorse or promote a product.[86]

Like other forms of invasion of privacy, misappropriation is a function of state laws, and states' laws do differ. California's statute prohibits someone from knowingly using

> another's name, voice, signature, photograph, or likeness, in any manner, on or in products, merchandise, or goods, or for purposes of advertising or selling . . . products, merchandise, goods or services, without such person's prior consent, or, in the case of a minor, the prior consent of his parent or legal guardian.

The statute defines "photograph" as including "any videotape or live television transmission, of any person, such that the person is readily identifiable."[87]

With respect to entertainment, what is the import of laws like these? Obviously you can't use someone's name or likeness to advertise your product. But what about using someone's name or likeness in a movie or TV show? What if I'm shooting on the street and I photograph someone who happens to be passing by? Could I be vulnerable to a misappropriation of name and likeness lawsuit if that person appears in my picture? One court has said that state appropriation laws must be subordinated to free speech concerns when it comes to films; that films deserve greater protection than garden-variety advertisements when misappropriation lawsuits are filed.[88] However, regardless of this one ruling, filmmakers *always* obtain signed consent forms, generally called "releases," from anyone who recognizably appears in productions.[89] There is an entirely practical reason for this: Without these releases, a producer may find it very difficult to obtain what's called an "Errors and Omissions" insurance policy. These policies insure the production against, among other things, defamation and invasion of privacy lawsuits. Distributors usually won't distribute a film that isn't fully insured, which means that filmmakers must get these policies. Since these insurance policies are a must, and since insurance companies insist on signed releases from people who appear in a film, producers routinely get releases.

Right of Publicity

The misappropriation form of invasion of privacy must be differentiated from the "right to publicity." The right to publicity protects the hard-earned *value* of a person's name or likeness.[90] Major stars, thanks to all their success, can command high fees when their names or likenesses are used to promote, endorse or otherwise market a product. The right to publicity protects the value of a person's name and likeness by preventing others from using them without permission.

The right to publicity is therefore a very close cousin of misappropriation. Unlike misappropriation, however, many state laws recognize that the right to publicity survives death and can be conferred by will to a person's heirs or to others.[91] Thus, though you usually can't invade a deceased person's privacy, in many states you can violate their right to publicity.

DEFAMATION AND INVASION OF PRIVACY: LIFE RIGHTS AGREEMENTS

Under the law, you can't legally defame or invade the privacy of someone who has specifically consented to what's being said or otherwise waived the right to sue. Therefore, when producers make films about real people and where concerns arise about possible defamation or any form of invasion of privacy, producers routinely sign agreements with the people involved.[92] These agreements transfer the party's "life rights" to the producer; the party acknowledges in writing that their life story may be fictionalized and also waives all rights to sue. In exchange, the party receives payment from the producer. These agreements will be discussed in Chapter 12.

NOTES

1 Even people who fervently believe we should only interpret the Constitution by looking at the plain meaning of its text would probably agree that "no law" doesn't really mean what it plainly says, because the result would likely be unacceptable.

2 The First Amendment was designed only to restrict the power of the federal government to pass laws abridging speech. So, you may be asking, can state legislatures pass laws that abridge speech? The answer is no. In the case of *Gitlow v. New York*, 268 U.S. 652 (1925), the U.S. Supreme Court said that the First Amendment's free speech protections apply to each of the states. So each state must guarantee the exact same freedoms provided by the First Amendment.

3 See *Cox v. Louisiana*, 379 U.S. 536, 554 (1965) (no one can "insist upon a street meeting in the middle of Times Square at the rush hour as a form of freedom of speech").

4 I feel compelled to say that by asking this question I am not presuming an answer. The truth is, as much as I don't personally like excessively violent movies, I think they should be considered "speech" and protected by the First Amendment.

5 236 U.S. 230 (1915).

6 The Ohio censorship law said that "Only such films as are, in the judgment and discretion of the board of censors, of a moral, educational, or amusing and harmless character shall be passed and approved by such board." *Id.* at 236.

7 343 U.S. 495 (1952).

8 *Id.* at 501–502.

9 *Id.* at 501.

10 180 L. Ed. 708 (2011).

11 *Id.* at 714. Interestingly, nine years before this decision, a federal district court judge ruled that video games were not speech. That judge likened video games to board games that were captured on video; the judge wouldn't extend First Amendment protection to a board game, so why extend it to a video of a board game? The judge was also not persuaded by the fact video games had scripts since, the judge said, all products start with expression that comprises plans, schematics and so on, so why should a video game's script be treated differently than any other product's originating script. See *Interactive Digital Software Ass'n v. St. Louis County, Missouri*, 200 F. Supp. 2d 1126 (E.D. Mo 2002). The judge's ruling was appealed and reversed the following year. See *Interactive Digital Software Ass'n v. St. Louis County*, 329 F.3d 954 (8th Cir. 2003).

12 413 U.S. 15 (1973).

13 *Id.* at 24–25.

14 See *Brown v. Entertainment Merchants Association*, 180 L. Ed. 708, 716 (2011) ("the obscenity exception to the First Amendment does not cover whatever a legislature finds shocking, but only depictions of 'sexual conduct' [V]iolence is not part of the obscenity that the Constitution permits to be regulated").

15 Cases decided by federal courts demonstrate that, in fact, a "community standard" need not have any strictly defined geographic boundary. See *Hamling v. United States*, 418 U.S. 87, 104–105 (1974) ("the relevant community is not to be geographically defined in federal obscenity prosecutions"). And at least one court has ruled that where allegedly obscene material is distributed by email, a "national community standard" should apply. See *United States v. Kilbride*, 584 F.3d 1240 (9th Cir. 2009). The court reasoned that, where email is involved, if the "community standards" test prevailed, the least tolerant community's standards would ultimately control nationally. Therefore, one presumes that a "national community standard" would be more forgiving than local community standards in many places in the United States.

16 For example, an adult film producer was convicted on obscenity charges in 2012 for selling films depicting bestiality and rather unusual fetishes. It took three trials to convict the producer and in each jurors had to watch a series of his films in their entirety. See "Adult Film Producer Convicted in Obscenity Trial," *New York Daily News*, April 27, 2012, last accessed on June 18, 2014, http://www.nydailynews.com/news/national/adult-film-producer-convicted-obscenity-trial-article-1.1068971. As a matter of both historical and legal interest, in 1990, a federal district judge ruled that a music album was obscene. See *Skywalker Records, Inc. v. Navarro*, 739 F. Supp. 578 (1990). The album in question, *As Nasty as They Wanna Be*, was the work of the popular recording group 2 Live Crew. The federal district judge's ruling was subsequently overturned on appeal. See *Luke Records, Inc. v. Navarro*, 960 F.2d 134 (11th Cir. 1992).

17 Broadcast network TV (ABC, CBS, NBC and Fox) as well as local, independent television stations can be received without any fee for the transmission. All that's needed is a simple antenna and a television set. This is also true for standard AM/FM radio. Channels requiring cable or satellite hookups are obviously not free.

18 Your author was among one of those stand-up audiences, and for the record I'll say I laughed a lot that evening. Today, however, I suspect the routine would feel rather dated given that most of those words are now heard every day in films and on cable TV, and all of them appear ubiquitously on the internet.

19 438 U.S. 726 (1978).

20 These rules are codified in the United States Code, a series of federal laws. See 18 U.S.C. Section 1464, which reads: "Whoever utters any obscene, indecent, or profane language by means of radio communication shall be fined under this title or imprisoned not more than two years, or both."

21 The FCC seems to agree. See "Regulation of Obscenity, Indecency and Profanity," *FCC*, July 17, 2012, last accessed on July 3, 1984, http://transition.fcc.gov/eb/oip/.

22 Justin Timberlake and Janet Jackson were performing on-stage when Timberlake yanked on Jackson's outfit, exposing one of her breasts for approximately one-half second. The event was seen by tens of millions watching on television and led to more than half-a-million complaints being filed with the Federal Communications Commission. See Paul C. Weiler and Gary Miles, *Entertainment, Media, and the Law*, 4th ed. (West 2011), page 75.

23 When the FCC sought to impose a fine on the broadcaster for Bono's language, the Supreme Court was asked to rule on the Constitutionality of sanctioning "fleeting expletives." See *FCC v. Fox Television Stations, Inc.*, 132 S.Ct. 2307 (2012); *FCC v. Fox Television Stations, Inc.*, 556 U.S. 502 (2009). So far, the court has declined to make a definitive ruling, and in the Bono case said only that fines previously levied were levied without fair, prior notice.

24 See *Action for Children's Television v. FCC (ACT III)*, 58 F.3d 654 (D.C. Cir. 1995), cert. denied, 516 U.S. 1043 (1996) (court advised FCC to adopt safe harbor from indecent speech between 6 a.m. and 10 p.m.); "Obscene, Indecent and Profane Broadcasts," *FCC*, last accessed on June 18, 2014, http://www.fcc.gov/guides/obscenity-indecency-and-profanity.

25 The Communications Decency Act was passed as part of the 1996 Telecommunications Reform Act.

26 521 U.S. 844 (1997).

27 The Child Online Protection Act (COPA) must be distinguished from the Children's Online Privacy Protection Act (COPPA), which regulates the ability of websites to collect information from children under the age of 13. See 15 U.S.C. Section 6501 et seq.

28 It is a general tenet of First Amendment jurisprudence that any law restricting speech must not be either too vague or drafted too broadly so as to chill the expression of speech that would otherwise be protected. See, e.g., *Lanzetta v. New Jersey*, 306 U.S. 451 (1939), *Brockett v. Spokane Arcades, Inc.*, 472 U.S. 491 (1985), *Broadrick v. Oklahoma*, 413 U.S. 601 (1973), *Arave v. Creech*, 507 U.S. 463 (1993).

29 See Nate Anderson, "Ten years of futility: COPA finally, truly dead," *ars technica*, January 21, 2009, last accessed on July 3, 2014, http://arstechnica.com/tech-policy/2009/01/ten-years-of-futility-copa-finally-truly-dead/.

30 In the famous, influential case *Palsgraf v. Long Island Railroad Co.*, 162 N.E. 99 (N.Y. 1928), Judge Benjamin Cardozo said that, where negligence is involved, the negligent party can only be held accountable for injuries that were reasonably foreseeable. Given the scenario described in the text, there would come a point where, if several cars swerved and caused some elaborate chain reaction taking place over several miles ending up in injury, the injury incurred would not be reasonably foreseeable and so the person texting would not be held responsible.

31 Recall that obscenity requires the work to appeal to the prurient interest and indecent speech requires the work refer to sexual or excretory activities or organs. Most violent films do primarily none of these.

32 395 U.S. 444 (1969).

33 *Id.* at 446.

34 *Id.* at 447.

35 The First Amendment *does* protect speech that merely has "a tendency to lead to violence." *Yakubowicz v. Paramount Pictures Corp.*, 404 Mass. 624, 629 (1989), quoting *Hess v. Indiana*, 414 U.S. 105, 109 (1973).

36 See Paul C. Weiler and Gary Miles, *Entertainment, Media, and the Law*, 4th ed. (West 2011), page 86.

37 Interestingly, the film's director, Oliver Stone, said, "the most pacifist people in the world said they came out of [*Natural Born Killers*] wanting to kill people." *Id.*

38 See, e.g., *James v. Meow Media*, 300 F.3d 683 (6th Cir. 2002) (where killer Michael Carneal shot three students at school and said that he had seen a film called *Basketball*

Diaries in which a character did much the same thing to the approval of fellow students, and where Carneal also played several violent video games before the killings, both New Line Cinema, which produced *Basketball Diaries*, and video game producers were sued. Held: Both New Line Cinema and the video game producers were not liable for Carneal's actions); *Waller v. Osbourne*, 763 F.Supp. 1144 (1991) (Ozzy Osbourne not responsible when young man committed suicide allegedly as a result of repeatedly listening to an Osborne song that included the lyrics, "Take the gun, 'n'try it, try it . . . Shoot! shoot! shoot! shoot!"); *Davidson v. Time Warner,* 25 Media L. Rep. 170 (S.D. Tex. 1997) (makers of songs containing lyrics about "blasting" police officers held not responsible for murder of policeman by a man listening to the music when he committed the crime); *Yakubowicz v. Paramount Pictures Corp.*, 404 Mass. 624 (1989) (Paramount Pictures held not responsible for young man's murder by someone who had just seen a Paramount Pictures film, *The Warriors*). But see *Weirum v. RKO General*, 15 Cal. 3d 40, 539 P.2d 36 (1975) (radio station held liable for fatal traffic accident when local disc jockey in a car announced his general location and offered a prize for the first person who could identify him; listeners in a car trying to find the disc jockey had a car accident killing another driver).

39 See, e.g., *James v. Meow Media,* 300 F.3d 683, 699–700 (6th Cir. 2002).

40 "Violent Television Programming and Its Impact on Children," *FCC*, April 6, 2007, page 31. You can read the report here: http://www.mediainstitute.org/ContentWars/fcc/2007/Violence/FCC-Violence-Full.pdf.

41 It is worth noting that, by 1922, censorship bills were being considered in 36 states. See John Lewis, *Hollywood v. Hard Core* (New York Press 2002), Kindle ed., location 1805.

42 In 1896, an on-screen kiss in one of cinema's earliest films elicited this response from a Chicago literary magazine editor: "When only life size [the kiss was featured in the stage drama, *The Widow Jones*, performed on Broadway in 1896 by Irwin and Rice] it was pronounced beastly. But that was nothing to the present sight. Manifested to Gargantuan proportions and repeated three times over it is absolutely disgusting. All delicacy or remnant of charm seems gone from Miss Irwin, and the performance comes near to being indecent in its emphasized vulgarity. Such things call for police interference." See John Lewis, *Hollywood v. Hard Core* (New York Press 2002), Kindle ed., location 1757, quoting Philip French, "No End in Sight: 100 Years of Censorship," *Index on Censorship*, vol. 24, no. 6 (1995), pages 22–23.

43 In his book *Hollywood v. Hard Core*, author John Lewis writes, "In the first comprehensive history of U.S. cinema, *A Million and One Nights* (1926), Terry Ramsaye described the medium as primarily an entertainment business, which, like the circus, pandered to an undiscerning, uncultured clientele. The cinema, Ramsaye wrote in terms that hardly conceal his elitist disdain, was 'definitely lowbrow, an entertainment for the great unwashed commonality.' Such a view was largely shared at the time by other art, theater, and film critics, reformers, legislators, and, most importantly, the courts." John Lewis, *Hollywood v. Hard Core* (New York Press 2002), Kindle ed., location 1824.

44 In *Gone with the Wind*, released in 1939, Rhett Butler famously says, "Frankly, my dear, I don't give a damn." At first, the Hays Office insisted the word "damn" be cut from the film. A letter from producer David O. Selznick, however, convinced the Hays Office to relent. See "Damn," *Letters of Note*, February 1, 2012, last accessed on July 3, 2014, http://www.lettersofnote.com/2012/02/damn.html.

45 See John Lewis, *Hollywood v. Hard Core* (New York Press 2002), Kindle ed., Appendix A. In truth, the list presented above was a precursor to the formal Hays Code, though much of this material was incorporated into the Hays Code itself. The entire Hays Code is reproduced in Mr. Lewis' book.

46 See "World Theatrical Attendance," *screenville*, September 2, 2011, last accessed on July 3, 2014, http://screenville.blogspot.com/2011/09/attendance-history-world-cinema-stats.html.

47 The first film released without the Hays stamp of approval was *The Moon is Blue*, starring William Holden and David Niven. United Artists released the film. See John Lewis, *Hollywood v. Hard Core* (New York Press 2002), Kindle ed., location 2111 et seq.

48 Cass Warner Sperling and Cork Millner, *Hollywood Be Thy Name: The Warner Brothers Story* (University of Kentucky Press 1998), page 326.

49 The ratings system includes the now very familiar ratings of "G"—General Audiences. All Ages Permitted; "PG"—Parental Guidance Suggested. Some Material May Not Be Suitable For Children; "PG-13"—Parents Strongly Cautioned. Some Material May Be Inappropriate For Children Under 13; "R"—Restricted. Children Under 17 Require Accompanying Parent or Adult Guardian; and "NC-17"—No One 17 and Under Admitted. A panel of parents (that is their only qualification) decides a film's rating.

50 See "Why: History of Ratings," *The Classification and Ratings Administration (CARA)*, last accessed on July 3, 2014, http://www.filmratings.com/why.html.

51 *Id.*

52 Movie theater owners, of course, enforce these rules. NATO, the National Association of Theater Owners, is a partner with the MPAA in the self-censorship program.

53 Many violent films were produced decades ago. Alfred Hitchcock's *Psycho*, with its famed shower stabbing scene and deranged psychotic killer Norman Bates, was both horrifically violent and shocking when it was released in 1960. Some argue that 1967 proved a real turning point for the depiction and mainstreaming of graphic on-screen violence. That year saw the release of *Bonnie and Clyde*, which graphically depicted murder in ways rarely seen in films. Some critics may have been disturbed by the violence, but the film itself was widely praised and the public made *Bonnie and Clyde* an enormous box office success. Then, in 1971, *Straw Dogs, Dirty Harry* and *A Clockwork Orange* appeared on screens across America raising the magnitude of graphic violence to new highs. *The Texas Chainsaw Massacre*, released in 1974, and *Halloween*, released in 1978, popularized so-called "slasher" films and helped further mainstream the combination of overt sexual and violent content. It is worth noting that while these slasher films drew some intense criticism, they were hugely profitable.

54 See, e,g., David Chen, "Why the MPAA Should be Ashamed of Itself," Film, November 8, 2010, last accessed on July 3, 2014, http://www.slashfilm.com/mpaa-rating-nc-17-blue-valentine-tillman-story-kings-speech/.

55 The filmmakers appealed the "R" rating to the MPAA, and lost.

56 See, e.g., James Henderson, Jr., Richard Pearson, Douglas Kysar, and John Siliciano, *The Torts Process*, 7th ed. (Aspen Publishers 2007), page 724.

57 See, e.g., Dan Dobbs, Paul Hayden and Ellen Bublick, *The Law of Torts v. 3* (West 2011), pages 167–178, 222.

58 This is subject to state law and so a state might allow a defamation lawsuit, or an invasion of privacy lawsuit, to survive the death of the complaining party, especially if the lawsuit was filed prior to the complaining party's death.

59 See *Curtis Pub. Co. v. Butts*, 388 U.S. 130 (1967).

60 See *Foretich v. Capital Cities/ABC, Inc.*, 37 F.3d 1541 (4th Cir. 1994).

61 It is worth noting that an image all by itself can be defamatory. In *Clark v. ABC*, 684 F.2d 1208 (6th Cir. 1982), an ABC news crew photographed an African-American woman in close-up walking down a street. Her face was clearly visible. Over this footage a reporter discussed how white men seeking prostitutes had become a nuisance in the neighborhood and how most of the prostitutes were African American. The woman shown on camera was not a prostitute. The court held that she could make out a case for libel against ABC.

62 This concern can be eliminated if the production has acquired the life rights of the living people depicted in the film. See pages 237–9.

63 See, e.g., *Bindrem v Mitchell*, 92 Cal App. 3d 61, 78 (1979) ("The test of whether a fictional character so closely resembles an actual person . . . is whether a reasonable person . . . would understand that the fictional character . . . was, in actual fact, [the actual person]").

64 376 U.S. 254 (1964).

65 Most plaintiffs in a tort case like libel or slander need only prove their case by a "prepon-derance" of the evidence. The "clear and convincing" standard requires the plaintiff to more demonstrably and obviously prove his case.

66 *Id.* at 279–280.

67 388 U.S. 130 (1967).

68 418 U.S. 323.

69 The *Gertz* Court defined a public figure as follows: "For the most part those who attain this status have assumed roles of especial prominence in the affairs of society. Some occupy positions of such persuasive power and influence that they are deemed public figures for all purposes. More commonly, those classed as public figures have thrust themselves to the forefront of particular public controversies in order to influence the resolution of the issues involved. In either event, they invite attention and comment." *Id.* at 345.

70 See, e.g., *Harte-Hanks Communications v. Connaughton*, 491 U.S. 657 (1989) (the actual malice standard was met where a newspaper failed to interview a relevant source and published a defamatory statement).

71 I could be held just as liable as the first person who made the defamatory statement. See, e.g., James Henderson, Jr., Richard Pearson, Douglas Kysar, and John Siliciano, *The Torts Process*, 7th ed. (Aspen Publishers 2007), page 738.

72 See, e.g., *Foretich v. Capital Cities/ABC, Inc.*, 37 F.3d 1541 (4th Cir. 1994). Courts do recognize that "In docudrama, minor fictionalization cannot be considered evidence or support for the requirement of actual malice The cases on point demonstrate that the First Amendment protects such dramatizations and does not demand literal truth in every episode depicted; publishing a dramatization is not of itself evidence of actual mal-ice." *Seale v. Gramercy Pictures*, 964 F. Supp. 918, 928 (E.D. Penn. 1997) quoting *Davis v. Costa-Gavras*, 654 F. Supp. 653, 658 (S.D.N.Y. 1987).

73 See *Biro v. Conde Nast*, 883 F. Supp. 2d 441, 459 (S.D.N.Y. 2012) ("statements of pure opinion are not actionable as defamation"); *Yeagle v. Collegiate Times*, 255 Va. 293 (1998) (collegiate official could not recover when referred to as the "director of butt-licking" in a campus newspaper article; court observed that such "rhetorical hyperbole" could not lead to a reasonable inference that the plaintiff engaged in the conduct described or to convey a false representation of fact).

74 See *Milkovich v. Lorain Journal Co.*, 497 U.S. 1, 18–19 (1990) ("If a speaker says, 'In my opinion John Jones is a liar,' he implies a knowledge of facts which lead to the conclusion that Jones told an untruth. Even if the speaker states the facts upon which he bases his opinion, if those facts are either incorrect or incomplete, or if his assessment of them is erroneous, the statement may still imply a false assertion of fact. Simply couching such statements in terms of opinion does not dispel these implications; and the statement, 'In my opinion Jones is a liar,' can cause as much damage to reputation as the statement, 'Jones is a liar.'" See also *Ollman v. Evans*, 750 F.2d 970 (1984) quoted in *Milkovich v. Lorain Journal Co.*, 497 U.S. 1 (1990) (four factors are considered to ascertain whether, under the "totality of circumstances," a statement is fact or opinion. These factors are: (1) "the specific language used"; (2) "whether the statement is verifiable"; (3) "the gen-eral context of the statement"; and (4) "the broader context in which the statement appeared").

75 Generally speaking, if no reasonable person could believe what was said was meant to be taken seriously, the answer is no. Judge Learned Hand, in *Burton v. Crowell Publish-ing Co.*, 82 F.2d 154, 155 (2nd Cir. 1936) famously said that "a man must not be too thin-skinned or a self-important prig." See, e.g., *Walko v. Kean College of New Jersey,* 561 A.2d 680 (N.J. Super.L. 1988) ("A parody or spoof that no *reasonable person* would read as a factual statement, or as anything other than a joke—albeit a bad joke—cannot be actionable as a defamation"). However jokes sometimes can lead to liability. A newspaper in Tennessee suffered a nearly million-dollar libel judgment against it when the paper published a joke about a 17-year-old boy, a joke that was never intended to be published.

A reporter inserted the joke—that the boy was having sex with a donkey—into the copy of the story with the intention that it would be deleted before publication. See Joe Nicholson, "No Joke: $1 Million Libel Award for Printed Prank," *Editor & Publisher*, May 2, 1998, last accessed on June 19, 2014, http://www.editorandpublisher.com/PrintArticle/No-Joke-1-Million-Libel-Award-For-Printed-Prank-p-8.

76 The right to privacy was first discussed in a *Harvard Law Review* article written by Samuel Warren and Louis Brandeis in 1890. The actual citation of the article is 4 *Harvard L.R.* 193 (1890). You can read the article here: http://faculty.uml.edu/sgallagher/Brandeisprivacy.htm.

77 See footnote 57 above.

78 See, e.g., *Shulman v. Group W productions*, 18 Cal.4th 200, 955 P.2d 469 (1998) (secretly recording conversations between an accident victim and emergency responders while the victim was being transported in a rescue helicopter was an offensive intrusion despite the potential newsworthiness of the information gathered).

79 See, e.g., *Dietemann v. Time, Inc.*, 449. F.2d 245 (9th Cir. 1971) (held actionable where a news magazine's reporter entered the home of a person who claimed to be a doctor, where the reporter pretended to be a patient, and where the reporter used a surreptitious microphone to record the ensuing conversation).

80 *Id.* Federal law makes it a crime to wiretap people or otherwise intercept communication surreptitiously without the knowledge and consent of the participants. See 18 U.S.C. Section 2511.

81 See *Galella v. Onassis*, 487 F.2d 986 (2nd Cir. 1973). Galella was a paparazzo who, to get photographs of President Kennedy's widow Jacqueline Onassis and her children, repeatedly approached both Onassis and her children. Among other things, Galella on more than one occasion entered the children's school without permission, once jumped out of the bushes to get a photo of one child riding a bicycle, and once drove a boat very near Onassis while she was swimming. Though the court recognized famous people have to put up with some loss of privacy, the court said, "Galella's constant surveillance, his obtrusive and intruding presence, was unwarranted and unreasonable." *Id.* at 995. California has now enacted certain laws aimed directly at curtailing the intrusive efforts of paparazzi. See California Penal Code Section 11414 (designed to curtail paparazzi hounding of children); California Civil Code Section 1708.8 (permitting large damages against people who invade the privacy of others while attempting to capture "in a manner that is offensive to a reasonable person, any type of visual image, sound recording, or other physical impression of the plaintiff engaging in a personal or familial activity under circumstances in which the plaintiff had a reasonable expectation of privacy, through the use of a visual or auditory enhancing device, regardless of whether there is a physical trespass, if this image, sound recording, or other physical impression could not have been achieved without a trespass unless the visual or auditory enhancing device was used").

82 While no direct case on point could be found, at least one court found no invasion of privacy when investigators used telephoto lenses to photograph a person moving about his private property but where the person's movements were clearly observable from a public place. See *York v. General Electric Company*, 144 Ohio App.3d 191 (2001); *State of Oregon v. Louis*, 296 Or. 57 (1983) (police officer could use telephoto lens to photograph a man engaging in lewd acts inside his home by a window open to public viewing).

83 See *Gill v. Hearst Publishing, Co.*, 40 Cal.2d 224, 253 P.2d 441 (1953) (newspaper was free to publish a photo of a young couple sitting on a park bench).

84 See *Cox Broadcasting v. Cohn*, 420 U.S. 469 (1975) (media's public disclosure of deceased rape victim's name protected where the name was found in a publicly available document).

85 385 U.S. 374 (1967).

86 See, e.g., *Pavesich v. New England Life Ins. Co.*, 50 S.E. 68 (Ga. 1905).

87 California Civil Code Section 3344.

88 See *Tyne v. Warner Entertainment Company*, 901 So.2d 802 (2005).

89 Actors' contracts always include language permitting the use of the actor's name and likeness in the film or TV show, in all publicity and so on. Releases become necessary when other people—non-actors—appear on screen.

90 See, e.g., *Lugosi v. Universal Pictures*, 25 Cal.3d 813 (1979).

91 See, e.g., *Martin Luther King, Jr. Center for Social Change v. American Heritage Products, Inc.*, 694 F.2d. 674, 682 (11th Cir. 1983). See also California Civil Code Section 3344.1.

92 Usually the life rights are first optioned and then later bought only if a production is actually made. You can read about option/purchase agreements in Chapter 12.

SECTION 2
Entertainment Companies
Growth and Power

Anyone who wants to understand the entertainment industry should know and understand the businesses that run it.

A little over a century ago, there were no large entertainment companies. The business was rooted in individuals, often immigrants, often without much money, who came to like something new called movies and radio. They got into film and radio production for both fun and profit, and unbeknownst to them arrived on the ground floor of the emerging mass entertainment industry.

In the past few decades, the media has undergone explosive growth and consolidation. The days when studios were mom and pop operations owned by family members are long gone; today, entertainment companies are primarily owned by a handful of giant media corporations with large global footprints.

Law and government regulation played a fundamental role in the growth of media conglomerates, so we'll start there. We'll look at the evolution of the mass media from its beginnings up to today, examine what media assets are owned by the conglomerates, and ask whether huge media companies are a good or bad thing for society. We'll also look at how internet companies are making significant inroads into the entertainment business.

As powerful as the large entertainment companies may be, they aren't the only business organizations that wield clout in the industry. Entertainment unions influence the business, as do agencies that represent filmmakers. Therefore, we'll look at how entertainment unions operate, and we'll also examine how agents and managers impact the business.

CHAPTER 6

The FCC and Government Regulation of the Media

INTRODUCTION

Our current entertainment industry exists not only because of copyright and First Amendment law, but also because of specific regulatory decisions made by government officials. Therefore, to fully understand the modern entertainment business, one must understand the government activity, and inactivity, which has made and continues to make possible the current media landscape.

Let's start with this assertion: America has long distrusted concentrations of power. Perhaps because of King George and his autocratic ways, we've been inherently suspicious of big government and, often throughout our history, big business as well. At different times in America's past and with varying degrees of zeal, our government has created laws and regulatory bodies to keep powerful businesses in check.

Our mistrust of business power stems not only from our political culture but also from economic theory. Economists determined long ago that large and powerful businesses are often harmful to society because they destroy competition. Why is competition so important? Because it leads to new ideas, innovation, better products, better ways of doing things, and lower costs, all of which help the public. Big businesses that completely control the market and unfairly suppress competition have no incentive to innovate or lower costs because they simply don't have to.

To strike a balance between acceptable business growth and harmful business practices by powerful corporations (known long ago as "trusts"), Congress passed a series of anti-trust laws, including the Sherman Anti-Trust Act of 1890. These laws empower the government, acting through the Department of Justice, to sue dominant businesses and ultimately force them to sell off parts of their business so free market competition can be restored.

Supreme Court justices have long noted the reasons for these laws. Justice Learned Hand wrote that "[T]hroughout the history of these [anti-trust] statutes it has been constantly assumed that one of their purposes was to perpetuate

and preserve . . . organization of industry in small units which can effectively compete with each other."[1] Many years later, Justice Black wrote: "[F]rom this country's beginning there has been an abiding and widespread fear of the evils which flow from monopoly—that is the concentration of economic power in the hands of a few."[2]

I raise the anti-trust laws because, back in the early twentieth century, government thought the media should be carefully regulated given that it controls messages heard by all of us everyday. The government didn't want one media company to get too large and dominate the public discussion or prevent others from entering what John Milton and John Stuart Mill called "the marketplace of ideas." So the government created something new, the Federal Communications Commission (FCC), which was designed to regulate the operations of many media businesses and to ensure, among other things, that unfair or harmful concentrations of media power did not exist.

VERTICAL AND HORIZONTAL INTEGRATION

Before specifically looking at the FCC and how it has regulated the entertainment industry, it's worth discussing a few important concepts.

Ever since movies arrived on the scene in the early 1900s, making money in the film business has required successful completion of three distinct steps: production, distribution and exhibition. Companies formed back in the very early days that specialized in just one of these steps. These companies would buy the necessary physical assets, such as production facilities or movie theaters, form important relationships that helped their business, and develop necessary expertise. Producers knew how to make movies, distributors knew how to market them, make prints and deliver them across the country to exhibitors, and exhibitors ran the films before paying customers. If all went well, each company would receive its negotiated share of the revenues.

Given humans' natural competitive instincts, it didn't take long for the early film pioneers to realize they'd be much better off if they owned companies that could do all of these things. Therefore, even as early as the 1910s, film companies engaged in what's called "vertical integration."

Vertical integration simply means owning companies that perform all of the necessary steps along the supply, production, distribution and retail chain. In the case of the movie business, a company is vertically integrated if it owns a production, distribution and exhibition operation.

"Horizontal integration" means buying different companies that perform the same step along the production, distribution and exhibition chain. Say, for example, someone buys several production companies—that's an example of horizontal integration.

It's a natural desire for businesspeople to want to integrate horizontally and vertically as much as possible. The more you own horizontally, the less competition you have in that particular sector. And if you're vertically integrated, you don't have to deal with other companies to get your films to market, which also reduces competition and allows you to keep all of the revenues.

Buy up enough companies in all sectors of the market, and effectively eliminate all competition, and your company can become a virtual or actual monopoly. And that's where the government comes in with its power to regulate.

THE FCC: BASICS

Congress officially created the Federal Communications Commission when it passed the 1934 Communications Act. The FCC is made up of five commissioners appointed by the president and confirmed by the Senate. Commissioners serve staggered five-year terms, no more than three commissioners may be from the same political party, and the president appoints one commissioner to act as chairperson.

Though created in 1934, the Commission can trace its formation back to the 1920s when radio first became a commercially viable enterprise. Why did radio lay the groundwork for the FCC? The answer lies in the physics of radio broadcasting.

As you no doubt know, radio signals are transmitted via radio waves, which form only one portion of the spectrum of electro-magnetic radiation. You'll recall from your basic physics class that electro-magnetic radiation moves all around us at a wide range of different frequencies. When those frequencies are between 380 and 760 nanometers in length, the radiation interacts with our eyes, allowing us to see the radiation as visible light. Waves with much longer frequencies, from around a meter in length or more, make up radio waves. We can't see this radiation, but scientists discovered that we can use it to transport sound and video images over large distances.

Unfortunately, nature provides us with only a finite number of radio wave frequencies that can be effectively used in any given locality. Back in the 1920s, a growing number of would-be radio stations began to vie for this limited air space. People could soon foresee a massive traffic jam in the air, with competing broadcasts on nearly identical frequencies causing a giant mish-mash of overlapping sound. So Congress stepped in. Since radio was then being used in the course of interstate commerce and since the Constitution expressly gives Congress the power to regulate interstate commerce,[3] Congress determined it could regulate the airwaves.

The 1934 Communications Act attempted to do just this. The law created the FCC and gave it the power to regulate "interstate and foreign commerce in

communication by wire and radio so as to make available, so far as possible, to all the people of the United States, a rapid, efficient, nationwide, and worldwide wire and radio communication service." To achieve this goal, Congress gave the FCC power to grant licenses to broadcasters, to make rules regarding broadcasting, to investigate whether those rules had been broken, and to levy sanctions against the rule-breakers.

As the years passed and new technologies changed how we communicate, Congress extended the FCC's jurisdiction, which now covers "interstate and international communications by radio, television, wire, satellite and cable"[4] The FCC therefore now has the power, subject to Congressional and judicial oversight, to regulate broadcast radio, broadcast television, cable television, satellite television, as well as the internet, since it usually comes into homes via cable or satellite.

Two of the Commission's wide-ranging powers are of particular interest. The first involves the FCC's power to regulate content, such as indecent speech. We've already been introduced to this power in the case of *Pacifica v. FCC*. You'll recall in that case the FCC made a rule banning indecent speech and the FCC decided the rule had been broken.

The second important power has to do with the FCC's licensing authority. Since broadcasters must be licensed, the FCC's rules and decisions regarding which companies can own broadcasting licenses have had a *profound* impact on the entertainment business, on American culture, and on American society.

THE RIGHT TO BROADCAST

Who wouldn't want a broadcasting license? I sure would. So ask yourself a question: Who should be entitled to receive one? Who should be allowed to broadcast over the airwaves, or via cable or satellite? Should it be the people or companies who can pay the most money? Or should it be the people or companies that demonstrate the most social responsibility? Are the airwaves and cable lines sufficiently scarce resources that we the people should own and control them, or are they akin to abundant commodities, such as minerals, which private companies can mine for their own economic benefit? Or are the airwaves and cable lines critically important public assets, like air and water and roads, which no private party ought to own or control?

Since the FCC has the power to license media broadcasters, we the people, via the FCC, ostensibly have a say in how broadcast licenses are granted. But do we want the FCC to treat licenses like free market "things" open to the highest bidder, or as community assets that must be carefully protected for the good of us all?

I think it's safe to say both views have held sway at different times.

Interestingly, at the birth of mass communications in America, politicians went so far as to say the government, and not private businesses, should *own* media assets. I have no doubt many modern conservative commentators would consider some of our forefathers to be fervent socialists. This would include the Great Compromiser himself, Kentucky Senator Henry Clay. As far back as 1844, Senator Clay argued that telegraph lines should be owned by the government, saying:

> It is quite manifest [the telegraph] is destined to exert great influence on the business affairs of society. In the hands of private individuals they will be able to monopolize intelligence and perform the greatest operations in commerce and other departments of business. I think such an engine should be exclusively under the control of the government.[5]

Indeed, throughout the nineteenth and into the early part of the twentieth century, congressional committees frequently drafted legislation designed to put telegraph and later telephone service under direct government ownership.[6] That legislation, however, never passed, so unlike many European countries that viewed telecommunications as public services requiring public ownership, American telecommunications remained in private hands. Despite this, when Congress created the FCC in 1934 it strongly believed that broadcasting was akin to a public asset that had to serve the public interest. Therefore, broadcasters were licensed "to serve the public good and not for furthering the private or selfish interest of individuals or groups of individuals."[7] Congress directed that broadcasting licenses should be distributed according to the "public interest, convenience and necessity," which meant that broadcasters had to air programming "responsive to the needs and problems of its local community."[8]

Licensing for the public good and serving the needs of the local community—these were the foundations of American broadcast policy. These were goals to be promoted.

FCC MEDIA OWNERSHIP RULES: 1934–1980

It's worth remembering that when the FCC came to life America was suffering through the Great Depression, a time when Americans' relationship with big business had soured as never before. This was a time when people strongly believed in the government's effectiveness, so government felt empowered to regulate the media industry.

The FCC did just this. From its inception until 1980, the FCC tried to promote the public good by ensuring broadcasters didn't accumulate too much business power, didn't control political discussions, didn't shut out diverse voices, and

didn't monopolize the creation and distribution of broadcast entertainment. Instead, the FCC fought to promote access and diversity.

Among the most important regulations designed to achieve these goals were:

- *National Ownership Rules*: In order to prevent wealthy broadcasting companies from obtaining too much power, in 1944 the FCC prohibited companies from owning more than five TV stations. In 1954, this was changed and companies were allowed to own seven TV stations, seven AM radio stations and seven FM radio stations. The FCC made clear that "The purpose of the multiple ownership rules is to promote diversification of ownership in order to maximize diversification of program and service viewpoint as well as to prevent any undue concentration of economic power contrary to the public interest."[9]
- *Local Ownership Rules*: Generally speaking, prior to the 1980s, a company could own only one television station, one AM radio station, and one FM radio station in any given locality. This rule was designed to prevent one broadcaster from dominating a local market.
- *The Financial Interest and Syndication Rules* (often referred to as the Fin-Syn Rules): Adopted in 1970, these rules were designed to limit the power of broadcast networks by limiting their ownership interest in the shows they aired. Among other things, the Fin-Syn Rules barred networks from having any ownership interest in a program's potentially lucrative syndication rights. What did this mean? Say an independent production company took an entrepreneurial risk and produced a TV program. Back then there were only three television networks that could distribute the program. This gave the networks tremendous leverage to extract favorable deals from producers. For example, a network could coerce producers to give it an ownership interest in the show, which meant that if the show was successful and rerun on stations for years to come (called syndication, which will be discussed in Chapter 10), then the network would reap much of the windfall. The Fin-Syn Rules put a stop to such deals by allowing networks to air but not own a show. These rules, then, favored entrepreneurial independent television producers who took the risk to produce shows rather than the networks that distributed them; the FCC argued this would ensure diverse voices being heard rather than the more monolithic voice of the networks.
- *The Fairness Doctrine*: The FCC instituted the Fairness Doctrine in 1949. It required broadcasters to devote some air time to a discussion of important social issues and to make sure that contrasting viewpoints were presented. The FCC hoped this rule would lead to a discussion of issues vital to local interests, would give diverse people and groups access to the airwaves, and would prevent broadcasters from imposing their own point of view on the audience.

FILM REGULATION: 1934–1980

The government's desire to maintain a diverse, competitive landscape open to many different players extended to the film business as well. True, the FCC had no jurisdiction to regulate film distribution or exhibition, since no wires or airwaves were used in the process. This didn't mean, however, that the government had no power to impact the film business.

Recall that, in the 1915 *Mutual Film Corporation* case, the Supreme Court said films were a business "pure and simple, originated and conducted for profit." Being a business "pure and simple" meant that film companies were subject to the same laws as any other business, including anti-trust laws.

Back in 1938, when America's distrust of big business still ran high, the federal government sued the major film companies, claiming the fact that they were all vertically integrated violated anti-trust laws. The five biggest film companies back then, Paramount, Warner Bros., 20th Century Fox, MGM and RKO, were all film producers and distributors, but they all also owned chains of movie theaters that showed their films.[10]

The federal government alleged that the companies' ownership of production, distribution and exhibition businesses gave them too much power to squash potential competitors and rig the system in anti-competitive ways. For example, studios agreed to fix their theaters' admission prices. Also, each would "block book" films with independent exhibitors, meaning these unaffiliated theater owners were forced either to take a large package of a studio's films sight unseen, and perhaps get some good films and a whole lot of bad ones, or get nothing at all. Independent exhibitors needed product for their screens, so of course they would agree to whatever the studios offered. Not only were these exhibitors coerced to take bad deals, but block booking made it harder for independent filmmakers to get their films screened. Finally, studios routinely engaged in "blind bidding," which meant independent exhibitors had to bid on films and sign exhibition agreements without first having the opportunity to see the films.

It took 10 years for the anti-trust lawsuit to be finally settled, but in 1948 the studios agreed to divest themselves of all theater ownership and to stop practices like block booking and blind bidding. Once again the government could claim it prevented companies from consolidating too much power, which it argued benefited competition and diversity and therefore the public.

TV AND FILM REGULATION SINCE 1980

So much changed after 1980. The prevailing public attitude towards government changed, moving towards a more conservative, anti-government viewpoint. In his 1981 inaugural address, President Ronald Reagan famously announced that "Government isn't the solution to our problem, it is the problem." If government

had suddenly become the problem, conservatives like Reagan saw the solution in an unfettered free market. Government, therefore, began to step aside and ease regulations on all types of businesses, including media businesses.

It's therefore not surprising that Reagan's FCC chairman, Mark Fowler, declared, "The perception of broadcasters as community trustees should be replaced by a view of broadcasters as market participants."[11] In other words, government no longer had a right to define the public interest—the marketplace would define the public interest.[12]

Years later, in 1998, Michael Powell, who would become President George W. Bush's choice to head the FCC, saw a somewhat different reason to dispense with regulation. He argued that, thanks to the exponential growth of cable channels as well as the internet, broadcasting was no longer a scarce resource. Instead, he was left with the "undeniable conclusion" that the government, via regulation, had "subvert[ed] the Constitution so it could impose its speech preferences on the public."[13] Powell's hyperbole notwithstanding, his view was similar to Fowler's— let broadcasters do what they want, let them speak freely, let the market decide. The promotion of diverse, local voices was no longer needed or accepted.

This new prevailing attitude led to the following FCC decisions and Congressional action after 1980:

- *National Ownership Rules*: In 1984 the FCC raised the number of television, AM radio and FM radio stations one company could own from 7 to 12. A dozen years later, when Congress passed and President Bill Clinton signed the 1996 Telecommunications Act, the numerical limit was completely repealed in favor of a rule that limited ownership to stations that reached no more than 35 percent of the nationwide marketplace. This allowed large companies to buy dozens of stations. For example, at the time of writing, the Sinclair Broadcast Group owns more than 160 television stations. Rules regarding ownership of radio stations were also greatly relaxed, allowing a company like Clear Channel Communications to now own more than 800 radio stations.
- *Local Ownership Rules*: The rules were changed to allow one company to own two local TV stations under certain circumstances.
- *The Financial Interest and Syndication Rules*: The FCC abolished the Fin-Syn Rules in 1995. This meant that a network could own the potentially lucrative syndication rights to shows it aired. This in turn created great incentive for networks to own the shows they broadcast, which in turn prompted large corporations to buy both a television network and television production companies. Since motion picture studios all had television production components, the financial marriage between television networks and motion picture studios became inevitable. The end result: These days, four media conglomerates own both a television network and a motion picture/

television production studio, and over 90 percent of all shows aired by networks are produced and owned by a financially related company. Contrast this with 1989, when 76 percent of all television shows were independently produced and owned by separate companies unaffiliated with networks.[14] The demise of Fin-Syn therefore effectively spelled the demise of independent television production.

- *The Fairness Doctrine*: The FCC abolished the Fairness Doctrine in 1987. This meant that media outlets no longer had to air differing points of view. What some called a victory for free speech others called an abdication of civic responsibility and an open invitation to one-sided discourse of public issues.

- *Cable Television Regulation*: Though cable television became a viable commercial enterprise during the 1970s, cable didn't really come of age until the 1980s. In order to spur the industry's growth, local municipalities usually franchised one cable company to lay cable and provide service, thus giving that cable company a monopoly in its geographical area (which still holds true today). Because local cable companies were in effect government-sanctioned monopolies, local governments could regulate the fees cable companies charged and require operators to provide certain kinds of programming. However, Congress' 1984 Cable Communications Policy Act and 1996 Telecommunication Act prohibited local governments from regulating cable fees, greatly reduced the power of local municipalities to require certain kinds of programming, and allowed cable operators to have a financial interest in many channels offered via its service. This means that, today, a company like Comcast can now own many of the channels it carries and, if its current proposed merger with Time Warner Cable is approved, its reach will extend to roughly the 35 percent national limit. This begs the question: What if Comcast refuses to carry a particular cable channel, no doubt one that Comcast doesn't own? Can that channel possibly survive if it's cut off from 35 percent of the American public? If the answer is no, it can't survive, doesn't Comcast then have tremendous power to negotiate the terms by which it will carry that channel? This also poses questions concerning internet access. Will a huge cable operator like Comcast, which also currently owns Universal Pictures and the NBC television network as well as many cable channels, allow content from competitors to move through the internet as easily as its own? In the coming years, questions regarding so-called net neutrality and who "owns" the internet—the cable companies or effectively all of us equally—will undoubtedly be debated by the FCC, by Congress, and litigated in court.

- *Film Exhibition*: During the 1980s, President Reagan's justice department signaled that it would not file suit if motion picture companies once again began assuming financial interests in film exhibition companies, which in fact has occurred.[15]

REGULATION: WHERE WE ARE TODAY

If the conflict between government regulation and unfettered business control were likened to a battle, this one has become a rout. The geometrically increasing amounts of money spent by large corporations to lobby government officials to get what they want, as well as the public's prevailing anti-government sentiment, has led to a full-scale government withdrawal from media business regulation. This in turn has led to a concentration of media power undreamed of decades ago when media operators were viewed more like public servants and less like free market enterprises. Whether this is a good thing or bad thing will be discussed in the next chapter, after we examine the birth and growth of the companies that have come to dominate Hollywood.

NOTES

1 *United States v. Aluminum Co. of America*, 148 F.2d 416, 429 (2nd Cir. 1945).

2 *United States v. Von's Grocery Co.*, 384 U.S. 270, 274 (1966).

3 Article 1, Section 8.

4 "What We Do," *FCC*, last accessed on June 17, 2014, http://www.fcc.gov/what-we-do.

5 Committee of the Post Office, Government Ownership of Electrical Means of Communication, quoted by Willam M. Kunz, *Culture Conglomerates: Consolidation in the Motion Picture and Television Industries*, Kindle ed., location 1476 (Rowman & Littlefield 2007).

6 *Id.* at location 1475–1480.

7 The Radio Act of 1927, Public Law 632, 69th Congress (1927); *Federal Radio Commission, In the Matter of the Application of Great Lakes Broadcasting Co.*, 3 FRC Ann. Rep. 32 (1929), quoted by Willam M. Kunz, *Culture Conglomerates: Consolidation in the Motion Picture and Television Industries*, Kindle ed., location 210 (Rowman & Littlefield 2007).

8 "The Public and Broadcasting," *FCC*, July 2008, last accessed on June 17, 2014, http://www.fcc.gov/guides/public-and-broadcasting-july-2008.

9 *Amendments of Section 3.35, 3.240 and 3.636 of the Rules and Regulations Relating to the Multiple Ownership of AM, FM and Television Broadcasting Stations*, 18 FCC 288 (1953), quoted in Willam M. Kunz, *Culture Conglomerates: Consolidation in the Motion Picture and Television Industries*, Kindle ed., location 1682 (Rowman & Littlefield 2007).

10 The federal government included in its lawsuit Columbia Pictures and Universal Pictures, which produced and distributed films, and United Artists, which then mainly distributed films. None of these three companies owned movie theaters. See Michael Conant, "The Paramount Decrees Reconsidered," *Law and Contemporary Problems*, vol. 44, no. 4 (1982).

11 Mark Fowler and David Brenner, "A Marketplace Approach to Broadcast Regulation," *Texas Law Review*, vol. 60, no. 2 (1981/2), pages 209–210.

12 *Id.*

13 Willam M. Kunz, *Culture Conglomerates: Consolidation in the Motion Picture and Television Industries*, Kindle ed., location 336 (Rowman & Littlefield 2007).

14 "Annual Assessment of the Status of Competition in the Market for the Delivery of Video Programming, Comments of the Writers Guild of America, West. Inc.," March 21, 2014, page 5. You can read this document here: http://apps.fcc.gov/ecfs/document/view?id=7521094670.

15 Willam M. Kunz, *Culture Conglomerates: Consolidation in the Motion Picture and Television Industries*, Kindle ed., location 2696–2703 (Rowman & Littlefield 2007).

CHAPTER 7
Media Growth and Ownership

INTRODUCTION

During the early twentieth century, creative geniuses like Charlie Chaplin, D.W. Griffith, Buster Keaton and Alfred Hitchcock immediately grasped the power of film. They, along with talented actors like Greta Garbo, Mary Pickford and Gloria Swanson, became wildly popular, idolized movie personalities. Other stars would leap to the top of the recording industry; by the late 1920s, Al Jolson, Rudi Vallee and Louis Armstrong were among the first singers and bandleaders adored by mass audiences. In the early 1950s, Sid Caeser, Lucille Ball, Milton Berle and Jackie Gleason would become the first monarchs of television, entertaining literally tens of millions of people each night.

Talented creators like these people, however, were not the only ones drawn to the nascent entertainment business. Gifted business people were attracted as well—tough-minded entrepreneurs who knew how to structure and grow their business. They weren't Harvard Law School attorneys or Stanford MBAs trained to run billion-dollar corporations; instead, they were primarily immigrants who happened to like moving pictures and saw a way to make a business out of it. These people learned about film production and then personally ran every aspect of their business as if their lives depended on it . . . because, at the start, they did. Indeed, many early film companies became family-owned enterprises, where family members kept tight-fisted control of the company for 40 years or more.

Though these pioneers would no longer recognize the modern media world, they are directly responsible for it. And they would certainly recognize the business instincts of modern CEOs because they shared them. The film pioneers we'll shortly discuss bought and sold production companies just like their modern counterparts, and they ferociously sought to integrate vertically.

Though they undoubtedly had the same business desires, their world was much newer and smaller back then; their wealth and reach a mere fraction of today's media conglomerates; and their interests far narrower, usually trying to grow one business instead of many with a global reach. Since they operated when government was more concerned about business concentration than it is today,

they remained keenly focused on what they knew best, which was making films, or in the case of the early broadcast networks, making radio programs.

Many of the companies they established still exist today: Columbia Pictures, Paramount Pictures, 20th Century Fox, Universal Pictures, Warner Brothers and The Walt Disney Company. Other companies, such as MGM, United Artists and RKO, still survive, but are only a shell of what they once were.

Those companies that do remain, of course, are no longer owned by their founders, but instead exist as small corporate cogs in massive entertainment conglomerates that have evolved over the past three decades and own dozens of separate businesses. Just what companies do our modern entertainment conglomerates own? Has conglomeration been good or bad for entertainment and American society? We'll discuss these questions at the end of the chapter. But first, let's look at some history and discuss the evolution of Hollywood's dominant companies.

Is looking at Hollywood's past and its evolution to today a relevant inquiry? Absolutely. As one of my favorite philosophers, Mr. Spock, once said in an episode of the original *Star Trek* series, "Change is the essential process of all existence." The entertainment industry's change over the past century has been enormous, and where we are today is informed by where we were yesterday, and perhaps signals where we'll be tomorrow.

FILM: THE FIRST FEW DECADES

Film companies flocked to the Hollywood area during the 1910s. There were primarily three reasons for this: First, the accommodating climate allowed for year-round film production; second, land for new production studios was dirt cheap; and third, the Pacific coast was as far away from Thomas Edison as possible. Back then, Thomas Edison's Motion Pictures Patents Company, located on the east coast, owned many film-related patents and would file lawsuit after lawsuit against anyone who it thought even remotely infringed them. This constant barrage of legal paperwork both intimidated and frustrated would-be filmmakers. Like anyone else, they could look at a map and see that Los Angeles was about as far away from Edison's lawyers as possible, and so the pioneers of mass entertainment moved west to set up shop where orange trees thrived, where the sun always shined, and where hopefully the courtrooms would remain blissfully empty.

Here, then, is a brief look at the origins and early growth of the film companies that came to define Hollywood. We'll start with the studios that owned significant theater chains and therefore dominated the early film business—Paramount, Warner Bros., MGM, Fox and RKO—and then turn to what were back then the "second tier" studios—Universal, Columbia, Disney and United Artists.

Paramount Pictures

Adolph Zukor, a Hungarian immigrant born in 1873, had already become wealthy in the fur trade when in 1903 he invested in an arcade that exhibited a new invention, motion pictures. His interest in film led him a decade later to create the Famous Players Film Company, which in 1916 merged with an upstart film distribution company called Paramount Pictures. Zukor was one of the first people to recognize the value of vertical integration in the film business, owning a production company, a distribution company and movie theaters (indeed, he was also one of the first to "block book" movies which, as we've seen, led to the Paramount anti-trust lawsuit). Zukor was also a keen talent scout, engaging Cecil B. De Mille as a partner and giving him a shot at directing his first film, *The Squaw Man*, in 1914. Zukor helped build the studio system, over the years signing stars like Mary Pickford, Douglas Fairbanks, Rudolf Valentino, Clara Bow, Gloria Swanson, Mae West, the Marx Brothers, W.C. Fields, Marlene Dietrich, Claudette Colbert, Bing Crosby, Bob Hope, Veronica Lake and Gary Cooper.

By the early 1920s, Zukor's studio was churning out dozens of films a year. In 1926, he bought the land on which Paramount Pictures now resides, the only major studio that remains within the city boundaries of Hollywood.

The Great Depression dealt Zukor and Paramount a serious blow, and eventually bankruptcy proceedings would lead to the company restructuring. Then came the Paramount anti-trust lawsuit of 1938, which ultimately led to Paramount selling off all of its theaters. Zukor remained with Paramount through it all, until 1959. Among the acclaimed films Paramount made during the latter part of Zukor's tenure were *Going My Way, Double Indemnity, The Lost Weekend, Sunset Boulevard, The Greatest Show on Earth, Shane, Roman Holiday, White Christmas* and *The Ten Commandments*.

MGM

Metro-Goldwyn-Mayer began in a classic move towards vertical integration. Marcus Lowe, who founded America's oldest theater chain in 1904, later decided he wanted to buy motion picture production companies so his theaters would have a steady stream of films to play. So, over the next 20 years Lowe bought Metro Pictures Corporation, Goldwyn Pictures and Louie B. Mayer Pictures, consolidating all three in 1924 into what became known as Metro-Goldwyn-Mayer. Lowe appointed Louie Mayer and his brilliant 25-year-old production chief, Irving Thalberg, to run MGM, a leadership structure that continued after Lowe died in 1927 and Nicholas Schenck took over. Under the leadership of Schenck and Mayer, and thanks to Thalberg's production brilliance, MGM became a hugely successful film company. Major film stars like Spencer Tracy, Clark Gable, Judy Garland, Jean Harlow and Katherine Hepburn appeared in MGM pictures, which included *Gone with the Wind, The Wizard of Oz* and many

great musicals. Thalberg tragically died in 1936 when he was only 37 years old, but Mayer and Schenck remained in power at MGM until the 1950s.

Warner Bros.

Harry, Albery, Sam and Jack Warner were all Polish immigrants who found their way into the film exhibition and distribution business. Like other exhibitors and distributors, they longed to make their own films, and so in 1918 they opened Warner Bros. studio in Hollywood. Rather amazingly, the studio, which moved to its present location in Burbank in 1928, was run by at least one of the brothers until 1966, when the surviving sibling, Jack, sold his interest to Seven Arts. During the five decades that the family ran the studio, Warner Bros. introduced the first talking picture, *The Jazz Singer*, pioneered gangster films in the 1930s with hits like *Little Caesar* and stars like Edward G. Robinson and James Cagney, released *Casablanca* during the 1940s and launched the careers of Humphrey Bogart, Lauren Becall, Barbara Stanwyck and Ronald Reagan. The studio also made famous such animated characters as Bugs Bunny, Porky Pig, Daffy Duck and other Looney Tunes favorites.

20th Century Fox

In 1933, Darryl F. Zanuck, who had written scripts in the 1920s and who was then production chief at Warner Bros., left the studio after crossing swords with Jack Warner and formed 20th Century Productions with partner Joseph Schenck. In 1935 they bought Fox Productions, which among other things owned movie theaters, and changed the company's name to 20th Century Fox. Except for a six-year hiatus when Zanuck left to produce movies, he stayed with Fox until 1971. He signed such stars as Henry Fonda, Tyrone Power and Betty Grable and launched the career of Shirley Temple. Zanuck is credited with producing an extraordinary 227 films, including *The Grapes of Wrath*, *How Green Was My Valley*, *Twelve O'Clock High*, *All About Eve*, *Viva Zapata*, *The King and I* and *The Longest Day*.

RKO Pictures

In the late 1920s, David Sarnoff, who was then head of the Radio Corporation of America (RCA), combined different production, distribution and exhibition companies to form RKO (which stood for Radio-Keith-Orpheum, a name given to chains of movie theaters Sarnoff purchased). Sarnoff became interested in the film business when talking films were introduced because RCA had developed a new film sound system. Showing off this new technology became a major reason why Sarnoff created RKO. The studio's twenty-nine-year-old production chief, David O. Selznick, oversaw production of the original *King Kong*[1] and helped launch RKO's success. The studio would go on to make many of the acclaimed Astaire-Rogers musicals as well as such

popular 1930s films as *Gunga Din* and *The Hunchback of Notre Dame*. During the 1940s, RKO distributed such great films as Orson Well's *Citizen Kane* and Alfred Hitchcock's *Notorious*.

The studio's slow death began in 1948 when Howard Hughes bought RKO. Seven years later it was sold to General Tire and Rubber Company, only to go out of business in 1958. Though the RKO name has been resuscitated over the years, the studio never truly came back to life.

Paramount, MGM, Warner Bros., 20th Century Fox and RKO may have been the early powerhouses, but other studios rose as well. All but one of these other studios, United Artists, survived as fully functioning studios into the twenty-first century. Here, then, are the "second tier" studios during the early days.

Universal Pictures

Carl Laemmle, a German immigrant, came to the film business in 1906 when he was 39 years old. That's when Laemmle bought nickelodeon film players, though he never did build an extensive theater chain. Laemmle went into film production in 1909, but the almost 300 lawsuits filed by Edison's patent company eventually drove Laemmle to head west. In 1915, Laemmle and his partners bought land just above the Cahuenga Pass in Los Angeles where they located their Universal Pictures Manufacturing Company, which is the current site of Universal Pictures and the Universal Studios theme park.

Laemmle and his son Carl Jr. ran Universal until 1936, when bankruptcy forced a sale to the Standard Capital Corporation. Universal did not enjoy the great success that other companies did during the quarter-century under the Laemmles' control, perhaps making its biggest mark in horror films during the 1930s, producing such classics as *Frankenstein*, *Dracula* and *The Mummy*.

The Walt Disney Company

Walt Disney came to California from Kansas City in 1923 and opened an animation studio with his brother Roy. An early foray into animated shorts featuring "Oswald, The Lucky Rabbit" met with success, but when Disney's distributor, which owned the character, tried to ram an unfavorable deal down Disney's throat, Disney refused. Most of Disney's employees left his fledgling company, but one remained—Disney's friend and fellow animator Ub Iwerks. Undaunted, Disney and Iwerks next created Mickey Mouse and featured him in the 1928 short, *Steamboat Willie*. This was the first animated film to include sound, and it was an enormous success. A string of animated shorts followed, and then, in 1934, Disney launched a multi-year effort to produce the world's first full-length animated film, *Snow White and the Seven Dwarfs*. Some predicted the project would bankrupt the studio, and indeed Disney did have to borrow money to finish the film. Disney's passion and courage, however, paid off, and *Snow White*

became 1938's largest grossing movie, earning an enormous (for its time) $8 million. Disney went on to make several classic animated films, including *Fantasia*, *Pinocchio*, *Bambi* and *Alice in Wonderland*. Later would come television shows and Disneyland, which opened in Southern California in 1955. Walt Disney remained in control of his studio until his death in 1966, and then his brother Roy took over until he died in 1971.

Columbia Pictures

Brothers Harry and Jack Cohn went into the film production and distribution business during the 1910s. In 1924, they formally organized Columbia Pictures. Harry became the studio chief, where he remained firmly in charge until his death in 1958. Not having the financial resources others did, Columbia got by on tough-fisted frugality and lower-budget films. During the 1930s, Columbia's biggest director, Frank Capra, put the studio on the map with such hits as *It Happened One Night*, *Lost Horizon* and *Mr. Smith Goes to Washington*. In 1934 the studio signed the comedy team The Three Stooges, who went on to make almost 200 short films for Columbia over the next two decades. Later, the studio would sign such stars as Rita Hayworth, William Holden and Jack Lemmon.

United Artists

UA was formed in 1919 by four huge stars of the silent screen—Mary Pickford, Douglas Fairbanks, Charlie Chaplin and D.W. Griffith. Even in the early days of silent films, major stars and directors chafed under the authoritarian control of studio moguls, so these four people decided to form their own talent-friendly production and distribution company. Early Chaplin films like *The Gold Rush* gave UA credibility, but eventually its founders' passions drifted elsewhere. The company, however, continued on, and by the 1950s became primarily a distribution company, having great success with films like *The African Queen*, *Marty*, *West Side Story*, *Dr. No* (thus launching the James Bond series), *Hard Days Night*, *The Pink Panther*, *In the Heat of the Night* and *The Graduate*. UA also became a major player in television before the studio's virtual death in the early 1980s, which happened primarily because UA backed the disastrous high-priced low-performing epic, *Heaven's Gate*.

THE EARLY DAYS OF RADIO AND TELEVISION

Back during television's infancy in the late 1940s, most film executives were very reluctant to cozy up to the new medium, naturally viewing it as a threat to their business, which indeed it was. There's no question that television siphoned off a significant part of the movie-going audience. Eventually, however, it made sense that studios with production facilities and production know-how would turn to television production as well as movies. Some did early on; for example,

Columbia Pictures, using the name "Screen Gems," started creating television shows in 1951. Walt Disney also produced his first television show in 1951, forming a close relationship with the ABC television network. Warner Bros. and MGM created television production arms in 1955, while latecomers Paramount and Universal didn't fully engage in television production until the 1960s.

Of course, making a television show was one thing, but having it broadcast by the growing number of television stations across the country was another. The film studios all had film distribution operations to get films into movie theaters, but television distribution by the early 1950s was already dominated by three major television networks, ABC, CBS and NBC.

Where did the networks come from? Like much of the movie business, the networks took shape in the 1920s when yet another new entertainment media, radio, burst onto the scene. The lure of wireless broadcasting drew its own set of young entrepreneurs who quickly grasped the power of radio networks. When television arrived in the 1940s, these same entrepreneurs naturally embraced this new form of wireless broadcasting, enticing independent television station owners to join their networks.

Like the movie moguls, network leaders were strong-minded business people who for decades tenaciously controlled every aspect of their business. Given the chance, they and their film studio brethren might well have negotiated deals to merge their operations in an effort to concentrate business power, but no one tried back then—perhaps because no one thought the government would allow it.

Here is a brief look at the early days of CBS, NBC and ABC.

Columbia Broadcasting System (CBS)

In 1928, 26-year-old William Paley became president of a 16-station radio network he named the Columbia Broadcasting System (which had no affiliation with Columbia Pictures). When he died in 1990, the *New York Times* eulogized Paley as a twentieth-century visionary harboring the ambitions of a nineteenth-century robber baron.[2] Paley signed up affiliate radio stations by providing a wide variety of content, including both sophisticated cultural programs as well as programs that appealed to mass audiences.

Paley created CBS's famed news division in 1935 and required that it be kept separate from CBS's entertainment division. Unfettered by bottom-line financial pressures, CBS News came to represent journalism excellence, thanks to correspondents like Edward R. Murrow, Charles Collingwood, Eric Sevareid and Walter Cronkite.

With the advent of television in the 1940s, Paley, along with his chief lieutenant Frank Stanton, oversaw the creation of the CBS television network. They both

passionately believed in the independent presentation of news, so they bravely (though with much heartburn on Paley's part) allowed Edward R. Murrow to challenge on air the dishonesty and cruel tactics of Senator Joseph McCarthy, then easily the most feared man in government.

If Paley could pick news stars, he could also pick radio and television stars, doing business with Lucille Ball, Jackie Gleason, Jack Benny, George Burns and Ed Sullivan. Paley's appreciation for all kinds of content led his network to air such diverse programming as the groundbreaking comedies *I Love Lucy, All in the Family* and *The Mary Tyler Moore Show,* the more mundane but popular *The Beverly Hillbillies, Green Acres* and *Petticoat Junction,* and the sophisticated *Playhouse 90* theatrical series as well as a number of New York Philharmonic concerts. Remarkably, Paley remained in complete control (some might say despotic control) of CBS for nearly 60 years.

National Broadcasting Company

NBC was formed in 1926 by the Radio Corporation of America (RCA), which itself was owned by General Electric and Westinghouse (though in 1930 an anti-trust lawsuit filed by the Justice Department forced GE and Westinghouse to divest themselves of RCA). David Sarnoff, an immigrant from Belarus who was often called "The Sergeant," ran RCA and therefore managed its subsidiary NBC. Like William Paley, Sarnoff quickly understood the value of radio networks and so he built several, calling them by such names as "NBC Red," NBC Blue," and "NBC Orange." The Justice Department in the late 1930s filed an anti-trust lawsuit against NBC, believing it was monopolizing radio. The result: In 1943, NBC sold the "Blue Network" to the man who made Life Savers popular, Edward Noble, who then changed the company's name to the American Broadcasting Company, and so ABC was born.

If Sarnoff understood the value of networks, he also understood the potential of television, saying in 1939 that television was:

> a new art so important in its implications that it is bound to affect all society. It is an art which shines like a torch of hope in the troubled world. It is a creative force which we must learn to utilize for the benefit of all mankind.[3]

Sarnoff's passion for television (and for selling RCA television sets) led NBC to become a pioneer in color television in the 1950s. Sarnoff stayed with the network until 1970, during which time NBC aired such shows as *Dragnet, Bonanza, I Dream of Jeannie, Daniel Boone, The Man from U.N.C.L.E., Star Trek, Ironside* and *Columbo.* NBC also led the way in late-night TV thanks to *The Tonight Show,* which has aired without interruption since 1954.

American Broadcasting Company

As just mentioned, ABC became a radio network late in the game, in 1943, when the Justice Department required NBC to divest itself of part of its assets. ABC broadcast its first television programs in 1948, but it had only a few stations signed up and it nearly went bankrupt. A merger, however, with United Paramount Theaters (UPT, recently divorced from Paramount thanks to the Paramount anti-trust case) saved ABC, and UPT's head, Leonard Goldenson, took over the network. Almost immediately he made a deal with Walt Disney to finance a part of Disneyland in return for a new Disney television show. Goldenson remained at ABC until the mid-1980s. While he ran the network it aired such memorable shows as *ABC's Wide World of Sports*, *The Flintstones*, *Bewitched*, *The Addams Family*, *Batman*, *Rowan and Martin's Laugh-In* and *Monday Night Football*.

MEDIA CONGLOMERATION
1962–1980

As we've seen, from the early days of entertainment, executives sought market power. The Paramount anti-trust lawsuit and other Justice Department legal actions kept the media from concentrating too much power, but as time wore on and attitudes changed, the government's willingness to intervene waned and then virtually disappeared. When this happened, companies rushed into the vacuum and expanded as fast as possible. The drive was on to grow market power and wealth by creating synergies between traditional film and television production and new technologies that began to appear.

The flood of media mergers didn't truly begin until the 1980s, when President Reagan was elected and Mark Fowler took over at the FCC. Still, during the 1960s and 1970s, large diversified companies began the process of prying film studios away from the people who founded them, and so we'll start there. These mergers were tame by modern standards, given that cable and digital media were still in their infancy and the FCC back then still remained faithful to its founding tenets. Still, there were the important moves outlined below.

UNIVERSAL PICTURES (SOLD TO MCA)

In 1962, the Music Corporation of America (MCA), which was a powerful talent agency, bought Universal Pictures. MCA was founded by, of all people, an eye doctor. In 1924, Dr. Jules Stein found himself drawn away from ophthalmology by the sound of jazz, and so he helped form MCA to book gigs for musicians. In 1939, MCA relocated its headquarters to Beverly Hills and represented some of the movie industry's biggest stars, including Bette Davis, Henry Fonda, Jimmy Stewart and Ronald Reagan.

Under the name Revue Productions, MCA began producing television shows in the 1950s, including *Leave It to Beaver, The Jack Benny Program* and *Alfred Hitchcock Presents*. MCA could only produce TV because its client Ronald Reagan, who was then president of the Screen Actors Guild, waived the Guild's prohibition against agents becoming producers.[4]

Controlling the careers of all those stars and producing television shows made film production an obvious next step, so in 1962 MCA bought Universal Pictures. Still concerned about business concentration, the government required MCA to divest itself of its agency business, which it did. For the next 28 years, Dr. Stein's chief lieutenant, Lew Wasserman, ran Universal, making such films as *The Birds* by former client Alfred Hitchcock, *The Sting*, Steven Spielberg's first mega-hit *Jaws*, and *National Lampoon's Animal House*.

Arguably, the MCA merger with Universal was the last involving people who were true entertainment industry pioneers. Jules Stein and Lew Wasserman helped create the modern talent agency business, and Wasserman's control of Universal was as complete as that of any of his predecessors. The major Hollywood mergers that followed had a far different feel to them, when corporations fundamentally unaffiliated with Hollywood began to buy entertainment assets.

PARAMOUNT PICTURES (SOLD TO GULF & WESTERN)

Gulf & Western was a conglomerate that owned, among other things, a clothing manufacturer, a zinc mining company and an auto parts manufacturer when it bought Paramount in 1966. Under the leadership of Charles Bludhorn, Gulf & Western later extended its entertainment holdings, buying Desilu Productions (then renaming it Paramount Television), Sega, a game manufacturer, Stax Records, publisher Simon & Schuster, Madison Square Garden, the New York Rangers hockey team and the New York Knicks basketball team.

One of Gulf & Western's greatest accomplishments was hiring talented executives, including Barry Diller, who became Paramount's CEO, Michael Eisner, who enjoyed great success at Paramount and then later as Disney's CEO, Jeffrey Katzenberg, one of DreamWorks eventual co-founders, and Dawn Steel. Ms. Steel became only the second woman (after Sherry Lansing) to run a film department, first at Paramount and then later at Columbia.

Gulf & Western owned Paramount until 1994, and during those days made *Saturday Night Fever, Raiders of the Lost Ark, Terms of Endearment* and *Beverly Hills Cop*, as well as television hits like *Taxi* and *Cheers*.

UNITED ARTISTS (SOLD TO TRANSAMERICA)

Transamerica was primarily an insurance company when it bought United Artists in 1967. Under Transamerica's ownership, UA managed to win three best picture Oscars during the 1970s—for *One Flew Over the Cuckoo's Nest,*

Rocky and *Annie Hall*. It also made such acclaimed films as *Raging Bull, Coming Home* and *Apocalypse Now*. UA's backing, however, of the vastly expensive and poorly received *Heaven's Gate* proved disastrous. Transamerica shortly thereafter decided it ought to focus on the insurance game where actuarial tables put the odds distinctly in its favor, unlike the film business where no amount of calculation could guarantee success. So, in 1981, Transamerica sold UA to MGM.

WARNER BROS. (SOLD TO SEVEN ARTS AND THEN TO KINNEY NATIONAL COMPANY)

Warner Bros. had been run by at least one Warner brother since the 1920s, but in 1967 the studio was sold to Seven Arts, a production company. Two years later, Seven Arts sold Warner Bros. to Kinney National Company, which was run by Stephen Ross, and which owned parking lots, funeral homes and a car rental service. During the 1970s, Ross bought record companies, cable companies and Atari, which manufactured computer games. He also changed the company's name to Warner Communications.

Unlike most studio chiefs, Ross was both widely liked and admired. He also arguably became the first studio head to truly see the synergies that existed between related modern entertainment enterprises.

MGM (SOLD TO KIRK KERKORIAN)

MGM was sold to Las Vegas hotel and casino mogul Kirk Kerkorian in 1969. Kerkorian's interests primarily lay in Las Vegas, not in Hollywood; one of his first major actions was to attach the MGM name to what was then the world's largest hotel, the MGM Grand (which is now called Balley's Las Vegas).[5] The great movie studio, however, suffered. It was sold back and forth until even its historic back lot was parceled off (and now houses Sony Pictures Entertainment).

The company still survives, but sadly its famous mascot, Leo the Lion, is rarely heard these days.

1980–2000

As we just saw, Universal, Paramount, UA, Warner Bros. and MGM all changed hands between 1960 and 1980. These transactions, however, generally did not merge the studios with other, pre-existing entertainment assets. True, people like Charles Bludhorn and Steven Ross began to buy entertainment assets after they purchased film studios, but for the most part the mergers themselves involved solely a change in ownership rather than a concentration of media business power.[6]

As previously discussed, President Reagan's election and a change in philosophy at the FCC opened the media merger floodgates. Reagan's business-friendly

Department of Justice no longer cared about media business concentration and so no longer raised the specter of anti-trust litigation.[7] This, combined with FCC decisions to relax or eradicate longstanding rules, unleashed new rounds of media mergers as corporations sought both horizontal and vertical integration in ways that would have been both unimaginable and likely unacceptable in previous years.

The frenzied drive to merge and consolidate was hastened by the fact that highly lucrative new technologies and capabilities were bursting on the scene, including the quick growth of cable TV, satellite TV, videotape machines, home computers, computer game consoles, and DVDs. Many companies (rightly or wrongly) thought films and TV would feed, grow and diversify their existing business, and so as the world got smaller and global communications became an easy reality, the drive was on for comprehensive global footprints encompassing all aspects of entertainment.

Below are the principle deals that took place between 1980 and 2000.

COLUMBIA PICTURES (SOLD TO COCA-COLA AND THEN TO SONY CORPORATION)

In 1982, Coca-Cola bought Columbia Pictures for $750 million dollars. I was working at Columbia at the time, and one of Coca-Cola's early pronouncements was that some blue coloring on the studio's office walls—the color of rival Pepsi—would be quickly painted over. Coke's passionate interest in Columbia Pictures and its wall paint, however, didn't last too long. Indeed, Columbia Pictures left a bad taste in Coke's corporate mouth, especially after the 1987 bomb *Ishtar*. So, in 1989, Coca-Cola sold its entertainment holdings, which included both Columbia Pictures and its sister company Tri-Star Pictures, created in 1983, to Sony Corporation for $3.4 billion dollars (more than a 300 percent mark-up on what Coke paid just seven years earlier).

Why did Sony, a Japanese company, pay so much to buy Columbia? It did so because it was a pioneer in electronics, manufacturing television sets, radios, portable musical players, home computers and eventually Play-Station game consoles. Owning a studio and the content it created made sense, and Sony continues to own Columbia Pictures to this day. Along the way, Sony bought significant recording interests as well as music publishing companies. Thus, Sony now owns one of the few remaining successful record labels as well as one of the world's largest music publishers, Sony ATV, which has a financial interest in the songs of such artists as the Beatles and Michael Jackson.

What differentiates Sony, however, from other media conglomerates is that Sony doesn't own a television network or large cable TV holdings.

WARNER COMMUNICATIONS (BOUGHT TIME INC. AND TURNER BROADCASTING SYSTEM)

In 1989, Steve Ross, head of what was now Warner Communications, bought Time Inc., which owned HBO and a publishing empire. Ross once again changed his company's name, this time to Time Warner. After Ross' death in 1992, his successor Gerald Levin greatly increased the company's holdings by buying Ted Turner's Turner Broadcasting System, which owned, among other assets, CNN, Headline News, TBS, TNT, Turner Classic Movies, The Cartoon Network, New Line Cinema, Castle Rock Productions and the Hanna-Barbera animation studio.

UNIVERSAL PICTURES (SOLD BY MCA TO MATSUSHITA, THEN SEAGRAMS, THEN VIVENDI)

In 1990, a year after Coca-Cola sold Columbia and Tri-Star Pictures to Sony, MCA sold Universal Pictures to another Japanese electronics manufacturer, Matsushita (now called Panasonic). Unlike Sony, however, Matsushita quickly soured of playing the unpredictable Hollywood game, selling Universal in 1995 to Seagrams, a Canadian alcoholic beverage company. Five years later, Seagrams sobered up and realized it didn't want to be in the film business, so it sold Universal to Vivendi, a French company, which of all things got its start providing water to French municipalities. The Vivendi/Universal marriage didn't last long either, as we'll soon see.

PARAMOUNT PICTURES (SOLD BY GULF & WESTERN TO VIACOM)

In 1994, Viacom Inc. bought Paramount from its previous owner, Gulf & Western. Viacom began its corporate life years earlier under a different name, CBS Films Inc., which operated as the CBS network's syndication arm. However, when the Fin-Syn Rules were announced in 1970 barring networks from owning syndication rights in shows it aired, CBS Films Inc. was freed from CBS control and changed its name to Viacom.

The company went on to buy both radio and television stations. Then, thanks in part to the government's lessened interest in anti-trust laws, National Amusements, a movie exhibition company, bought Viacom in 1986. This placed National Amusement's head, Sumner Redstone, in command of Viacom—where he remains as of May 2014.

After buying Viacom, Redstone continued to expand his broadcasting assets, buying more television and radio stations, along with MTV, VH-1 and Nickelodeon.

Though the purchase of Paramount added a major studio to Viacom's holding, it was not done buying media assets, as we'll soon see.

MGM (SOLD MULTIPLE TIMES)

After buying United Artists in 1981, MGM itself was bought and sold several times between 1980 and 2000, including once by media mogul Ted Turner in 1986. Turner's interest wasn't in film production; he wanted MGM's vast film library, which he planned to monetize by showing on his TV stations. So Turner kept the film library (later bought by Time Warner in 1996) and ended up selling MGM and UA back to Kirk Kerkorian, who you'll recall first bought MGM in 1969. In the end, Kerkorian would resell and then re-buy the company one more time, and ultimately the once great studio all but disappeared as a viable, functioning entertainment company.

20TH CENTURY FOX (SOLD TO NEWS CORP.)

Rupert Murdoch, head of News Corporation, went on a massive buying spree in the 1980s. An early entrant in international cable and satellite television, Murdoch perhaps more than any other person understood the synergies between cross-ownership of various media assets. His two biggest acquisitions in the United States during the 1980s were 20th Century Fox and Metromedia, which owned television and radio stations in sizable U.S. markets.

After buying Metromedia, Murdoch launched the Fox Network in 1986 on his newly owned stations, the first national television network to be started in over three decades. As Murdoch hoped, independent stations across the company signed on to the Fox Network. Murdoch would later create a large number of Fox cable channels, including the vastly successful though nakedly political Fox News with its now cynically humorous tagline "Fair and Balanced." Murdoch's marriage of a film and television studio with a national television network and assorted cable channels was groundbreaking, creating the model that others would soon copy.[8]

NBC (SOLD TO GENERAL ELECTRIC)

The same year the Fox Network launched, General Electric bought NBC by buying its parent company, RCA. Interestingly, back in the early days of broadcasting, General Electric owned RCA and NBC, but a government anti-trust action forced GE to relinquish control. Now 56 years later, with the FCC unconcerned, GE regained control of RCA and NBC.

GE began as an electronics company but would also become an early pioneer in computers, energy development and kitchen appliances. It also was one of the Department of Defense's biggest contractors.[9] With its acquisition of RCA and NBC, GE moved into entertainment as well, becoming one of America's largest corporations.

CBS (SOLD TO LOWES INC. AND THEN TO WESTINGHOUSE)

Lawrence Tisch, who had made a fortune in hotels and movie theaters running Lowes Inc., acquired a substantial interest in CBS in 1986. Nine years later, Westinghouse Electronic Corporation, which by then owned a number of TV stations and a large radio network, bought CBS. Westinghouse would go on to buy Infinity Broadcasting two years later, thereby adding dozens of radio stations to its holdings, but it would soon sell CBS to yet another suitor.

ABC (SOLD TO CAPITAL CITIES)

In 1985, ABC, which had bought ESPN, was itself bought by Capital Cities Communications, a media company that owned TV stations, radio stations and various publications nationwide.

WALT DISNEY COMPANY (BOUGHT CAPITAL CITIES COMMUNICATIONS)

Ten years after Capital Cities bought ABC, Disney bought Capital Cities, thus becoming the first major studio to buy a television network (as opposed to Fox which created one). In the years that followed, Disney expanded both horizontally and vertically, ultimately owning several prominent production companies, such as Marvel Films, Pixar and LucasFilm, several cable television channels, such as the ESPN channels, A&E, Lifetime and the Disney Channel, television and radio stations across America, publications, theme parks, hotels and a cruise line.

DREAMWORKS SKG CREATED

Steven Spielberg, Jeffrey Katzenberg and David Geffen, who had all been immensely successful as either filmmakers or entertainment executives, founded DreamWorks SKG in 1994. This represented the first serious attempt in decades to create a new major production and distribution studio. Given the tremendous success of its founders, hopes were high that DreamWorks would become a creative juggernaut, and between 1997 and 2001 the studio released such acclaimed films as *Saving Private Ryan*, *American Beauty*, *Gladiator* and *A Beautiful Mind*.

2000–2014

With Michael Powell at the FCC, the growing concentration of media power continued after the turn of the new century. Long gone were the days when studio heads knew and controlled all operations of the business. Now studios functioned as units of international conglomerates, where the revenues studios earned (or lost) represented only a small fraction of the conglomerate's balance sheet, where entertainment was meant to feed any number of different

corporate entities and brands, and where corporate CEOs far removed from film and television production called the shots.

Some of the major deals completed between 2000 and 2014 are listed below.

CBS (SOLD BY WESTINGHOUSE TO VIACOM)

In 2000, Westinghouse sold CBS to Viacom. Five years later, Viacom would split up its own company, placing CBS under the corporate control of CBS Corporation, and retaining other assets under the Viacom name. Sumner Redstone and his National Amusements company, however, control both corporations.

TIME WARNER (BOUGHT BY AOL, THEN DIVORCED AOL)

In 2000, at the height of the dotcom bubble, AOL bought Time Warner for an unheard of $164 billion. The merger seemed to signal what would be an enormous shift in media power to new media companies like AOL, Yahoo and Google. As of 2014, the latter two companies are clearly involved in entertainment, as are Amazon and of course Netflix, but additional mega-mergers between internet powerhouses and studios have yet to take place. Perhaps this is in part because the AOL-Time Warner merger failed so badly.

The merger seemed to make perfect sense: AOL would use Time Warner cable to drive Time Warner content to millions of subscribers. Unfortunately for all concerned, a dotcom bust occurred as the deal was consummated and AOL quickly lost value, leading to an unprecedented $99 billion corporate loss in 2002. The marriage between AOL and Time Warner quickly soured, top executives lost their jobs and others resigned, and by 2009 Time Warner spun off AOL into a separate company.

UNIVERSAL PICTURES (SOLD BY VIVENDI TO GENERAL ELECTRIC)

When we last left Universal, it had been bought by a Japanese electronics firm (Matsushita), a Canadian booze manufacturer (Seagrams), and a French water company that diversified into entertainment (Vivendi). In 2004, General Electric, which already owned NBC, bought a controlling interest in Universal Pictures.

DREAMWORKS SKG (BOUGHT BY PARAMOUNT PICTURES, THEN DIVORCED FROM PARAMOUNT)

In the winter of 2005/6, DreamWorks' attempt to operate as a full-fledged studio ended when DreamWorks was sold to the Viacom-owned Paramount Pictures. DreamWorks' affiliation with Paramount, however, lasted only a few

years; by the end of the decade, DreamWorks operated solely as an independent production company.

UNIVERSAL AND NBC (SOLD BY GE TO COMCAST)

In a series of transactions between 2009 and 2013, Comcast, America's biggest cable company, bought NBC and Universal Pictures from General Electric, combining film and television companies with the country's largest cable provider.

TIME WARNER CABLE (PROPOSED ACQUISITION BY COMCAST)

As of this writing, Comcast has announced the purchase of Time Warner Cable, which would give Comcast access to about a third of the country's households. The deal will have to be approved by the FCC.

DIRECT TV (PROPOSED ACQUISITION BY AT&T)

At the time of writing, another cable company, AT&T, has announced it will buy satellite TV provider DirectTV. This deal will also have to be approved by the FCC.

Between 2000 and 2014, there was one other large purchase worth mentioning. In 2006, Google bought YouTube, which was then only 18 months old and losing money. Nevertheless, Google saw YouTube's potential and bought the company for $1.65 billion. Some questioned the deal, which was dwarfed by the ill-fated AOL-Time Warner $164 billion deal as well as by many other deals, including Comcast's nearly $40 billion purchase of NBC and Universal Pictures. Time will tell whether Google made a great purchase, but since analysts estimated YouTube's advertising revenues would equal $5.6 billion in 2013,[10] here's guessing the answer is a distinct yes.

MEDIA OWNERSHIP TODAY

The deals described above represent only a fraction of the media transactions that have occurred over the past 20 years, though they are easily the biggest. Here are just some of the assets owned by the six largest media conglomerates at the time of writing:[11]

CBS/VIACOM

FILM: Paramount Pictures, Paramount Home Video, Paramount Animation, MTV Films, CBS Films.

TELEVISION AND CABLE TELEVISION: CBS Television Network, CBS Sports, CBS Studios, CBS Studios International, CBS Television Distribution, CBS College Sports Network, CW Showtime Networks Inc., Showtime, Showtime 2, Showtime Showcase, Showtime Extreme,

Showtime Beyond, Showtime Next, Showtime On Demand, Showtime Women, Showtime Family Zone, The Movie Channel, The Movie Channel On Demand, The Movie Channel Xtra, Flix, Flix On Demand, Smithsonian Networks (Smithsonian Channel), Shockwave, BET, BET Event Productions, BET Gospel, BET Hip Hop, BET International, BET Mobile, BET Pictures, CMT, CMT Loaded, CMT Mobil, CMT On Demand, CMT Pure Country, CMT Radio, Comedy Central, MTV, MTV Hits, MTV Jams, MTV2, MTVN International, Nick at Nite, Nick Jr., Nickelodeon, Nicktoons Network, Palladia, TeenNick, Spike TV, Spike Filmed Entertainment, TV Land, VH1, VH1 Classic.

TV STATIONS: 26 television stations.

RADIO STATIONS: Over 100 radio stations.

PUBLISHING: Simon & Schuster Adult Publishing Group, Simon & Schuster Children's Publishing, Simon & Schuster International.

OTHER: Help.com, CNET, ZDNet, Neopets, EPIX.

COMCAST

FILM: Universal Pictures, Focus Features.

TELEVISION: NBC Television Network, NBC Entertainment, NBC News, NBC Sport Group, NBC Universal Domestic Television Distribution, NBCUniversal International Television Distribution, Telemundo, Bravo, Chiller, CNBC, Comcast Charter Sports Southeast, Comcast Sports Group, Comcast SportsNet Bay Area, Comcast SportsNet California, Comcast SportsNet Chicago, Comcast SportsNet Houston, Comcast SportsNet Mid-Atlantic, Comcast SportsNet New England, Comcast SportsNet Northwest, Comcast SportsNet Philadelphia, Comcast Sports Southwest, NBC Sports Network, E! Entertainment Television, G4, Golf Channel, MSNBC, Oxygen Media, the Style Network, Syfy, and other international channels.

TV STATIONS: More than two-dozen television stations.

CABLE: Nation's largest cable provider and will service about a third of the nation's homes if the Time Warner Cable sale is approved.

OTHER: Universal Studios theme parks, About.com, Fandango, Hulu (co-owner with Fox and Disney), the Philadelphia Flyers Hockey Team, the Wells Fargo Center (home to the Flyers and the Philadelphia 76s Basketball team).

TIME WARNER

FILM: Warner Bros. Pictures, Warner Bros. Pictures International, Warner Bros. Studio Facilities, Warner Bros. Animation, Warner Bros. International Cinemas, Warner Home Video, New Line Cinema, Castle Rock Entertainment, DC Entertainment, Flixter.

TELEVISION: Warner Bros. Television Group, Warner Bros. Television, Warner Bros. Domestic Television Distribution, Warner Bros.

International Television Distribution, Warner Bros. International Television Production, HBO (and dozens of international HBO channels), Cartoon Network (and dozens of international Cartoon Networks), CNN, CNN International, HLN, TNT, TBS, Turner Classic Movies (and TCM international channels), The CW Television Network.

PUBLICATIONS: CNNMoney.com, DC Comics, Elle, Entertainment Weekly, Fortune, People, Sports Illustrated, Time, Life.com, InStyle, Golf Monthly, Horse and Hound (included here as a nod to the film *Notting Hill*), Mad Magazine, Marie Claire, Nascar.com, PGA. com, Sunset, Women's Weekly and dozens of other publications worldwide.

21st CENTURY FOX

FILM: Twentieth Century Fox Film, Twentieth Century Fox, Fox 2000 Pictures, Fox Searchlight Pictures, Fox International Productions, Twentieth Century Fox Animation, FOX Home Entertainment, many international film companies.

TELEVISION: Twentieth Century Fox Television, Fox Television Studios, Fox Broadcasting Company, Fox Sports, National Geographic Channel, Nat Geo WILD, Nat Geo Mundo, Fox Sports Network (FSN) and 22 regional cable sports networks, FOX Sports 1, FOX Sports 2, Yes Network, FOX Soccer Plus, FOX College Sports, FOX Deportes, FOX Life, Fox Business Channel, Fox News Channel, Baby TV, and dozens of other channels worldwide.

TV STATIONS: 28 television stations in the United States.

SATELLITE TELEVISION SERVICES: Numerous around the globe.

FINANCIAL AND PUBLISHING: Dow Jones, The Wall Street Journal, Wall Street Journal Global (Asia, Europe, Latin America, Brazil, China, Germany, India, Indonesia, Japan, Korea, Turkey), The Wall Street Journal Radio, The Wall Street Journal Digital Network, The Wall Street Journal Classroom Edition, Barron's, the New York Post, dozens of news and financial publications worldwide, HarperCollins and its many imprints, smartmoney.com.

OTHER: Hulu (co-owner with Comcast and Disney).

THE WALT DISNEY COMPANY

FILM: Walt Disney Pictures, Marvel Entertainment, Touchstone Pictures, LucasFilm, Pixar Animation Studios, Walt Disney Animation Studios, Walt Disney Studios Motion Pictures International, Walt Disney Studios Home Entertainment.

TELEVISION: ABC Television Network, Disney ABC Domestic Television, Disney ABC International Television, ABC Entertainment, ABC News, ABC Studios, A&E Television Networks (co-owned with Hearst Corporation), The Biography Channel (co-owned with

Hearst Corporation), Disney Channel Worldwide, History Channel (co-owned with Hearst Corporation), H2 (co-owned with Hearst Corporation), Lifetime Entertainment Services (co-owned with Hearst Corporation), ESPN, ESPN 2,

ESPN Classic, ESPN Deportes, ESPNEWS, ESPNU, ESPN International, ESPN Mobile Properties, ESPN on Demand, ESPN PPV.

TELEVISION STATIONS: 8.

RADIO STATIONS: 35.

THEATER: Disney Theatrical Productions.

PUBLISHING: Hyperion Books, ABC Daytime Press, ESPN The Magazine and many others.

PARKS AND RECREATION: Disney Cruise Line, Walt Disney Imagineering, Disneyland Resort, Walt Disney World Resort, and varying ownership interests in Disneyland parks in Paris, Tokyo, Hong Kong, and Shanghai.

OTHER: Hulu (co-owner with Fox and Comcast), the Baby Einstein Company, the Disney Store, Disney Apparel, Disney Toys.

SONY

FILM: Columbia Pictures, Columbia Pictures Classics, Screen Gems, Sony Pictures Releasing, Sony Pictures Releasing International, TriStar Pictures, Sony Pictures Animation, Sony Pictures Studios, Sony Pictures Home Entertainment, and production facilities worldwide.

MUSIC: Columbia Records, Epic Records, RCA Records, Sony Masterworks, Sony Music Nashville, Arista Nashville, Columbia Nashville, RCA Records Nashville, Provident Music Group, Sony/ATV Publishing (co-owned with Michael Jackson's estate).

ELECTRONICS: Too numerous to mention.

These are not the only companies with large entertainment holdings. Clear Channel Communications now owns more than 800 radio stations, Cumulus Media owns just over 450 radio stations, and the Sinclair Broadcast Group owns more than 140 television stations.[12]

THE IMPACT OF MEDIA CONGLOMERATION

Only a handful of corporations control the vast majority of what we see and hear every day in movie theaters, on television, on radio, on broadcast news and on cable news.[13] The question is whether this is harmful to competition, to creativity, to our culture and to our national dialogue.

Back in the 1990s, before even our current stage of media concentration, former FCC Chairman Nicholas Johnson lamented the rapid concentration of media power, which he termed the "annihilation of competition":

> [W]hen you contract with an author to write a book and sell it in the stores you own, produce the movie in the studio you own and run it in the theaters you own, make it into a video and distribute it through the stores you own, then put it on the cable system you own and the broadcast stations you own, promote it on the TV network you own, write it up in the entertainment magazine you own, that's pretty tough to compete with.[14]

Ted Turner shares these concerns. Turner founded the Turner Broadcasting System in the 1970s, a time when individual entrepreneurs could still find their way into the media broadcast and cable media business. Turner's foresight and willingness to take risks led him to create, among other things, CNN, HLN, TNT, TBS and TCM. But then times changed, the FCC changed, and in 2004 Turner decried the FCC's apparent lack of concern with media concentration, writing in the *Washington Monthly*:

> Today, media companies are more concentrated than at any time over the past 40 years . . . yet instead of balancing the rules to give independent broadcasters a fair chance in the market, Washington continues to tilt the playing field to favor the biggest players When you lose small businesses, you lose big ideas. People who own their own businesses are independent thinkers. They know they can't compete by imitating the big guys—they have to innovate When the independent businesses are gone, where will the new ideas come from? . . . The FCC defends its actions by saying that we have more media choices than ever before. But only a few corporations decide what we can choose. That is not choice. That's like a dictator deciding what candidates are allowed to stand for parliamentary elections, and then claiming that the people choose their leaders.[15]

Of course, in the decade since Turner wrote those words and the nearly two decades since Johnson wrote his, traditional media companies have become even more concentrated, and this raises three areas of concern.

The first is whether individuals with new and revolutionary ways of doing business can gain access to the broadcast or cable marketplace. There's no doubt a single person can broadcast his or her message over the internet, but can someone new break into established media businesses, or are those doors forever closed to all newcomers? Can someone successfully start a new film distribution company, or television network, or cable or satellite company? Probably not, given the tremendous costs, risks and competitive disadvantages such a venture would surely face.

It's also become extremely difficult for an independent outsider to produce television shows given that the conglomerates own more than 90 percent of the

shows they air. With films, yes, independent filmmakers can still make movies. New technologies have made this far easier and less expensive than ever before. Still, traditional distribution continues to depend on just a handful of companies that often flood the market with huge advertising dollars, making it extremely difficult for smaller films to be marketed effectively. Alternatively, films can now be initially distributed on Netflix as well as other less well-known sites, or via Redbox, but as of now these are far less lucrative alternatives to first distributing a film in theaters.[16] So the question remains, has traditional media concentration become sufficiently anti-competitive to warrant government action?

The second area of concern involves the merging of media assets with cable companies. Cable company chiefs, who no doubt fully believe in free market capitalism, have long benefited from the fact that their companies are essentially monopolies. If you want or need cable, usually you have only one choice in your community. That's because local municipalities franchised cable operators and gave them territorial control as an incentive to lay cable.[17] So, if a cable supplier like Comcast provides cable to as many as a third of the nation's homes, that means a third of all homes have to buy from Comcast unless they are able and willing to opt for satellite TV or some other much smaller service. But even if customers do opt for something else, high-speed internet must usually come into the home through cable. Therefore it's likely that wherever Comcast operates, many people feel obliged to sign up for its services.

What does this market power theoretically give Comcast, given its current extensive media holdings? Certainly, if Comcast refuses to carry a cable channel, it's hard to see how that channel can survive. Cable channels depend on fees paid by cable companies as well as advertising revenue, so if a channel is shut out from a third of the population, it's likely to die or else remain truly insignificant. Given this, a large cable company like Comcast has great leverage to extract tough-minded deals from cable channels that want to be offered on its service. Of course, no problems will likely occur with Comcast-owned cable channels—no doubt NBC and all of its cable channels will do just fine.

And then there's the issue of net neutrality. What if Comcast elects to slow the internet transmission of a competitor's content over its cable? This raises the question, do companies like Comcast and AT&T effectively "own" the internet because they own access to it, or is the web "neutral," something we all "own" and therefore something we all should be able to access equally? Recently we've heard discussion about the FCC permitting a "fast" and "less fast" lane over the internet, and we've heard companies like Netflix talking about paying more to get its content streamed quicker. If cable operators like Comcast are able to charge content providers more money for faster streaming, no doubt the rich will get richer, the big bigger, and the concentrated even more so.

Cable executives will surely argue that increased fees from content providers for fast-lane service will allow cable companies to lower what it charges customers like you. Maybe so. We'll see. But don't hold your breath.

The third area of concern has to do with the quality of news and public debate. Decades ago, William Paley believed CBS broadcasting was a public trust and its news division had to be run accordingly. Though it may now seem pretentious or quaint, people once believed that with access to the limited public airwaves came real broadcasting responsibilities. One of those was the serious dissemination of news.

Those days are obviously long gone, replaced by a singular drive to attract eyeballs in any way possible. This has resulted in a real loss to society—the demise of quality broadcast journalism in favor of infotainment, celebrity gossip, political gossip, sensationalism, fear-mongering, political extremism and, arguably, restraint on the part of news organizations when it comes to serious, controversial investigation. With regard to the latter: When a huge corporation is vested in the maintenance of the status quo and the good will of politicians, will that corporation's news division rock any significant boats that might hurt the corporation or cause political blowback?[18]

Having said all of this, there are legitimate arguments that the status quo is just fine and that government should stay out of the media's affairs. If media concentration is thought to breed banality, a lack of creativity or a singularity of ideas, it's very hard to look at the current television landscape and make this point. It's equally hard to argue the quality of television has decreased. Quite the opposite is true: the quality of television shows has never been higher, thanks to a proliferation of highly acclaimed programs such as *Breaking Bad*, *Game of Thrones*, *Mad Men*, *Homeland*, *Arrested Development*, *Modern Family* and many others.[19]

Perhaps far more importantly, the internet has become a serious competitor for eyeballs, a competition it has arguably already won. People who are now safely ensconced in middle age may look at the film and television industry as something entirely separate from the internet, which they may view as a distinct entity. If one sees things this way, then surely the traditional media is highly concentrated in ways that would never have been accepted in the past. Others, however, will claim that they aren't separate businesses but competitors in the same entertainment arena. If so, then the traditional media is surely being challenged by the likes of Netflix, YouTube, Yahoo and Amazon.[20] Netflix has become a very successful new media company, and its entry into producing shows has met with wide critical acclaim. Though it obviously doesn't broadcast on television, Netflix has become a new content provider and the darling of many filmmakers with distinctive and well-made shows like *House of Cards* and *Orange Is the New Black*. Amazon is also producing its own original shows and Yahoo, as well as other internet companies, intend to produce shows as well.

Then there's YouTube. YouTube hosts uncounted numbers of viewer-supplied content channels, the top 100 of which have more subscribers than people who daily watch CNN, Fox News and MSNBC *combined*.[21] Indeed, YouTube claims that people spend 6 billion hours a month watching video on its site.[22] Given all this, it's hard to argue that, when it comes to television and small screen viewing, people don't currently have either choice or quality.

With regard to news, certainly the internet provides news and information from an endless array of sources. No doubt former FCC Chairman Michael Powell will argue that there's never been more diversity in communications, and if one counts each website as a diverse voice, then he's clearly correct. Still, as of now, it seems that broadcast and cable news set the public agenda and tone. As time moves on and more people turn to the internet for information, this may well change.

So has the media grown too concentrated for our own good? Has entry to the communications marketplace been made too difficult? Has competition and innovation been stifled, and do a handful of rich and powerful corporations control too much of what we hear and see every day? Or has the internet opened the playing field to new competitors who now compete on the conglomerate's turf? These are questions we should all ponder and debate.

NOTES

1 Selznick left RKO in 1933 to join MGM and then later formed his own production company. During his career he produced such classic films as *Anna Karenina, A Star is Born, Gone with the Wind, Rebecca* and *Spellbound*.

2 Jeremy Gerand, "William S. Paley, Builder of CBS, Dies at 89," *The New York Times*, October 27, 1990, last accessed on June 18, 2014, http://www.nytimes.com/1990/10/27/obituaries/william-s-paley-builder-of-cbs-dies-at-89.html.

3 Marcy Carsey and Tom Werner, "Father of Broadcasting David Sarnoff," *Time Magazine*, December 7, 1998, last accessed on June 18, 2014, http://content.time.com/time/magazine/article/0,9171,989773-1,00.html.

4 See page 166 for a discussion of whether agents can act as producers.

5 There is now an MGM Grand Hotel in Las Vegas, though it is not the same hotel as the one Kerkorian built.

6 Arguably MGM's purchase of United Artists concentrated power, but the fact is both companies were nearly moribund at the time.

7 Reagan's close friends, his former agent Lew Wasserman, then in control of Universal Pictures, and Jack Valenti, then MPAA chief, undoubtedly got exactly what they wanted.

8 In 2013, Murdoch officially created "21st Century Fox," which now holds all of News Corp.'s broadcasting and film assets, while News Corp. retained legal control over the publications assets. Murdoch controls both corporations.

9 The fact that GE had strong financial ties to the defense department and owned a network and its news organization raised concerns whether or not the network would undertake serious investigation of U.S. military action, such as the Iraq War. Phil Donahue was a liberal commentator on MSNBC during the run-up to the Iraq War in 2003. He opposed the impending war and was fired. An internal MSNBC memo warned that Donahue was a "difficult public face for NBC in a time of war," providing "a home for the liberal antiwar agenda at the same time that our competitors are waving the flag at every opportunity." See http://www.democracynow.org/2013/3/21/phil_donahue_on_his_2003_firing. Donahue himself argues that, back in 2003, "Antiwar voices were not popular. And if you're

General Electric, you certainly don't want an antiwar voice on a cable channel that you own; [Defense Secretary] Donald Rumsfeld is your biggest customer." *Id.* When Second World War hero and commanding general Dwight D. Eisenhower left the White House after serving two terms as U.S. president, he warned that America "must guard against the acquisition of unwarranted influence, whether sought or unsought, by the military-industrial complex." This raises the question, should a company with close ties to the government control a major news organization?

10 See Tim Worstall, "Google's YouTube Ad Revenues May Hit $5.6 Billion in 2013," *Forbes*, December 12, 2013, last accessed on July 14, 2014, http://www.forbes.com/sites/timworstall/2013/12/12/googles-youtube-ad-revenues-may-hit-5-6-billion-in-2013/.

11 The list of the conglomerates' holdings was in part culled from lists that can be found at "Who Owns the Media," freepress, which can be accessed at http://www.freepress.net/ownership/chart, and at "Resources," Columbia Journalism Review, which can be accessed at http://www.cjr.org/resources/.

12 German company Bertelsmann AG is another media conglomerate, owning extensive European broadcasting assets, as well as publishers Random House, Alfred A. Knopf, Ballantine and Doubleday.

13 During the summer of 2014, Rupert Murdoch, chief of 21st Century Fox and News Corp., sought to further concentrate the entertainment business by acquiring Time Warner, which would have left us with only four major media conglomerates. Time Warner, however, rebuffed Murdoch's overtures and, as of this writing, Murdoch has announced he no longer seeks to buy the company.

14 James Bock, "Citizen Kane as Conglomerate," *Baltimore Sun*, Apr. 3, 1996, at A2, quoted by Keith Conrad "Media Mergers: First Step in a New Shift of Antitrust Analysis?," *Federal Communications Law Journal,* vol. 49, no. 3 (1997), last accessed on June 18, 2014, http://www.fclj.org/volumes.

15 See Ted Turner, "My Beef with Big Media, *Washington Monthly*, July/August 2004, last accessed on June 18, 2014, http://www.washingtonmonthly.com/features/2004/0407.turner.html.

16 The issue of distribution will be further discussed in Chapter 10.

17 If the cable chiefs ever want to make a case for free market capitalism and competition, they can start by pointing to a 2012 Yahoo survey of the 15 most disliked companies in America. Fully one-third of these disliked companies had no competition and therefore no need to better their performance. Why no competition? Because they were cable companies, including Comcast and Time Warner Cable. See Dina Spector, Gus Lubin and Vivian Giang, "The 15 Most Disliked Companies in America," *Yahoo Finance*, June 29, 2012, last accessed on June 18, 2014, http://finance.yahoo.com/news/the-15-most-disliked-companies-in-america.html. And the 2014 American Consumer Satisfaction Index placed internet service providers at the very bottom of companies Americans like. See David Lieberman, "Consumers Dislike Cable Companies More Than Any Other Industry: Report," *Deadline Hollywood*, May 20, 2014, last accessed on June 18, 2014, http://www.deadline.com/2014/05/consumers-dislike-cable-companies-more-than-any-other-industry-report/.

18 See footnote 9 above for a further discussion of this issue.

19 Arguably the quality of movies has vastly decreased over the past decade thanks to an emphasis on escapism and branding, but this is certainly due in large part to many factors other than media concentration, factors we'll discuss in the next chapter.

20 I've omitted Hulu from this list because it's owned by Disney, Universal and Fox.

21 "YouTube Top 100 Most Subscribed Channels List: Top by Subscribers," *VidStatsX*, last accessed on June 17, 2014, http://vidstatsx.com/youtube-top-100-most-subscribed-channels; Jesse Holcomb and Amy Mitchell, "The State of the News Media 2013: An Annual Report on American Journalism; Cable: A Growing Medium Reaching Its Ceiling," *The Pew Research Center's Project for Excellence in Journalism*, last accessed on June 18, 2014, http://stateofthemedia.org/2013/cable-a-growing-medium-reaching-its-ceiling/.

22 See http://www.youtube.com/yt/press/statistics.html, last accessed on June 18, 2014.

CHAPTER 8

Unions, Agents and Managers

Studios are not the only important players in Hollywood. Entertainment unions significantly shape the business landscape, and agents and managers often exercise enormous business clout. Since people reading this book may one day find themselves in a union or working with one or want to be an agent or manager or be represented by one, we'll now look at these groups and how they operate.

ENTERTAINMENT UNIONS

Introduction

During the depths of the Great Depression Congress passed and President Franklin Roosevelt signed two laws making it easier for workers to unionize—the National Industrial Recovery Act of 1933 and the National Labor Relations Act of 1935. At precisely the same time, out in Hollywood, small groups of writers, directors and actors were forming their own separate unions. Usually referred to as "guilds," the studio heads wanted nothing to do with them; indeed, the studios went so far as to create their own puppet guild for writers to join. Ultimately, however, that phony guild was shuttered and the so-called creative guilds came to collectively represent the interests of their members.

These days, the Writers Guild of America, West ("WGA")[1] has a little more than 8,000 active members, the Directors Guild of America ("DGA") has roughly 15,000 members, The Screen Actors Guild ("SAG"), which recently merged with another union, the American Federation of Television and Radio Artists ("SAG-AFTRA"), has over 160,000 members, and the International Alliance of Theatrical Stage Employees ("IATSE," or "IA" for short) has about 120,000 members, including cinematographers, editors, art directors, set designers, camera operators, still photographers and model makers.

If you end up becoming a filmmaker, the odds are you'll be in a union.

One's attitudes towards unions undoubtedly rest on one's values, sympathies and attitudes towards business. Human nature being what it is, employers would like to keep every cent of profit they can, and employees would like to

get every cent they can. Employees who earn a paycheck and the employers who pay them may feel differently about what's proper and just.

I believe history does teach us this: Employers keep a greater share of the profit and employees get less when there are no unions. Individual employees simply don't have enough bargaining power to raise their own wages, and employers generally won't pay more unless they're given no choice. Only strikes, or the threat of strikes, have enabled workers to receive higher wages and health and pension plans, all of which shifts some of a company's profits away from the employers and to the employees.

As I said, how you feel about this no doubt depends on where your sympathies lie.

Guild Governance

Union members govern themselves by electing from their membership a president, vice president and board of directors. These people determine the guild's policies. They also hire the guild's executive director, who serves as labor expert, negotiator and chief administrator. The executive director takes policy direction from the guild's elected leaders and runs the organization's day-to-day affairs by managing a staff of guild employees.

Guild Contracts

Any union's principal mission is to negotiate and enforce union contracts with employers. These contracts, which often last three years and must then be renegotiated, create general guidelines that govern the working relationship between employers and the guild members they hire. We'll discuss these contracts in more detail momentarily.

It would be highly impractical for guilds to negotiate union contracts with every production company, big and small, so instead the guilds negotiate with a representative group of employers known as the Alliance of Motion Picture and Television Producers ("AMPTP"). Made up of powerful film and television executives, this group acts as a negotiating agent for all production companies. Once a deal is reached between a union and the AMPTP, production companies can become "guild signatories" by signing on to the negotiated agreement and abiding by its terms.

Does every single possible employer who hires film and TV people have to become a guild signatory? The answer is no. Indeed, no company has to be a guild signatory. If, however, a company doesn't sign a Guild contract, guild members generally can't work for that employer. In other words, XYZ productions must sign the Writers Guild agreement, and abide by its terms, if it wants to hire a WGA writer. The same goes if the company wants to hire a SAG actor,

or DGA director, or IATSE cameraperson—the production company must sign the relevant guild agreements.

And once a company becomes a guild signatory, it can then usually hire only guild members while the guild contract is in effect.

Which brings us, potentially, to you. You may be just starting out, great at what you do, but unknown and not a union member. If guild signatories may only hire guild members, how can you ever become one of them? You can, because guild signatories may hire non-union members *provided* these people quickly join the union. That's how my wife and I became WGA members; shortly after leaving film school, we optioned a script to Universal Pictures, which then paid us to do a rewrite. As a condition of that employment we had to join the WGA, which we were both delighted to do.

Given that production companies don't have to become guild signatories and are free to hire non-union people for less money, why do production companies ever sign a guild agreement and hire union workers? The answer is, because union members are known to be first-rate directors, actors, writers, cinematographers, editors, set designers and so on. Most employers find it makes good business sense to pay more to hire good people. And for independent filmmakers who often cast well-known actors in their productions, becoming a SAG signatory is generally a must.

So what specifically do guilds negotiate in union contracts? The entertainment guilds negotiate the following broad issues with the AMPTP:

- minimum salaries and benefits such as health care and pension plans;
- working conditions;
- credits;
- jurisdiction;
- residuals.

Minimum Salaries and Benefits

Minimum salaries, referred to as "scale," represent the least amount of money a union member can be offered to do a specific job. At the time of writing, the DGA scale for directing a high-budget[2] feature film is about $170,000. If you were hired tomorrow to direct your first feature for a guild signatory, that's the lowest salary you could receive. Not bad if you can land the job! The WGA scale for writing a first-draft screenplay for a high-budget movie based on one's own original story is just under $100,000, and for an original episode of a one-hour prime-time network TV show, about $35,000.[3]

Employers are always free to go above scale and offer more and they frequently do. I can assure you Christopher Nolan doesn't need to work for scale (unless he's willing to do so to reduce costs on a film he desperately wants to make). But

you don't have to be one of our great directors to receive more than scale. Many writers, directors, actors and others are paid well above scale because employers think these people are worth the money.

In addition to minimum salaries, guild contracts require employers to pay an amount into a guild's health and pension funds when union members are hired. For example, at the time of writing, if a company hires a WGA member and pays her $100,000, the company must pay about $8,000 into the WGA's pension fund and about $8,500 into the WGA's health care fund. The aggregate pension and health funds are then used to provide health insurance and defined benefit pension plans to union members who are deemed deserving under guild guidelines.

Working Conditions

Recently, a second assistant camera operator, Sarah Jones, was tragically killed while filming a scene for a movie called *Midnight Rider*. The crew had been placed on a narrow railroad trestle when a train suddenly bore down, killing Ms. Jones and injuring four other people. At the time of writing, the film's director and two others have been indicted for involuntary manslaughter.

Sadly, Ms. Jones is not the first person to have been killed while filming. In a business where movies and TV shows are shot in the vicinity of speeding cars, boats, trains, helicopters, cranes and explosive devices, accidents can happen. Of course, no one in charge ever wants to see someone injured, but where every shooting day can cost hundreds of thousands of dollars, there is sometimes pressure to cut a corner or two and get shots quickly. A kind of bravura can take over, leading filmmakers to believe nothing can possibly go wrong. And the young people who populate film crews, such as Ms. Jones, usually find it impossible to raise objections if they feel their safety is threatened. Who among us would say "no" to a director or producer while on set?

Both the federal government and state governments maintain worker safety rules, but unions also try to do their part to promote safe working conditions. For example, IATSE Local 600, which represents cinematographers, publishes security bulletins, conducts safety training, maintains an anonymous 24/7 hotline to report dangerous on-set conditions, and requires higher pay for union members engaged in hazardous filmmaking. The SAG contract permits an actor to refuse any hazardous stunt or activity the actor thinks might be dangerous and to always require a stunt double. SAG also provides a 24/7 hotline to report problems and it maintains guidelines for actors when working in potentially dangerous situations, such as on boats, around firearms, near potentially dangerous animals, when subject to a possible fall, or when working near electrical lines.

Ultimately, you and your co-workers on-set must protect each other if dangerous situations arise. The guilds do what they can to protect their members' safety, but only you and your fellow filmmakers are actually on set. Therefore,

if something feels wrong, take charge and report the situation to the appropriate guild office.

Credit

Some guild contracts, such as the DGA and WGA contracts, strictly regulate how their members' credit must appear on screen and in paid advertisements. For example, it may surprise you to know that neither the producer, nor director, nor even the studio head determines the writing credit you see on most movies or TV shows. Instead, per its union contract, only the WGA can determine who gets writing credit when its members have written films.

Long ago it used to be that producers gave writing credit to people who didn't even remotely deserve it. So, eventually the writers won the right to decide this issue for themselves. The union determines credit by having a panel of writers read all of the scripts written in connection with a project and then decide which writer or writers most deserve credit for the final shooting script.

Credit is immensely important to all filmmakers. It not only gives them professional credibility but also triggers bonus compensation based on screen credit[4] as well as residual[5] payments, which we'll discuss shortly.

Jurisdiction

Guilds have both a geographical and a work jurisdiction. A guild's geographical jurisdiction covers the territory where someone must live and work to be covered by a guild's agreement. For example, the WGA agreement only covers writers who live in America or who are required to work in America under the direct supervision of an employer.

A guild's work jurisdiction refers to what specific kinds of work are covered by the union contract, and these issues can create conflict between guilds trying to cover the same work. If I write a live action movie, I'll be covered by the WGA's contract, which means the Guild's rules regarding minimum salaries, health and pension payments and residuals apply to me. If, however, I write an animated feature film, the overwhelming likelihood is that none of the WGA rules will apply to me. That's because feature film animation producers have refused to sign the WGA's contract, so feature film animation is not part of the WGA's work jurisdiction.[6]

Residuals and the 2007–2008 WGA Strike

As we'll discuss in Chapter 12 on contracts later in the book, studio executives and filmmakers routinely negotiate over money. Filmmakers want to be paid as much as possible, and studios want to pay as little as possible. While studios and

filmmakers are basically free to negotiate whatever they want, guild agreements do place some firm requirements on how the financial pie is split. Minimum salaries are one example, and residuals are another.

Residuals are payments made for the *reuse* of someone's credited work after its *initial exhibition*. A movie's initial exhibition is almost always in movie theaters. A TV show's initial exhibition is, of course, the episode's initial broadcast. If that movie or TV show is commercially exploited *after* its initial exhibition, say by distributing it on DVDs or rerunning it on television, then the credited writers, actors and director receive additional compensation called residuals. These residual payments are usually calculated based on the sales revenues producers receive from DVD sales, television license fees, or revenues from other forms of subsequent exploitation.[7] Residual payments represent only a tiny fraction of these total sales revenues, but they can nevertheless add up to hefty amounts and help keep filmmakers afloat during slow periods of their careers.

It's interesting to examine how residuals evolved. Let's go back to the 1930s and imagine you wrote a screenplay about this Kansas girl named Dorothy who gets whisked to the land of Oz. Back then, your screenwriting contract would be premised on the film being commercially exploited solely in movie theaters, because there was no other way to commercially exploit films back then. So, when a producer and writer agreed to a screenwriting fee, that dollar amount reflected assumptions of the writer's worth based only on a film's theatrical exploitation.

Now fast-forward a decade or so and suddenly this thing called television started appearing in everyone's homes. And television had to fill hours of viewing time. So the studios got the clever idea of licensing their old films to TV networks and independent TV stations. TV executives gladly paid money to air films like *The Wizard of Oz* because they realized advertising revenue would cover the cost and generate profit.

The license fee TV stations paid went directly into the studios' pockets. They owned the films' copyright, so they kept the money. Filmmakers, however, looked at this new landscape and said, wait a minute, studios are suddenly making all sorts of money no one anticipated when film contracts were signed prior to the television era. Filmmakers thought studios should share this newfound wealth with the filmmakers who helped make the wealth possible.

The studios did not agree and pointed out that their old contracts with writers, directors and actors said nothing about handing over any portion of license fees generated by inventions unimagined when the original contracts were written. In short, the studios said sorry, but that's the way the cookie crumbles.

That's the way the cookie crumbled until 1960. That year, strikes by the WGA and SAG (led by a then noted liberal actor and union activist named Ronald

Reagan) forced producers to relent and pay residuals when films were aired on television. However, residuals were made payable only on films produced after the strike ended. Thus, to this day, despite the ungodly amounts earned by studios from the countless reruns of pre-1960 films like *Casablanca, The Wizard of Oz, Citizen Kane, Gone with the Wind, Top Hat, Singin' in the Rain, The Ten Commandments, African Queen, Frankenstein, Dracula, The Maltese Falcon, The Treasure of the Sierra Madre, Some Like It Hot* and so many other great films, the filmmakers themselves never saw a dime of all this new money.

Television writers faired only marginally better. While writers did receive residuals for reruns during the 1950s, they only received payments for the first few reruns of a show. So imagine how you might feel were you either Madelyn Pugh Davis or Bob Carroll. In the 1950s, they co-wrote every episode of the groundbreaking *I Love Lucy* show. For decades since then the show's 180 episodes have been constantly rerun all over the world, earning a fortune for the show's owner, a fortune no one could contemplate when the original episodes were paid for and written during television's infancy. Ms. Pugh recalled receiving a $3000 residual check in 1957 for her efforts and then not a penny more,[8] despite the fortune generated by the show's constant global exhibition.[9] The unwillingness to share even a small portion of the vast wealth created by people like Ms. Pugh and Mr. Carroll is a greedy and immoral stain on the industry.

The next big residual fight came 25 years later. This time around, the burgeoning home video market took center stage. Old films and TV shows could now be sold on videocassette, creating yet another revenue stream for studios. Producers wanted to give writers what amounted to about 0.3 percent of what producers received from videocassette sales. The WGA wanted 1.2 percent, which was a customary residual amount. The producers refused, arguing that the home video market was new, untested and expensive to service given the production and distribution costs of videocassettes. So the WGA went on strike in 1985. The strike lasted two weeks and ended with the producers' 0.3 percent residual demand accepted by the writers, a settlement the writers would come to resent.

Not long after the strike ended, the home video market began to grow rapidly and quickly became a source of significant revenue for studios. The introduction of DVDs, which were much cheaper to make and distribute than videocassettes, only helped increase the studios' profit, becoming in the early 2000s the largest single component of studio revenue. Indeed, by 2004, home video revenue equaled roughly $22 billion.[10] The residual rate of roughly 0.3 percent, however, remained unchanged. For every $1,000,000 the studios received from DVD sales, writers received about $3,500.

By 2007 it was clear that the internet would further reduce the studios' cost of bringing old movies and TV shows into homes and become another substantial

source of home video revenue. Once again the studios refused to change the home video residual rate, and so once again the WGA went on strike.

The strike lasted 100 days, the second longest strike in Guild history, and was fought over more than just residuals. Jurisdiction also became a critical issue. The Guild agreement did not cover new media work, and so the Guild sought to cover members employed to write new media productions. The Guild also sought to cover people who write scenarios and outlines for reality TV shows.

In the end the Directors Guild of America reached its own contract agreement with the studios while the WGA strike was ongoing. The DGA's agreement became the basis for settlement of the WGA's strike. Ultimately, the WGA got some of what it wanted but not all. The DVD residual formula remained unchanged but, importantly, studios agreed to roughly double the DVD residual formula for internet download sales. Given that internet sales will unquestionably eclipse DVD sales one day, this was a victory.[11] Just as importantly, the studios agreed that any new media projects they pursued, including internet productions, would now be covered by the Guild agreement. The Guild's coverage of new media work grew when powerful internet companies, including Netflix, also signed the Guild's agreement. Reality television, however, remained beyond the Guild's reach and is not covered by the Guild's contract.

Unions, Strikes and Sharing the Wealth

The WGA has gone on strike in 1960, 1981, 1985, 1988 and 2007–2008. SAG has held several strikes, including the 1960 industry-wide strike, though more frequently its strikes have targeted the advertising industry. The DGA struck once, in 1987. That strike lasted five minutes, and was then settled.[12]

The five WGA strikes alone collectively lasted more than a year. Both writers and studios suffered mightily. But they were not the only ones to suffer. People who earn a living servicing the industry—people like office assistants, restaurant owners and advertising representatives—suffered, too. Some estimate the Southern California economy took a $2 billion hit during the 2007–2008 strike, leaving a weakened industry in its wake. Could it have been avoided? Of course it could have, if only people were willing to trust, relentlessly honest and even remotely generous. Too many people are none of these things. As with any conflict, intentions get misconstrued, arguments spun, steadfastness disbelieved and greed relentlessly heeded. The zealous usually shout loudest, using fear and anger to back others into an emotional corner. A gigantic game of chicken ensues as the combatants try to stare each other down, always expecting the other to blink. When no one does, next comes fury, obstinacy and the inevitable game of how to save face. Like all wars, a strike represents failure to solve differences peacefully.

Having said that, should you find yourself in an entertainment union someday, know that the health care you get, the pension you receive, the residuals you pocket and the other benefits you enjoy were all won on the backs of those who fought for them. What's sad is that they had to fight in the first place.

VOICES—DANIEL PETRIE, JR.

Daniel Petrie, Jr., began his filmmaking career by writing *Beverly Hills Cop*. It's a major understatement to say this was not a bad way to break into the business; he was nominated for an Academy Award and the film became the highest grossing movie of 1984, making more money in theatrical box office than *Ghostbusters* or *Indiana Jones and the Temple of Doom*. Since then he has earned writing credit on several more films, including *The Big Easy*, *Shoot to Kill* and *Turner and Hooch*. He has also directed and produced more than a dozen movies as well as executive produced several television series.

Along the way, Mr. Petrie has found time to serve as WGA president twice (1997–1999, 2004–2005) and WGA vice president three times (1995–1997, 1999–2001, 2004). He also served on the Guild's Board of Directors and on numerous Writers Guild and Writers Guild Foundation committees. For his extraordinary commitment to the union he was awarded the 2013 Morgan Cox award for distinguished service to the Writers Guild.

GB: *When you joined the Guild after writing* Beverly Hills Cop, *did you already know a lot about how the Guild worked?*

DP: I came armed with a fair amount of information. Remember, before I turned to writing I had been an agent at ICM, and [laughing] I eventually got fired because of the WGA strike in 1981. When the Guild went on strike ICM cut loose a lot of junior literary agents.

GB: *You first ran for Guild office in 1994 when you were elected to the Board of Directors. Did anything specifically cause you to get involved in Guild affairs?*

DP: Nothing specific. I had publicly supported previous members running for the Board, and eventually people said to me why don't you run.

GB: *Being on the Board, or serving as president or vice president, is a huge time commitment. What made you give that commitment?*

DP: I had a philosophy of WGA negotiations that I thought was important and, to be candid, better than others. I think of myself as a member of the pragmatic wing of the Guild. There is a much more militant wing that believes better negotiated results can be obtained from a more confrontational posture vis-à-vis the studios and by

going on strike. I agree that our power as a union ultimately derives from our power to withdraw our services, so a possibility of a strike underlies every negotiation, but there are different ways to play that card. I choose to play it with less militancy.

GB: *What would you say about the importance of guilds to those people either new to professional filmmaking or who perhaps hope to become filmmakers one day?*

DP: I would say a few things. First of all, if you're a writer, would you like your credit of authorship to be determined by producers at their whim and discretion, able to give the credit to whomever they want, or would you like those credits to belong to you by right, and if there's a credit dispute it will be determined solely by disinterested fellow writers? Economically, I would say do you want health insurance or a pension, because you're not going to get it absent a guild's collective effort to obtain it for you. And do you want rules that establish minimum salaries and proper working conditions, because, again, without a guild you won't get either.

GB: *What would you say to someone who doesn't want to be bound by a union's decisions—someone who says they neither want to pay union dues nor have to conform to the group?*

DP: My response is that person is short-sighted and unable to recognize they are better off because of the union's bargaining power. Having said that, a person is free under the law to benefit from union contracts without joining the union under a status known as "financial core." My argument, however, is that if you profit from a community of fellow creative people you should join that community.

GB: *You met with AMPTP representatives, studio heads and other powerful Hollywood players. Did you find great antipathy to unions or a general willingness to work with unions?*

DP: I think there's a general willingness to work with unions, and a feeling that if there weren't unions the studios would find it necessary to invent them.

GB: *Why would the studios feel the need to create a union?*

DP: Because they feel there are certain things best bargained for collectively. If the studios had to bargain in each and every negotiation for health care and credits and what rights are conveyed and all the rest, that would be a logistical nightmare.

GB: *Studios frequently claim a majority of films lose money. What's your opinion about this claim?*

DP: Studios make money on many more pictures than it appears, otherwise they wouldn't be in the business of making movies. It's as simple as that. I had the president of a studio stop me on the lot one day and say there had just been a presentation for the board of directors where two movies I made came in for special praise because of the money they made for the studio. I told the president that I had just

received my profit statements on both pictures showing an identical $20 million loss. So, on the individual film side, the way their accounting works it adds up to a loss, but in their internal accounting these films made money.

GB: *Guild members lose residual income thanks to piracy. How big an issue is this for Guild members?*

DP: It's huge, getting bigger, and potentially as devastating to the film business as it was to the music business.

GB: *Given this, how do you view the long-term health of Guilds?*

DP: There are certain challenges for guilds as the business undergoes these huge systemic changes we're now seeing. Piracy is just one of them. Frankly, it's much more difficult for unions to represent people working in the emerging technologies. People who make films for YouTube do so without Guild protections and benefits, and as the industry fragments and the means of production and distribution fragment, the sway of the traditional media, including the unions, becomes proportionately weaker.

GB: *Do you then feel that the media conglomerates will grow weaker over time?*

DP: Absolutely. I think the dominance of these companies is naturally eroding. Probably the leading edge of this erosion is in news, given that now there are so many ways to get news in nontraditional ways. The sway the conglomerates once had is gone for good in terms of news, and eventually I think it will include everything else.

AGENTS AND MANAGERS
Introduction

During the 1960s, 1970s and 1980s, arguably the most powerful person in Hollywood was Lew Wasserman, who ran Universal Pictures. He began his career as an agent. So did Ron Meyers, current Vice Chairman of NBCUniversal. So did Jeff Rabinov, former president of Warner Bros. Pictures Group. And so did David Geffen, who became a hugely successful record and film producer and a founding member of DreamWorks SKG.

I've just named four people, but I could easily name 400 or perhaps 4,000; the entertainment business is rife with studio executives, producers and other professionals who cut their teeth at agencies before going on to other estimable careers.

Why have agencies been fertile ground for people on their way up? And why do successful agents wield enormous clout in the business? The answer has to do with the fact that agencies are metaphorical cauldrons into which pour talent, money and deals.

Agents to a large extent control clients' careers. These clients, among them successful actors, directors, writers, producers, cinematographers and editors, are a major part of Hollywood's lifeblood. Studios need constant transfusions of this lifeblood, and agents are the people who can help make it happen. This gives agents power and influence. Money also wields influence, and agents often have their hands on financing as well.

It's because agencies handle talent, money and deals that they're great places to learn the business and build one's career.

Types of Agents and Agencies

There are many different kinds of agents representing many different kinds of artists. Talent agents, for example, represent actors. Some are fortunate to represent huge stars. Others work within specialized niches; some represent only child actors, or stunt people, or actors seeking work in commercials, or stage actors.

Literary agents represent writers. Some may handle only television writers, or screenwriters, or new media writers, or book authors. There are agents who represent film directors, or TV directors, and agents who represent directors of photography, editors and other below-the-line[13] talent.

There are also agents who specialize in "packaging." Acting much like producers, these people take certain clients at their agency and marry them together for a particular project. For example, a director, writer, producer and actor may be packaged by their agency to work on a specific film or television show.

Along with different kinds of agents, there are different kinds of agencies. There are large and powerful agencies that represent successful artists working across the entertainment business, and then there are "boutique" agencies that represent a much more specific kind of clientele.

The largest and most powerful agencies currently include Creative Artists Agency (CAA), William Morris Endeavor (WME), United Talent Agency (UTA) and International Creative Management (ICM). These agencies usually represent artists at the top of their profession or artists deemed to be quickly heading there. Therefore, to be represented by an agency like CAA or WME serves as shining evidence of an artist's success.

Along with prestige, filmmakers at these agencies benefit from the agency's clout and packaging power. If your agency represents many major stars, directors, and producers, there's always the chance that your collective success will breed job after job. On the other hand, clients at these powerful agencies find themselves surrounded by dozens of other talented people jockeying for work and demanding their agent's attention. So, if any particular client's star begins to dim, that client may suddenly feel a bit lost or abandoned.

Boutique agencies, on the other hand, are smaller ponds where clients become bigger fish. Boutiques can't package you like the big agencies can, but they usually have great expertise within their specific niche. Therefore, an artist doesn't need to be represented by one of the large agencies to earn a good living in the business, since boutique agencies can serve clients extremely well.

What Do Agents Do?

Agents perform a variety of jobs. First, and most importantly, they procure work. Indeed, California Labor Code Section 1700.4 defines an agent as someone who engages "in the occupation of procuring, offering, promising, or attempting to procure employment or engagements for an artist or artists." How do agents do this? Lots of meetings and lots of reading. If you're a talent agent, you're investigating the casting needs of films and TV shows and then setting your clients up for auditions. If you're a literary agent, you're meeting with executives and producers to learn about open writing assignments and promoting your clients to fill those positions. Or, you're reading your clients' scripts and figuring out which producers and studios might be willing to become involved in the projects.

Though agents work hard, filmmakers understand they must procure work for themselves through their own network of friends and colleagues. This can't be stressed enough: To rely solely on your agent for work fails to utilize a great selling tool—yourself. So for those who resist self-promotion and networking, my strong advice is to quickly overcome that resistance.

Once work is procured, someone has to negotiate a legal agreement, and agents do this as well. Clients usually have neither the expertise nor the inclination to negotiate deals—nor should they, since working relationships can be sullied if negotiations become difficult. It's always best to let your agent play bad cop and negotiate the best possible deal for you.

Agents perform a variety of other services for their clients. For example, good agents strategize how best to build a client's career over a number of years. Agents may also provide a bit of psychotherapy now and then, though most agents have little time for hand-holding unless you're a superstar, in which case they'll go full "Jerry McGuire" and be with you nights, weekends, whenever and wherever to solve problems you may be having.

In a grander sense, agents serve a very useful function for studios: They weed out material that studios don't need to see. Agents' reputations are built on delivering to studios and producers worthwhile projects, and so the editorial screening they undertake saves everyone else a tremendous amount of time. In this sense, agencies truly are partners in production, filtering out the also-rans and promoting what they believe will be successful projects.

Rules Governing Agents

Most agents operate in California and so are bound by California state law, which regulates the agency business. The state does this to protect artists from unscrupulous people who might call themselves agents but who are nothing more than conmen intent on separating artists from their money.

The following are just some of the legal rules agents must follow:

- Agents must be licensed by the state (California Labor Code Section 1700.5).
- Agents must post a surety bond with the state (California Labor Code Section 1700.15).
- A talent agent who receives payment on behalf of an artist must immediately deposit the amount in a trust fund account, and the funds, less commission, must be disbursed within 30 days (California Labor Code Section 1700.25).
- No talent agency may divide fees with an employer, an agent or other employee of an employer (California Labor Code Section 1700.39).
- A talent agent may not collect a registration fee from a client, and no talent agency may refer an artist to any business in which the talent agency has a financial interest (California Labor Code Section 1700.40).
- A talent agent's contract with a client must include a provision that says, if the client is ready and able to perform but doesn't receive a bona fide offer from a responsible employer for more than four consecutive months, then either party can terminate the agency agreement (California Code of Regulations, Title 8, Chapter 6, Section 12001).[14]

Guilds, ever protective of their members, also seek to regulate agencies by "franchising" them. This means guilds give agencies their stamp of approval if the agencies sign the guild's franchise agreement and abide by its rules. Two very important rules agents must follow are:

- *Agents may charge no more than a 10 percent commission.* California state law actually makes a 20 percent commission possible, but the guild's franchise agreement restricts the commission to 10 percent.
- *Agents may not produce movies.* If they could, they might try to get their clients involved in their own movies, which means they might not be acting in their clients' best interests. Moreover, as producers, the incentive would usually be to reduce the picture's cost, which means paying the client as little as possible. That's called a major conflict of interest.[15]

Becoming an Agent

What does it take to be a good agent? For a start, you have to be willing to work very long hours. You must be prepared to make the job your life, because if you don't there are many capable people who will and potentially push you aside. In addition to having a great work ethic, you must also understand the business inside and out, know how to negotiate, maintain relationships under

what can be trying and stressful circumstances, understand story and how to read scripts, intuit what will be good projects for clients, thrive on competition, have a very tough skin, be personable and possess a genuine desire to help your clients' careers.

Getting an Agent

People often say to get into the business you need a break, which means you need to be where breaks happen. Usually, that means being in Los Angeles.

There's no formula for getting a break and finding an agent other than doing excellent work and being near where agents do business. Most agents won't consider a new client without a referral from someone the agent knows. Not surprisingly, most people that agents know work and live near them, so that's where you need to be. You build your network through whatever job you take or organizations you join, and eventually someone you know will know someone who knows an agent.[16] If your work is good, it will eventually be noticed.

These days there are some possible shortcuts. For example, film festivals offer venues where agents can see a filmmaker's work. A burgeoning number of websites dedicated to digital film distribution can perform the same function, though with less caché at this time of writing. For writers, scripts can get noticed via writing competitions or blcklst.com.

Managers

Managers differ from agents in a variety of ways.

First, *managers don't need to be licensed.* This means anyone can be a manager, which means potential clients must be careful and do their homework when retaining a manger.

Second, *managers may not procure work for their clients,* since only agents can legally do this. Managers do many things that help clients get work, such as making introductions to potential employers and sending scripts to studio executives and producers. Managers can therefore help clients become employable, but generally speaking they may not solicit or procure work. Just where the line is between helping a client become employable and actually procuring work is extremely fuzzy, but managers are best advised to stay on the right side of the line; if a manager is judged to have procured work, then the manager might have to forfeit his commission.[17]

You may be thinking, why don't managers just get licensed like their agent counterparts? True, if they did they could procure work all day long. But if managers did get licensed like agents and procured work, they'd also be required to sign the guilds' franchise agreements, and this managers don't want to do. Why not? The reason has to do with the third big difference between agents and

managers: *Managers are not prohibited from producing their clients' work.* Recall that the guild franchise agreements bar agents from producing. Managers, however, are under no such restriction and do in fact act as producers.

Fourth, *managers render more comprehensive services than agents.* Managers can become true architects of an artist's career. Managers often develop projects with their clients, handle the client's schedule, speak on a client's behalf with agents, producers and executives, and serve as trusted friend, respected counselor, and when times are tough, bartender and shrink.

Fifth, *a manager's roster of clients is usually much smaller than an agent's.* This is because a manager performs so many personal services for each client. Agents may represent fifty or more clients; a manager may represent only ten.

Sixth, *managers can and sometimes do charge a higher commission than agents.* Because managers fall outside of the guilds' franchise agreements, managers have historically charged a 15 percent commission. Now, however, many managers mirror their agent counterparts and charge 10 percent.

The California Supreme Court summed up nicely some of the major differences between agents and managers when it noted that an agent's 10 percent commissions cap and inability to produce clients' work

> create incentives [for agents] to establish a high volume clientele, offer more limited services, and focus on those lower risk artists with established track records who can more readily be marketed to talent buyers Personal managers, in contrast, are not franchised by the guilds They typically accept a higher risk clientele and offer a much broader range of services, focusing on advising and counseling each artist with an eye to making the artist as marketable and attractive to talent buyers as possible, as well as managing the artist's personal and professional life in a way that allows the artist to focus on creative productivity Given this greater degree of involvement and risk, managers typically have a smaller client base and charge higher commissions than agents (as they may, in the absence of guild price caps); managers may also produce their clients' work and thus receive compensation in that fashion.[18]

NOTES

1 There is also a Writers Guild of America, East.
2 "High Budget" is currently defined by the DGA as any film budgeted at more than $11 million.
3 These minimum salaries will be lower if the production company intends to produce a low-budget film. What constitutes "low budget" is defined in the WGA and DGA guild agreements.
4 For example, writers typically receive both a cash bonus plus a profit participation if they receive credit on a film. This is discussed on page 242.

5 Residuals are discussed on pages 157–60.

6 IATSE Local 839 does cover some animated movies. Because feature film animation is not covered by the WGA agreement, WGA members are free to do non-union feature film animation work if they want; WGA members are only prohibited from working for a non-union employer in areas that are covered by the WGA agreement. Thus, if a WGA member wants to write for Pixar, which is not a union signatory, they can. Some producers of animated televisions shows, such as *The Simpsons*, have signed the union agreement.

7 In the case of certain television residuals, payments are calculated as flat fees.

8 Faye Fiori, "Show Biz Icons with Little to Show for It," *Los Angeles Times*, May 17, 2000, last accessed on June 18, 2014, http://articles.latimes.com/2000/may/17/news/mn-30945.

9 Residuals for foreign exploitation of TV programs began in the 1960s. See "Residuals Survival Guide, Revised December 2013," *WGA*, pages 3–4, last accessed on July 4, 2013, http://www.wga.org/uploadedFiles/writers_resources/residuals/residualssurvival2013.pdf.

10 See Mike Snider, "Home Video Sales Slide; More Opt for Blu-Ray Players," *USA Today*, May 3, 2011, last accessed on July 10, 2014, http://usatoday30.usatoday.com/tech/news/2011-05-02-dvd-movie-sales-continue-slide_n.htm.

11 It should be noted that, during the 2001 contract negotiation, WGA Executive Director John McLean and President John Wells negotiated an internet rental residual equal to the customary 1.2 percent. Given the growing use of iTunes and Amazon as a means to instantly rent movies, this was a good bit of farsighted negotiating on McLean and Wells' part. The 1.2 percent internet rental residual is still part of the WGA agreement today.

12 "70 Years of Milestone," *Directors Guild of America*, last accessed on June 18, 2014, http://www.dga.org/Craft/DGAQ/All-Articles/0604-Winter2006-07/Features-70-Years-of-Milestones.aspx.

13 "Above-the-line" talent and "below-the-line" talent is merely a euphemism borrowed from production budgets. These budgets usually have a line on them, above which are listed the producer(s), writer(s), director, actors and rights holders. All other crew members are listed below the line.

14 The Association of Talent Agents (ATA) is a trade association that promotes the interests of agencies. You can find on its website a list of all legal restrictions agents must observe. See "Talent Agent Licensing," *Association of Talent Agents*, May 7, 2014, last accessed on July 4, 2014, http://www.agentassociation.com/frontdoor/agency_licensing_detail.cfm?id=742.

15 In his book, *How to Manage Your Agent*, author Chad Gervich points out that no state law prevents agents from producing their clients' work—only the guilds' franchise agreements bar agents from becoming producers. Still, as Gervich notes, California Labor Code Section 1700.39 bars talent agencies from dividing fees with an employer, demonstrating the legislature's intent to keep agents from engaging in financial transactions with employers, which they themselves would become were they to produce clients' projects. Chad Gervich, *How to Manage Your Agent* (Focal Press 2014), Kindle ed., location 619.

16 For an example of this, see the interview with television writer Michael Poryes on pages 279–81.

17 See *Marathon Entertainment v. Blasi*, 2 Cal.4th 974 (2008).

18 *Id.*

SECTION 3
What Studios Do

Studios may now be part of wealthy entertainment conglomerates, but they must still earn their keep. That means doing what studios have done for more than a century—developing, financing, producing, marketing and distributing successful movies and shows. Internet companies that produce entertainment, like Netflix and Hulu, must do precisely the same things.

Since this is a business book, we'll focus on the business side of production as opposed to production itself, which is when the business people primarily step aside and the filmmakers take over.

The initial business decisions any studio must make are (a) which projects to develop, i.e., which projects will the studio pay to be written and otherwise made ready for production, and (b) which of these projects will the studio actually finance and produce. Not every developed project gets produced. Far from it. Sometimes studios can't get a script to their liking. Sometimes a studio's preferred actors and director aren't interested in a project, or aren't available at the same time.

It used to be that studios developed as many as a hundred movie projects for every one actually produced; now it's closer to ten to one and shrinking. Television networks and cable channels are also developing fewer projects than in the past.

It's important to point out that studio executives aren't the only people who make important decisions about what to develop. Filmmakers do too. Since

writers, producers and directors generate so many new projects, they constantly have to decide which projects to pursue. While many filmmakers use the same calculations as studios when deciding what to develop, this certainly isn't always the case, and so we'll spend time discussing development from the filmmaker's perspective.

What do studios think about when making development decisions? Don't let this shock you, but fundamentally it's money. The bottom line. Profits. Branding. Revenue streams. This means that, when making development decisions, studios consider the business activities that come *after* production ends—marketing and distribution. Within the hallowed halls of studios, it is the likelihood of successfully marketing and distributing films and TV shows that substantially drives decisions about what projects to develop.

We'll discuss distribution in Chapter 10, but here it's worth emphasizing what differentiates studios, networks and companies like Netflix from all other content producers: They *distribute*. Anyone with a script, a camera and money can make a movie. Small production companies, just like studios, can develop, finance and produce entertainment. But only the major studios can do those things *plus* distribute movies worldwide in theaters, on television, on DVDs and on the internet. Only a network or cable channel can put television shows on TV sets everywhere, and only Netflix or YouTube can currently air content on a website with more than 40 million regular viewers.

That's why studios and networks are so powerful. Because they distribute to very large audiences, they reach lots of paying customers and generate lots of revenue, which means the artists who create the entertainment get paid a lot of money. This is what currently separates studios and networks from small, niche distributors and many internet sites (though not all) that distribute original productions; studios and networks can significantly monetize their productions, while small distributors and the majority of internet companies can't.

CHAPTER 9
Development

The development process comes at the beginning of a project's life. This is the time when good ideas are identified and then "developed"—that is, written, then rewritten, then re-rewritten, and then re-re-rewritten. During this time, actors and a director hopefully become attached to the project. Ultimately, development ends when either a studio or other financing entity is prepared to produce the project, or says "no" and dumps it.

We'll discuss studio development and which studio departments play a role in the process, but it's worth starting at the very beginning, when a filmmaker decides to sit down and write something. Choosing *what* to write is a critical decision that involves both significant time and opportunity costs, and therefore it's a decision that must be made carefully and thoughtfully.

CHOOSING IDEAS

A film or TV show may end up as a multi-million dollar business, but it always starts as an idea in someone's head. Who comes up with ideas? Obviously, writers do—it's part of their livelihood and their passion to create and write stories. Writers, however, are not the only ones who originate projects. Producers generate ideas, as do studio executives, directors and actors. Indeed, anyone, anywhere can come up with a good story idea, though as I'll discuss shortly, it's certainly much more difficult for nonprofessionals to get their ideas to the screen.

Where Do Film and TV Pros Look for Ideas to Develop?

Because films are so tremendously expensive to produce and distribute, film companies try to hedge their bets by developing projects that come with large built-in audiences. In other words, they look for films that are relatively easy to market and distribute because the public already knows and likes the material. These are projects that can spawn sequels and be franchised and branded and merchandised across a conglomerate's slew of businesses. Sometimes referred to as "tent-pole" movies, ideas for these projects often come from hugely popular

books (*Harry Potter, Hunger Games, Lord of the Rings*) or comic books (*Iron Man, Thor, Spiderman, Batman, X-Men*), and on at least one occasion, from a theme park ride (*Pirates of the Caribbean*). Tent-pole movies can also come from past TV shows (*Star Trek*), though like any other pre-existing project, past TV shows don't guarantee success (*Lone Ranger*).[1] Tent-pole movies can also come from someone's imagination (*Indiana Jones*), though studios today would be loath to risk huge production budgets on untested ideas.

Besides potential tent-pole projects, where else do studios and film professionals look? Certainly studios look to past breakout films and make sequels (*Rocky II, III, IV* ad infinitum, *Saw II, III, IV* ad infinitum), to recent world events (*Zero Dark Thirty*), to people's lives (*The Aviator, The Social Network, Ray, A Beautiful Mind*), to history (*The King's Speech, Twelve Years a Slave, Argo, Lincoln*), or to a really unusual take on history (*Abraham Lincoln: Vampire Hunter*).

Fortunately for us all, ideas can still come from someone's original thinking (*Inception, Pulp Fiction*) and from imagining what the world would be like if only such and such happened (*Armageddon, The Hangover, Sharknado*—okay, *Sharknado* was not produced as a feature film but instead as a cable TV film, but I just had to add *Sharknado* somewhere and this was as good a place as any).

Historically, television has been different. TV ideas have not usually been based on pre-existing works but have traditionally been original ideas tied to established formats. From the early days of TV, audiences became familiar with the rhythms and themes of sitcoms, detective procedurals, medical shows, legal shows and soaps, and so these specific formats tended to drive new stories.

Recently, however, television has broken free from old formulae and started telling wildly different, original stories. HBO (*Larry Sanders, Curb Your Enthusiasm, The Sopranos, Deadwood, Sex in the City*) led the way with inventive programming, but now cable channels are producing such exceptional shows as *Breaking Bad, Mad Men* and *The Americans*.[2]

Despite the success of original programming, television executives also like to hedge their bets, and so they also look for established properties on which to base content. For example, a show featuring Marvel characters is now in the works, and programs like *Homeland, The Office, Once Upon a Time*, and *Sherlock* were based on pre-existing works.

New Writers and Producers: Choosing Ideas

As should come as no surprise, studios ask established pros to develop projects based on best sellers, prior films and Marvel comics. So what if you're just starting out and want to write or produce something that doesn't have a huge built-in audience? You may have a number of ideas in your head; maybe something entirely original, or based on history, or on an old work in the public

domain, or maybe you're thinking about optioning an obscure book and adapting it into a screenplay.

Now you must choose, and as Indiana Jones said in *Indiana Jones and the Last Crusade*, you must choose wisely. You may not think of choosing an idea to develop as a "business decision," but it is, because the months you spend developing something are months you won't spend developing something else. According to Ted Elliott and Terry Rossio, who wrote *Aladdin, Shrek* and the *Pirates of the Caribbean* movies, choosing which story to develop is the single most important decision a writer makes.[3]

So how do you determine what is and what isn't a good idea? I can't give you a Google-worthy algorithm to solve the problem, but I can give you some food for thought. When trying to decide if an idea is any good, you can look at the question from two different viewpoints—from an artistic viewpoint and from a business viewpoint. I think it's fair to say most professional writers think about both.

The Artistic Perspective

Regardless of a project's apparent commercial appeal, I believe no writer can commit to a story without an abiding passion for it. Perhaps for some writers that passion may be rooted entirely in the fact the story is marketable, but I suspect that's rare. I think very few writers deliver a great script *solely* because they think it will make money. Quite the opposite—I think most writers who develop ideas *only* because they think it will sell are likely to fail.

Why? Because writing to sell means usually writing from that part of your brain where every film you've ever seen is stored, and this usually leads to rehashed banality. Writing from that part of your brain leaves *you* out of the equation.

There is only one of each of us. We all have our own backgrounds, experiences, failings, successes, hardships, fears, quirks, dark side, bright side. We all have our own muse. Ignore your muse, ignore what makes you *you*, and just write for a sale, and what you're likely to get is an uninspired rehash of someone else's work.

Many years ago, a friend and I looked at a classic horror movie, charted its scenes and beats to the second, then spent two weeks writing our own screenplay with precisely the same structure and timing. The only inspiration we had was to precisely copy the structure of a classic horror film, not to dig deep within ourselves to find what scared *us* and artistically reveal it to others. For fun I later had our script anonymously slipped to someone I knew who evaluated scripts. Here's the evaluation that came back: "Well written, good scenes, entirely derivative."

It's hard to hide utter rehash.

I'm not suggesting that you have to engage in profound introspection and heavy personal revelation every time you write. I am suggesting you need to have some real passion for the story itself, not merely for the story's commercial prospects. Your passion should be rooted in the characters, in their journeys, in the themes that underlie the story, and in your deep desire to make the audience constantly *feel* something, experience something, and perhaps quietly, even subconsciously, learn something. If you have that passion, you won't need to consciously dig inside yourself to find your unique voice—it will be there in your storytelling.

Along with having passion for the story, having a personal connection to some aspect of the story is also very helpful. A personal connection, often enhanced by rigorous research, allows writers to bring details and authenticity to the storytelling that other, less connected writers simply won't be able to.

Take *The King's Speech*. David Seidler wrote the Academy Award-winning screenplay for the film, which won the best picture Oscar in 2011. The film, based on a true story, takes place in England during World War II when the new British king, King George VI, who had to buck up his nation with radio broadcasts, had a terrible stammer. The film examines the British king's attempts to get past his speech impediment and the terrible shame he felt.

Screenwriter Seidler had a bad stammer himself when he was young. He was born in England just before World War II started. He did extensive research on the king's attempts to improve his speech. I loved the film, and I would have loved the project had I discovered it. But who would you want to write the film, me or David Seidler? To say that's a no-brainer is to do insult to the term. Seidler's deep personal connections to the story, to the protagonist's journey and to the environment where the story took place, along with his tremendous talent, made him the perfect writer.

The broad message here is this: Just because you have some interest in a story or think it might be commercially successful doesn't mean *you* should choose to write it. You must have the ability to deliver on the story's promise. This requires real passion and often, though not always, some personal connection to something in the story, such as an emotional familiarity with the protagonist's needs, desires and problems. As previously mentioned, writers usually augment what they know by conducting a good deal of research.

There's a line in a film called *Leap of Faith*, written by Janus Cercone, where a con-man preacher, wonderfully played by Steve Martin, angrily believes he himself has been conned. Furious that a kid supposedly deceived him by claiming he was hit by a truck, Martin's character fumes to a friend, "Not hit by just anyone, but by a *trucker*! *Details*, always the mark of a great con." I don't really want to equate good storytelling with cons, but I will say this: It's the details, be they about character, emotions, setting or anything else, which give stories

breadth, depth, believability and life. It's the details that permit a writer's unique perspective and knowledge to be infused in the writing. Those details usually come from personal experience and research, and without them stories can easily feel phony and derivative.

The Business Perspective

Let's assume you have a good story you want to write. Should you also take into account business considerations? I think most professional writers do. You may love a story and have a deep connection to it, but you're going to be out of luck if the budget needed to tell the story far outstrips the revenues it's likely to produce. You want to make a $200 million romantic comedy featuring characters in their seventies? Lots of luck. You want to make *The King's Speech* for $100 million? Lots of luck. *The King's Speech* cost an estimated $15 million to produce; it would never have been made at a significantly higher budget because people would not have believed it could generate a huge audience. The movie's now made worldwide over $400 million.[4]

People get things wrong. They often mistake a film's commercial appeal. Still, producers have no choice but to make a bet on whether a film budgeted at "X" or "2X" or "3X" will find a sufficiently large audience to make the film profitable. So, if you want to develop a $65 million film about Abraham Lincoln and his support for the 13th Amendment (*Lincoln*), lots of luck on that too, unless your name is Steven Spielberg, and even *he* had great difficulty getting *Lincoln* made as a theatrical film.[5]

Along with ruthlessly weighing a film's budget and audience size, studios will also look at these factors, all of which have bottom-line implications:

- Is a similar project already in development or currently being produced?
- Is the project's genre currently in vogue? For example, in 2014, TV sitcoms are not really in vogue.
- Will the project require a major star to get made? Higher budget films usually do, and the need for a star limits the pool of possible actors.
- If the project isn't based on a pre-existing, popular work, will it nevertheless be easy to market—will the public be able to readily grasp the film's concept and, of course, be interested by it?
- Can the project be exploited by the various entertainment companies and other assets owned by the parent conglomerate?
- Will the project play well overseas? Right now, international audiences account for roughly two-thirds of all income that American movies make at the theatrical box office.[6] If you were a film executive and if two-thirds of your film exhibition dollars come from overseas, who would you be aiming your films at, people in Kansas or people in India and China, which between them have 10 times America's total population? Horror and hard action travel well

across the world, better than comedies do and certainly much better than films on American-centric topics like baseball or the Civil War. Does this mean comedies, baseball movies and Civil War movies will never get made again? Not at all; it just means the budget must conform to the potential audience size. Does it mean that a hard action or horror film that takes place (at least partly) in Asia has a better chance of getting made right now? Probably so.

I'll conclude this discussion with two thoughts. First, generally speaking, films and TV shows that focus on fundamental human needs and concerns travel better around the world because everyone can identify with them. Everyone understands life and death, the yearning for justice, love and sex, issues of self-identity and belonging.[7] Everyone, everywhere gets horror because everyone knows what it's like to think there's a monster under your bed or a monster outside with a gun. Compare this with protagonists who have problems that are interesting but very specific to *them*, or very specific to the time and place where they live. These stories are often autobiographical; they may be interesting but still not have great appeal, because people around the world just can't connect to the protagonist's issues.

The second thought stems from famed screenwriter William Goldman's observation that, in Hollywood, "nobody knows anything."[8] It's blithely easy to make this argument. Yes, Columbia Pictures could have made Spielberg's *E.T.*, but passed. Universal Pictures did make the movie, which went on to be one of the most successful films of all time. Yes, 20th Century Fox allowed George Lucas to keep merchandising rights to *Star Wars* in return for a reduced directing fee because Fox executives thought the film would amount to nothing.[9] I could include a list of a thousand movies people just knew would be hits but bombed, or movies no one thought would be hits but were.

When it comes to filmmaking, there are just too many variables, too many intangibles that can't be controlled. Even our greatest directors, writers and producers, who have track records of uncommon success and artistic achievement, sometimes fail. So do people who couldn't care less about quality, who care only about producing something, *anything*, which will make money. Despite all their calculations and market-driven data, they too often fail. These people may make schlock entertainment, but I can assure you no one makes schlock entertainment thinking they'll lose money. No one usually makes *any* entertainment thinking they'll lose money. And yet it happens.

And so people can say nobody knows anything. If what they're saying is that filmmaking is an unpredictable, risky business because of its artistic nature and variables that can't be controlled, I totally agree. If they're saying that despite the best laid plans of mice and men people sometimes fail, or that against all odds they sometimes succeed, I agree. If they're saying the filmmaking business defies all logic and rationality, and therefore you should just pursue whatever project you want to pursue, that I think is false.

So yes, develop what you're passionate about and believe in unequivocally. There's no compromising on this. Ever. It won't hurt, however, to do a little business homework so your decision-making is as informed as possible.

STUDIO FILM DEVELOPMENT

You've chosen your idea. You're passionate about it and think you can deliver on the idea's potential. How do you get your project into development and onto the screen?

For independent filmmakers, the process is quite different from studio development and is discussed in Chapter 13. Here, we'll concentrate on studio development.

The truth is, many people, even people attracted to independent filmmaking, would rather develop with studios. Why? It could be that someone doesn't have the wherewithal to go the independent route or a project is too expensive to independently finance. Or, for professional writers and producers, developing stories with studios means getting paid up front, which allows mortgages and credit card bills to be paid on time. And then there's the issue of distribution—if you develop with a studio and it makes the movie, you have distribution guaranteed.

So let's say you have a good idea and want to develop it with a studio. What do you do? If you're a professional screenwriter you have a choice: (1) You can write a screenplay on your own,[10] and then once it's finished hope to interest a studio and get paid to further develop it, or (2) you can have your agent arrange a pitch to a producer or studio executive and hope to be paid up front to write the screenplay's first draft.

Getting paid up front is great, but fewer and fewer pitches are being bought these days. Still, it does happen. Pitches are short, spoken synopses of your story meant to convey why it will interest an audience. Things go best when the pitcher is a bit of a ham and can distill a story's entertainment value into a tight recitation of the story's events, character arcs, theme, tone, and if a comedy, its sense of humor. Pitches generally last somewhere between 5 and 15 minutes, and a story well pitched lets the listener understand why it will keep audiences firmly focused on the screen and not dozing in their popcorn.

So-called high-concept stories, which are stories that have easily graspable premises that drive the action, are far easier to pitch. It's a lot easier to pitch in three minutes the entertainment value of "a bunch of snakes get loose on a plane" than films like *Shawshank Redemption* or *As Good as It Gets*, which are entirely based on their characters' complexities and relationships. If I pitch you *Snakes on a Plane*, or even best picture winner *Argo*, you'd understand in five minutes why the movie could interest an audience. Same thing if I pitched you *Ghost*, *The Hangover*, or *Iron Man*. They are concept-driven movies.

Because high-concept stories are so easily understood, a studio executive might buy a pitch *even if* the executive thinks the pitcher might not deliver a great script. That's because if the pitcher fails, someone else can take over. I think I could have been a babbling illiterate and sold the following pitch: "This is a story about someone who figures out how to clone dinosaurs from dino DNA trapped inside mosquitoes, and who then plays God by building a dino amusement park where everything goes horribly wrong." *Jurassic Park* wasn't an original pitch— it was based on Michael Crichton's book—but I think if I had come up with the idea and pitched it, I could have sold it in a second because the concept was so good. If I then wrote a bad screenplay, someone else would write a good one.

Stories like *Shawshank Redemption*, however, can't really be judged until written, and this makes them extremely difficult to sell on a pitch. Try pitching *Broadcast News, Annie Hall,* or a wonderful low-budget film, *Short Term 12;* it's very difficult to convince someone in five minutes that these stories are likely to connect with audiences, and unless you're one of the most acclaimed writers alive, odds are you'll have to write a spec script before anyone gets interested.

It may also be difficult to pitch some stories that fundamentally rely on animation or special effects. In these cases, visual aids that accompany a pitch, such as high-concept artwork or storyboards, can prove very useful.

What if you're not an insider, don't have an agent yet and want to develop a script with studios? In this case, the road ahead is unquestionably difficult, though it can be traveled. Your best choice is usually to write a script, or if you can't write, have someone you know write the script and attach yourself as a producer. Once the script is written, it can be brought to the industry's attention by (a) entering it into screenwriting competitions; (b) networking with industry people, either by living in Los Angeles or via social media, until your network includes someone who both likes your script and can get it to established producers, agents or other industry insiders; (c) sending a query letter to agencies asking if they'll read your script (almost all will say no but some may say yes);[11] or (d) uploading your script to blcklst.com,[12] where for a fee your script will be read and if deemed exceptional will be seen by industry insiders.

If somehow, some way, a producer or other industry professional reads your script and wants to further develop it, that means he or she will want to option your script, or as happens only very rarely, purchase it outright. (Both options and purchases are discussed in Chapter 12).

Once your script is optioned, it will then be rewritten (unless you're both the world's greatest writer and luckiest person). Either you will be paid to rewrite it, or someone else will be hired to do it. If you want to be paid to rewrite it, a screenwriting agreement *must* be negotiated when you negotiate the option otherwise you will have no legal right to demand anything. (Screenwriting contracts are also discussed in Chapter 12.)

TELEVISION DEVELOPMENT

The television development process has traditionally begun with professional writers pitching series ideas to network executives. If the executives like an idea, they pay for the writer to write a "pilot" episode, which simply means writing the series' first episode. If the network executives like the pilot script, then they may pay for the production of that one show. If they then like the produced pilot episode and it tests well before focus groups, and if a lot of other important elements fall into place, then the network may green-light the series.

For decades, TV development took place according to an inviolable schedule. That schedule was rooted in the traditional TV season. Series would premier in September and run to May of the following year, at which point the series (and its writers, producers and actors) went on summer hiatus while reruns filled the time. If the show got picked up for another season, new shows would go on the air the following September. If the show got cancelled, a new series would take its place in September. This meant that new series had to be developed, and their pilots shot for network review, the preceding winter and early spring. By May networks would decide which of these new shows it would add to its slate the following September to replace whatever shows got cancelled.

For television writers, then, winter and spring became the crazed, rushed time when networks developed programming that might replace the shows that would not be renewed the following September. May and June became the time when out-of-work writers tried to get hired by the new shows' executive producers.

Like so much in entertainment these days, the television development schedule is changing rapidly. One reason for this has to do with the demise of the rigidly defined television season. Years ago, cable channels began airing original programming in the summer when broadcast channels were showing reruns or summer replacement shows. Some of those shows met with great success, and now cable channels premiere shows at all times of the year. They also develop shows more slowly—shows that have fewer episodes per season and more flexible shooting schedules. All this led Fox Entertainment Chairman Kevin Reilly to declare "RIP pilot season" at the start of 2014.[13] Reilly noted the old formula of rushing shows into development during a fixed winter/spring schedule wasn't working—"Look at the batting average," he said, "we couldn't do any worse."[14] Just a few months after making this statement, however, Mr. Reilly announced his resignation, so time will tell what the development process will or won't look like at Fox.

Also changing is the traditional "write-a-pilot, shoot-a-pilot, make-a-series decision" paradigm. Netflix famously made a series commitment to *House of Cards* without shooting a pilot, and other TV executives are starting to follow suit, thus eliminating a major segment of the development process. The theory

is, if you believe in a show, then commit to it and do everything you can to support it, including giving showrunners more freedom and more effective production schedules.

The fact that some television executives are willing to forego producing a pilot before committing to a series is a fascinating turn of events. The TV pilot process has always differentiated television development from film development. With films, once someone commits to production, you have to film the whole movie. This means film companies must spend tens if not hundreds of millions of dollars before they know if everything has worked as planned. Television networks, however, have had the chance to see a produced pilot episode before making a go, no-go decision. They've therefore traditionally had the opportunity to see if the actors' chemistry is good on screen and to play the pilot episode for test audiences to judge their reaction. If a network thought a produced pilot wouldn't make a good series, it had the chance to pull the plug before tens of millions of dollars were potentially flushed down the toilet.

TV executives' willingness to dispense with this process and commit to a show outright—admittedly still a rare thing—is in many ways a refreshing demonstration of faith in the artists who develop a show. It's also true that the commitments made these days are smaller than in the past, limiting the potential downside, because the number of shows in a "season" these days is smaller. Today, 12 or fewer episodes may constitute a season, whereas in the 1960s some shows produced more than 30 episodes per season, and the medical drama ER, which ran from 1994–2009, produced an average of 22 shows per season. It's clearly easier to commit to, say, 10 shows without a pilot than committing to two dozen. Still, I suspect some TV executives are chomping down an extra Rolaids after giving a straight-to-series commitment without a pilot.

Who can actually pitch and develop TV shows? It used to be that independent production companies could pitch, develop, produce and own shows and hope to license them to the broadcast networks. Those days, however, are effectively gone. Now the networks and cable channels are all owned by conglomerates that also own television production companies that create television content.[15] Therefore, unless you are hired to develop a show by one of these companies, it's extremely difficult to independently create a show that a network or cable channel will air.[16]

In this sense, then, there is a great difference between TV and movies. When it comes to movies, anyone can go out and make a film, and if they are extremely talented and equally lucky, the film could appear in theaters worldwide. There really is no such equivalent independent route when it comes to television.

So how do you get to create your own show? I teach college students who would love to do this. They write spec TV episodes of their favorite shows, or spec pilots for a show they'd like to see aired. If they can get those scripts in front of the right executives and if those executives like the scripts, then they might

be hired to write a freelance episode of a show. If all goes well, they might then become a junior member of a show's writing staff. With time and good work, they can move up in seniority and eventually pitch their own series.

Of course, YouTube and similar sites permit users to show off their writing and producing talent. For the moment, however, the money isn't remotely the same except in very rare instances. Yes, there are people who regularly upload YouTube content and who routinely get tens of millions of views, and they do make significant money. But, as of 2014, most people make far more money working for a TV network or cable channel. It will be fascinating to see to what extent this changes over the next decade.

SOME THOUGHTS ABOUT DEVELOPMENT HELL

Once a project finds its way to a studio, network, cable channel or other major production company, the development process moves forward as scripts are written, analyzed, commented on (called notes) and rewritten. Executives give notes and either the original writer, or a new writer, continues work on the script. These days in film, it's commonplace for the original writer to be replaced by someone else. It's not unusual for that someone else to be replaced as well, as the studio tries to find screenwriting perfection. The development period can go on for a long, *long* time before either the green light is given or the script is dumped, which in the film world means it's put in "turnaround."[17]

You might wonder if it's really that hard to get a script right. It is hard, very hard. Writing narrative scripts well is an extremely difficult thing to do, but there's more to development hell than just that. Sometimes the process drags on because you're trying to get a script to the liking of a particular star or director who has come on board the project. If that star or director subsequently leaves the project, which can happen for any number of reasons, you then have to get the script to the liking of whoever replaces them. And sometimes it's the studio executive who leaves for one reason or another, which means you have to get the script to the liking of the new executive in charge.

But there's still another reason for development hell. Anxiety. People tend to get very nervous when they give a project the green light. Tens or even hundreds of millions of dollars may be on the line, which means the executive's job may be on the line. Saying yes and investing all that money when "nobody knows anything" is one reason why gastroenterologists, psychotherapists and pharmacies do so well in Hollywood. It's so much less stressful to say no, or to say let's do another rewrite.

Here's the real danger of development hell: I call it my "three-frame" rule. This rule requires we forget we've moved into the age of widespread digital projection and remember the old days when 35mm film was projected onto movie screens. For those who don't know, film runs through a movie projector at 24

frames per second. Three frames therefore go by in one-eighth of a second. If an editor, when making a cut, either clipped or extended a shot by three frames too many or two few, that probably wasn't a big deal. The natural rhythm of the cut might be off by one-eighth of a second, but no one might care. But do that over and over and over again during a 10-minute sequence and the audience would be going out of its mind. People might not be able to identify what's bugging them, but cuts that jump or lag by even one-eighth of a second, one after another, will drive people nuts.

Each small script change can be like this. One change might not mean much and may be relatively invisible, but throw together a string of small seemingly minor changes and a script's tone, rhythm, heart, characters and meaning may be subtly changed, then changed again, until what's left has lost what made the script uniquely good.

Those who give notes on scripts may not realize the ripple effects each change has. Changing *this* may subtly affect *that*, which can start a chain reaction through the entire script. Unfortunately, when a producer or studio executive reads a script quickly, that person may not fully understand the interconnections between story events, characters and theme. Therefore, writers have to carefully analyze notes to make sure (a) they are addressing a definite problem, (b) that if a suggested solution is offered, that solution solves the problem, and (c) the offered solution doesn't create new problems where none existed before.

People always want to make scripts better, but the effort to do so often subtly, or not so subtly, takes something from the script that made it attractive in the first place. Perhaps it's coincidence, but when I've been asked by the Writers Guild to read every script written for a project to determine who ought to get screen credit, an interesting phenomenon has usually occurred.[18] What I've tended to see is that the first draft is quite good, which is why the studio bought it in the first place. The subsequent drafts, however, often start a downward trend as executives and new writers struggle to find that something extra, some elusive magic. Then, at some point in the development process, the drafts start heading back towards the original draft, until the final draft somewhat approximates it.

This isn't to say that development doesn't improve scripts—I have no doubt that it can and frequently does. But not always.

THE END OF DEVELOPMENT

Ultimately, a studio agrees to produce a project or stops developing it and puts it in turnaround. To get a project made is something less than a miracle but more than a mere long shot. So much has to happen right: The script has to be good; the concept and appeal have to feel timely; the project's cost has to make sense when compared with the size of the potential audience; there usually can't be anything too similar already in another studio's pipeline (though this

isn't always the case);[19] and there must be actors and a director who the studio really wants, who are willing to spend a chunk of their lives working on the project, and who are all available at exactly the same time. So many projects haven't been made not because they weren't good but because the timing never worked out.

WHICH STUDIO DEPARTMENTS MANAGE DEVELOPMENT?

If you develop a project with a studio, you'll deal principally with three studio departments—production, business affairs and legal affairs.

Production Department

The production department in many ways sits at the center of studio activities. This is the department that develops projects and serves as the gatekeeper for what gets made, thus driving the studio's output.

Members of the production department generate ideas and hire writers, read scripts submitted by agents and decide whether to develop them, woo talented directors, actors and producers, and ultimately recommend what to finance and produce. In the past, the president of production could often unilaterally decide what got made, but generally no more. Now, this decision is usually made in conjunction with the conglomerate CEO and other head corporate honchos.

Members of the department range from the president of production down to vice presidents of production (there are generally more than one), down to junior creative executives and readers whose primary job is to read submitted scripts and prepare "coverage," that is, synopses of projects along with the reader's evaluation.[20] If a reader really likes a script, the higher-ups will read it while the junior person no doubt sweats it out hoping the bosses don't hate it.

As you may suspect, having a say in what gets made, getting paid a six-figure salary and hobnobbing with stars and directors is a coveted job. Most often, people fill these positions only after they've backed successful projects at smaller production companies or worked at an agency where they've learned the business and established relationships with talent who can benefit a studio. These are high-risk, high-reward jobs where developing and championing a film that fails can quickly get you a one-way ticket back to wherever you came from, but developing and backing the right films can make you very rich and everyone's best friend.

What does it take to succeed in these jobs? A cast-iron stomach for sure. The workload is endless and the stress is high. It's not a great job for someone who wants a life, as you'll work every weekend, usually reading a stack of scripts, and many of your breakfasts, lunches and dinners will be spent networking,

digging for information or wooing someone. You should have a profound and abiding passion for film or television; you should have an encyclopedic knowledge of film or television; you should know what audiences like today and be at least somewhat prescient about what they'll like tomorrow; you should know story and be able to read and analyze scripts; you should understand the dollars and cents of contracts, marketing and distribution; you should be personable, an excellent schmoozer, and unafraid to use raw power when you need to; and you should be sufficiently political to survive your mistakes. And, it always helps a lot if you're a decent human being.

Business Affairs

When the production department wants to develop a project and hire a writer, the business affairs executives negotiate the terms of the deal with the writer's agent or lawyer. The business affairs department also negotiates deals for producers, directors and actors and for rights to projects, along with various financing and distribution deals with third parties. Though it's not absolutely required, almost all business affairs executives are lawyers.

I spent six years doing this job at Columbia and Tri-Star Pictures, haggling on the phone with agents about the terms of their clients' deals.[21] Most of the time it was pleasant enough. The people who engage in these discussions make up a very small community and negotiate together frequently, and so most try to maintain cordial relationships. Yes, some members of the community may be unpleasant and have only a passing relationship with the truth, but their reputations are well known. It doesn't make it pleasant to deal with them—you just know to be very careful when doing so.

Deals are usually based on an artist's previous "quote," which simply means what the artist was last paid (no one expects these numbers will be kept private). Basing new deals on the artist's last contract gives the negotiators a solid starting point and generally creates a narrow zone of possible agreement, which skilled negotiators move towards quickly. As should come as no surprise, since the studio has the money and is doing the hiring, it usually has all the leverage, though this isn't always the case, especially when the studios want to hire a hot actor, director or showrunner.

The quirkiness of the entertainment business can be on full display here. Back in the 1980s I was once asked to make a deal for a famous actress the studio wanted in one of its films. Her last quote was $1 million. Her agents wanted $1.5 million this time round. We were prepared to go to $1.25 million and that's where I was holding firm. Then, in a morning staff meeting, after I had presented the negotiation's current status, the president of production asked if anyone had seen the actress' new movie, which had just came out. One hand was raised. The president of production asked how the actress was in the film. With an approving nod

and a cheery voice, the person said, "Pretty good." At which point the president of production turned to me and said, "Oh what the hell, give them a million and a half." And with that we paid an additional quarter million dollars.

When a deal is concluded, the business affairs executive usually drafts a deal memorandum, which describes the deal's terms. That memo is sent to the agent and is eventually signed by the filmmaker. The same memo also goes to the legal affairs department. In Chapters 12 and 13, we'll examine customary deal terms included in contracts for directors, writers, actors and producers and for rights acquisition.

Legal Department

When the deal memo arrives in the legal department, a studio lawyer takes the deal points and incorporates them into a long-form contract, which covers in painful detail every single contractual element. Business affairs executives don't negotiate every aspect of the deal, since that would be both too time-consuming and unnecessary, because many of the minor contractual terms are quite standard and readily agreed to by the parties.

PRODUCTION AND POST-PRODUCTION: THE FILMMAKERS TAKE OVER

During the production and post-production periods, the filmmakers take over and do their jobs, implementing what for the studio has been a very important business decision. Studios, however, remain thoroughly involved in production by maintaining physical production and post-production departments where executives monitor and assist the filmmakers.

Production and post-production executives these days often get involved in projects long before production and post-production begin—during the development stage. That's because creative executives, trying to assess a project's bottom-line prospects, will consult with the physical production and post-production departments about such issues as where a project could be filmed, whether possible locations offer budget-lowering tax incentives,[22] and what special effects costs might be.

Once a project is greenlit and moves forward towards production, members of the physical production department will recommend and approve crewmembers, monitor the construction of sets and assist with all logistics. After filming starts, the physical production executives will continually check in with the producers, field requests for budget and scheduling changes as they arise, scrutinize expenditures, watch dailies[23] to make sure the film looks good, and periodically come to the set to make sure everything is running smoothly.

The post-production executives take over when filming ends and perform the same kinds of tasks as their physical production colleagues: they monitor expenditures and work with film and sound editors, music supervisors and composers, as well as other filmmakers.

Studios usually hire these executives only after they've gained real-world experience producing movies or working in post-production. Along with knowing the production or post-production process, these executives also need good diplomacy skills. Why? Because they frequently have to navigate between the filmmakers on the ground who want or need something and the executives back at the studio who may be reluctant to pay for it. Ultimately, their job is to do whatever they can to help the filmmakers realize their vision, so long as that vision conforms to the studio's vision and budget.

For those interested in breaking into the entertainment business, Chapter 14 includes interviews with creative personnel and business executives who found their way into the industry.

NOTES

1 *The Lone Ranger* television series starring Clayton Moore and Jay Silverheels was produced from 1949 until 1957 and ran on the ABC television network. The series then reran on television well into the 1960s. Prior to 1949, *The Lone Ranger* was produced as both a radio series and a film series.
2 As we'll discuss in Chapter 10 on distribution, one reason why cable channels can take chances with challenging, original material and film companies can't (or won't) has a lot to do with the financial challenges film companies face and the economic advantages cable and pay-TV channels enjoy.
3 Terry Rossio, "A Foot in the Door," *Wordplayer*, last accessed on June 17, 2014, http://www.wordplayer.com/columns/wp01.A.Foot.in.the.Door.html.
4 See http://www.boxofficemojo.com/movies/?id=kingsspeech.htm, last accessed on July 6, 2014.
5 Ken Guidry, "Steven Spielberg Says 'Lincoln' Was Almost an HBO Project, Warns Of Film Industry 'Implosion,'" *Indiewire*, June 13, 2013, last accessed on June 17, 2014, http://blogs.indiewire.com/theplaylist/steven-spielberg-says-lincoln-was-almost-an-hbo-project-warns-of-film-industry-implosion-20130613.
6 See "Theatrical Market Statistics 2013," *MPAA*, last accessed on June 17, 2014 http://www.mpaa.org/wp-content/uploads/2014/03/MPAA-Theatrical-Market-Statistics-2013_032514-v2.pdf.
7 The late Blake Snyder discusses this issue in his book, *Save the Cat* (Michael Wiese Productions 2005), at pages 52 et seq.
8 William Goldman, *Adventures in the Screen Trade* (Grand Central Publishing 1989), page 39.
9 Alex Ben Block, "The Real Force Behind 'Star Wars': How George Lucas Built an Empire," *The Hollywood Reporter*, February 9, 2012, last accessed on June 17, 2014, http://www.hollywoodreporter.com/news/george-lucas-star-wars-288513.
10 These are called "spec" screenplays, because people write them with the speculative hope they can sell them at a later date.
11 Most will say no because of the potential legal liability. See pages 35–41.
12 For the record, I have absolutely no financial interest whatsoever in this website.
13 Lacey Rose, "Kevin Reilly's War on TV Pilot Season: Will Other Networks Follow Fox? (Analysis)," *The Hollywood Reporter*, January 22, 2014, last accessed on June 17, 2014, http://www.hollywoodreporter.com/news/foxs-kevin-reillys-war-tv-673006.

14 *Id.*

15 It is true that not all conglomerates own a broadcast television network. Sony doesn't, nor does Warner Bros. Also, conglomerate-owned production companies do not always sell programming to one of the parent conglomerate's television outlets. In other words, a Viacom-owned TV production company need not sell a program to CBS, which Viacom also owns; it could theoretically sell the program to Fox or ABC. This may not happen frequently, but it does happen on occasion.

16 Reality television and nonfiction cable series are often exceptions to this rule. Many reality and nonfiction programs are produced by independent companies.

17 Turnaround is further discussed in Chapter 12.

18 Members of the WGA can serve on panels that determine who should get screen credit based on the overall contribution to the finished screenplay. This subject is discussed in Chapter 8.

19 For example, in 1998, different distributors released such similar films as *Armageddon* and *Deep Impact*, and *Antz* and *A Bug's Life*.

20 If you're interested in writing scripts, becoming a reader is a great job for you. You'll read and analyze hundreds of scripts, which is a tremendous way to learn both the craft and the business.

21 See Chapter 12 for a discussion of standard entertainment contracts.

22 See pages 267–8.

23 Dailies refers to the footage shot on a particular day.

CHAPTER 10
Distribution

INTRODUCTION

Film marketing and distribution is the process of generating revenues. Marketing creates and intensifies the public's desire to see a production, and distribution makes it available to the public in movie theaters, on television, DVDs and internet sites, and in a variety of other media outlets.

As we're about to discuss, movies cost a great deal of money to market and distribute these days (and, from this point on, I'll collectively refer to marketing and distribution costs as simply "distribution costs" since industry professionals often use this shorthand). Therefore, when a movie studio considers whether or not to make a film, it must calculate whether the project's production costs, plus its total distribution costs, will be more than offset by the expected future revenues, thereby leaving the studio with a profit.

THE COST OF FILM DISTRIBUTION

You would think the actual cost of movie production would far outstrip the cost of distribution, but that's not the case. Movie and television companies don't routinely publicize their distribution costs, but it's well known that films like *Man of Steel,* which cost Warner Bros. a little more than $200 million to make, cost an additional $150 million or so to distribute.[1] For large tent-pole movies, distribution costs routinely exceed $100 million, and can approach $200 million. For "average" films, which cost somewhere between $50 million and $100 million to produce, distribution costs can sometimes equal the film's total production budget, or come close. Indeed, sometimes distribution costs even exceed production costs; for example, *Despicable Me 2* reportedly cost $76 million to make and $136 million to distribute worldwide.[2]

The bottom line is, if you make a movie for "X" number of dollars, the distribution expenses can make your all-in cost come close to "2X," or occasionally exceed it. Thus, when someone tells you the production budget for a summer blockbuster was $200 million, you know the studio's actual out-of-pocket costs may be as much as $400 million.

The Need to Market Big, Spend Big and Open Big

Why does it cost so much to distribute films? To answer this question, a little historical perspective is required.

Back in the 1960s, a film did not have to generate huge audiences from day one. Instead, films could linger in theaters for weeks or even months as word of mouth helped people discover the film. Back then marketing campaigns principally consisted of relatively inexpensive newspaper, billboard and radio ads.

Then, in the 1970s and early 1980s, studios learned that audiences, especially young audiences, would respond to a marketing blitzkrieg before the film opened. Films like *Jaws, Raiders of the Lost Ark, E.T.* and the *Star Wars* sequels became "events" when audience anticipation was raised by pre-release marketing campaigns. This in turn led to hit films enjoying huge opening weekends at the box office. Newspapers began reporting box office numbers, and soon a film's opening weekend became a benchmark for a film's success. Being #1 at the box office suddenly mattered more than ever before; it helped create the perception that a film was "good" or "bad," and it affected the film's staying power.

If the opening weekend suddenly mattered, then the way to get people into theaters was to market more heavily.

At roughly the same time, our current media conglomerates were being born, and this led to an exponential increase in the importance of a film's theatrical performance. Why was this? Because the conglomerates quickly learned that how a film performed at the box office drove all of the conglomerate's other film-related revenue streams, such as TV distribution, DVD sales and rentals, publishing, merchandising and so on. If a film did well in theaters, its DVD revenues would be higher, its TV revenues would be higher, merchandising sales would be higher—everything down the line would be higher. This gave studios tremendous incentive to push for a film's success in theaters, which meant an inevitable increase in marketing expenses.

Then, in recent years, other circumstances have given studios even more impetus to engage in costly marketing campaigns. Today, internet buzz can instantly injure a film and sites like rottentomatoes.com let people know immediately whether a film is "good" or "bad." Because of this, as well as a never-ending competition to get films on available screens, gone are the days when a film can linger in theaters as studios tweak and retool the marketing campaign, hoping to build an audience. Now, almost always, a film either opens well in the first week or it doesn't, and if it doesn't then usually that's that, over and out—it's soon off to the tiny theater at the back of the Cineplex or out of the theater altogether.[3] And if it *is* over and out, all the potential revenues from other forms of distribution will be damaged.

Given how critically important the first week of theatrical release has become, studios now blanket us with pre-release hype. We see frequent television ads, which on a prime-time network show cost more than $100,000 per ad to air,

radio ads, newspaper ads, internet ads, internet sites devoted to marketing the film, trailers, billboards and celebrities traveling around the world to promote a film's opening. There are now expensive international marketing campaigns and marketing tie-ins with establishments like fast food restaurants, so kids can routinely receive a marketing message along their burger and fries. Studios also routinely pay for focus groups to test market trailers and other forms of advertising, and then constantly track (which means poll) awareness of an upcoming film very closely once the marketing campaign is launched. If a specific demographic is not sufficiently aware of the film, the marketing can be tweaked.[4]

All of this costs a lot of money. Like an escalating war no one can stop, studios believe they have no choice but to spend big. If they don't, the danger is that their message just won't be heard amid the cacophony of competing campaigns, and if that happens, then not enough people will come out in week one, dooming the film.

The math is really quite simple: Blockbusters cost a fortune to make and the first week in theaters is critical, therefore a marketing fortune must be spent to get a big opening weekend to protect the fortune spent to make the film.

DISTRIBUTION STRATEGY

The large amounts spent to distribute films are designed to produce results. They're designed to get you into the movie theater and then to consume the film over and over again. Think of all the ways you can see a film. You can go to the theater, rent the movie in your hotel room, buy a pay-per-view showing from your cable or satellite TV provider, buy a DVD, buy the film online, rent it from iTunes or Amazon or from a local store or from Redbox, watch it on an airplane, watch it on a pay-TV channel like HBO, and eventually watch it on a free broadcast TV channel or on a cable channel. You can sometimes buy film-related merchandise, or the film's soundtrack album, or even go on a theme park ride based on the movie.

Though you may not have studied the ways movies are distributed, you probably know from experience that films traditionally become available in particular outlets only after various amounts of time have passed. This is hardly by accident. As Jeffrey Ulin describes in his excellent book, *The Business of Media Distribution*,[5] studios have carefully examined all of these consumption possibilities and all of the different price points and determined how best to maximize both your consumption and their revenues. What studios have learned is that more money will flow their way if they *sequentially and exclusively* distribute films in different outlets. First a film is exclusively licensed to theaters. Once the film has left theaters, it's sequentially and exclusively licensed to other distribution outlets: hotel video-on-demand, DVD, residential video-on-demand, pay-TV, broadcast television and so on.

Piracy, however, has thrown a monkey wrench into this way of distributing films. Obviously, thanks to piracy, people can see films for free on pirated DVDs or over the internet before studios intend films to be available in these outlets. This has led some to argue that if films were distributed in all formats on the same day, piracy would be substantially reduced. Maybe so.[6] On the other hand, as of today studios would lose money by foregoing the sequential distribution of films that's become routine.

Going forward, studios will have to continually assess whether different distribution schemes will maximize revenues. As this book goes to press, Sony has just released *The Interview* in a wide number of digital and pay per view formats, but in only a handful of theaters. This happened because theater owners balked at showing the film after threats were levied reportedly by people working on behalf of the North Korean government. Only time will tell whether the unfortunate circumstances surrounding the film's release will nevertheless work to usher in new distribution strategies. Meanwhile, Netflix is also helping to shake up traditional distribution by announcing it will distribute an original slate of Adam Sandler films, along with other movie projects. Theater owners have said they will not exhibit films which are initially and widely exhibited in other outlets; it will be fascinating to see going forward if traditional distribution strategies persevere or if they slowly change thanks to digital media.

DISTRIBUTION PERSONNEL AND ACTIVITIES

It takes a large group of people and significant overhead costs to distribute films worldwide. Imagine you're an independent filmmaker and you want to do all the things that studios do. Think about the challenges you'd face. How would you physically knock on every movie theater's door in America and around the world to ask the theater owner to please play your movie? Do you pay for several translations of the film, or pay for subtitles so the film can be understood internationally? Do you pay for various television versions in different formats or for versions with proper codecs so the film's internet-ready? Could you negotiate all the various TV licensing deals that must be made? How would you get hotels and airplanes to play your film? And how would you pay to advertise your film, let alone do all the footwork to place those ads on TV and radio, in newspapers, on billboards and the internet?

To do these things requires a large operation. Studios employ people worldwide to manage marketing and distribution, so this is certainly one way to work in the industry for anyone who might be interested.

Everyday marketing personnel have to design and implement advertising campaigns both in America and in other countries. Create a marketing campaign that doesn't click with the public and that will obviously injure the film's chances. Distribution executives have to decide when to release a film, and they have to book the film into the best theaters. Choose a release date one week after *The*

Avengers or *Avatar* is released and your film will drown in the backwash of those films' success. Lose a good theater in the heart of a college town to a competing film and, incrementally, your revenues could be hurt.

How do films actually get into any particular theater? Distribution personnel must negotiate deals with the exhibitors. This means, among other things, negotiating how many of the dollars you spend to buy a ticket will be kept by the theater owner and how many dollars will go back to the distributor.[7] *The money that goes back to the distributor is called "film rentals."* Historically, theater exhibition deals involved a sliding scale where the distributor might receive as much as 90 percent of ticket sales during the first two weeks (after the theater owner deducted his operating costs), and then receive a progressively smaller percentage over time. Because theater owners kept a higher and higher percentage of ticket sales the longer the film played, they were incentivized to keep films in theaters for as long as possible, something that made distributors very happy.

These days, deals are often structured differently, but the end result is pretty much the same: Theater owners and distributors split your movie ticket dollars roughly 50-50. Studios likely end up with slightly more than 50 percent, perhaps closer to 55 percent, but a 50-50 split is a decent rule of thumb for distribution in America. Therefore, when you look at boxofficemojo.com and see that a movie made $100 million dollars at the U.S. box office, you know that the theater owners collectively kept approximately $50 million and the distributor got approximately $50 million in film rentals.

Overseas distribution is a different matter. Because of middlemen and for other reasons, U.S. distributors end up with less than a 50-50 split. For example, U.S. distributors currently end up with approximately 25 percent of ticket sales in China.[8]

As we've discussed, theatrical exhibition only begins the distribution process, and so distribution personnel must negotiate deals when a film leaves theaters and heads for other outlets. As we're about to see, these downstream revenues, sometimes called ancillary revenues, generally *exceed* what films earn in theaters.

FOLLOWING THE MONEY

According to an MPAA report, American movies in 2013 earned $35.9 billion at the worldwide box office. $10.9 billion was earned in the United States and Canada, commonly referred to as the "domestic" box office, and $25 billion was earned elsewhere.[9] This means that roughly five-sevenths of all ticket sales revenue occurred in international markets, but because less than 50 percent of foreign ticket sales are returned to studios as film rentals, foreign exhibition accounts for roughly two-thirds of all film rental dollars received by studios. According to the report, the Asia Pacific region spent $11.1 billion in ticket sales, with China spending $3.6 billion, up a whopping 27 percent even though strict quotas restrict the number of American films that can be shown there.

We've discussed the importance of traditional theatrical exhibition because it drives all the other, ancillary revenues. Those ancillary revenues are critical, because revenues from film exhibition do *not* routinely cover a film's production and distribution costs. In fact, film rentals only rarely cover these costs. Take for example the 2013 film, *Star Trek Into Darkness*, which by any reasonable measure was a success, earning more than $467 million worldwide. Of that total, $228 million was earned at the domestic box office, which by our 50-50 rule of thumb means that Paramount Pictures, the film's distributor, received in the neighborhood of $114 million in domestic film rentals.[10] The remaining $239 million was earned at the international box office, and if Paramount received 40 percent of that amount in film rentals (and I'm guessing here), Paramount earned around $96 million in international rentals. This means Paramount made approximately $210 million in worldwide film rentals.[11]

The film, however, cost more than $300 million to produce and distribute.[12] Therefore, after Paramount received all of its money from theatrical exhibition, it was still in the hole by more than $90 million.

Let's try another example and look at an "average" film—to the extent there is such a thing these days. Say you make a film that costs $80 million to produce and $50 million to distribute. In order to recoup your $130 million investment *solely* from theatrical exhibition, the film would have to earn roughly $300 million at the worldwide box office if one half of all receipts came from domestic theaters and the other half came from international theaters.[13] Most films, however, don't usually make $300 million at the worldwide box office, especially less spectacular films that cost "only" $80 million to produce.

Thus, if the vast majority of films are to reach profit, they must do so from ancillary revenues earned after theatrical exhibition. And here it's important to recognize this fact: Theatrical exhibition revenues are *not* the single greatest source of film-related revenue for studios. Indeed, a top studio executive recently told me that theatrical film rentals account for about 30 percent of all film-related revenues earned at his studio. It's therefore not surprising to see that, in 2013, when worldwide box office reached nearly $36 billion, *total estimated U.S. film revenues from all worldwide sources* topped $90 billion.[14]

The single biggest downstream revenue producer, indeed the single biggest revenue producer of any form of distribution, is home video, which means DVD and online sales and rentals. Back in 2005, home video accounted for a reported 46 percent of all revenues earned by studios.[15] Since that time, home video revenues have decreased. For example, in America, home video sales went from a high of roughly $22 billion dollars in 2004 down to the $18.2 billion in 2013.[16] Home video sales were undoubtedly hurt by both piracy and the Great Recession of 2008 and now account for perhaps a little less than 40 percent of all film revenues. The good news for studios is that the decline in home video revenue

has recently stopped and has indeed started edging up again, thanks to increasing online sales and rentals.[17]

DVD sales may have declined from their peak, and are about to be eclipsed by digital sales and rental revenue, but that's not to say they don't still generate an awful lot of money. In 2013, home video consumers spent a reported $169 million to buy copies of *Despicable Me 2*. *The Hobbit: An Unexpected Journey*, *Monsters University*, *Fast and Furious 6* and *Wreck-It Ralph* reportedly all generated over $100 million in home video sales. Consumers spent $95 million buying copies of *Skyfall*, $62 million on *Lincoln*, and $31 million on *Looper*.[18]

In addition to home video, TV licensing of movies also generates a great deal of money for studios. In 2005, TV licensing reportedly accounted for 27 percent of all film-related revenues, exactly the same percentage as theatrical film rentals.[19]

We all get caught up in the theatrical box office numbers, and that's fine, because as mentioned those numbers drive the revenues downstream. Still, it's those downstream revenues, such as home video sales, TV sales and merchandising, that are critical to a film's profitability, and which combined usually far exceed the money studios earn from theatrical exhibition.

Conglomerates and Arm's-Length Dealing

Where a film is owned by Conglomerate X and licensed to a network, cable channel or home video company also owned by Conglomerate X, people may wonder if the transaction costs reflect full market value. Ostensibly the conglomerate's accountants won't care since, regardless of the price, the money is coming from one corporate pocket and going into another. However, the amounts paid do matter to filmmakers who, thanks to residuals, have a right to share in the film's ancillary revenues. If internal transaction fees are unfairly reduced below full market value, then artists could end up with less money. This issue formed the basis of a lawsuit filed in December 2013 by Frank Darabont, creator of the blockbuster program *The Walking Dead*, against AMC, which has denied the allegations.[20]

THE IMPACT OF HIGH DISTRIBUTION COSTS

One unfortunate casualty of very high distribution costs has been the types of films that can get made nowadays. Back when both production and distribution costs were a mere fraction of what they are today, studios had greater leeway to take chances with riskier material. As mentioned, a film could hang around in theaters for weeks and months as it built an audience. Now, given that films must succeed immediately and succeed big given the huge costs involved, movie executives shy away from challenging, original movies that may be risky and more difficult to market. Instead, executives opt for what seems to be the safe, albeit very

expensive option, of making large spectacles based on projects that moviegoers—primarily people younger than 25 years old—already know and like.

Movies like *Argo* and *Lincoln*, which both likely cost around $100 million to produce and distribute but which are riskier propositions than *Transformers 347*, are currently being squeezed out of the market. Irving Thalberg would think the world had gone nuts if he knew how much money films like *Argo* and *Lincoln* cost, but such is life since production and distribution costs have skyrocketed. And even though both *Argo* and *Lincoln* made money, this likely won't make it any easier for other people to produce similar projects at those budgets unless their names carry the same clout as Clooney, Affleck and Spielberg.

While mid-range films will continue to get made when the right talent is attached, we really do seem to be moving towards there being just two types of films that can get theatrical distribution today: The extremely expensive, familiar, branded mega-spectacle that costs $200–$400 million or more to produce and distribute, and fairly inexpensive original films ranging from next to nothing to $60 or $70 million to produce and distribute.

The tent-poles will continue to get made because when they hit they still hit very big—in 2013, movies like *Iron Man 3*, *Despicable Me 2*, *The Hunger Games: Catching Fire*, *Fast and Furious 6*, *Monsters University*, *Man of Steel*, *Gravity*, *The Hobbit: The Desolation of Smaug*, *Thor: The Dark World*, *Star Trek Into Darkness*, and *The Wolverine* all made a lot of money for their studios. I would estimate the average cost to produce and distribute these movies was around $300 million, with some approaching $400 million. Only one of them, *Gravity*, was a completely original movie.

Generally speaking, original films have to cost far, *far* less because, usually, they're harder to market and often their audience is older and therefore goes to movie theaters less frequently. Original films that did well in 2013 include *The Heat* (budget of $43 million), *American Hustle* (budget of $40 million), *We're the Millers* (budget of $37 million), *Lee Daniels' The Butler* (budget $32 million), *Her* (budget just over $23 million), *The Conjuring* (budget of $20 million), *Dallas Buyers Club* (budget of $5 million) and *The Purge* (budget of $3 million).

The current glut of enormously expensive films recently led Steven Spielberg to say that a Hollywood "implosion" is coming.[21] His reasoning: Costs have grown so high that some inevitable flops will cause real financial damage to studios and lead to a drastic rethinking of how Hollywood makes, markets and distributes movies. However, Disney lost nearly $400 million during the last 36 months on two enormous flops, *The Lone Ranger* and *John Carter*, and yet, as of the time of writing, no change is apparent in the studios' steadfast willingness to bet on expensive, effects-laden, pre-packaged movies. Perhaps emerging digital distribution strategies, such as those now being formulated by Netflix—strategies that will drastically reduce distribution costs—will entice

production companies to take a chance on more daring and far less expensive productions.

TELEVISION DISTRIBUTION

Imagine it's 1953, you're sitting in an office somewhere and you have a great idea for a TV show. Being highly entrepreneurial, you raise some money, hire filmmakers and shoot the first episode of the show. Eventually you'd have to get that episode, and others, on TV sets across America. Back then, you only had three options: The CBS, NBC and ABC television networks. That was it.

Like the major film studios that have dominated film distribution, these three broadcast networks determined back then what would be distributed and seen across America. The shows came to viewers over the airwaves free of charge because commercials paid for network programming. All a viewer needed was an antenna and a television set.

Then, in the 1970s, cable TV arrived on the scene. Instead of using airwaves, companies transmitted shows to the public over wires. The service wasn't free, but the wires themselves could transmit dozens of different channels, and so the number of channels offering television programs began to increase dramatically. Soon came a fourth broadcast network, Fox, and a fifth, the CW,[22] along with satellite providers beaming TV shows to us from outer space.

Today, all of the networks and cable channels and many internet sites produce their own programming, but it's important to note that they must also license content from others. For example, the broadcast networks provide their affiliate stations with only a few hours of programming per day. Typically, affiliates receive a weekday morning news/conversation show such as NBC's *Today*, an evening national newscast, three hours of nighttime programming, and then a late night show or two, such as *The Tonight Show*. Networks also provide sports programming and a news-oriented program on Sundays, such as CBS' *Face the Nation*. That's essentially it—network affiliate stations have to fill up all the other hours in the day with programming they either produce themselves or license from others. And not every station in your town may be a network affiliate. Large cities typically have three or more non-affiliated stations, and they have to find programming to fill up *all* hours of the day. Cable channels and pay-TV services like HBO also have to license programming to cover the hours their own shows don't fill.

As we'll soon see, the economics of TV distribution are very different from film, but they do have one very important thing in common: Each drives what content actually gets made.[23] There's a reason why AMC aired shows like *Breaking Bad* and *Mad Men*, but film executives these days would be very reticent to make intelligent dramas. AMC did so because, first, film companies won't, so it's a way to program to audiences who have been discarded by the current economics of film, and second, because the economics of TV distribution, unlike the economics of film, make a show like *Breaking Bad* a plausible financial risk.

We've discussed the fact that film distribution principally generates revenues via tickets sales, home video sales, TV sales and merchandising. Here are the ways that television distribution generates revenue.

Advertising

If we want to say that television was "born" back in the middle of the twentieth century, then the obstetrician was probably a guy hawking cigarettes or laundry detergent. Since the days of the Kraft Television Theater, which ABC aired thanks to Kraft's desire to promote Cheez-Whiz,[24] advertising has helped make it all possible. These days, television companies earn revenues in other important ways as well, but since commercials are still very important to the bottom line, and critically so for broadcast networks, let's take a look at ad revenue.

The cost of a commercial, and therefore the revenue it generates to the TV company, depends on both the size and age of a show's audience. Obviously, the bigger the audience, the better. Also, advertisers will pay more for an ad if a high-spending demographic, people between 18 and 49 years old, are watching the show.

Because over 110 million people watched the 2014 Super Bowl, and because most people watch the game live and see the ads rather than skipping past them on a DVR, a 30-second ad cost as much as $4 million.[25] The average cost of a 30-second ad on a broadcast network primetime show is now a bit more than $100,000.[26]

Since the cost of an ad depends on the size and demographic of the audience, determining these numbers becomes very important. A ratings company, like the Nielson Company, comes up with the numbers. They do this by monitoring what roughly 20,000 households watch every day, and from those results Nielson extrapolates what the national audience looks like.[27] In essence, Neilson takes a daily poll of what we watch and like.

Along with demographic information, Nielson reports its findings in terms of ratings "points" and ratings "share." Ratings points are based on the percentage of all households with television sets, whether turned on or not, that watch your program. There are currently 116 million households with TVs in America,[28] so if 1.16 million are watching your show, that would equal exactly one ratings point (i.e. 1.16 million is 1 percent of 116 million). Ratings share equals the percentage of all TVs actually turned on that are watching your show. Thus, if 50 million sets are turned on and 2 million are watching your show, you'll get a ratings share of 4 (i.e. 2 million is 4 percent of 50 million).

Networks these days don't have anything remotely like the number of viewers they once did, because we all have so many more entertainment choices. The final episode of M*A*S*H in 1983 drew an astounding 106 million viewers and a rating of 60 points. The hugely successful final episode of Breaking Bad had

about 10 million total viewers and a 5.2 rating. The top-rated series in 1986 was *The Cosby Show*, which had an average rating of 30 points; in other words, more than 30 million households were tuned in. *The Big Bang Theory* was 2012's top rated series, and it had a 6.2 rating, which is about 7 million households.

Social scientists and philosophers can determine what our fractionalized audience means for our culture and society; for our purposes, it means TV broadcasters have been sweating bullets for a while now, worried that their audience and ad dollars will soon disappear.

The large market penetration of DVRs has certainly added to the problem. Nielson traditionally measured how many people were watching a show when it aired live. DVRs, of course, let you see programs whenever you want, thus diminishing the size of the actual broadcast audience.[29] Recognizing the fact that lots of people these days watch shows after they're aired, Nielson now determines viewership by a method called "live +3" and "live +7," which simply means counting the number of people who see the show live plus those who see it on their DVR within three days and seven days of the air date.[30]

Neilson has also instituted a Twitter TV ratings service that measures the Twitter activity generated by shows, the number of people sending out tweets and the number of people who read them.

Advertisers and broadcasters look at all this information and negotiate ad rates. If, as frequently occurs, the negotiation takes place before a show is aired, the rates will be based on the show's anticipated audience. If the negotiation occurs after the show is aired, then the rates will be based on the actual audience size. If rates are agreed to in advance and the ratings turn out differently than anticipated, the parties will usually make adjustments.

Carriage Fees

Cable channels sell advertising just like broadcast networks do, but they have an additional important source of revenues: carriage fees. These are the fees cable companies like Comcast and Time Warner Cable pay for the right to carry each cable channel. Very popular channels, like ESPN, can negotiate much higher carriage fees than could the LBN, the Lawn Bowling Network, were there such a thing.

When AMC makes shows like *Breaking Bad* or *Mad Men*, which were absolutely loved by what, in the scheme of things, were fairly small audiences, AMC can nevertheless start to extract higher carriage fees from cable and satellite operators. If the cable or satellite company refuses to pay the higher fee and the channel is removed from its service, the show's ardent supporters will go nuts and flood the cable/satellite company with an endless stream of complaints and ill-will.[31]

All of these carriage fees get passed on to you in your monthly cable bill. You may not watch AMC, but the odds are you pay for it. And this leads to an important point to make. As we all know, we currently have no choice but to buy

bundles of channels when we sign up for cable or satellite TV. In other words, we have no choice but to have cable channels distributed to us whether we want them or not, and we have to pay for them.

The media conglomerates obviously see it in their economic interest to force you to buy their product, which is why they lobby the government not to ban this practice. If you could pick and choose what channels you want (often referred to as choosing "à la carte"), and you choose to buy only 10 cable channels, your cable bill would go down because the carriage fees you'd be covering would go down. Assuming we all did this, a whole lot of cable channels would undoubtedly go out of business because those channels would no longer receive carriage fees en masse from all cable subscribers. At least one industry prognosticator forecast that $70 billion worth of TV revenues would be lost if we could pick what cable channels we want to see.[32]

The fact is, the bundles we all have to pay for give cable channels a lot of carriage fee revenue, which when added to their advertising revenue allows cable channels to make a lot of money and take creative risk. That's why a *Breaking Bad* or *Mad Men* can get made on cable—it's a risk cable channels can more readily afford.

So, should you and I subsidize cable channels by allowing bundling? You can decide that for yourself. Were I a cable company executive, however, I'd be pretty nervous these days. Most of the students I teach don't buy cable. It's just not part of their "routine." They get free television over the air, and they watch shows on Netflix, iTunes, Hulu, Amazon—or pirate them. What they don't do is pay very high cable bills. Maybe they will later in life, but I suspect far fewer will than the generation that preceded them.

Subscription Fees

Pay TV services like HBO and internet companies like Netflix charge monthly subscription fees, which means these companies know precisely what their revenues will be. Time Warner, HBO's parent, recently reported that HBO has a little more than 30 million U.S. subscribers, much like Netflix, and revenues just under $5 billion, somewhat more than Netflix's revenues of $4.36 billion.[33] These revenues pay for the company's operation, and what's left over can be devoted to either production or a savings account. The programming goal here isn't to sell ads but to retain subscribers and sign up new ones. That's why Jeffrey Bewkes, CEO of Time Warner, doesn't lament all the piracy of HBO's *Game of Thrones*—he believes the piracy "buzz" serves to increase subscribers.

DVDs and Internet Sales

Just like films, television shows earn a great deal of revenue from DVD and internet sales. For example, in 2009, the fifth season of *The Office* reportedly earned $30 million from home video sales, the fifth season of *Grey's Anatomy* earned $23 million and the twelfth season of *South Park* earned $15 million.[34]

Syndication

A few pages ago, I mentioned that almost all TV stations, whether broadcast, cable or pay-TV, have to license programming to fill up all the hours in the day. The same goes for an internet company like Netflix—it may now produce its own original programs, but the overwhelming majority of what it offers is licensed from studios and independent filmmakers.

Movies have traditionally helped fill up TV schedules. New and old movies have long been a staple of television. As we've previously discussed, TV companies around the world annually pay billions of dollars to license new and old films.

The other principal means to fill the 24-hour TV schedule has been syndication. This simply means individual TV stations license old successful TV shows and rerun them, or buy newly produced shows, such as *Jeopardy, Wheel of Fortune, Judge Judy* and *Ellen*, which are immediately syndicated to TV stations.[35]

There's a very important point to make here with respect to television economics. The initial run of a TV show, like the initial run of a film in theaters, doesn't generally cover the show's production costs.[36] Most production companies that produce TV shows,[37] with a one-hour program today costing around $3 million, recoup roughly only half that from license fees paid by a network or cable channel to air the show.[38] That's because the advertising revenue the network or cable channel will receive from commercials simply can't sustain a higher license fee.

Therefore, if a production company makes 15 episodes of an hour show that costs $3 million per episode, the production company will have invested $45 million but will likely receive only roughly half that when the shows initially air. Which might lead you to ask, how then do these production companies stay in business?

Licensing shows to foreign television markets is one way to erase this deficit. The other is syndication, which becomes an available option only if a show is a hit.

When a television show is wildly popular and stays on the air a long time, that program becomes alluring to TV station operators around the world who have all those hours to fill every day. The expectation is that the show's popularity will generate viewers and thus advertising revenue.

It used to be that a series had to run for at least a 100 episodes to be syndicated to TV stations for reruns. That number guaranteed both that a show was very popular and that viewers wouldn't get bored watching the same episode over and over again. Today the number of shows needed for syndication is a bit less, somewhere between 80 and 90 episodes.

The hits that do get syndicated have historically made a fortune for the show's owner. *Seinfeld*, for example, has earned just over $3 billion in syndication.[39] That means each of *Seinfeld's* 180 episodes, which probably averaged about $500,000 to produce (another guess on my part), have earned $17 million. For those of you keeping score at home, that's a 3,300 percent profit, and that makes

up for a lot of shows that get canceled quickly and lose money. This is why the networks fought so hard to end the Fin-Syn Rules we previously discussed; now a network's production company, and not an independent producer, can reap the syndication and other ancillary revenues a big hit can generate.

Film studios live off their major hits. So, too, do television production companies, thanks to the huge revenues earned from syndication.

INTERNET DISTRIBUTION

Netflix, Hulu, Amazon, iTunes and YouTube, along with other internet sites, have recently become important content distributors. Some of this content is original. Netflix has made enormous strides with its original programs, *House of Cards* and *Orange Is the New Black*. Amazon has also produced original programs, such as *Alpha House* and *Betas*, and Yahoo has announced that it, too, will produce original programming in the near future.

For the moment, however, most of what Netflix, Hulu, Amazon and others currently offer is licensed from others. Indeed, both new and old shows can be viewed on the web, which means the syndication market no longer is solely the province of broadcast and cable television outlets.

YouTube has so far offered content providers, in this case usually individuals, a very different kind of distribution opportunity. YouTube distributes whatever you upload, and in some cases tens of millions of people have viewed a particular piece of content. For example, the video blogger PewDiePie, who comments on video games as he plays them, had 192.6 million page views in October 2013.[40] More than 27 million people subscribe to his YouTube channel,[41] and his earnings from ad revenue top $1 million per year.[42] Meanwhile, his production expenses are effectively zero.

Admittedly PewDiePie makes niche non-narrative entertainment, and his success is shared by only a handful of others. Still, these people have shown the internet can generate huge audiences for original content.

OTHER STUDIO DEPARTMENTS

We've discussed various studio departments, including production, business affairs, legal affairs, physical production, post-production, marketing and distribution. These are not, however, the only departments studios maintain. For those who want to get involved in the entertainment business, it's worth pointing out that there are other opportunities out there. On the business side, for example, studios employ finance personnel and labor relations specialists who deal with union-related matters. Some studios have an acquisitions department that acquires films mainly for non-theatrical exhibition, such as films that go straight to home video distribution or video on demand.[43] Studios also have licensing divisions,

which handle deals for the company's properties that others want to use in some way. You want to make a retro Indiana Jones doll? It's Paramount's licensing department you'd need to call. Want to make a Scooby-Doo pillow? Then you'd have to call Warner Bros.' consumer products division. Studios also maintain departments that manage the studio's physical facilities, human resources, as well as other types of operations. Netflix and other internet content providers already have, or will need in the future, divisions that perform many of these tasks.

Entertainment companies also have divisions that might interest you if you're involved in certain specialized aspects of filmmaking. For example, Sony Pictures maintains its Imageworks unit, which specializes in visual effects. At the time of writing, many studios also maintain animation divisions, including Sony, Warner Bros., DreamWorks and Disney.

The point is, there are many ways to get into the film business. For those who are looking for a way in, you need to thoroughly research your area of interest and then reach out to people who work in the field, asking for interviews and advice. If you do your homework, present yourself well and can be patient, good things often happen.

NOTES

1 Dave McNary, "Warner Bros. Sets Bar High for Latest—and Priciest—Incarnation of Superman," *Variety*, June 6, 2013, last accessed on July 7, 2014, http://variety.com/2013/film/news/warner-bros-sets-bar-high-for-latest-and-priciest-incarnation-of-superman-1200493334/.

2 Mike Fleming, Jr., "2013 Most Valuable Blockbuster Championship Game," *Deadline Hollywood*, March 27, 2014, last accessed on June 17, 2014, http://www.deadline.com/2014/03/iron-man-3-despicable-me-2-profit-most-profitable-movies-2013/.

3 It is true that every now and then a film comes along that picks up box office steam as the weeks go along. Usually these films open in a very small number of theaters—usually referred to as a "platform" release—and if the film is well received, it will then be placed in more and more theaters as word of mouth and good PR spreads. Though the modern internet will likely make it impossible to reproduce the phenomenal success of *My Big Fat Greek Wedding*, that film earned its highest weekly box office revenue in its twentieth week of release. See http://www.boxofficemojo.com/movies/?page=weekly&id=mybigfatgreekwedding.htm, last accessed on July 7, 2014. Woody Allen's film *Blue Jasmine*, released in 2013, earned the most weekly box office receipts during the film's sixth week of release. http://www.boxofficemojo.com/movies/?page=weekly&id=bluejasmine.htm. Compare these results with any tent-pole movie, which will inevitably receive the most weekly revenue during its first week in theaters.

4 Studios have tracking down to a science; based on the public's awareness of and interest in an upcoming film, studio executives can predict with great accuracy what the opening weekend box office will be.

5 I highly recommend this book to anyone who wants to read about distribution in depth.

6 Others argue that simultaneously releasing a film in all formats on the same day would *increase* piracy. Why? Because would-be pirates would immediately get their hands on high-quality DVD versions of the film, whereas now many pirates are left to secretly record films playing in movie theaters on hand-held cameras, leading to poor quality knock-offs.

7 Theater owners only share your ticket money with distributors. Theater owners keep every cent of the money you spend at the concession stand. For most theater owners, it's the concession money that gives them a profit and allows them to stay in business.

8 Roy McCall, "China's Film Industry: Strategic Opportunities," *China Briefing*, February 11, 2014, last accessed on June 17, 2014, http://www.mpaa.org/wp-content/uploads/2014/03/MPAA-Theatrical-Market-Statistics-2013_032514-v2.pdf.

9 "Theatrical Market Statistics 2013," *MPAA*, last accessed on June 17, 2014, http://www.mpaa.org/wp-content/uploads/2014/03/MPAA-Theatrical-Market-Statistics-2013_032514-v2.pdf.

10 If one assumes domestic film rentals equal 55 percent of ticket sales, then Paramount would have received roughly $120 million in domestic film rentals.

11 See "Star Trek Into Darkness," *Box Office Mojo*, last accessed on June 17, 2014, http://www.boxofficemojo.com/movies/?id=startrek12.htm.

12 I base this estimate on the film's reported $190 million production budget and what I assume was a marketing budget of more than $100 million. See *Id.*

13 If the $300 million in receipts were split evenly, the $150 million in domestic box office would lead to roughly $75 million in rentals, and the $150 million in international box office would lead to approximately $60 million in rentals (assuming the distributor received 40 percent of all international receipts). Of course, this isn't customary, since foreign receipts typically account for roughly two-thirds of a film's total theatrical income.

14 See "Filmed entertainment revenue worldwide from 2012 to 2017, by region (in billion U.S. dollars)," *statista*, last accessed on July 10 2014, http://www.statista.com/statistics/260198/filmed-entertainment-revenue-worldwide-by-region/. Compare this $90 billion figure with a reported $85 billion earned worldwide in 2005. See Guy Di Piazza and Martin Olausson, "The Television and Movie Industry Explained: Where Does All the Money Go?," *Strategy Analytics*, June 2007, last accessed on June 17, 2014, http://www.strategyanalytics.com/reports/vg5d52vcWt/single.htm.

15 *Id.*

16 See Mike Snider, "Home Video Sales Slide; More Opt for Blu-Ray Players," *USA Today*, May 3, 2011, last accessed on July 10, 2014, http://usatoday30.usatoday.com/tech/news/2011-05-02-dvd-movie-sales-continue-slide_n.htm; "2013 Home Entertainment Report," *The Digital Entertainment Group*, January 7, 2014, last accessed on June 17, 2014, http://degonline.org/wp-content/uploads/2014/01/DEG-Year-End-2013-Home-Entertainment-Report.pdf.

17 "2013 Home Entertainment Report," *The Digital Entertainment Group*, January 7, 2014, last accessed on June 17, 2014, http://degonline.org/wp-content/uploads/2014/01/DEG-Year-End-2013-Home-Entertainment-Report.pdf.

18 "Top-Selling Video Titles in the United States 2013," *The Numbers*, last accessed on June 17, 2014, http://www.the-numbers.com/home-market/packaged-media-sales/2013.

19 See Guy Di Piazza and Martin Olausson, "The Television and Movie Industry Explained: Where Does All the Money Go?," *Strategy Analytics*, June 2007, last accessed on June 17, 2014, http://www.strategyanalytics.com/reports/vg5d52vcWt/single.htm.

20 See Dominic Patten, "AMC Slams 'Ill-Conceived' Walking Dead Lawsuit from Frank Darabont and CAA," *Deadline Hollywood*, May 16, 2014, last accessed on June 17, 2014, http://www.deadline.com/2014/05/walking-dead-lawsuit-amc-slams-frank-darabont-caa-mad-men/.

21 Paul Bond, "Steven Spielberg Predicts 'Implosion' of Film Industry," *Hollywood Reporter*, June 12, 2013, last accessed on June 17, 2014, http://www.hollywoodreporter.com/news/steven-spielberg-predicts-implosion-film-567604.

22 The CW was formed when two prior start-up networks, the WB owned by Warner Bros. and UPN owned by Viacom, were merged to form the CW. CBS Corporation and Warner Bros. jointly own the CW.

23 In a macro sense, TV and film distribution share something else in common: Both rely on the revenues produced by relatively few hits to cover the losses of the majority of films and shows that fail.

24 See "Kraft Television Theater," *Museum of Broadcasting*, last accessed on July 15, 2014, http://www.museum.tv/eotv/krafttelevis.htm.

25 Alex Konrad, "Even With Record Prices, Expect A $10 Million Super Bowl Ad Soon," *Forbes*, February 12, 2013, last accessed on June 17, 2013, http://www.forbes.com/sites/alexkonrad/2013/02/02/even-with-record-prices-10-million-spot/.

26 Anthony Crupi, "In Their Prime: Broadcast Spots Cost Soar," *Adweek*, June 22, 2011, last accessed on June 17, 2014, http://www.adweek.com/news/television/their-prime-broadcast-spot-costs-soar-132805.

27 "Intro to Nielsen Ratings: Basics and Definitions," *Spotted Ratings*, September 3, 2013, last accessed on June 17, 2014, http://www.spottedratings.com/2013/09/intro-to-nielsen-ratings-basics-and.html.

28 *Id.*

29 Of course DVRs also let viewers skip through commercials, causing even more headaches for broadcasters and advertisers.

30 Many broadcasters would like Nielson to measure live +30, believing (no doubt correctly) that counting viewers who see the show within 30 days of the air date will raise ratings and thus increase ad costs.

31 See Adam Davidson, "The Mad Men Miracle," *The New York Times*, last accessed on July 15, 2014, http://www.nytimes.com/2012/12/09/magazine/the-mad-men-economic-miracle.html?pagewanted=1&_r=0.

32 "The Future of TV," *Needham Insights*, July 11, 2013, page 1, last accessed on June 17, 2014, http://assets.fiercemarkets.com/public/sites/cable/futuretv.pdf.

33 Netflix's worldwide subscriber base exceeds 44 million people and HBO's exceeds 110 million. See Amol Sharma and Ben Fox Rubin, "HBO More Profitable Than Netflix, but Slower-Growing," *The Wall Street Journal*, February 5, 2014, last accessed on June 17, 2014, http://online.wsj.com/news/articles/SB10001424052702303496804579364441588141618; Justin Bachman, "HBO Finally Reveals Profit Numbers. Take That, Netflix," *Business Week*, February 5, 2014, last accessed on June 17, 2014, http://www.businessweek.com/articles/2014-02-05/hbo-finally-reveals-profit-numbers-dot-take-that-netflix.

34 See Robert Seldman, "Serialized Dramas Overwhelmingly Top TV Show DVD Sales in 2009," *TV by the Numbers*, February 1, 2010, last accessed on June 17, 2014, http://tvbythenumbers.zap2it.com/2010/02/01/serialized-dramas-overwhelmingly-top-tv-show-dvd-sales/40666/.

35 "First-run syndication" is the term usually applied to shows that are produced with the intention of being immediately syndicated. This term, then, would apply to shows like *Jeopardy, Wheel of Fortune* and *Judge Judy*.

36 Recall that in the previous section we mentioned films rarely make back their production and distribution costs from theatrical exhibition.

37 It's worth noting that an entertainment conglomerate may own several television production companies. For example, a conglomerate-owned network and film studio may both have their own TV production company. The conglomerate may also have bought other production companies.

38 Cable shows are generally produced for lower budgets.

39 Adam Chandler, "'Seinfeld' Eclipses $3 Billion in Syndication," *The Scroll*, April 5, 2013, last accessed on June 17, 2014, http://www.tabletmag.com/scroll/128652/seinfeld-eclipses-3-billion-in-syndication.

40 Joshua Cohen, "Top 100 Most Viewed YouTube Channels Worldwide, October 2013," *Tubefilter*, November 7, 2013, last accessed on June 17, 2014, http://www.tubefilter.com/2013/11/07/top-100-most-subscribed-youtube-channels-worldwide-october-2013/.

41 "YouTube Top 100 Most Subscribed Channels List-Top by Subscribers," *VidStatsX*, last accessed on June 17, 2014, http://vidstatsx.com/youtube-top-100-most-subscribed-channels.

42 Joshua Cohen, "Top 100 Most Viewed YouTube Channels Worldwide, October 2013," *Tubefilter*, November 7, 2013, last accessed on June 17, 2014, http://www.tubefilter.com/2013/11/07/top-100-most-subscribed-youtube-channels-worldwide-october-2013/.

43 Eric Kohn, "Paramount Launches Division For Acquiring Indie Films, Hires IFC's Jeff Deutchman As Director of Acquisitions," *Indiewire*, July 30, 2013, last accessed on June 17, 2014, http://www.indiewire.com/article/paramount-launches-division-for-acquiring-indie-films-hires-ifcs-jeff-deutchman-for-acquisitions.

SECTION 4
Money and Contracts

For those of you who want to make films, TV shows, games and other forms of entertainment, I hope one day you'll get to read a contract with your name on it and a place for you to sign. But even if you never write, direct, edit or shoot anything—even if you never set foot on a set—you may still have to read and understand entertainment contracts. And if you're a producer, agent, studio business executive or entertainment lawyer, you not only have to read them, you also have to negotiate them.

The fact is, entertainment productions may start as promising ideas, but they only become "real" in the legal sense when contracts are negotiated, written and signed. These contracts, like any other type of business agreement, define and make enforceable the respective rights and responsibilities of the parties involved.

I doubt it will come as a major shock, but a key part of any contract negotiation concerns money. People tend to argue about it. Creative people want to be paid as much as possible while studios want to pay as little as possible. Filmmakers want to share in the enormous profits entertainment can generate; entertainment companies want to keep every dollar.

Contracts, of course, concern much more than just money; they describe what services people will provide, how long they have to provide them, what creative rights they have, what ownership interest they're entitled to in the end product, as well as many other things. If you stop and think about it for a moment, these

contracts when looked at in the broadest sense possible reflect the industry's business norms. These norms are rooted in what makes operational and financial sense for the people who produce entertainment. This makes studying contracts a useful endeavor, since the more you understand them, the more you'll understand how the entertainment business operates.

As you may suspect, entertainment contracts are not a fun summer beach read. They're choked with long and stilted sentences, because lawyers try to *very precisely* describe the rights and obligations of the contracting parties. While the underlying motive for all the legalese is laudable, the result can be mind-numbing. Fortunately, you won't have to read contracts in this book, but if you do want to look at examples in light of the following discussion, you'll find representative contracts at focalpress.com/cw/bernstein.

We can't examine every type of entertainment contract in this book, so we'll look at some particularly important ones, including agreements for rights to an existing project and agreements for hiring screenwriters, producers, directors and actors. Those readers who want to be editors, cinematographers or do some other kind of creative work will benefit from the discussion, because many of the concepts discussed here appear in other contracts as well.

For those who think contracts are best left to lawyers, I won't dispute the need for lawyers, but I have yet to meet a successful filmmaker or executive who isn't savvy about what goes into these agreements and why. Either you understand these contracts or you become fully reliant on lawyers to explain everything to you. I don't know any artist or executive who wants to be in such a subservient position.

We'll conclude this section with a chapter about independent filmmaking. Many people reading this book may contemplate writing, producing, directing or otherwise working on independent films. We'll therefore address some of the financial, contractual and creative topics previously discussed in the specific context of independent filmmaking. These selected topics don't necessarily flow elegantly one from the other, but I thought it nevertheless worthwhile to offer some additional information to those people who have the wherewithal to go out and make movies on their own.[1]

A FEW WORDS ABOUT THE NEGOTIATING PROCESS

The negotiation process in the entertainment industry is a bit unusual and can impact agreements, so it's an important topic to discuss.

Entertainment contract negotiations often take place in very compressed time frames. For those who make a living trying to get studios to say "yes" to projects, the speed of contract negotiations often seems a bit ironic. That's because

when you're waiting for a studio to call with the good news that they're accepting your project, you'd swear the phone is weirdly malfunctioning, because no one ever calls. But when a studio finally does say yes, suddenly the phone rings a lot. Your agent calls you every day. Now, a deal needs to be negotiated. And the studio usually wants the deal done *yesterday*.

Why all the sudden pressure to get things done quickly? Because studio executives, so used to saying no to projects, want to get going on yours immediately because their passion for it is real and exciting.

The sense of urgency is sometimes increased by the fact that one negotiation often directly impacts another. For example, a screenwriting deal may hinge on the negotiation for a producer's services; a directing deal may impact the negotiation for a star actor; a producing deal may only happen after the rights to a book are secured. People hungry to get a project rolling want all of these interlocking deals done ASAP, and this puts pressure on the people who negotiate the agreements.

How does all this affect the agreements themselves? The answer is, many entertainment deals are negotiated in a two-step process. First comes the "deal memo" stage. During this part of the process, only the most *essential* aspects of the deal are discussed and agreed to. Money, of course, is always at the top of the list. If the agreement is for an actor, such things as the on-screen credit, rehearsal times and the number of shooting days or weeks will be discussed, as these are issues actors truly care about. If the agreement is for a director, the parties will undoubtedly discuss what cast and script approvals the director may have, or how many cuts and previews the director is permitted.[2]

Once the essential terms are fully negotiated, a deal memo will be drafted and circulated amongst the parties. The expectation is that all parties will sign the deal memo, which gives people some comfort that a legally binding agreement is essentially in place. Only after this happens will all the other, less critical terms of the agreement—the so-called "boilerplate"—be completely negotiated and a full-blown contract drafted ready for signing or "execution," as the lawyers call it.

It may seem strange, but in Hollywood the larger, final contract frequently isn't drafted and signed until months after the deal memo is written and months after a person has already started working. Because of the rush to get people going very quickly, the custom has developed that verbal agreements, or signed or unsigned deal memo agreements, give people sufficient comfort to proceed in the absence of a signed, fully negotiated contract. This can occasionally lead to real problems. Where some form of interim agreement has been negotiated—say, a deal memo—people may believe they have a legally binding deal, but then one party may suddenly bow out of the project. Though this doesn't happen frequently, when it does it can lead to lawsuits

in which judges and juries must decide if the interim agreement sufficed to bind the parties.[3]

So if you're responsible for or affected by a contract negotiation, get a complete contract finalized, written and signed as soon as possible. It's the only way to fully protect your interests. Always remember: Just because someone shakes your hand, looks you in the eye and says, "We have a deal," it doesn't necessarily mean you do as far as courts are concerned.[4]

CHAPTER 11

Gross and Net Proceeds

INTRODUCTION

Before looking closely at different kinds of entertainment agreements, there is one provision that goes into many of them that deserves special attention. This provision gives filmmakers the right to participate in a production's profits if, indeed, there are any. Because profit participations are important and can be (albeit very rarely) worth millions of dollars, but are also confusing, frustrating and sometimes the cause of contentious debate, it's worth looking separately in detail at this one contractual issue.

In order to understand how profit participations work, we need to go back and look at the revenues studios generate from distribution. More specifically, we have to analyze what a studio does with the money it receives and how it determines whether or not a production is actually "profitable." This will clarify how profit participations are defined and how likely they are to be paid to those entitled to receive them.

FILM ACCOUNTING: WHEN IS A FILM "PROFITABLE"?

As we've discussed, money from film distribution flows to studios from a variety of sources. The initial source is movie theaters. Later, money arrives from television distribution, DVD sales, various kinds of online sales and rental services, merchandising and other sources. Studios use this money to recoup the production and distribution costs of a film and, hopefully, earn a profit.

The word "profit," however, can be a squirrely term, one hard to pin down. For example, let's say a film costs $50 million to make and $50 million to distribute. We'd all agree the studio invested $100 million in the project. If the studio earned a total of $101 million from the film's distribution, we'd all say the studio earned a $1 million profit. Who could argue with us, right?

If only it were that easy! A studio executive could look at those numbers and happily trumpet the film made a million dollars. A studio accountant, however,

might disagree. That's because the accountant, under acceptable accounting rules, might argue that a portion of the studio's large overhead expenses—salaries, office supplies, electricity and other necessary expenses—can be properly allocated to the film. If a portion of the studio's overhead expenses is allocated to the film, this will drive up its cost and reduce its profitability. Indeed, under prevailing law, an accountant can do many things that impact whether or not a film has, for accounting purposes, become profitable.

Then there's a third perspective, that of the filmmakers—including the directors, producers, writers and actors who routinely negotiate a contractual right to share in a film's profits. When does a film become profitable for them?

The simple answer is that a film becomes profitable when the contracts negotiated with studios say it becomes profitable. In other words, the contracting parties are free to come up with whatever accounting formula they want to define when profit begins.

Surely, you're saying, this need not be too complicated. All you have to do is agree on the following: Take all the money the studio receives, deduct the production and distribution costs, and everything left over is profit.

This makes intuitive sense, but it's not the common contractual definition of when profit begins. For most filmmakers, their contracts say profit begins long after a studio has recouped its production and distribution costs.

Film artists, of course, would like profit defined so that money starts flowing to them as soon as possible. Studios want money to flow as late as possible. When a negotiation takes place, who do you think wins most of the time, the artist or the studio? That's right, the studio does. Studios generally have all the negotiating leverage to dictate what accounting formulas will be used to define profit. From the studio's perspective, if you don't like the formula they offer, that's fine—don't sign a deal, don't get a paycheck, don't make a movie, go somewhere else. Everyone signs.

GROSS PROCEEDS AND NET PROCEEDS

Broadly speaking, filmmakers can receive two different kinds of profit participation in their contracts: a so-called "gross proceeds" participation or a "net proceeds" participation, and each has its own accounting formulas and definitions. Note the term "proceeds" and not "profits." "Proceeds" is the term most entertainment lawyers use, so I'll use it here, though in fact people in the industry often casually use the words "proceeds" and "profits" interchangeably.

Just remember: No matter what term you use, these concepts are nothing more than contractual formulas that describe when a filmmaker starts

receiving a portion of a film's revenues as compensation for services rendered. Because there's usually no guarantee that a profit participation will actually pay off, this form of compensation is customarily referred to as "contingent compensation."

"Defined Gross"—i.e. the Revenue Pot

Before discussing the specifics of gross and net proceeds formulas, we need to briefly discuss what film revenues go into a metaphorical revenue pot from which the studio's costs are deducted and profitability is determined. Films generate revenue from different types of distribution, and filmmakers would like every dollar of revenue to go into the pot, as this would increase the chances for a film to be profitable. You might think every dollar does go into the revenue pot, but that's not the case because accounting formulas used in filmmakers' contracts specifically exclude certain revenues.

Studios' contracts often use the term "Defined Gross" to refer to the revenues that *do* go into the revenue pot, and while the accounting minutiae of Defined Gross get too complex to discuss in great detail, the following is generally true: (1) All theatrical film rentals are included in Defined Gross and therefore go into the revenue pot; (2) all television licensing revenues are included and go into the revenue pot; (3) only (usually) 20 percent of wholesale home video sales and rentals are included and go into the revenue pot—the other 80 percent goes directly into the studio's bank account; and (4) a fraction of merchandising, music publishing and soundtrack album revenues goes into the pot.[5]

As mentioned in the previous chapter, home video is the single greatest revenue generator, so when studios put 80 percent of this money directly into their own pockets rather than into the revenue pot, this is a huge loss for artists. Why do studios do this? Because in the 1980s, when videocassettes first came on the scene, studios elected to keep for themselves 80 percent of all videocassette sales revenue to cover the costs of manufacturing, marketing and distributing the cassettes. Videocassettes, however, are long gone, replaced by DVDs and digital sales, which are much cheaper to distribute. Still, the 80 percent exclusion remains, and studios have generally been unwilling to budge on this. I know that some directors, actors and producers can negotiate to have a greater percentage of home video revenue put into their revenue pot, and a very few can likely negotiate to have all home video revenue included, but most filmmakers lack the clout to do this.

The exclusion from Defined Gross of a significant chunk of merchandising revenue—often 50 percent of merchandising revenue—also can keep a lot of money out of the revenue pot, as do exclusions of large chunks of soundtrack and music publishing revenues.[6]

With all this in mind, let's look at how gross and net proceeds are generally defined.

Gross Proceeds

"Gross proceeds" formulas are *much* more favorable for filmmakers than "net proceeds" formulas. When gross proceeds formulas are used in a filmmaker's contract, a film has to earn far less money before the filmmaker begins to see some of it flow his or her way. Not surprisingly, gross proceeds participations are much harder to win in a negotiation, and only extremely successful actors, directors, producers, and on very rare occasions writers, can negotiate to receive them.

Even among these powerful few, the definition of gross proceeds varies. For example, a tiny number of mega-star actors and directors may be able to negotiate what's called "first dollar gross proceeds." This simply means that the mega-star filmmaker gets a percentage of all the money that goes into the revenue pot per the Defined Gross formula. So let's say you're one of our great directors and your contract includes the right to receive 5 percent of all first dollar gross proceeds. If your film subsequently generates $200 million in Defined Gross, congratulations—you just earned $10 million.[7]

The vast majority of people who receive a gross proceeds participation—and, just as reminder, there aren't many of them—start receiving money later down the line, only after the studio reaches what's called "cash breakeven." This occurs when a studio has recouped its actual out-of-pocket costs to produce and distribute the movie.[8] In this sense, then, "cash breakeven" exists at the point when the average person would intuitively say true profitability begins.

Not all "cash breakeven" participations, however, are the same. The studio may insist on taking a distribution fee on all Defined Gross revenue in excess of cash breakeven before it begins paying the profit participant. The distribution fee might be equal to 10 percent of all remaining Defined Gross revenues in excess of cash breakeven (this participation is referred to as "cash break 10"), or 20 percent of all remaining Defined Gross revenues in excess of cash breakeven ("cash break 20"), or whatever the parties agree to. "Cash break zero" means no distribution fee is charged by the studio, which means the filmmaker's percentage is taken on all revenues in excess of cash breakeven.

Let's look at some examples. Say a movie costs $100 million to produce and distribute. This means the film will have to earn $100 million in Defined Gross revenues to reach the cash breakeven point. Let's say, however, the film earns $150 million in Defined Gross and so $150 million has gone in the revenue pot. If a filmmaker has a 5 percent "cash beak zero" participation, the filmmaker

would receive 5 percent of all the money remaining in the revenue pot after the studio recouped its production and distribution costs, i.e. $100 million. This means, the filmmaker would earn 5 percent of the final $50 million, or $2.5 million. Not bad.

What if, in the above example, the filmmaker's participation was "cash break 20"? In this case, the studio would charge a 20 percent distribution fee on all money remaining in the revenue pot after cash breakeven. Since there's $50 million in excess of cash breakeven in the above example, the 20 percent distribution fee would be applied to this $50 million. This means the studio's distribution fee would equal $10 million; this money would come out of the pot and go directly into the studio's pocket, leaving $40 million remaining in the revenue pot. Now our filmmaker's 5 percent participation equals 5 percent of $40 million, or $2 million.

Net Proceeds

For the vast majority of screenwriters, actors, producers and directors, gross proceeds participations are beyond reach. That's because the clout to negotiate gross proceeds participations only comes with making box office hits, and for most in the industry this still remains somewhere over the horizon. Therefore, most filmmakers must settle for a net proceeds participation.

Net proceeds is determined by deducting a series of fees and expenses from all Defined Gross revenues. If after deducting these fees and expenses there's money left over in the revenue pot, this money is deemed "net proceeds" and is paid to those people who have a net proceeds participation in their contract.

To arrive at net proceeds, here are the fees and costs that are typically deducted from the revenue pot, in the order they are deducted:

- *Distribution fee*: Studios first take off a distribution fee. The fee equals a percentage of the Defined Gross and varies with respect to the different forms of revenue that make up Defined Gross. The distribution fee normally equals 30 percent of all Defined Gross revenues earned in the U.S. and Canada, 35 percent of all Defined Gross revenues earned in the United Kingdom, and 40 percent of all Defined Gross revenues earned internationally. Studios justify the distribution fee by pointing out that the studio takes enormous risk when financing, marketing and distributing films and this fee compensates the studio for the risk it takes.[9]
- *Distribution expenses*: All distribution expenses, which include all marketing costs, are next deducted from the pot. Typically, studios will also deduct as an overhead fee an additional amount equal to 10 percent of all money spent on advertising. Studios justify this overhead fee by arguing that since its marketing executives work on a film's advertising campaign,

a portion of these executives' salaries should be charged to the film, and the studio is consequently justified in recouping this charge from a film's revenues.[10]

- *Negative cost*: Next, "negative cost" is deducted. Negative cost is calculated by adding together (a) the movie's actual production costs, (b) typically an overhead fee equal to 15 percent of the actual production costs, (c) an amount equal to all gross profit participations paid to third parties such as actors and a director, (d) an amount equal to all other contingent compensation such as "deferments"[11] paid to third parties, (e) plus an interest charge on all of the above that's fractionally higher than the prime lending rate. The justification I've always heard for the interest charge is that a studio would earn this amount if the film's production costs were placed in a bank rather than invested in a movie.[12]

If after deducting all of the above[13] there is Defined Gross revenue left over, then that remaining revenue is called "net proceeds."[14]

So let's take a look at some examples and work some numbers.

Let's say you know a screenwriter, producer and director who work as a team. Let's say they all work on three produced films:

- "Wonderman"—a high budget mega-hit that makes $700 million at the worldwide box office.
- "Motors Running"—a mid-level budgeted film that makes $125 million at the worldwide box office.
- "Weird Happenings"—a low-budget film that becomes a hit and makes $80 million at the worldwide box office.

Now let's assume the screenwriter is contractually entitled to receive 5 percent of the net proceeds from these films, the producer is entitled to receive 10 percent of the net proceeds, and the director is entitled to receive 5 percent of cash break zero gross proceeds. All of these profit participations are well within the realm of reason, though the director's participation would indicate this person is an "A" list director. As an "A" list director, it's possible the Defined Gross definition would include more than just 20 percent of home video revenues, but for the examples below we'll assume the director, like the writer and producer, only gets the customary 20 percent of home video revenue put into the revenue pot.

Let's further assume that the filmmakers come to you with the facts and figures shown on the following page.

Before doing some math, let's be clear about one thing: None of these movies were bombs. Indeed, just the opposite—they all did extremely well at the box office. "Wonderman" was in fact a big hit, earning $700 million at the worldwide box office. That amount would put "Wonderman" in the top 10 of all films released in 2013, just behind *Gravity*.[15]

TABLE 11.1 "Wonderman," "Motors Running," and "Weird Happenings": Data for Net Profits Calculation

	Production costs	Distribution costs	Overall studio distribution fee*	Gross proceeds participations	Deferments	Worldwide box office receipts	Film rentals (45% of all box office revenue)**	Total revenues received by studio from ancillary distribution (TV exploitation, home video, etc.)***	Total revenues received by studio (film rentals + ancillary revenues)
"Wonderman"	$200 million	$150 million Advertising expenses = $125 million	35%	5% first dollar gross to mega-star 5% cost break zero to director	None	$700 million	$315 million	$260 million split: $150 million from home video; $100 million from TV licenses; $10 million from other sources	$575 million
"Motors Running"	$60 million	$50 million Advertising expenses = $40 million	35%	5% cost break zero to director	None	$125 million	$56.25 million	$50 million split: $30 million from home video; $15 million from TV licenses; $5 million from other sources	$106.25 million
"Weird Happenings"	$5 million	$10 million Advertising expenses = $9 million	35%	5% cost break zero to director	None	$80 million	$36 million	$80 million split: $50 million from home video; 25 million from TV licenses; $5 million from other sources	$116 million

Notes: * Earlier I mentioned that distribution fees typically equal 30 percent of all domestically derived Defined Gross, 35% of all Defined Gross earned in the United Kingdom, and 40 percent of all internationally derived Defined Gross. This means the overall distribution fee would approximate 36–37 percent of all Defined Gross if revenues were split one-third from domestic sources and two-thirds from international sources, which is typical these days. I have used an overall 35 percent distribution fee in the text's examples purely for simplicity's sake.

** Because international film rentals usually equal less than 50 percent of the international box office take, I've opted to assume all combined film rentals will equal 45 percent of ticket sales.

*** For the sake of this example, we'll assume the home video rentals included below are combined wholesale sales and rental revenues. I have also assumed the revenues from "other sources" all go into Defined Gross though this would almost certainly not be the case. For example, if some of this "other source" revenue came from merchandising, only 50 percent would be included in Defined Gross. I have included 100 percent of these revenues, however, simply because the "other source" revenue in these examples is too small to significantly change the overall outcome.

"Motors Running" also made over $100 million at the worldwide box office, something only a small fraction of films are able to do.

"Weird Happenings," a film budgeted at $5 million, managed to earn $80 million, this despite the fact the studio spent only $15 million to make and distribute the film.

Given that all three of these films did extremely well, our screenwriter, producer and director understandably ask if they'll receive anything from their profit participations. So let's answer their question by following the appropriate profit participation formulas described above and do a little math. For those of you who are new to this sort of calculation, keeping in mind all of the numbers and accounting concepts won't be easy. It will no doubt require some time for all the numbers and concepts to sink in and make sense. But if you think about it for a while, it should start to add up.

But first, a disclaimer: The numbers and calculations included here do not precisely reflect real-world examples. To do so would require too many caveats, calculations and complex math. I have therefore sacrificed some accuracy for math simplicity, and while the numbers may be somewhat inaccurate, the gist of the overall result isn't. The point of the following is to approximate some profit participation calculations, and in this regard the numbers below are certainly accurate enough.

WONDERMAN

MONEY THAT GOES IN THE REVENUE POT PER "DEFINED GROSS"

Total worldwide film rentals ... $315 million
Total revenues from television distribution $100 million
Total revenues from home video = 20% of $150 million $30 million
Total revenues from other distribution sources $10 million[16]

Total revenues in the pot ... **$455 million**

DEDUCTIONS FROM DEFINED GROSS

35% distribution fee[17] (35% of $455 million) $159.25 million

Distribution expenses = Actual distribution costs = $150 million +
 10% advertising overhead fee = 10% of $125 million = .. $12.5 million

 Total Distribution Expenses ... $162.5 million

Negative Cost = Actual production costs = $200 million +
 15% overhead fee = ... $30 million +
 Gross proceed participation (actor) =
 5% of dollar one gross proceeds =
 5% of $455 million = ... $22.75 million +

Gross participation (director) =
5% of cash break zero gross =
5% of $105 million[18] = .. $5.25 million +
Interest – hypothetically we'll say = $5 million

Total Negative Cost = ... $263 million

Total deductions from revenues **$584.75 million**

Revenues – Deductions = Net Proceeds **–$129.75 million**

Based on these figures, our screenwriter and producer would not share in the film's profits because, per the customary net proceeds definition, the film would still be in the hole to the tune of $129.75 million,[19] even though the film, having earned $700 million at the worldwide box office, would be among the top grossing films in any given year. Our director, however, will have earned $5.25 million in cash break zero gross proceeds. As for the studio, it recouped all $455 million of the gross receipts (thanks to its distribution fee and recoupment of its distribution expenses and part of its negative cost), *less* the amounts paid in gross proceeds participations payable to the actor and director, which equal $28 million. The studio, however, also received the 80 percent of home video money that never went into the pot in the first place, or $120 million. This means the studio received a total of $547 million, about $200 million more than it spent to produce and distribute the movie.

MOTORS RUNNING

MONEY THAT GOES INTO THE REVENUE POT

Total worldwide film rentals ... $56.25 million
Total revenues from television distribution $15 million
Total revenues from home video = 20% of $30 million = $6 million
Total revenues from other sources ... $5 million[20]

Total revenues in the pot ...**$82.25 million**

DEDUCTIONS FROM DEFINED GROSS

35% distribution fee[21] (35% of $82.25 million) $28.8 million

Distribution Expenses = Actual distribution costs = $50 million +
　10% advertising overhead fee =
　10% of $40 million = .. $4 million

Total Distribution Expenses .. $54 million

Negative Cost = Actual production cost $60 million +
 15% overhead fee...$9 million +
 Gross participation (director) =
 5% of cash break zero gross = $0 +
 Interest – hypothetically we'll say $1 million

 Total Negative Cost ... $70 million

Total deductions from revenues **$152.8 million**
Revenues – Deductions = Net Proceeds **−$70.55 million**

In this case, all of our filmmakers receive nothing. As for our hypothetical studio, it spent $110 million in production and distribution costs and kept all the $82.25 million that went into the revenue pot (thanks to its distribution fee and recoupment of its distribution expenses and part of its negative cost), along with the 80 percent of home video income that never went in, i.e. $24 million, for a total of $106.25 million. On this project, the studio lost $3.75 million.

WEIRD HAPPENINGS

MONEY THAT GOES INTO THE REVENUE POT

Total worldwide film rentals .. $36 million
Total revenues from television distribution $25 million
Total revenues from home video = 20% of $50 million =...... $10 million
Total revenues from other sources....................................... $5 million[22]

Total revenues in the pot... **$76 million**

DEDUCTIONS FROM DEFINED GROSS

35% distribution fee[23] (35% of $76 million) $26.6 million

Distribution Expenses = Actual distribution costs............. $10 million +
 10% advertising overhead fee =
 10% of $9 million.. $.9 million
 Total Distribution Expenses ... $10.9 million

Negative Cost = Actual production cost $5 million +
 15% overhead fee... $.75 million +
 Gross participation (director) =
 5% of cash break zero gross =
 5% of $61 million =.. $3.05 million +
 Interest – hypothetically we'll say $.5 million

Total Negative Cost ... $9.3 million

Total deductions from revenues **$46.8 million**

Revenues – Deductions = Net Proceeds **$29.2 million**

Now everyone is happy. The screenwriter, who has the right to receive 5 percent of the net proceeds, will pocket 5 percent of $29.2 million, which equals $1,460,000. The producer, who gets 10 percent of the net proceeds, will receive $2,920,000 million. And our director receives $3,050,000.

What conclusions can we draw from these examples? Can we say that all low-budget films end up making enough Defined Gross to pay net proceeds? Of course not, though if you do produce the next *Paranormal Activity*, which cost next to nothing to make but earned hundreds of millions of dollars worldwide, then you will end up a very wealthy person.

What can be said is that the overwhelming majority of films do not pay net proceeds to those who have a net proceeds participation in their contract. This doesn't mean you shouldn't negotiate to receive a net proceeds participation, but I wouldn't buy a house on the French Riviera expecting to pay it off with net proceeds income.

Finally, we can say studios make out far better than do almost all profit participants. Of course, filmmakers do receive a salary for their work, and often a very handsome salary at that. Moreover, studio executives will argue that studios must absorb losses—sometimes huge—on films that don't pan out, while the filmmakers always come out ahead thanks to their salary.

People can debate the economic merits and whether these profit definitions are fair or unfair. What can be said with certainty is that, in the business world, where people contract with each other voluntarily, contractual terms like profit participation will be decided by the relative strengths of the negotiating parties and the desire each has to make a deal. No one has to sign a lousy net proceeds definition, but most do because they believe it's in their overall interest to sign a deal.

NOTES

1 There are many wonderful books about independent filmmaking that can help you, including *Make Your Movie: What You Need to Know about the Business and Politics of Filmmaking*, by Barbara Freedman Doyle (Elsevier, Inc. 2012); Jon M. Garon, *The Independent Filmmaker's Law and Business Guide* (Chicago Review Press 2009); Reed Martin, *The Reel Truth* (Faber & Faber 2009); Christine Vachon, *Shooting to Kill* (William Morrow Paperbacks 1998).

2 "Cuts and previews" refers to how many times the director can edit the film (or "cut" it) into a specific version that can be shown to a preview audience. See page 247.

3 Standard contract law poses a number of issues for attorneys and filmmakers, including whether an oral contract may be enforceable (answer: sometimes) or whether an otherwise insufficient agreement may nevertheless create legal liability for a party who refuses to perform (answer: sometimes). See, e.g., *Elvin Associates v. Aretha Franklin*, 735 F. Supp. 1170 (S.D.N.Y. 1990); *Gold Seal Productions v. RKO Radio Pictures*, 134 Cal.App.2d 843 (2nd Dis. 1955).

4 See generally, Paul C. Weiler and Gary Myers, *Entertainment, Media and the Law: Text, Cases, and Problems*, 4th edition, pages 596–617 (West 2011).

5 See paragraph 3 of the Net Proceeds definition you can read online at http://focalpress.com/cw/bernstein.

6 Studios will make some minor changes in their Defined Gross definition, as well as their gross and net proceeds definitions, depending on the clout of the filmmaker and the nature of the negotiation. Therefore, the definitions here may be tweaked in any individual agreement.

7 In point of fact, even with first dollar gross participations, certain Defined Gross revenues may be taken off the table by the studio to cover certain costs. But these amounts are minor, and thus I've left them out of the calculation.

8 Like everything else in a contract, the exact definition of cash break zero is subject to negotiation by the parties. The definition given in the text, therefore, could be tweaked if the parties so desire. It's also worth noting that, because studios continue spending money on distribution after a film is released (e.g. advertising continues), the cash breakeven point changes from day-to-day. Contractual definition of when cash breakeven occurs may take into account the fact that breakeven "rolls" over time.

9 See paragraphs 2 and 4 of the Net Proceeds definition you can read online at http://focal press.com/cw/bernstein.

10 See paragraph 5 of the Net Proceeds definition you can read online at http://focalpress. com/cw/bernstein.

11 Deferments are a form of contingent compensation like gross and net proceeds—participations that filmmakers often negotiate in their contracts. Unlike profit participations, which are defined as a percentage of applicable revenues, deferments are typically set dollar amounts that become payable if and when a specific revenue benchmark is hit. For example, a writer might negotiate to receive a $50,000 deferment if and when a film's box office receipts equal $100 million.

12 See paragraph 9 of the Net Proceeds definition you can read online at http://focalpress. com/cw/bernstein.

13 Other costs may be deducted as well per a net proceeds definition, but these costs are far more insignificant than the costs included in the text and thus need not concern us here.

14 See paragraph 2 of the Net Proceeds definition you can read online at http://focalpress. com/cw/bernstein.

15 "2013 Worldwide Grosses," *Box Office Mojo*, last accessed on June 17, 2014, http://www. boxofficemojo.com/yearly/chart/?view2=worldwide&yr=2013.

16 I have also assumed the revenues from "other sources" all go into Defined Gross, though this would almost certainly not be the case. For example, if some of this "other source" revenue came from merchandising, only 50 percent would be included in Defined Gross. I have included 100 percent of these revenues, however, simply because the "other source" revenue in these examples is sufficiently small to not significantly change the overall outcome.

17 See footnote 15 above.

18 Recall that cash break zero occurs when gross proceeds equal the actual production and distribution costs. In this example, cash break zero would therefore occur when gross receipts equal $350 million. Since gross receipts actually equal $455 million, that means there are $105 million in excess of cash break zero. Since the director is entitled to 5 percent of this amount, he is entitled to receive $5.25 million.

19 Note that after taking its distribution fee and distribution expenses and paying the two gross proceeds participations, there wasn't enough money left in the pot for the studio to fully recoup its negative cost. Thus, the studio would say it's in the hole to the tune of $129.75 million, because that's the amount of negative cost that has yet to be recouped.

20 I have also assumed the revenues from "other sources" all go into Defined Gross, though this would almost certainly not be the case. For example, if some of this "other source" revenue came from merchandising, only 50 percent would be included in Defined Gross. I have included 100 percent of these revenues, however, simply because the "other source" revenue in these examples is sufficiently small to not significantly change the overall outcome.

21 See footnote 15 above.

22 I have also assumed the revenues from "other sources" all go into Defined Gross, though this would almost certainly not be the case. For example, if some of this "other source" revenue came from merchandising, only 50 percent would be included in Defined Gross. I have included 100 percent of these revenues, however, simply because the "other source" revenue in these examples is sufficiently small to not significantly change the overall outcome.

23 See footnote 15 above.

CHAPTER 12
Entertainment Contracts

INTRODUCTION

Having examined profit participations, let's now look at other important terms usually included in contracts for rights acquisition, for writers, directors, actors and producers. We'll start with option/purchase agreements, since these are often the very first agreements negotiated in connection with an entertainment project.

Please note that the contracts discussed in this book are all film-related contracts. Why make this choice? Because many readers may be interested in independent filmmaking and might one day be directly responsible for negotiating several kinds of contracts. Making an independent television show is nearly impossible, so for those of you who end up in television, odds are you won't be responsible for negotiating agreements other than your own, which the television production company will prepare for you and which tend to be rather standard. Having said that, the discussion that follows will benefit people who end up working in television. And for those who want to take a closer look at television contracts, I suggest consulting *Contracts for the Film and Television Industry,* written by Mark Litwak, and *The Business of Television*, written by Howard Blumenthal and Oliver Goodenough.

RIGHTS AGREEMENTS: OPTION/PURCHASE CONTRACTS
What It Means to Option a "Property"

Option/purchase agreements are extremely important and frequently used in Hollywood. Simply stated, an option/purchase agreement permits studios, producers and others to develop interesting material that already exists but which someone else owns.

People who create entertainment are always looking for the next great project. Their job is to find and corral it before someone else does. The option/purchase agreement allows people to take legal possession of a project, at least for a while, and at a reasonable cost.

The existing project, or "property" as it's called in Hollywood, may be an original treatment or screenplay, or a book, magazine article, comic book, short story or game—anything that someone believes can be adapted into a great entertainment production.

Regardless of what the property is, the process of developing it usually takes a lot of time and money. As should be obvious, if you're going to devote your energy and hard-earned dollars to developing a property, you'd better make sure you avoid legal problems. And foremost among these legal problems is copyright.

When thinking about copyright in this context, it's actually quite apt to refer to pre-existing screenplays, books or other works as "properties." No one would ever develop real estate unless they owned the property in question or had permission from the landowner. Likewise, if you're going to develop a property in the entertainment business, you'd better own that property or else have permission from whoever does. To go forward and produce a project based on a work you don't own would inevitably violate the copyright owner's exclusive right to copy the work, make a derivative work or distribute the work—or likely all three.

So let's say you're a producer and you want to make a movie based on a great book you just read. Let's further assume the book is still protected by copyright. Clearly, you're going to have to go to the copyright owner—usually the author[1]— and negotiate a deal to purchase all the rights you need to make and distribute a film based on the book.

Purchasing these rights, however, generally costs a lot of money. In the case of books or screenplays, you can pay anywhere from $50,000 to $500,000, and sometimes much more if the work is in very high demand.

Naturally, buyers don't want to spend this kind of money unless they know *for sure* they're making a movie. The problem is, no one can ever be sure at the start of the development process. Far too many things must serendipitously come together for projects to get made—the script must turn out well, an acceptable director and cast must want to work on the movie and be free to do so at the same time, and there's always the issue of finding the necessary financing.

Because of this tremendous uncertainty, no reasonable person would spend a ton of money to purchase rights when they start to develop a book or screenplay. So, producers do something different—instead of buying the rights, they "rent" them for a while.

How do you "rent" rights from a copyright owner? You do it by negotiating an option/purchase agreement. These agreements permit producers to option the required rights for a defined period of time, which costs far less than actually

purchasing the rights. Producers then develop the property during the rental or "option period"; they have screenplays written or rewritten, try to interest stars, and search for financing. If things work out, the producer has the choice before the defined option period ends to plunk down a lot of money and actually buy the necessary rights. Or, even better, if during the option period the producer has interested a studio or other financing party in the project, the studio or financing party will pay the money to buy the rights, which is great because most producers don't usually have a couple of hundred thousand dollars in cash lying around.

If, however, what seemed liked a promising project turns out to be a dud, then the rights will never be purchased and the option period will end. And when the option period ends, that's that—the producer no longer owns any rights to the property, and the copyright owner regains full ownership of the property's copyright.

Let's be clear about this: Say a producer options a book, pays to have a script written, then lets the book option expire without actually purchasing the rights. When the option expires, the producer will have no rights in the book but will own the screenplay as a work for hire. But can the producer exploit the screenplay by producing it? The answer is no. The screenplay is a derivative work of the book, and in order to distribute a derivative work one must have the necessary rights from the copyright owner. However, the producer lost all rights when the option expired. Thus, the producer owns a script but has no right to do anything with it.

We'll now turn to a point-by-point examination of the key provisions that generally go into these agreements. Though what you are about to see may seem like a daunting list of provisions, understand the following: This book does not seek to make you an entertainment attorney. Rather, the hope is that you come to broadly understand what goes into these agreements and why. Therefore, the text will cover each of these provisions briefly and generally. Additionally, you should know that some of the terms that go into option/purchase agreements also go into other types of agreements, including those discussed later in the text, so discussing them here means we won't discuss them later on. Finally, you should understand there are several ways you can write a contract and no one version may be better than another. Therefore, the versions discussed in this book and provided at focalpress.com/cw/bernstein, which are amalgams of actual studio agreements, represent only one way that agreements can be constructed.

Here is a list of important provisions commonly found in option/purchase agreements:

- Conditions precedent
- Exclusivity

- Option periods—initial option period and option extension periods
- Option period costs
- Permitted option period activities
- Exercise of option
- Purchase price—fixed compensation
- Purchase price—contingent compensation
- Grant of rights
- Reserved rights
- Payments for movie sequels, remakes
- Warranties, representations and indemnities
- Credit
- Consultation/approval rights
- Travel and perks
- Reversion
- Force majeure
- Right to assign
- No obligation to produce

Conditions Precedent

As mentioned earlier, sometimes one entertainment deal, such as an option/ purchase agreement, hinges on finalizing another. For example, a producer may want to option the rights to a book or screenplay but not want to commit to the agreement unless a deal for a particular screenwriter can be completed. Obviously, the screenwriter's deal could be negotiated first, but anxious producers often want to option a property right away so no one else can beat them to it.

The solution is to negotiate the option/purchase agreement but make it conditioned on successfully concluding and signing the screenwriting deal. The language of this provision will say the agreement itself only goes into full force and effect if and when the screenwriting deal is signed, which means until that happens the option period will not begin nor will any money exchange hands.[2]

While not all rights owners may want to agree to this sort of pre-condition, most will if you're the only party interested in optioning the property.

Exclusivity

Option/purchase agreements will include a provision that says whether the option is "exclusive" or "nonexclusive." An *exclusive* option means that, during the option periods, *only* the optioning party has the right to develop the property and potentially purchase the rights described in the contract—no one

else in the world can touch the property while the option/purchase contract is in effect. If, however, the option is nonexclusive, then someone else may be granted a similar option to purchase the very same rights, and whoever pays the purchase price first will own the rights. People in the entertainment business who option rights always do so on an exclusive basis, since no one wants to spend time and money developing a property only to find that someone else has bought the rights to it.[3] Therefore, it's very important that contracts say the option is exclusive.

Option Periods—Initial Option Period and Option Extension Periods

People who option rights do so for defined periods of time. Therefore, provisions in option agreements must say how long these time periods last.

The initial time period is usually called, not surprisingly, the "initial option period," and often lasts for one year, though it can last for whatever time period the parties negotiate, such as 6 months or 18 months.[4]

Because it usually takes longer than 6, 12 or even 18 months to develop a property, option/purchase agreements usually allow the optioning party, at his or her sole discretion, to extend the option period by an additional length of time agreed to by the parties. For example, a "first option extension period" could add another 6, 12 or 18 months to the option period. Sometimes, parties even negotiate a "second option extension" period.

If there are extension periods in the agreement, *the optioning party must always elect to extend the option while the previous option period is still in effect*; if an option period ends without an election to extend it, the deal is over and done.

Option Period Costs

Option/purchase agreements include a provision that spells out how much money each option period will cost the optioning party. For example, the parties might agree that the initial option period will cost the optioning party $5,000, the first option extension period will cost the optioning party an additional $10,000, and the second option period will cost an additional $15,000.[5] If each of the three option periods last one year, then in this example $30,000 would buy the optioning party three years to develop the project, a price far less then what the purchase price of the rights would normally be.

Option costs do vary widely. I have seen option periods cost anywhere between $0 and $25,000 or more. When someone wants to option a property that is in very high demand, then the option can cost a lot of money.

However, when someone wants to option a property that is old or no one wants or has never heard of, or if a student just out of film school wants to option a friend's script so she can try and produce it, then free option periods can be negotiated. Why would a rights owner option a property for free? Put yourself in the owner's shoes: If someone suddenly shows interest in your property for the first time ever or for the first time in a long time, and the person asks for a free option period, it might just be worth it. Perhaps the person can develop the property into something that's produced. If so, then the rights will have to be purchased at some time in the future for some real cash. If, however, nothing comes of the project, then what has the owner lost? The owner's lost nothing if no one else has been knocking on the door wanting to option the property.

Regardless of the option costs negotiated by the parties, another issue that comes up is whether or not the negotiated option costs are "applicable" against the purchase price. If option costs are "applicable," this means they are deducted from the purchase price should it ever be paid. Stated another way, if you negotiate applicability and if the rights are actually purchased, the purchase price will be reduced by the previous option payments.

Here's the producer's argument for why option payments should be applicable against the purchase price: The producer is paying the option money to have the right to develop the project for a period of time. The rights owner gets to keep that money regardless of whether or not the property is ever produced. But if it is produced, then the negotiated purchase price (which we'll discuss shortly) is the *total* amount the owner should receive, not the purchase price plus the options costs.

Needless to say, rights owners will reject applicability of option costs if they have the power to do so. When one is dealing with a large production company such as a studio, one rarely has this power. Sometimes, however, the parties can compromise and make the initial option period cost applicable but not the option extension period costs.

Permitted Option Period Activities

Parties will usually explicitly say in the option/purchase agreement what specific activities the optioning party can perform during the option periods—such as having a script written and circulated.[6] Recall that any exploitation of the owner's copyright without permission can be considered copyright infringement; parties therefore try to avoid misunderstandings by spelling out specifically what development and pre-production activities are acceptable during the option periods. Alternatively, parties sometimes very briefly say in the contract that the optioning party can engage in all "customary development and pre-production activities" and simply leave it at that.

Exercise of Option

This provision says the optioning party may at any time during any of the option periods exercise the option and actually purchase the rights. To do this, the optioning party must usually notify the owner in writing and include full payment.[7]

Purchase Price—Fixed Compensation

If the optioning party wants to exercise the option and actually purchase the rights, the purchase price usually includes two components: "fixed compensation" and "contingent compensation." We'll address the latter momentarily and focus now on the fixed compensation, which simply means cash.

The purchase price always includes a cash amount, which as previously mentioned usually ranges between $50,000 for very low budget films and $500,000 or more for expensive studio pictures. What determines the exact price? The main factors are (a) whether the property is in high or low demand; (b) whether the property owner has sold similar projects in the past, and if so, at what price; and (c) whether the production will likely be expensive or inexpensive.

Let's look more closely at the issue of how a production's anticipated cost can impact the property's purchase price. Generally speaking, a rights owner will more readily accept a low purchase when the project's expected budget is low. It's a lot easier to get a rights owner to accept a $100,000 purchase price if the project's budget will be $10 million rather than $100 million. The problem is, when development begins, people may not know what the future holds; they may think, for example, that they're developing a low-budget film, but everything may change should a huge star get involved. While this rarely happens with studio films, it can happen with independent films. Given that the project's ultimate budget may be unknowable when the contract is negotiated, parties often don't want to tie themselves down to a specific fixed purchase price.

The way parties can solve this problem is to determine the fixed compensation—the cash purchase price—by using a mathematical formula tied to the project's actual final budget. For example, I have seen deals where the purchase price of the rights ranges somewhere between 1.5 and 2.5 percent of the project's final budget. Thus, if the parties accept a 1.5 percent calculation and if the final budget is $20 million, then the purchase price of the rights would be $300,000.

Still, using this sort of formula doesn't solve everything. That's because if the budget should reach, let's say, $100 million, then a 1.5 percent formula would trigger a purchase price of $1.5 million, an amount much higher than producers and studios are usually willing to pay. Conversely, if the budget ends up being only $1 million, then the purchase price would be $15,000, an amount far below what most rights owners are willing to sell at. The solution: Say that the purchase price will equal a percentage of the budget, but also that in no

event can the purchase price be smaller than a "floor" of "X" amount and no greater than a "ceiling" of "Y" amount. X and Y might be $75,000 and $500,000 respectively, or any other amounts the parties choose. In this way, the purchase price will be greatly affected by the project's final budget, but in no event will it get too low or too high.[8]

What if you didn't bother negotiating a purchase price up front but agreed to deal with this issue when time passed and more was known about the project? Here's the problem: If you don't build in a purchase price from the beginning, then the producer has no guarantee she'll be able to buy the rights in the future. Who knows what purchase price the rights owner will eventually ask? And if you were a rights owner and you knew a project was going to be produced based on your property, what might that do to your asking price for the rights? Most likely it would send it sky high. Therefore, the purchase price must be negotiated and included in the contract from the get-go.

Purchase Price—Contingent Compensation

Contingent compensation is exactly what the name suggests—compensation that isn't guaranteed but instead depends on something else happening. In other words, contingent compensation is speculative and may never be paid at all unless the contingency in question actually happens.

In the previous chapter we discussed a very important kind of contingent compensation—profit participations. Rights owners usually receive a profit participation in their contracts, either 5 percent of the net proceeds or 2.5 percent of the net proceeds. The exact amount is simply a function of whatever the parties choose to negotiate, but either 2.5 or 5 percent of the net is customary.[9]

The second type of contingent compensation that might be negotiated, usually called a "deferment," entitles the rights owner to receive a cash amount—it might be $10,000 or $25,000 or more—if certain revenue benchmarks are hit, such as when a film earns $100 million dollars in total box office. Not all option/purchase agreements will include deferments; as with everything else, they are subject to negotiation.

Grant of Rights

This provision is extremely important and absolutely requires the assistance of an experienced attorney. The provision describes in detail the exact copyright interests in the property that will be transferred to the optioning party if the option is exercised and the rights purchased. Financing entities, including studios, care tremendously about the specific rights they own, so the grant of rights must include a bevy of rights, including the right to make film and television adaptations of the work, to produce sequels, remakes or other productions based on those adaptations, to distribute any and all productions in all forms of

media "whether now known or later invented," and to fully market and distribute the work. Additionally, all of these rights will be granted "in perpetuity" and "throughout the universe," meaning the rights are granted forever and without any geographical limitation.[10]

Reserved Rights

Rights that are not granted to the buyer per the above provision are called "reserved rights," and these rights are typically spelled out in the agreement. Where, for example, the property is a book, the book author will usually reserve the right to publish the book, to write and publish sequels, and to make a stage play based on the book.

Payments for Sequels and Remakes

As mentioned above, the grant of rights will typically include the right of buyers to make sequels, remakes and other secondary productions based on any produced adaptation of the property. If, for example, you buy the rights to a book and make a movie and the movie is a big success, odds are you may want to produce a sequel to that film, or perhaps a television show based on the film. When sequels, remakes or other secondary productions are made, the rights owner usually receives some kind of payment. For sequels, the payment typically equals half the rights purchase price. For remakes, the payment usually equals one third of the purchase price.[11]

Representations, Warranties and Indemnities

When you buy a product, the manufacturer warrants that the product is free from defects. So, too, when buying rights. What kind of "defects" might a book or other property have? Theoretically, the book could be plagiarized, which means it may infringe someone else's copyright. Or, the book may libel a third party or invade someone's privacy. It's also been known to happen that a rights owner purports to sell certain rights to party "A" when those exact rights were in fact previously sold to party "B." Therefore, the rights owner must warrant and represent in the contract that the property doesn't infringe any copyright, doesn't libel or invade anyone's privacy, and that the owner indeed has the authority and the right to option and potentially sell the rights mentioned in the agreement.[12]

What if the rights owner represents and warrants something in the contract that isn't true? What if, for example, a rights owner represents that his work doesn't infringe someone else's copyright when in fact it does? Then the buyer may be sued and have to pay court-ordered damages if the buyer makes a film based on the property.[13] The indemnity provision says that, if this happens, the rights owner must reimburse, or "indemnify," the buyer for whatever amount the buyer was required to pay.[14]

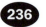

Credit

Rights owners usually receive screen credit. For example, if the rights owner is a book author, then you'll likely see this credit in the film: "Based on a Book By _____." The parties negotiate whether the credit will go in the main title or end title credits,[15] whether it will appear all by itself on screen or share the screen with other credits, what size the credit will be, and whether or not the credit will appear in any or all of the advertising, such as posters, billboards and television ads. Subject to the various rules and restrictions of the Guild agreements, established book authors often receive a contractual right to receive credit in the same size as the screenwriter's credit and in all paid advertising where the screenwriter's credit appears.[16]

Consultation/Approval Rights

This provision deals with what power the rights owner has to creatively impact a production once a contract is signed.

As should come as no surprise, everyone involved in a production would like to have a significant say in how it unfolds. Everyone would like to choose the cast, or the director, or have the right to change the script. Ultimately, however, only a very few people get to exercise creative control, and usually the rights owner isn't one of them.[17]

When negotiating an option/purchase agreement, the rights owner may try to take some creative control by negotiating a contractual right to approve the final script, approve cast members or approve a director. If granted, this means the rights owner will have veto power over who is hired to direct and act in the film and what the final script will look like. Such approval rights are hardly ever granted. Production companies that foot the enormous bill for projects will only rarely grant such power to others, including rights owners. Therefore, if you negotiate a rights agreement, you should generally not give approval rights to the rights owner.

Instead, the rights owner is far more likely to receive a "consultation" right. This means that the rights owner will have the opportunity from time to time to talk with the powers that be so he can hear what's going on and offer advice. That advice, however, need not be taken.[18]

Travel and Perks

If the rights owner is asked to travel for any reason, this provision describes whether she'll fly first class or coach, what caliber hotel she'll stay in, and how much spending money she'll be given per week. Contracts also address whether the rights owner will get to attend the movie's premiere, and if so, what air travel, hotel and per diem she'll receive.[19]

Force Majeure

"Force majeure" is a French term that literally means "greater or superior force"—in other words, a force beyond anyone's control. In the entertainment world, a "force majeure" is some kind of catastrophic event, such as an earthquake, a flood or other natural disaster, or a man-made disaster like a riot or terrorist attack. A force majeure provision in an option/purchase agreement usually says the parties can suspend or even terminate their agreement should a force majeure event occur. Sometimes parties agree the contract may be suspended for only a certain amount of time if a force majeure event happens, perhaps up to six months, but after that six-month period ends the contract resumes. Sometimes these provisions say if a force majeure event lasts a defined length of time, a party can choose to terminate the contract altogether.[20]

Right to Assign

This provision allows a party, usually the buyer, to transfer its entire interest in the contract to a third party. When this occurs, the third party assumes all of the assigning party's contractual rights and obligations.

This is a critically important clause for producers. Assume, for example, that a producer loves a book and negotiates an option/purchase agreement with the author. Assume further that the development process goes extremely well and now a major studio wants to make the project. This means the rights to the book will have to be purchased. Producers often don't have the cash to purchase the rights, but studios do. So, during the option period, the producer will assign his interest in the option/purchase contract to the studio.[21] The studio will then assume all of the producer's rights and obligations, including the obligation to pay the purchase price.[22] In the end, the studio gets a project it wants and is prepared to pay for, and the producer usually gets a producing deal from the studio in return.

No Obligation to Produce

Sometimes you'll see a provision in option/purchase agreements that say the buyer (or, of course, an assignee if there is one) is under no obligation to actually produce anything based on the property. Very protective attorneys insert this clause just to make sure everyone understands no promises of any kind regarding possible production have been made.[23]

Options and Life Rights Agreements

Filmmakers often want to make movies and TV shows about real people. A person's life, therefore, becomes the underlying "property" on which the project is based.

We can all agree a person's life is not a work of authorship fixed in a tangible medium of expression. An autobiography is, but a *life* isn't. Therefore, a life is not copyrightable like a book or screenplay. There are, however, rights we all have as human beings—the right to privacy, the right to publicity, the right to be free from defamation—that a film might violate were it to depict us.

Producers therefore often sign what are called "life rights" agreements with living people who will be portrayed in a film or TV show. These agreements are often structured as option/purchase agreements under which the "life rights" are first-optioned and can be bought later if the producer so desires.

There are two important provisions that are specifically included in a life rights option/purchase agreement. The first explicitly allows producers to embellish and fictionalize the person's life. Needless to say, some life rights owners are very queasy about including this provision, but it's a must because writers routinely need the freedom to take "creative license" and alter facts to make a film or TV show entertaining.

The second, usually included in the warranties and representations portion of the agreement, includes an explicit promise that the life rights owner will never sue for invasion of privacy, invasion of the right to publicity, or defamation.

In return for the right to fictionalize and the prohibition against lawsuits, the life rights owner will receive money. If the deal is structured as an option/purchase agreement, then the option fees and purchase price will roughly mirror what we've previously discussed. Purchase prices can range from a very small amount for someone who will be briefly depicted in a film to hundreds of thousands of dollars when the entire film documents that person's life.

Some producers may pause and ask if the payment of money is really necessary. They might think they can fictionalize the story to such a degree that the real person's identity in the film can be "disguised," that the film therefore won't invade privacy or defame and thus the person's life rights won't need to be purchased. Of course, many stories have value specifically because they are well known to the public and can be marketed as true stories. In these cases, the living person's name is a big selling point so large-scale fictionalization isn't feasible. Where, however, the identity of the living person is not well known and not really needed, then large-scale fictionalization is a possibility—provided the living person's true identity is so utterly and completely changed that no reasonable person could identify who the on-screen character really is.

It's been my experience that producers would much rather negotiate agreements with life rights owners than try to fictionalize to such a degree that the living person (or people where more than one living person is depicted) isn't recognizable. There are many reasons for this. First, such wide-scale

fictionalization can injure the truth of the story. Second, if you sign life rights agreements, the real people can help the production by serving as advisors and providing valuable information. Third, companies that insure productions against legal claims will often require signed life rights agreements as a precondition to issuing an insurance policy, which is something distributors will routinely require.[24] Fourth, you'll sleep better at night if you don't have to worry about being sued.

The complete terms of a life rights option/purchase agreement will essentially mirror the terms mentioned above, with the inclusion of the right to fictionalize the life story and the prohibition against filing lawsuits for defamation and invasion of privacy.

AGREEMENTS FOR SCREENWRITERS

Screenwriters can be hired to write new scripts from scratch, to rewrite someone else's script, or to rewrite their own script. Since studios and producers can't hire you if they don't know you and won't hire you if they don't respect you, only successful writers—usually WGA members—get paid by studios and large production companies to write brand new scripts or rewrite existing scripts.

Writers, however, can start their career by writing scripts in their own time and then shopping those scripts to film and TV producers. This is called writing on "spec," or speculation, because the writer is guaranteed absolutely nothing when he first starts typing.

If a TV company becomes interested in a spec script, say a proposed episode of a series already on the air, the writer might be hired on a freelance basis to write a single episode of the series, or possibly be invited one day to join its writing staff. If the spec script is a pilot episode of a proposed new series, a television production company could buy the script with the intent to produce a pilot and hopefully start a new series, though this rarely happens.

If a film company likes a spec script, two things can happen. First, if several companies badly want the script, one of them may purchase the rights at the very beginning. This means giving the writer a very big check. Sadly for writers, this rarely happens. Instead, in the absence of a bidding war for the script, a producer or company will option the rights just like a book or any other existing property and, at the same time, usually hire the writer to make whatever script changes the company wants (indeed, if the writer is a WGA member, she must get the first chance to rewrite). In these cases, the option/purchase agreement for the existing screenplay will look like the rights agreement we previously discussed. The difference is that if the writer is paid to rewrite the draft, a writing services agreement will be included to cover the writing services.

Regardless of whether a screenwriter is hired to make changes to her own spec screenplay or changes to someone else's screenplay or to write a brand new screenplay, a film writing services contract will look pretty much the same. Here is a list of the most important provisions usually included in screenwriting agreements:

- Conditions
- Guaranteed writing services
- Optional writing services
- Writing periods
- Reading periods
- Exclusivity
- Compensation—fixed, bonus and contingent
- Credit
- Work for hire—grant of rights/results and proceeds
- Right of first negotiation
- Warranties, representations and indemnities
- Travel and perks
- Force majeure
- Right to assign
- Certificate of authorship

Let's take a closer look at these provisions.

Conditions Precedent

This provision in screenwriting deals is no different conceptually from the same provision we discussed in relation to option agreements—the deal becomes legally binding only if and when the conditions described in the provision are satisfied. Script deals are most often conditioned on either (a) successfully concluding an option agreement for a book or other underlying property on which the script will be based, or (b) successfully concluding one or more creative meetings between the writer and the producer or other interested parties; if those meetings don't go well and the parties don't see eye to eye creatively, then the optioning party will have the right to terminate the deal.

Guaranteed Writing Services

This part of the contract details the specific writing services the writer is guaranteed to perform and be paid for. For example, the writer may be guaranteed to write just one draft—and that's it, over and out. Or the writer may be guaranteed to write a draft and then, after the producer and others have made comments, a rewrite, or maybe a rewrite and then later a polish.

The more guaranteed work, the more the writer will be paid, so you can guess what the writer is rooting for. Unfortunately for writers, while in the past they were often guaranteed at least two or more writing passes at a project, now it's far more likely they will only be guaranteed one.[25]

Optional Writing Services

While producers may only want to guarantee one specific piece of writing, they may also want the option of having the writer continue with the project if things are going well. Thus, writing contracts frequently include an option for additional writing services that only the producer can exercise. Optional writing services may include rewrites, a polish, or a so-called set of revisions, which loosely speaking is something less than a full rewrite and something more than a quick polish.[26]

Writing Periods

The contract will say how long the writer gets to complete each piece of guaranteed or optional writing. For example, the writer might get 12 weeks to complete a first-draft screenplay, eight weeks to complete a rewrite, and just two or three weeks to complete a polish.[27] While producers always want work handed in on time, I have never yet heard of serious repercussions because work was handed in late. Handing in work on time is great; handing in great work is better.

Reading Periods

After the writer hands in a completed piece of writing, the producer will have a period of time, usually four weeks, to read and evaluate the script. If the writer has been guaranteed another piece of writing, then the producer will provide notes to the writer towards the end of the reading period and the writer will set to work making changes. If no additional writing services have been guaranteed but the producer has the option to have the writer do more work, then the option must be exercised before the end of the reading period.[28]

Exclusivity

Contracts usually provide that a writer renders services exclusively to the producer during all writing periods. This means that, when actually writing on a paid project, the writer may not work for anyone else. During all reading periods, the writer's services are usually nonexclusive, which means during this time the writer can work for others.[29]

Compensation

Writers usually receive both fixed and contingent compensation. Professional writers who have been previously employed always make known their last set of writing fees, called "quotes," as these fees serve as a baseline for the next agreement's negotiations.

Fixed Compensation

Fixed compensation is the cash amount paid to writers for each piece of writing actually performed. Contracts normally provide that producers pay one half of the fixed compensation when the writer starts working on a piece of writing and the other half when the writer delivers it. The parties must also negotiate whether any or all of the fixed compensation will be applicable against possible future compensation, such as the bonus compensation described directly below.[30]

Bonus and Contingent Compensation

Screenwriting contracts usually include a provision stating that the writer will receive a cash bonus plus a contingent net proceeds participation if (a) the film is actually made, and (b) the writer receives either "Screenplay By" credit or "Written By" credit on the film.[31] Normally, the bonus will be one amount, say $200,000 plus 5 percent of the net proceeds, if the writer receives *sole* "Written By" or "Screenplay By" credit, and half of that amount, or $100,000 and 2.5 percent of the net proceeds, if the writer *shares* "Written By" or "Screenplay By" credit. While the cash bonus amount for sole and shared credit will vary from contract to contract, it is customary for writers to receive 5 percent of the net proceeds for sole credit and 2.5 percent of the net proceeds for shared credit.[32]

Credit

As discussed on page 157, only the WGA can determine who gets screen credit when WGA members are involved. If a film production company does not sign the WGA agreement and hires non-union writers, then the writer's contract will reflect whatever the parties negotiate regarding credit.

Work for Hire—Grant of Rights/Results and Proceeds

As discussed in Chapter 1, when a producer pays someone to write a screenplay, that screenplay will be considered a work for hire and the producer will therefore own the screenplay's copyright if the contract includes specific work for hire language. Needless to say, every contract I've ever signed included a work for hire provision. Because producers fully own the copyright, they own all rights to the screenplay forever, in all media, throughout the universe and

beyond. Notwithstanding this, screenwriting agreements usually discuss in great detail all of the specific rights owned by the producer.[33]

Right of First Negotiation

Sometimes a writer can negotiate a provision that says, should either a sequel, remake or a television series based on the film be developed in the future, the writer will get the first chance to negotiate a deal to write the sequel, remake or television series. The provision might say this first negotiation right lasts for 30 days and that, if a sequel or remake is involved, the producer *must* offer at the very least the exact same terms included in the original deal. Usually, however, a writer only gets this first negotiation right if she is the only writer hired in connection with the original picture, or alternatively if she receives sole writing credit.

Warranties, Representations and Indemnities

Writers, like rights owners, must warrant and represent, among other things, that their writing will not infringe copyright, defame anyone, or invade someone's privacy. A writer must also agree to indemnify the producer should the writer breach any of these warranties.[34]

Travel and Perks

The screenwriter's agreement will include a travel and perks provision much like the one we discussed regarding the option/purchase agreement above. The WGA does provide that all Guild writers must receive first-class air transportation.[35]

Force Majeure and Right to Assign

These provision are the same as previously discussed.

Certificate of Authorship

Frequently, producers will ask writers to sign a one-or two-page document called a Certificate of Authorship. Writers are usually asked to sign this when writing services begin and first payments are made, which often occur long before the writing contract itself can be fully negotiated and signed. A Certificate of Authorship typically includes work for hire language as well as the warranties, representations and indemnities provisions. These, then, are the contractual terms that give producers complete ownership over the screenplay and protect them from various lawsuits. Writers should only sign a Certificate of Authorship after all the important parts of the writing deal have been fully

negotiated, drafted into a deal memo, and signed by the parties. In this way, both parties can feel somewhat protected, and can begin services and make payments confident that a long-form contract will be signed after the generally unimportant boilerplate language is negotiated.[36]

AGREEMENTS FOR DIRECTORS

Unlike television, where the executive producer clearly rules the set and directors work for and under the executive producer, film directors usually rule the movie set.[37] Stop for a moment and ask yourself which contractual rights a film director likely cares about most. If you answered having the right to make a film free from the creative interference of others, I think you're right. Only a handful of directors, however, enjoy such freedom, because the people who finance films usually want absolute authority over how their money is spent.

That said, here is a list of important provisions commonly found in a film director's agreement:

- Conditions precedent
- Services
- Exclusivity
- Compensation
- Pay or play
- Credit
- Approvals/consultation rights
- Cuts and previews
- Production requirements
- Grant of rights (a.k.a. "results and proceeds")
- Suspension and termination
- Publicity services
- Sequels and remakes
- Representation, warranties and indemnities
- Work for hire
- Right to assign
- Travel and perks

Conditions Precedent

In the case of a director's agreement, the conditions precedent can include receipt of signed agreements by a screenwriter, actor or producer, or for the necessary rights to a book or other property or for the necessary financing.

Services

Contracts will stipulate what specific services the director will perform and how long the director will have to perform them. The services themselves are usually of four types: development services, pre-production services, production services and post-production services. Development services happen first and primarily involve working with a writer to develop, change and finalize the script as well as enticing other talented filmmakers to join the project. Not all directors render development services; many are hired after development is complete and the studio has elected to make the film.

If a film does get made, the director will render pre-production services, which last several weeks and which include casting, rehearsals, location scouting and set building—everything necessary to get the production ready for filming. Production services, or services rendered during "principal photography," as contracts often say, cover the period of actual filming—on a low-budget film they may last as little as 3 weeks and on a high-budget film as long as 12 weeks or far more. Post-production typically lasts for many months and requires the director to oversee, among other things, editing, sound editing, visual and sound effects, recording additional dialogue (also known as ADR or "looping"), a musical score and songs.[38]

Exclusivity

Normally directors render their development services on a nonexclusive basis and all other services on an exclusive basis.[39]

Compensation

DEVELOPMENT FEE

If the director renders development services, she will receive a development fee, typically somewhere between $15,000 and $25,000 or more on moderately to high-priced projects. This development fee will usually be applicable against the fixed directing fee.[40]

FIXED DIRECTING FEE

If a project moves out of the development stage and is greenlit for production, then the director will receive a fixed directing fee payable proportionately during the pre-production, production and post-production periods. At the moment, the Directors Guild of America's minimum salary is just over $170,000 for directing films with budgets over $2.6 million, and star directors can command salaries of several million dollars. If the production is non-union, the producer and director are free to negotiate whatever salary they want.[41]

CONTINGENT COMPENSATION

Directors customarily share in their film's profits, if there are any, although the nature of their profit participation can vary widely. First-time directors may be able to negotiate a 5–10 percent net proceeds participation.[42] Star directors, on the other hand, may receive a percentage of the film's gross proceeds as discussed in Chapter 11.

Pay or Play

"Pay or play" is an important provision in any director's agreement. When a director becomes "pay or play," the director *must* receive her full fixed compensation regardless of whether the film is ever made or her services are ever used, unless the studio has the right to terminate the agreement because of a force majeure or the director's inability to perform. A contract's pay or play language describes when this right to full payment kicks in.

Directors want to go pay or play as early in the process as possible. Most will only go pay or play for their fixed compensation on the day principal photography begins; in other words, it's only when cameras start rolling that studios guarantee salaries. More powerful directors may go pay or play when pre-production starts or if and when a star actor goes pay or play. A very few directors may go pay or play when they sign a deal, which may be months before a production starts—if indeed it ever does.[43]

Credit

The DGA agreement stipulates that the director's "Directed By" credit must be the last credit on screen if main titles are used, or the first credit on screen if only end titles are used. The DGA agreement also mandates that the director must receive credit in all paid advertising.

Though not mandated by the DGA, many directors also negotiate for and receive an additional "Film By" credit. Also known as a "possessory credit," this credit usually appears just above or below the picture's title both on-screen and in paid ads, and if the parties so negotiate, on posters as well. It's a credit many writers have objected to for years, saying it's pretentious for any one person—the director or anyone else—to declare the film is, essentially, theirs. Other writers simply shrug and don't care.[44]

Approval/Consultation Rights

Very successful directors often receive the contractual right to approve the cast members, including the male and female leads. Some may even have the right to approve the final shooting script. All directors would love to have these approval rights, but not many get it; most have to settle for a consultation

right. Having said that, a director is hired ostensibly because she has expertise in visual storytelling; therefore, one would think the director's opinion concerning cast and script would carry a lot of weight with studios and financing entities. Generally it does. Despite this, studios usually reserve for themselves the *legal* right to make all final decisions, offering directors merely a consultation right.[45]

Cuts and Previews

Edited films are like scripts—the first draft often needs improvement. Films usually have to be edited and re-edited and re-edited again, just as scripts usually require a number of rewrites. All directors would love the right to edit and re-edit a film until they think it's done, and then require that version to go out into the world, but as a contractual matter perhaps fewer than five directors currently working have this legal right.

DGA directors are by Guild agreement entitled to complete one edit of the film and to preview that edit once before an audience.[46] If things are going well, the production company may happily keep the director on the job. However, if the director has the contractual right to only one cut and preview, then after that's done the production company has the authority to complete the editing itself.

Some directors may be given the right to two cuts and two previews, or three cuts and three previews. And a hallowed few—the true giants of the field—may receive the contractual right to "final cut," which means that if the distributor goes ahead and distributes the movie, it must send out into the world the director's final cut, no changes allowed. Given the amount of money it takes to produce and distribute movies, granting a director "final cut" puts all of the financing entity's creative and financial eggs into the director's basket, in the hope that the director's vision is what works best. On the other hand, the giants of the field have proved that their vision usually does.

Production Requirements

Production companies want to ensure the director will deliver a film that meets several desired specifications. Among these specifications are: Length—the contract will usually say the film must be no shorter that "X" minutes and no longer than "Y" minutes; Rating—the contract will stipulate what rating the film must receive; Budget—the director will have to agree to make the film within the stipulated budget; Screenplay—the director will have to agree that the film will adhere to the final approved screenplay; and Cover Shots—these are sanitized retakes of scenes that otherwise have nudity, graphic violence or explicit language; the sanitized retakes are used in versions of the film given

to airplanes, free TV or other revenue-generating venues where kids may be present.[47]

Grant of Rights

As with the other contracts we've seen, directors will grant all rights in and to their work to the studio.[48]

Suspension and Termination

Studios and producers usually negotiate the right to suspend and/or terminate a director's services for a variety of reasons, such as if the director is more than "X" percent behind schedule or "X" percent over-budget—often 10 percent in both cases. A director may also be suspended or terminated if, due to illness or for any other reason, he can't perform for a certain number of days, or if there is a force majeure event.[49]

Publicity Services

Though the following could be included in the "services" provision of the contract, it is often included in a separate provision that details what specific promotional and publicity work the director is obligated to perform. Usually directors render these services for no additional compensation, though the production company pays all travel, lodging and per diem costs. Additionally, production companies will routinely negotiate the right to use the director's name and likeness and biographical information in all advertising and promotion materials.[50]

Sequels and Remakes

Directing contracts often include a provision that gives the director a first negotiation and/or last refusal right[51] to direct a sequel or remake if he completes services on the first film on time and on budget, and also if he is still actively directing movies when a sequel or remake is produced.

Warranties, Representations and Indemnities

Since directors may change scripts either before or during filming, it is customary for directors' contracts to include the same kind of warranties, representations and indemnities provision that writers sign.[52]

Travel and Perks, Work for Hire and Right to Assign

These provisions will be the same as previously discussed.

AGREEMENTS FOR ACTORS

Acting agreements involve a different set of contractual issues from those we've already seen. Here are the most important provisions usually negotiated in an actor's agreement:

- Services
- Start date
- Compensation
- Pay or play
- Credit
- Dressing room
- Hair and makeup and wardrobe
- Still photograph and likeness approval
- Nudity
- Merchandising
- Representations, Warranties and Indemnities/Suspension and termination/force majeure
- Right to assign
- Travel and perks

Services

An actor's services are usually broken up into three distinct parts in an actor's contract: First, there will be a certain number of days or weeks for pre-production services, such as rehearsals and wardrobe fittings; second, there will be a certain number of days or weeks for principal photography, plus a certain number of so-called "free weeks" in case the production goes over-schedule; and third, there will be a certain number of days for post-production work, such as ADR and PR work.[53]

Start Date

Unlike directors, who usually work on a film for a year or more, actors render their services over a matter of days or weeks, and then, hopefully, go on to the next project. Piggy-backing jobs one after another becomes very important for actors, which leads them to want a definitive start date for principal photography included in their contracts.

Of course, given the myriad of problems that can impact a production's start, producers may get a bad case of acid reflux if they have to commit to a start date far in advance of production. Producers obviously want as much flexibility as possible when it comes to contractual start dates, and can often negotiate flexibility if the actor isn't in high demand.[54]

Compensation

Like screenwriters and directors, actors generally receive both fixed and contingent compensation, and the amount actors receive usually depends on their last quote.[55]

The fixed compensation—the cash acting fee—covers all of the services included in the contract. So, by way of example, if you pay an actor $100,000 to be in your film, that fee will typically cover all pre-production, production and post-production services included in the agreement.

The parties must also negotiate what happens if the production runs over-schedule. Here we have to specifically focus on how many days or weeks of principal photography are included in the agreement and how many free days or free weeks are included. Let's say our actor's contract calls for 10 weeks of principal photography plus 2 free weeks. This means the actor's fixed compensation covers, along with pre-production and post-production services, 12 full weeks of principal photography. But what if principal photography goes 13 weeks? If the actor is being paid $100,000, is the additional week worth $10,000 (i.e. $100,000 divided by 10 weeks of principal photography) or $8,333 (i.e. $100,000 divided by the 10 weeks of principal photography *and* the 2 free weeks)? Or what if the production goes long by two days; how do you calculate the overages? Do you divide the weekly compensation by five if the company is working a five-day week, or by six if the company is working a six-day week? All of these issues must be negotiated.[56]

Principal lead actors will also typically receive some form of contingent compensation. Usually, this will be a small number of net proceeds points. More established performers, including major stars, can negotiate to receive a larger number of net proceeds points or potentially some form of gross proceeds points. As with any other type of contract, the parties will have to negotiate whether the fixed compensation is applicable against the contingent compensation.

Pay or Play

Some mega-stars may be able to negotiate to go pay or play immediately upon signing a contract, though this would be extremely rare. More typically, big stars go pay or play if and when another star or director goes pay or play. Most actors, however, go pay or play when principal photography begins.[57]

Credit

This is another subject that can cause producers to develop a little acid reflux. Why? Because the Screen Actors Guild has few rules about credits, which means producers must negotiate credit issues with each actor. These issues include in what order an actor's credit will appear, in what size and in what media. For example, a producer must negotiate whether a star's credit will be first on screen, or second, or third, or somewhere else; whether it will appear before the picture's title—the most prominent position—or after the title, and what size it will be in relation to the picture's title; whether the producer has to use a star's likeness in a poster, or whether the producer

has to use a star's likeness in a poster if another star's likeness is used, and whether each star's likeness has to be equally prominent (and yes, people do really care about such things); whether the credit will appear in all paid ads or in only certain kinds of paid ads; and, whether the actor's name must appear on a separate card or on a shared card with another actor.[58]

Dressing Room

Major stars negotiate for a dressing room in huge trailers outfitted with an equipped kitchen, king-size bed, couches, plasma TVs, and just about anything else the star feels is necessary. More minor players get much smaller facilities that they usually share with others.

Hair and Makeup and Wardrobe

Major stars can often require the production company to hire their preferred hair and makeup people, who then only serve the star. I recall once negotiating a big star's deal, and the studio agreed to pay a six-figure sum to hire the star's preferred stylists and cosmeticians for 10 weeks. Stars also often get the right to approve all wardrobe and to keep it after the production ends.

Actors with less clout don't have the right to approve either their hair and makeup people or their wardrobe, but instead use the hair stylists and the clothes the production supplies.

Still Photograph and Likeness Approval

Actors understandably want to control how they appear when their image is used for publicity purposes. Therefore, major stars are often given the right to approve either all or a portion of proposed publicity photos or created images. More minor players generally don't get this right.

Nudity

The Screen Actors Guild regulates the use of nudity in films. Directors or producers may want a performer to appear nude; however, they must first obtain the performer's permission in a separate document that specifically details how the performer will be photographed on screen.

Merchandising

If a contract says a performer's likeness can be used on some item of merchandising, the performer usually negotiates to receive a percentage of all revenues derived from such merchandising.[59]

Representations, Warranties and Indemnities/ Suspension and Termination/Force Majeure/ Right to Assign

These provisions are the same as previously discussed.

Travel and Perks

All SAG actors must receive first-class transportation, lodging and a per diem if they are asked to travel more than 50 miles from their main residence. As with everything else, a major star's perks will exceed those offered to supporting players; stars' hotels will be nicer, the per diems higher, and they may receive not only a first-class air ticket for themselves when they go on location but also receive air transportation for members of their entourage. Stars will also receive the contractual right to attend the film's premiere along with first-class transportation and lodging; other performers may or may not be able to negotiate this.[60]

AGREEMENTS FOR PRODUCERS

Unlike contracts involving writers, directors and actors, contracts involving producers do not have any union-mandated provisions. That's because there is no producer's union. There is the Producers Guild of America, but it's not a union—it's a trade association that cannot collectively bargain on behalf of its members. Therefore, a producer's agreement can include whatever the parties choose to negotiate. Nevertheless, producers' contracts normally include many of the same general provisions we've already seen, with a few additions.

We'll begin by looking at one provision included in producing agreements that we've already seen—a "services" provision. Like any other services provision, it describes what a producer is required to do. But let's ask a question: What *do* producers do?

We've all seen the various producer credits: "Executive Producer," "Produced By," "Co-Producer," "Associate Producer." On television shows, there are *many* producer credits.[61] But what do people do to earn these credits? In truth, it's an easier question to ask than to answer.

Speaking broadly, when it comes to movies, there are four things people can do to justify a producer credit: (1) They can own or develop properties, such as scripts, that studios want; (2) they can provide financing; (3) they can have access to talent, such as actors and directors, who become attached to a project and thus help get it made, and (4) they can have the skill to run a film set effectively and efficiently.

A film requires a script, money, talented performers and expert filmmakers, and someone who can supply one or more of these things generally earns the right to be called a producer of some sort.

Some producers generally supply only financing. Often these people receive 'Executive Producer" credit, though sometimes they receive "Produced By" credit.[62]

Some producers supply their skill at making film sets operate smoothly, timely and cost-effectively. Usually called "line producers," these people often receive a "Produced By" credit; however, I've seen instances where line producers received "Executive Producer" credit and "Co-Producer" credit.

Other producers may generate script ideas or option underlying properties with an eye towards developing them into screenplays. Often called "creative producers," these people demonstrate a keen understanding of what makes a script entertaining and commercial. They may also have close associations with actors, directors or studio heads, all people who can help get films made. These associations are often forged from past professional experience, such as previously working as an agent or studio executive. These "creative producers" often receive a "Produced By" credit, though they might receive an "Executive Producer" credit. It's all subject to negotiation.

Who receives an "Associate Producer" or "Co-Producer" credit? These credits may be given to less experienced people who own underlying rights to a project and who assign those rights to other more established producers or studios in return for the credit. Or they could be given to someone who works closely with an executive producer or line producer.

As you can see, the credits themselves do not communicate precisely what someone does on a film. The Producers Guild of America has done its best to write and promote producer credit guidelines, which at the time of writing are being voluntarily adopted with increasing frequency.[63]

Recognizing that producers perform a wide variety of services, let's now take a close look at producers' contracts. These are the most important provisions:

- Conditions precedent
- Services
- Exclusivity
- Compensation
- Pay or play
- Credit
- Approval/consultation rights
- Grant of rights
- Turnaround right

- Warranties, representations and indemnities
- Production requirements
- Suspension and termination/force majeure
- Right to assign
- Travel and perks

Conditions Precedent

Producers' deals are most frequently conditioned on conclusion of a deal for underlying rights or a screenwriter's or director's services.

Services

We've already discussed this topic in some detail. What we need to add here is that contracts will specify what development services, if any, the producer will perform, and what pre-production, production and post-production services will be performed. As discussed above, the services will depend on what role the producer plays. For example, a line producer will likely render no development and few post-production services, but will render extensive pre-production and production services.[64]

Exclusivity

Whether a producer renders services exclusively or non-exclusively depends entirely on what the producer specifically does. A line producer, for example, renders services on an exclusive basis during pre-production and production. A creative producer, however, may render development services non-exclusively, pre-production and production services exclusively, and post-production services non-exclusively. An associate producer who receives credit purely because he owned certain rights to a project usually renders services non-exclusively, if for no other reason than in reality this person may render no services at all.[65]

Compensation

Like writers, directors and actors, producers receive both fixed and contingent compensation.[66]

Producers who help develop a project on behalf of a production company or studio usually receive a development fee, which generally ranges from $10,000 to $25,000 or more and which is typically applicable against the fixed producing fee.

Fixed producing fees vary depending on one's credit on the picture, stature in the industry and last quote. On a major Hollywood production an associate

producer may earn $75,000 or sometimes more; a co-producer may earn a salary in the $100,000–$150,000 range; producer and executive producer fees can range from $200,000 to $500,000 or more.

It's in the area of contingent compensation that producer deals vary most from the other agreements we've seen. While associate and co-producers may receive no contingent compensation at all (or a couple of net proceeds points on some occasions), the producer will receive either a flat percentage of the net proceeds—perhaps 10 percent, could be more, could be less—or 50 percent of all net proceeds reducible by a negotiated formula down to a specified floor.

The formula used to reduce the producer's share involves the net proceed percentages given away to other parties (and note that, on a studio film, those percentages will usually be given away by the studio as it sees fit, without need for the producer's approval). For example, the producer may start with 50 percent of the net proceeds but be reducible by every percentage point given to someone else. Thus, if a total of 40 percent of the net proceeds were divided among the actors, director and others, the producer would end up with 10 percent of the net proceeds, assuming the producer's contractual floor was 10 percent or lower. Sometimes the producer will bear all of the points given away until she is reduced to "X" amount, say 35 percent of the net proceeds, and then is only reduced by a fraction of all additional net proceed percentages given to third parties. As always this is subject to negotiation between the producer and production company.

Finally, a very few extremely successful producers may be able to negotiate and receive a gross proceeds participation.

Pay or Play

Producers with real clout may be able to negotiate that they become pay or play if and when a director or star becomes pay or play. Otherwise, like everyone else, producers will go pay or play on the first day of shooting.[67]

Credit

At the beginning of this section we discussed the types of credits producers receive. The "Produced By" credit usually screens just before the writer's credit if main titles are used or just after the writer's credit if end titles are used. Executive producer, co-producer and associate producer credits generally appear in the principal title sequence, on a separate card, usually in the same size as any other producer credit, with exact location up to the production company's discretion. In other words, there is no specific formula for where these particular credits appear.

Finally, some successful producers can negotiate a so-called "production" credit, such as "A Joe Blow Production." This credit will come either just before or just after the picture's title and will usually appear in all paid ads. If the director receives a "film by" credit then this production credit usually comes either just before or just after the director's "film by" credit.[68]

Approval/Consultation Rights

Producers would love to have the right to approve the director, the cast, the marketing campaign, the shooting schedule, the budget, the final edit and so on. Most producers get none of this, instead settling for a consultation right.

Grant of Rights

Like other contracts we've seen, producers grant all rights in and to their work to the studio.[69]

Turnaround Right

Producers customarily receive a turnaround right (though on rare occasions a writer may negotiate to receive this right).[70]

Turnaround comes into play when a project in development dies for whatever reason. For example, let's say a studio options a writer's script and pays both the writer and producer to complete a second draft. If the studio later no longer wants to pursue the project and lets the option expire, the studio will nevertheless own the second draft on a work-for-hire basis. Sure, the rights to the original, underlying script will come back to the writer if the option expires, but the *rewrite* will be owned by the studio. Therefore, should the producer and writer ever "borrow" from that rewrite in any subsequent drafts, they would be infringing the studio's copyright in that second draft. What this effectively means is that when a studio dumps a project, the project is quite dead unless the producer can pursue the project *without using any material paid for and owned by the studio.*

A so-called "turnaround" right, however, gives the producer the chance to recapture the work paid for by the studio. The turnaround right begins when the project dies, i.e. when it's put "in turnaround" by the studio. Typically, the producer will then have either 12 or 18 months to find another party to buy into the project. If a new buyer is found, then that new buyer can acquire ownership in the previously paid-for drafts *if* the new buyer pays to the first studio an amount equal to the prior development costs, plus interest, plus typically 5 percent of the net proceeds from any work based on the project if one is subsequently made. Finally, most turnaround provisions include a clause that permits the first studio to cut off the turnaround right if

there's been a material change to a project's status—for example, if a major star has suddenly become attached to the project.[71]

Warranties, Representations and Indemnities

These provisions are the same as we've previously discussed.[72]

Production Requirements

Even though a director typically controls the film shoot, producers often find the same sort of production requirement provision in their agreements that directors typically sign. This provision requires the producer to use his best efforts to ensure the finished film is a certain length, receives a certain rating, is shot in accordance with the approved budget and screenplay, and includes appropriate cover shots.

Suspension and Termination, Force Majeure, Right to Assign, Travel and Perks

These provisions are the same as previously discussed.

NOTES

1 A book author can always sell her copyright to someone else or transfer ownership via a will or by some other means.
2 To read an example of this sort of condition (in this case, dealing with chain of title), see the preamble of the option/purchase agreement you can read at focalpress.com/cw/bernstein.
3 To read an example of exclusivity language, see paragraph 1 of the option/purchase agreement you can read at focalpress.com/cw/bernstein.
4 To read an example of a initial option period provision, see paragraph 1(a) of the option/purchase agreement you can read at focalpress.com/cw/bernstein.
5 To read an example of option period costs, see paragraph 1(b) of the option/purchase agreement you can read at focalpress.com/cw/bernstein.
6 To read an example of permitted option period activities, see paragraph 1(c) of the option/purchase agreement you can read at focalpress.com/cw/bernstein.
7 When the option/purchase agreement is negotiated and signed, included in the agreement is a separate, completed document called an "assignment." If the buyer ever elects to exercise the option and purchase the rights, the buyer can file the assignment with the U.S. Copyright Office, and this serves as proof that the buyer now owns the rights previously owned by the copyright owner. To read an "exercise of option" provision and an assignment see paragraph 2 of the option/purchase agreement and the assignment at the back of the option purchase agreement you can read at focalpress.com/cw/bernstein.
8 To read an example of a purchase price fixed compensation provision, see paragraph 2 of the option/purchase agreement you can read at focalpress.com/cw/bernstein.
9 To read an example of a contingent compensation provision, see paragraph 3(a) of the option/purchase agreement you can read at focalpress.com/cw/bernstein.
10 I am aware of at least one rights owner who found the "throughout the universe" language a bit grandiose for his taste, so he wrote a letter to the studio's legal department

saying he was disappointed as he had hoped to retain distribution rights to the Crab Nebula and the moons of Pluto. The studio never responded. To read an example of a grant of rights provision, see paragraph 4 of the option/purchase agreement you can read at focalpress.com/cw/bernstein.

11 To read an example of this sort of payments provision, see paragraphs 3(b)–3(d) of the option/purchase agreement you can read at focalpress.com/cw/bernstein.

12 To read an example of a warranties and representations provision, see paragraph 5 of the option/purchase agreement you can read at focalpress.com/cw/bernstein.

13 You may be wondering why the buyer would be sued and not the rights owner who did the improper thing in the first place. The answer is that the buyer—often a production company—almost always has a much bigger bank account than the rights owner and is thus a much more attractive target for a lawsuit.

14 To read an example of an indemnities provision, see paragraph 5 of the option/purchase agreement you can read at focalpress.com/cw/bernstein.

15 "Main title" credits appear at the very beginning of a production, and end title credits appear at the end of the production. People prefer to have their credit appear in the main titles when main title credits are used.

16 To read an example of a credit provision, see paragraph 7 of the option/purchase agreement you can read at focalpress.com/cw/bernstein.

17 There are always exceptions. When the rights owner is extremely successful and well known and where the property in question is in very high demand, the rights owner may be able to exercise some real creative control.

18 Ultimately, one's power to affect a production depends primarily on one's influence with those who do have power. Someone may only have a consultation right, but, if the powers-that-be respect their opinion, they can certainly influence the production's outcome.

19 To read an example of a travel and perks provision, see paragraph 4(a) of the Director agreement you can read at focalpress.com/cw/bernstein.

20 To read an example of a force majeure provision, see paragraph 1(d) of the option/purchase agreement you can read at focalpress.com/cw/bernstein.

21 In the world of independent filmmaking, an option/purchase contract may be assigned to a production company the filmmakers and investors have formed to produce the independent film.

22 To read an example of a right to assign provision, see paragraph 9 of the option/purchase agreement you can read at focalpress.com/cw/bernstein.

23 To read an example of a no obligation to produce provision, see paragraph 7 of the producer agreement you can read at focalpress.com/cw/bernstein.

24 Insurance companies issue what are called Errors and Omissions (E&O) policies that insure productions against libel and invasion of privacy claims, as well as claims of copyright infringement. These E&O policies are extremely important and must generally be secured, so meeting the E&O insurer's requirements becomes a necessity.

25 For an example of this provision, see paragraph 2 of the screenwriting agreement you can read at focalpress.com/cw/bernstein and note that guaranteed services are referred to as "Committed Material" in this agreement.

26 For an example of this provision, see paragraphs 3 and 4 of the screenwriting agreement you can read at focalpress.com/cw/bernstein.

27 For an example of this provision, see paragraphs 2(b), 3(c) and 4(c) of the screenwriting agreement you can read at focalpress.com/cw/bernstein.

28 For an example of this provision, see paragraph 5(a) of the screenwriting agreement you can read at focalpress.com/cw/bernstein.

29 For an example of this provision, see paragraph 8 of the screenwriting agreement you can read at focalpress.com/cw/bernstein.

30 For an example of this provision, see paragraphs 2(c), 3(d) and 4(d) of the screenwriting agreement you can read at focalpress.com/cw/bernstein.

31 "Written By" credit means the writer is responsible for both the underlying story and the screenplay. "Screenplay By" credit means the writer is responsible for the screenplay but the underlying story came from another source.

32 For an example of this provision, see paragraph 6 of the screenwriting agreement you can read at focalpress.com/cw/bernstein.

33 For an example of this provision, see paragraph 9 of the screenwriting agreement you can read at focalpress.com/cw/bernstein.

34 For an example of these provisions, see paragraphs 11 and 12 of the screenwriting agreement you can read at focalpress.com/cw/bernstein.

35 For an example of this provision, see paragraph 7 of the screenwriting agreement you can read at focalpress.com/cw/bernstein.

36 The potential problem here is signing a Certificate of Authorship and granting ownership of the screenplay to the studio before a full contract is negotiated and signed. It's always possible a court will say that a signed deal memo is not a binding agreement. See pages 210–12. Still, studios want writers working right away and usually pay starting fees after execution of a Certificate of Authorship, so writers usually sign the Certificate of Authorship, start working and get their money prior to execution of a long-form contract. For an example of a Certificate of Authorship, see focalpress.com/cw/bernstein.

37 The reason most often given for why executive producers control television productions and film directors control movie productions is: Television is more of a writer's medium and most (though not all) TV executive producers are writers who know what it takes to churn out episode after episode. Film, so the argument goes, is more of a visual medium, and thus the director, who is a visual storyteller, is in control.

38 For an example of this provision, see paragraphs 1 and 2 of the director agreement you can read at focalpress.com/cw/bernstein.

39 For an example of this provision, see paragraphs 1(a) and 2(b)(i) of the director agreement you can read at focalpress.com/cw/bernstein.

40 For an example of this provision, see paragraph 3(a) of the director agreement you can read at focalpress.com/cw/bernstein.

41 For an example of this provision, see paragraph 3(b) of the director agreement you can read at focalpress.com/cw/bernstein.

42 For an example of this provision, see paragraph 3(d) of the director agreement you can read at focalpress.com/cw/bernstein.

43 For an example of this provision, see paragraph 3(e) of the director agreement you can read at focalpress.com/cw/bernstein.

44 For an example of this provision, see paragraph 5 of the director agreement you can read at focalpress.com/cw/bernstein. Note that this example does not include a "film by" possessory credit.

45 For an example of this provision, see paragraph 2(c) of the director agreement you can read at focalpress.com/cw/bernstein. Note that this example gives the director and the studio mutual approval over the director of photography, production designer or art director, film editor, first assistant director and the principal cast members. The studio retains sole approval over the script.

46 For an example of this provision, see paragraph 15 of the director agreement you can read at focalpress.com/cw/bernstein.

47 For an example of this provision, see paragraphs 15(c) and 2(c) of the director agreement you can read at focalpress.com/cw/bernstein.

48 For an example of this provision, see paragraph 6 of the director agreement you can read at focalpress.com/cw/bernstein.

49 For an example of this provision, see paragraph 11 of the director agreement you can read at focalpress.com/cw/bernstein. Note that this example does not include suspension or termination for being over budget or behind schedule, but either could be construed

as a material breach of the first sentence of paragraph 2(c), which could then lead to termination pursuant to 11(b)(iv).

50 For an example of this provision, see paragraphs 2(b)(ii) and (iii) of the director agreement you can read at focalpress.com/cw/bernstein.

51 A last refusal right gives someone, in this case a director, the chance to accept a deal based on the best deal terms offered a third party.

52 For an example of this provision, see paragraphs 9 and 10 of the director agreement you can read at focalpress.com/cw/bernstein.

53 For an example of this provision, see paragraph 2 of the actor agreement you can read at focalpress.com/cw/bernstein.

54 For an example of this provision, see paragraph 1 of the actor agreement you can read at focalpress.com/cw/bernstein.

55 An actor's "quote" means the compensation the actor received on her last project. If the current project's producer can't pay the actor's quote but the actor wants to do the project anyway, the actor may agree to lower the acting fee but may also likely want a higher profit participation.

56 For an example of this provision, see paragraph 3 of the actor agreement you can read at focalpress.com/cw/bernstein.

57 For an example of this provision, see paragraph 3(c) of the actor agreement you can read at focalpress.com/cw/bernstein.

58 For an example of this provision, see paragraph 5 of the actor agreement you can read at focalpress.com/cw/bernstein.

59 For an example of this provision, see paragraph 6(f) of the actor agreement you can read at focalpress.com/cw/bernstein.

60 For an example of this provision, see paragraph 4(a) of the actor agreement you can read at focalpress.com/cw/bernstein.

61 Many people who receive producer credit on TV shows are writers who have sufficient longevity on the show or standing in the industry to receive a producer credit and the higher salary that usually comes with it. Showrunners receive executive producer credit, and while there can be more than one executive producer on a show, at least one is usually a writer who has the experience and success to become a showrunner. Other people who receive producer credit on TV shows may be line producers, or actors who have the clout to negotiate a producer credit, or company executives who take the credit.

62 Only people who receive a "produced by" credit are eligible to receive a Best Picture Oscar, so some people who could receive an executive producer credit might fight for a "produced by" credit.

63 See Dave McNary, "PGA Credits Certification Gains Momentum with 150 Movie," *Variety*, June 6, 2014, last accessed on July 17, 2014. You can read about the Producers Guild of America's credit guidelines here: http://www.producersguild.org/?page=code_of_credits.

64 For an example of this provision, see paragraphs 1(a) and 2(b) and (c) of the producer agreement you can read at focalpress.com/cw/bernstein.

65 For an example of this provision, see paragraphs 1(a) and 2(a) and (c) of the producer agreement you can read at focalpress.com/cw/bernstein.

66 For an example of this provision, see paragraph 3 of the producer agreement you can read at focalpress.com/cw/bernstein.

67 For an example of this provision, see paragraph 3(d) of the producer agreement you can read at focalpress.com/cw/bernstein.

68 For an example of this provision, see paragraph 5 of the producer agreement you can read at focalpress.com/cw/bernstein. Note that in this agreement there is no "production" credit.

69 For an example of this provision, see paragraph 6 of the producer agreement you can read at focalpress.com/cw/bernstein.

70 Writers have a chance to negotiate a turnaround provision in their agreements if they originated the project and no producer is attached when a financing entity pays for further

script development. However, because producers expect to receive a turnaround right in their agreements, a savvy financing entity like a studio may not grant the writer a turn-around right even where no producer is yet attached. Why? Because when a producer does come aboard, he will expect to receive this right. Interestingly, WGA members have another method other than turnaround to reacquire material from studios, provided the material is entirely original and had never been previously exploited. The specifics of this reacquisition right can be found in the WGA's Guild agreement in Article 16(A)(8).

71 For an example of this provision, see Appendix 1A of the producer agreement you can read at focalpress.com/cw/bernstein.

72 For an example of this provision, see paragraphs 9 and 10 of the producer agreement you can read at focalpress.com/cw/bernstein.

Independent Film Development, Financing, Contracts and Distribution

INTRODUCTION

Though we have already discussed film financing, film contracts and film distribution, it's worthwhile discussing these topics in the context of independent filmmaking. Because independent films are usually developed in a different manner from studio films, we'll discuss this subject as well.

DEVELOPMENT

In Chapter 9 we discussed the development process. For those who want to make independent films, the beginning of development is comparatively easy—you do it yourself.

Someone has an idea worth writing.[1] That idea could be original, or perhaps based on a work in the public domain, or based on a pre-existing work. If the latter, the work will need to be optioned. Low-budget filmmakers may think they can't possibly afford to option a pre-existing work, but if the work is obscure or otherwise not in demand, obtaining a free option is always a possibility.[2]

Since scripts meant for independent production are usually written before a financing party has been identified, filmmakers get to write exactly what they want to write. Of course, the logistics involved in lower-budget independent filmmaking must be considered when developing stories. This generally means developing scripts that have smaller casts and no fancy effects, that run between (usually) 85 and 110 pages and that use at most a handful of locations or just one main location set-dressed to look like multiple locations. Horror has always been a staple of low-budget filmmaking, as have intimate relationship stories such as *Before Sunrise* and *Short-Term 12*, which tend to be heavy on dialogue and therefore quicker and easier to shoot.

Once the script is finished, it's used to attract investors. If the filmmakers find a financing party who likes the script as it is, then development is over. However, just as with studio films, if the financier wants script changes, then that's what

will happen because if the financier doesn't like the script no checks will be written. Still, some independent film financiers feel incapable of playing script doctor or may be in the game to have fun and take chances, and therefore may be more hands off than their studio counterparts when it comes to development. Often times, script development and finalizing a script are the least of an independent filmmaker's problems.

FILM FINANCING

Finding money is usually a much bigger problem independent filmmakers face. So, where might you find financing?

Studio Financing

I know this chapter is devoted to independent filmmaking, but I thought I would be heretical and mention studio financing, for one reason: As we've discussed, the tremendous upside of studios is that, if they produce the movie, distribution is guaranteed.

Make no mistake about it—finding money for independent films is far easier than finding distribution. Neither is a walk in the park, but there are far more wealthy people and institutions in this world that can finance a project than there are distribution outlets that can significantly monetize it. And without competent distribution, all is lost; the investment in time, passion and money has essentially gone down the drain. So, having a built-in distributor come with your financing is a fabulous advantage, and the reason so many professionals who might think about independent filmmaking end up back at the studios. Creative people may gripe about studios, but they still want to work with them because (a) they pay up front, and (b) they distribute.

However, as we've discussed earlier in the book, with these great advantages comes a cost. When you accept your studio paycheck, you effectively give up all control over the project unless you have a track record of uncommon success. This isn't to say that all creative people lose all influence once they sign a studio deal. Your ability to remain involved becomes purely dependent on your relationship with the studio and the other powerful people who work on the project. If you're in everyone's good graces, then you may have influence. If you're not, you could be gone tomorrow.

Okay, let's say you want to keep as much creative control as possible. Let's say you're just starting out, studios don't know you're alive and you want to make your film your way, so you're going the independent route. Where then can you look for money?

Crowdfunding

Actor Zach Braff's *Wish I Was Here*, writer Charlie Kaufman's *Anomalisa*, director Paul Schrader's *The Canyons* and the *Veronica Mars* film were all crowdfunded. So were many other films and documentaries created by people less well known than Braff, Kaufman and Schrader. In fact, 20 films screened at the 2014 Sundance Film Festival, including feature-length narrative films, shorts and documentaries, were produced in whole or in part with crowdfunding money.[3]

If you can make a compelling case to the public at large about your project, you might consider crowdfunding sites like *kickstarter.com, indiegogo.com* and *Seed&Spark.com*. Certainly one advantage of crowdfunding is that donors do *not* become equity investors entitled to a financial interest in the film's revenues. Instead, donors usually receive small film-related gifts like posters or "rewards" such as an opportunity to meet the filmmakers, depending on the size of the donation.

Crowdfunding can also be used to finance just part of your project. For example, you might raise some crowdfunding cash to help develop your film and get it off the ground, say by making a trailer, so it might attract the attention of larger investors. Alternatively, depending on your budget, you can try to use crowdfunding to raise all the money you need to make your movie.

Angel Investors

Angel investors are people with halos over their heads, compassion in their hearts and money in their bank accounts. One or a handful of angel investors can make a film happen, provided you know how to reach and entice them.

As mentioned earlier, some people with money will always be attracted to the high-stakes glitz and glamour world of filmmaking. They may like calling themselves "Executive Producer" or "Producer," titles that come with providing all or a substantial part of a project's financing; they may like the creative meetings and the fun of being on set, not to mention the theoretical chance to make a huge return on their investment. They may be drawn by a project's subject matter or its point of view or the actors involved. And they may like the chance to put on the auteur's hat and provide some significant creative input. If someone puts up the money, they have that right. On the other hand, if the angel investor is not experienced in the ways of filmmaking, then he or she may choose to stand aside, leaving the filmmakers freer to do what they want.

Importantly, angel investors will want something that *Kickstarter* donors don't—an actual financial return on their investment. The posters, signed scripts, dinners with the director and set walk-ons that satisfy small *Kickstarter* donors

won't work with wealthy investors. They will want signed contracts carefully spelling out all of their rights, including their right to receive money from the production's revenues. We will discuss these contracts later in this section.

Foreign Pre-Sales

Sometimes independent filmmakers have an excellent script, an experienced director and cast members, but no money. The filmmakers may not know any potential angel investors, so where to turn? Foreign pre-sales have historically been one way to get money for production, though in recent years these deals have become harder to negotiate. Nevertheless, they are worth exploring.

You'll recall from our discussion of copyright law in Chapter 1 that a copyright owner's exclusive distribution right can be segmented and licensed to as many different distributors as are willing to make a deal. This is what happens with foreign pre-sales. Before the movie is made, the film's distribution rights in foreign territories are segmented and licensed to different local distributors around the world. In return, the filmmaker receives a contract guaranteeing a specific license fee from each distributor when the film is delivered. The filmmaker may also receive a cash advance when the agreement is signed. The cash advance can then be used to pay for actual production costs. The distribution contract can be used as collateral for a bank loan, which may also be used to help finance production.

By way of example, let's assume you have a great low-budget project and both a competent director and an actor who is popular in France, Germany, Japan and several other countries. Given the star's popularity, a French distributor may guarantee you a specific fee upon delivery of the film. The same sort of deal can then be negotiated with a German distributor, a Japanese distributor, and so on. The distributors nail down the film's distribution rights before it's completed at what they hope is a discount price, and the filmmaker gets very valuable distribution agreements that can generate money via a bank loan. These sorts of deals can be complex and negotiated in a variety of ways, but there are foreign sales companies and lawyers who specialize in pre-sale agreements.

Bear in mind, however, that people don't offer pre-sale money if they don't believe the project will play well in their territory or if they doubt you can actually deliver a quality film. It's a good start to have an excellent script in a genre that plays well worldwide, such as action or horror, but that's not enough. These days, you'll likely need an experienced director and a recognizable actor. And, since a film's American distribution often spurs worldwide interest in a movie, foreign pre-sales may greatly depend on a foreign distributor's assessment of the film's chances in America.

You'll also need what's called a completion bond, since any bank that loans money based on a pre-sale agreement (or any other agreement for that matter)

will require one.[4] A completion bond company, often called a completion guarantor, issues the completion bond and thereby promises the film will be completed and delivered pursuant to an agreed set of specifications. Think of a completion bond primarily as a cost-overrun insurance policy, where the completion guarantor agrees to pay all budget overages should problems occur during filming. Films can go over budget for all sorts of reasons, and completion bonds insure that money will be available should this happen. Sounds great, doesn't it? Except for this: Completion bonds come with a price, both monetary and creative. These bonds cost money, usually in the neighborhood of 3 percent of a project's budget. Additionally, if the completion guarantor has to actually get involved in the production, because cost overruns appear likely or have already occurred, or indeed for any other reason, the completion guarantor will have a contractual right to kick you and anybody else it wants off the film and hire other people to complete it.

Tax Incentives

Municipal governments, U.S. states and many foreign countries often entice filmmakers to come shoot in their territory with financial giveaways. Why? Because film companies do two things locally: They hire people and spend lots of money at places like restaurants and hotels. The theory is, if the government gives away "X" dollars to woo filmmakers to come shoot in its territory, the government gets back those dollars and more. It does this, so the argument goes, from a better local economy and increased tax revenues from people who financially benefited from the film company's presence.

Governments lure filmmakers by providing tax credits, rebates and other money-saving programs. For producers who can take advantage of these offers, more than 20 percent of a film's budget might be provided by a government entity.

In return for the money, the government entity will *not* take a financial interest in the film's subsequent revenues. Instead, the government entity will require the film company to shoot a significant percentage of the film in the location providing the money, and/or spend a certain percentage of the budget in the locality, and/or hire a certain number of actors or crew members, or both, from the region. Every incentive program is different, but they all save productions a lot of money.

It's worth mentioning that these programs have been the subject of debate recently. Some lawmakers say that the higher rates of local employment, the production money spent in-state and the resulting higher tax revenues more than offset the state funds given to filmmakers. Others cite studies that claim the opposite is true. For example, in Massachusetts, a 2013 state report cast doubt on the efficacy of state tax incentives. That was followed by an MPAA report showing the state's $37.9 million tax incentive payments

to filmmakers in 2011 led to $375 million being added to the state's overall economy that year.[5]

The same debate recently occurred in Maryland, production site of the Netflix series *House of Cards*. According to reports, the show's first two seasons' combined budget of $119 million was partially offset by as much as $26.6 million in Maryland state tax credits.[6] Some Maryland legislators thought this was excessive and wanted to significantly reduce the available tax credits, leading the show's producers to warn that they'd produce the show elsewhere if that happened. The producers also demonstrated they've learned a thing or two about politics by throwing a party for state legislators. The guest of honor was "Frank Underwood," a.k.a. Kevin Spacey, who came to the party to "whip votes" for continuation of the tax credits. Spacey obviously proved as adept as his character—a deal was subsequently reached giving the show $11.5 million dollars in state subsidies for its third season.[7]

Gap Financing

Under certain circumstances a bank may loan sufficient funds to close the gap between what a production has raised and what it still needs. Since filmmaking is a risky business, banks are reluctant to get involved, especially with people who don't have a track record, so obtaining a bank loan is never easy. However, on occasion banks will make up the difference provided the bank is the first party to be paid back out of any subsequent revenues. One advantage of a bank loan is that banks normally want repayment of the loan plus interest and not an equity interest in the film's revenues.

Negative Pick-Ups

These types of arrangements provide that a distributor will "pick up" a film for distribution from the producer after it's been made, provided the final film adheres to all sorts of contractual specifications the distributor wants. These specifications usually include the film's approved script, budget, cast, rating and running time. Where a producer negotiates a negative pick-up deal, the agreement can be given to a bank as collateral for a loan. The loan can then pay for the production costs along with a completion bond that will inevitably be required.

TELEVISION FINANCING

As previously discussed, television is a whole different ballgame. In the 1970s and 1980s, independent producers could realistically hope to finance, produce and get their own shows on the air. Now that's nearly impossible, since almost all shows are financed and produced by conglomerate-owned companies.

Beyond that, the methods independent filmmakers use to raise money generally won't work in a television context. For example, raising money to produce a television series via foreign pre-sales is extremely difficult, because foreign companies are reluctant to spend on a television show until after it has already had a successful run. Also, unlike independent film, it would be very difficult to get a completion bond for a television series. Completion guarantors would likely balk at theoretically having to manage a large number of shows all being produced under a strict deadline. These guarantors are comfortable managing a single production, such as a film, where the delivery date can be somewhat flexible. But managing a TV series would likely be more than a completion guarantor would want to handle.

Not that independent TV production is entirely impossible. There are successful independent companies that finance and produce reality TV and other non-fiction television programming.

NEGOTIATING CONTRACTS WITH INDEPENDENT FILMMAKERS

Though independent film budgets may be much smaller than those of studio films, independent film deals for writers, actors, directors, producers and rights acquisition are all similar to the deals discussed in the previous chapter. Yes, the dollar figures will be much smaller, but most other issues will likely be the same, including the right to receive both fixed and contingent compensation such as net proceeds points.

When negotiating deals with fellow filmmakers, however, independent film producers must bear two very important players in mind: The investors and the hoped-for distributor. Both will have expectations and demands when it comes to their deals (which we'll discuss shortly) that must be considered when negotiating other deals.

For example, it might be great to give your best friend, the director, the right to final cut, but what happens if a distributor likes your movie and wants to edit it? It might be great to give an actor a gross proceeds participation, but such participations reduce a distributor's income and consequently the distributor may not accept them. The bottom line is, if you make a deal along the way that the distributor doesn't like, that deal could block a sale. You may therefore find yourself desperately trying to undo the deal you previously made.

Finally, given how little independent filmmakers often get paid, it would be great to lure people to your project by offering significant net proceeds participations, which on a very successful low-budget film can be valuable.[8] Before negotiating these participations, however, you'd better consider what kind of profit participations your investors will demand, a topic we'll turn to shortly.

FILM DISTRIBUTION

Distribution is the great bottleneck. Distributors owned by the six big media conglomerates, plus Lionsgate, now earn roughly 90 percent of all American theatrical films revenues.[9] In other words, if they turn down your film, as happens with most independent films, your chances for widespread distribution are very low, though not zero.

There are companies that specialize in independent film distribution, such as the Weinstein Company, IFC Films, Tribeca Film, Samuel Goldwyn Films, Strand Releasing, Screen Media and Film Movement. Lionsgate is also a large distributor of independent films. They, along with other distributors, routinely attend film festivals[10] looking for something new, something good—which might be your film if you can get the festival to show it. But by "good" I mean marketable. Distributors are not in the business of philanthropy—far from it. If they decide your truly interesting and unique film won't generate audience dollars, then they won't care about its artistic virtues.

The fact is, most independent films aren't shown at Sundance or Cannes and don't get widespread theatrical distribution. Indeed, the vast majority of independent films that do get distribution go straight to home video or cable or the internet. There are producers' representatives who, for a fee or a percentage of revenues, will work with you to get your film to all kinds of distributors.

If you cannot find distribution, self-distribution is always a possibility. You can "four-wall" your movie, which means literally renting movie theaters and showing the film before (hopefully) paying audiences. Those audiences will have to be attracted via local paid ads you finance, social media and other online marketing tools. Makers of niche films that appeal to identifiable audiences living in reasonably compact geographical areas can adopt this approach and make some money off of ticket sales. At the very least, four-walling may be a way to get your film noticed by movie reviewers, and if luck is distinctly in your corner, those reviews might spur interest among distributors who otherwise may not have seen your film.

You can also distribute your film over the internet. There are any number of sites that will make deals to distribute your work, though of course the amount of money will usually be small. There are so-called aggregators, sites like distribber.com now owned by indiegogo.com, and tunecore.com,[11] which for a fee will try to place your film with online distributors like iTunes, Netflix and Hulu or cable VOD operators like Comcast. Sites like CreateSpace.com can help you distribute DVDs online, and you can also try to distribute your film via Redbox.[12]

Like so many other aspects of the film business, digital distribution is quickly evolving as different companies try to figure out how best to monetize films.

For those who want to learn more about independent film distribution, there are ample resources online, including websites like thefilmcollaborative.org, indiewire.com, filmmaker.com and MovieMaker.com, among many others.

FILM FINANCE AND DISTRIBUTION DEALS

I think it's fair to say that when most filmmakers set out to produce an independent film, they don't dream small. Most dream their film will be shown in theaters and everywhere else. Most dream their film will move global audiences, put the filmmakers on the filmmaking map and make some money in the process.

This dream's fulfillment requires that you sign a deal with a heavyweight distributor. As mentioned, this only rarely happens. But long odds have never stopped artists from doing what they do. Artists do what they do because their passion drives them there, as it may drive you. In case it does, and in case you're among the talented, fortunate few, the following section describes some of the major issues involved in a distribution and financing deal. Independent filmmakers should bear in mind the parameters of a possible distribution deal when they negotiate deals with fellow filmmakers and investors. As always, you *must* consult with an experienced attorney when negotiating any of these kinds of agreements—there's simply too much at stake to entrust these deals to anyone else.

Before beginning I have two disclaimers. First, the examples provided below are entirely hypothetical; they reflect only one of a thousand different deals that could be negotiated between you, investors and a distributor. I give these examples to illustrate aspects of these deals, not to suggest that all deals are like this, because they aren't. Second, the hypothetical case below illustrates a very successful low-budget film, which is statistically atypical.

Assume you produce a film that costs $1 million. Assume you've raised this money from 10 different investors who each put up $100,000 to finance the film. Assume you and the investors have formed a production company that will hopefully receive revenue one day from a film distributor, revenue that will be shared by you, the investors and the filmmakers with profit participations.

Now assume you've shown the film at a film festival and a first-rate distributor wants it. Congrats to you, you just beat very long odds; your investors will be thrilled, but first a distribution deal must be negotiated.

The key elements of the distribution deal will include: (a) The specific distribution rights the distributor will receive; (b) whether the distributor will pay you an advance when you sign the distribution agreement and how the distributor will recoup that advance; (c) what the distribution fee will be (distribution fees are discussed on page 217); (d) how much the distributor will spend

on marketing and distribution and how the distributor will recoup these costs; and (e) how profits will be defined and what percentage will the production company receive.

Let's look at these issues one at a time:

- What specific distribution rights will the distributor receive? A distributor's specific rights must be clearly delineated in the agreement. There are dozens of issues at play here; I'll name just two: Does the distributor have worldwide rights in all media, or just certain rights in specific territories, and for how long will the distributor have those rights? A thorough discussion of this subject is well beyond the scope of this book, and as I said above, experienced legal counsel is required when grappling with these issues in the real world.

- Will the distributor pay you an advance when you sign the distribution agreement, and how will the distributor recoup that advance? When you hand over the movie, the distributor may cut you a check as an advance against future revenues. You'd be very happy if that check equaled the cost of production so you could hand over the money to your investors and fully repay their original investment. The amount of this up-front payment, however, is entirely negotiable—i.e. there are no hard and fast guarantees about whether you'll receive anything, or if you do, how much it will be. The distributor will undoubtedly seek to recoup this advance from first revenues, before your production company starts sharing in the film's income.

- What will the distribution fee be? As discussed previously, distributors usually take a 30 percent distribution fee on all domestic revenues and a higher fee, up to 40 percent, on international revenues. The justification for these fees is that studios take severe financial risks when they produce and distribute films. However, when *you've* produced an independent film, the studio didn't take a production risk. In this case, the studio is taking only a distribution risk, which is far lower than normal because the studio actually sees the finished film before electing to distribute it. For these reasons, the studio's distribution fee should be lower than 30–40 percent (though a distributor with all the negotiating leverage can always refuse to lower its fee). Let's say hypothetically you negotiate a 20 percent distribution fee on all revenues.

- How much will the distributor spend on marketing and distribution, and how will the distributor recoup these costs? The distributor should identify in the distribution agreement the scope and reach of the distribution plan as well as commit to pay a certain amount of distribution costs to support that plan. The dollar amount matters a great deal, because without an acceptable distribution effort audiences may never discover your film. Let's say the distributor commits to spend $5 million distributing your film, of which $4 million will be spent on advertising. The distributor will undoubtedly seek to recoup this $5 million from first revenues, before your production

company starts sharing in the income, and may seek to tack on an advertising overhead fee.

■ How will profits be defined, and what percentage will you get? In Chapter 11 we said that studios define "net proceeds" by deducting from Defined Gross revenues[13] the following costs and fees in the following order: The distribution fee, all distribution expenses plus a 10 percent advertising overhead fee, and negative cost, including a 15 percent overhead fee and all amounts payable as gross profits participations or deferments. In this case, the distributor will likely want to do something similar, reaching net proceeds after the deduction of:

 ■ The negotiated distribution fee;
 ■ All distribution expenses plus perhaps a typical 10 percent advertising overhead fee;
 ■ The amount of the advance. There should be no 15 percent overhead fee typically charged as part of negative cost, because the distributor's personnel were not involved in the film's production. Whether the distributor is entitled to recoup out of first revenues any amounts paid as gross profit participations and deferments is subject to negotiation.

What remains is net proceeds and might be split 50-50 between the distributor and the production company.

Per the above discussion, we'll say your film cost $1 million to make and $5 million to distribute, of which $4 million was spent on advertising. We'll assume you didn't give any fellow filmmaker a gross proceeds participation or deferment. We'll further assume your film does very well when it's distributed, earning $20 million in worldwide box office and thus about $9 million in film rentals.[14] Let's say further that all other ancillary Defined Gross revenues (such as television licensing and home video revenues) equal $11 million, which means total Defined Gross equals $20 million.

Given the above distribution deal, the $20 million in Defined Gross will be allocated as follows:

DEFINED GROSS .. $20 million

Distribution Fee (20%) $4 million to distributor

Distribution Expenses = $5 million + 10% advertising
 Overhead fee = $400,000 = $5.4 million to distributor

Reimbursement of Distributor's Advance $1 million to distributor

TOTAL DEDUCTIONS = ... $10.4 million

TOTAL NET PROCEEDS = $20 million – $10.4 million = $9.6 million

**PRODUCTION COMPANY'S SHARE OF NET
PROCEEDS (50% of all Net Proceeds) =** $4,800,000

Now let's go back to the investors. Recall that in our hypothetical there are 10 investors who each invested $100,000. When they did so, they will each have signed a contract that described (a) how their investment was to be paid back, and (b) how all other revenues would be split, i.e. between the investors and the production company.

Let's start with how investors might recoup their initial investment. The investors will want their initial investment fully reimbursed out of all first revenues received by the production company. Indeed, the investors almost certainly will want to fully recoup their investment along with a stated premium amount before the production company can take any money for itself.

Recall that, in our hypothetical, the distributor gave you a $1 million advance, which equaled the cost of the film. If your investors negotiated with you to receive 100 percent of all incoming money until they recouped their investment plus a 10 percent premium, then the $1 million advance would entirely go to your investors; each of the 10 investors would get $100,000 and would fully recoup their original investment. However, each would still be owed a 10 percent premium, or $10,000 each, out of the next batch of revenues.

That next batch of revenues would be the $4,800,000 in net proceeds returned to the production company by the distributor. Since the 10 investors would each still be owed $10,000, a total of $100,000 would come off the top and be split among the investors, leaving the production company with $4,700,000.

What happens to this remaining money? How is it divided between the investors and anyone else who has a net proceeds definition? Customarily, at this point 50 percent of the money would go to the investors per their contracts (though this is always negotiable), and 50 percent would go to the production company. If such a customary deal were negotiated, the investors would thus split 50 percent of the remaining $4,700,000, or $2,350,000. Since the investors all put up an equal amount, each investor would receive an equal share, or $235,000. This would mean that, for the initial $100,000 investment, each investor received back $100,000 (initial investment) + $10,000 (premium on investment) + $235,000 (share of net proceeds) = $345,000, or a 245 percent return on their investment.

The production company would keep the other $2,350,000 and dole it out to whoever has a net proceeds participation in their contract. Each net proceeds point would be worth $23,500, *provided net proceeds are defined in the relevant contracts as a percentage of whatever the production company keeps after deduction of the investors' share.*

Bear in mind that, in our hypothetical, the production company received a total of $4,800,000. If a director was given 10 percent of the production company's total net proceeds, that would equal $480,000. If the director was given 10 percent of the production company's net proceeds after deduction of the

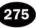
investors' share, then the actor would receive 10 percent of $2,350,000, or $235,000. Big difference! It therefore becomes *extremely important* how someone's net proceeds participation is specifically defined.

NOTES

1 See pages 173–9 for a discussion about choosing ideas to write.
2 See pages 227–37 for a discussion about optioning pre-existing works.
3 Linda Ge, "The Case for Kickstarter: 20 Crowdfunded Films Headed for Sundance," January 15, 2014, last accessed on June 17, 2014, http://www.bleedingcool.com/2014/01/15/the-case-for-kickstarter-20-crowdfunded-films-headed-for-sundance/.
4 Angel investors will also likely require a completion bond so their investment is protected.
5 Steve Annear, "Study: Film Tax Created Thousands of Jobs, Millions in Economic Output," *Boston Magazine*, last accessed June 17, 2014, http://www.bostonmagazine.com/news/blog/2013/05/22/massachusetts-film-tax-credit-study/.
6 Jenna Johnson, "How did 'House of Cards' get millions in Maryland tax credits?" *Washington Post*, February 21, 2014, last accessed on June 17, 2014, http://www.washingtonpost.com/local/md-politics/how-did-house-of-cards-get-millions-in-maryland-tax-credits/2014/02/21/c1eb375c-9b16-11e3-975d-107dfef7b668_story.html.
7 Dominic Patten, "Deal Reached to Film 'House of Cards' Season 3 in Maryland After All," Deadline Hollywood, April 25, 2014, last accessed June 17, 2014, http://deadline.com/2014/04/house-of-cards-maryland-deal-season-3-production-720132
8 Alternatively, you might entice people by offering them a deferred cash payment after the investors have recouped their initial investment but before net proceeds become payable. However, this sort of arrangement will delay the investors from receiving their profit participations and may not be acceptable to them.
9 "Studio Market Share," *Box Office Mojo*, last accessed on June 17, 2014, http://www.boxofficemojo.com/studio/?view=company&view2=yearly&yr=2013&p=.htm.
10 Important festivals include Sundance, Toronto, Cannes, Berlin, Tribeca, SXSW and AFI.
11 I have neither worked with these aggregator sites nor do I endorse them. I name them in the text purely as examples of aggregator services.
12 Redbox generally only takes films that have a distributor attached. Additionally, you should know that Redbox cares a great deal about your cover art, as that's what attracts buyers browsing through films. See http://www.beyondtheboxoffice.com/blog/film-distribution/redbox-and-indie-film/ and http://www.beyondtheboxoffice.com/blog/film-distribution/redbox-and-indie-film/.
13 Defined Gross is discussed on pages 215–16, and just like anything else in the distribution agreement, Defined Gross, including what specific revenues constitute it, is subject to negotiation.
14 Recall that distributors usually get perhaps just over half of all domestic ticket sales and roughly 40 percent of all international ticket sales.

SECTION 5
Voices

I was once a film student hoping to break into the industry. Back then I would listen to seasoned pros tell their success stories and wonder what the point was—what did it matter how they got *their* start? Wasn't everyone's situation different? Could I really extrapolate from their past to inform my future?

It's clear to me now that, while everyone's path to success follows its own idiosyncratic course, there are some very valuable lessons to be learned from others. Not that those lessons are profoundly deep or revelatory, because they aren't. The lessons are really quite obvious—hard work, knowledge, passion, perseverance and a thick skin are essential to success. I suppose it's mainly a matter of degree. There's hard work and then there's *hard work*. There's knowing a lot about the industry, and then there's *really* knowing a lot. Some people may be passionate about wanting to succeed, and then there are those who are *really passionate*—so passionate they can accept failure and rejection over and over again and somehow keep going when others might pack it in.

Some of the people interviewed below have achieved great creative success, though you likely won't recognize their names. Some have achieved success as studio executives, and you most definitely won't recognize their names. Some have achieved success as independent producers, and they, too, will be unfamiliar to you. It would be presumptuous to suggest they represent all people working in the industry, but their stories are instructive for anyone wanting to follow in their footsteps.

CHAPTER 14
Making It Into the Business

MICHAEL PORYES

Michael Poryes has written sitcoms for more than thirty years. The shows he's worked on include *The Jeffersons*, *Alice*, *The Love Boat*, *Who's the Boss*, *Facts of Life*, *Veronica's Closet*, *Cybill* and *Roseanne*. In more recent years, Michael created and executive produced two wildly successful shows aimed at young audiences—*That's So Raven* and *Hannah Montana*.

From staff writer to showrunner, his career has been marked by tremendous success. And yet he started off waiting tables in a restaurant, telling jokes to the customers, both his writing and stand-up careers apparently going nowhere. His experience breaking into the business demonstrates the importance of tenacity, being located where breaks happen, hanging in there even after apparent break after break turn into disappointment after disappointment, and carefully studying the credits on television shows.

GB: *When you were in college, what did you think you'd be doing with your life?*

MP: I went to college thinking I'd be a lawyer. After the first year, however, I began to waffle, so I started taking some creative writing courses. Eventually, I dropped out of college and joined a comedy troupe. When I was 23, I moved to L.A. strictly to be a stand-up comic.

GB: *How'd that go?*

MP: It didn't. I never did make a living as a stand-up.

GB: *How did you make ends meet?*

MP: I got a job waiting tables in Beverly Hills.

GB: *So how did you find your way into a writing job?*

MP: When I was struggling, a friend of a relative knew this guy named Gary Shandling. He was writing at the time, and I thought that was an interesting idea. I thought maybe I could write in the daytime and still do stand-up at night. So I started learning how to write on my own but, as it turned out, I never did do stand-up again.

GB: *How did you get your first actual writing job?*

MP: My roommate's brother was going to Whittier College and his teacher's husband was a staff writer on a show called *Different Strokes*. I got introduced

and we became friends. He eventually got me a pitch meeting and I managed to sell a story and got paid to write an outline. As it turns out, that story was never done, because shortly after the sale the Writers Guild went on strike, and by the time the strike was over they'd lost interest in the story. That was, however, the first time I got paid, and I took that money and joined the WGA.

GB: *Did that* Different Strokes *sale lead to anything specific?*

MP: No, not really. I ended up making a lot of calls to shows on my own—I had no agent, no nothing—and one of the shows I called was *Love Sidney*. Out of the blue they invited me to pitch, which I did, and they bought a story. I wrote an outline, which they then gave to another writer, and that was that, which actually wasn't very pleasant.

GB: *You mean that was it as far as that show was concerned?*

MP: Yes. And I wasn't happy about it.

GB: *So what did you do next?*

MP: We have to go back to waiting tables. So one day I'm doing my waiter job, right, and I would always joke around with the customers, and this guy asks me what I want to do, and I said write sitcoms. He told me his name was Bob Schiller. And because I studied credits all the time I said, "You mean the Schiller of Schiller and Weiskopf?" And you could see a little twinkle in his eye because I knew who he was. And he got me in to pitch on a show called *Archie Bunker's Place*.

GB: *That's a wonderful story. So is that when you really broke into the business?*

MP: No. That went nowhere, too. [Laughs]. But eventually I did get a real break on a show called *Facts of Life*. Someone I knew liked a pilot idea I had and so I ended up pitching the idea to this person's parents, who were Irma and Austin Kalish, two very successful television writers and producers. When Irma got hired to executive produce *Facts of Life*, she hired me as a full-time writer on the show.

GB: *I assume not everyone who wants to be a sitcom writer would be able to actually do the job should the opportunity present itself. What had you done on your own time that made success on* Facts of Life *possible?*

MP: To be honest, it was only after I got on the show that I learned how to do it. When I started on *Facts of Life*, I was too paranoid about being careful, about not rocking any boats, about being political. That's all well and good, but it stops your mind from being agile, from in effect being as funny as you can be. I had to learn to free myself up from the fear of making a joke or suggestion no one liked.

GB: *But how were you capable of actually writing a script?*

MP: Because I watched everything and anything on TV. That's where I learned the rhythms and sensibilities of sitcom writing. And I knew who all the players were—I studied their names even in high school, not because I then wanted to be a writer, but just because I loved the shows so much. Knowing who did what didn't help me write, but it sure helped with getting work.

GB: *Tell me about what the writers' room is like?*

MP: These days the writers' rooms are much smaller. Usually 7 or 8 or 9 writers, whereas back when *Roseanne* was being made that room had 24 writers. So the rooms now are smaller, which makes them easier to maneuver through and get things done, but they're also harder for a young writer to hide in. You just can't go into the room thinking you'll mainly observe—you better perform. You'll learn quicker, but you have to do well. Rooms also have the personality of the show's leader. Some rooms are mean and biting, and others are nurturing. Some showrunners are organized and efficient and some aren't.

GB: *What advice would you give to a new writer on his or her first day in a writer's room?*

MP: Get the lay of the land, respect the hierarchy, and try your best to pitch into the showrunner's vision. Help the showrunner realize their vision of what the show is.

GB: *Can new writers expect to have a life outside of the writers' room?*

MP: It depends entirely on the showrunner. Some are efficient and you may leave at six or seven at night, and some are wildly inefficient and you'll repeatedly see the sun rise from your office window. I've had many seven-day work-weeks on shows, but not on shows I ran.

GB: *What personal characteristics are required to be good in a writers' room?*

MP: Obviously you need a good sense of humor, a good sense of story and character, but along with that you need a tough skin, you have to be agile and able to think on your feet and not be afraid to be an idiot. There are many excellent writers, great writers, who just can't handle the room, and so obviously doing this kind of work just isn't for them.

GB: *To those contemplating writing television comedy, what would you say are the greatest pleasures you've taken from the job?*

MP: There's a terrific pleasure in writing a joke and seeing it aired a few weeks later—I could never be a feature writer, sitting alone all day, not laughing as we do in a writers' room, and waiting years to get something up on a screen. And I have to say, no matter what show I've been on, no matter how tough it's been, I've laughed incredibly hard every day.

CYNTHIA KANNER

Cynthia Kanner has worked in post-production at HBO for 20 years, 15 of those as Head of Post-Production for Films and Miniseries. Her story demonstrates the value of a business background, a tremendous thirst for knowledge, experiencing all aspects of filmmaking, and knowing how to work computers when others don't.

GB: *When you were in college did you want to be in the film or television business?*

CK: No. I studied history and art history in college and I wanted to be a museum curator.

GB: *Did you?*

CK: I never got the chance. I couldn't afford graduate school and I had to work, so I accepted a position at Coopers & Lybrand in a program that trained liberal arts majors to be accountants and management consultants.

GB: *Wait a minute—had you ever studied accounting?*

CK: Never. They sent me to a master's program at NYU where I also got an MBA. When I wasn't in school, I was working.

GB: *How long did you stay at Coopers & Lybrand?*

CK: Five years. I had managed to get myself transferred to their San Francisco office, but after five years I wanted to do something creative and connecting business and the arts.

GB: *So what did you do?*

CK: I decided to try my hand at film.

GB: *Did the MBA either help you get your first film job or help you succeed once you were in?*

CK: It certainly helped me a great deal after I found my way into the industry. It's helped at HBO.

GB: *How did you get your first industry job?*

CK: [Laughing] I was hired to work for two writers, one of whom had started to direct, and I was going to be their assistant. So I drove down from San Francisco to L.A. and got to their house with all my possessions in my car, and when I got there they had changed their mind. So I had no job and no place to stay.

GB: *Nice. Where did you go?*

CK: I found a place to stay, went to the library and read as much as I could, and got my hands on a *Hollywood Reporter* which said what was then in production. I then walked into every production office and said, "Hey, do you need somebody?"

GB: *Who said yes?*

CK: A low-budget film producer. When I first walked into his office, someone was having trouble with a computer and I managed to fix it. He didn't hire me on the spot, but I kept calling him, and eventually he gave me an office assistant job working on a film called *Rock and Roll High School Forever*.

GB: *How did that go?*

CK: Actually, really well. It turns out I could help with production accounting thanks to my business background, and I also got involved in product placement. On that same show, because I speak Spanish, I was asked to help the location manager at a couple of the locations. When she left the film to go to another project, I was bumped to location manager. I was really only in charge of the final location where we were shooting for two weeks.

GB: *Did that lead to other jobs?*

CK: Absolutely. I followed the unit production manager (UPM) to two other low-budget films. I became a location scout, which worked well as I had

grown up in a family of architects and was engaged to one. Eventually, a friend of mine was going to direct a short movie and I asked if I could budget it. When her producer got stuck on another show she asked if I would produce, and of course I said yes.

GB: *Did you like it?*

CK: I never worked so hard in my life, but I learned so much. I would constantly talk to all the departments and do whatever I could, pull cable for the gaffers, whatever was needed. We did post at Amblin because my friend knew someone there. I knew nothing about post-production so I worked as an apprentice editor and the producer. When I needed advice on 'post, I walked down the hall to the head of post-production and asked him.

GB: *Did that job lead to HBO?*

CK: Not quite. It led to a job as a production and post-production executive at Kings Road Entertainment. Eventually, I was offered the chance to produce some low-budget films overseas, but I really wanted to stay in Los Angeles so I became a freelance post-production supervisor, which would keep me in town. I got a job as a post-supervisor on an HBO film, and from there I got a staff job at HBO.

GB: *Can you give a sense of what it's like to manage post-production at a company like HBO?*

CK: It's been fantastic. Our job is always to help the filmmakers realize what they're trying to achieve, and that's been exciting. I've gotten to work on a lot of great shows with editors, assistant editors, sound editors, music editors, sound mixers, composers, visual effects artists, title designers, colorists, online editors.

GB: *Do you also keep an eye on budgets?*

CK: Of course. And we make sure HBO receives everything it needs to exploit the project once it's been completed.

GB: *Do you get involved in projects before filming is done, say in the pre-production stage?*

CK: We do. These days, given the effects used in films, you have to start to prepare very early on. But beyond that, I've always thought all departments, creative, production and 'post, should act like a team and work together right from the start.

GB: *What about staff who you've supervised—what do they do?*

CK: They oversee shows, making sure 'post goes as well as possible. Some people tend to like particular kinds of shows, so I've always tried to assign them that kind of project if I could.

GB: *What makes someone qualified to be an exec in your department? Must they have extensive experience in 'post?*

CK: To be a post-production executive, yes. To be an assistant and work in the department, no. It obviously helps, but it's not imperative. What is imperative is that you have a great, hard-working attitude, that you'll do

what's asked, what's needed, and you'll do it thoroughly and thoughtfully. An entitlement attitude, a sense that you've done enough so you don't have to do anymore, just won't work. So work ethic and attitude are huge.

GB: *Then you might hire someone who doesn't have a lot of experience and teach them from the ground up?*

CK: Sure, it's happened where someone shows great ability and attitude. It depends on the show and whether there's someone who can adequately mentor the person.

MIKE KNOBLOCH

Currently President, Film Music and Publishing at Universal Pictures, and calling this his dream job, Mike Knobloch found his way to Universal by following the predictably long and winding road, which started when he realized he probably wasn't going to be a rock star. Still, his love of music remained, and it focused his attention on work that ultimately took him to the top of the film music world. His story demonstrates the importance of being in L.A., seeing filmmaking up close, experiencing different aspects of movie making, leveraging each job into the next opportunity that comes along, and discovering along the way what you love and where you belong.

GB: *When you were in college what did you hope to do?*

MK: I thought maybe I'd be a rock star. I was in bands in high school and college and thought I was a better player than I probably was. If you wanted to be in music, and I did, then you thought about being the front man for a rock band. The truth is, I didn't really know there were other options other than playing rock and roll.

GB: *So back in college you never thought of pursuing other music-related jobs?*

MK: No, never. I grew up in New York, as far removed from the entertainment business as you could possibly be. I had no connection at all to the business, which in some ways was a good thing because I didn't go to a music conservatory or a school designed to get me into the music business. Instead, I went to Northwestern University where I got an excellent liberal arts education, which was very helpful when I discovered that I wasn't destined to be a rock star.

GB: *How did you find your way to Los Angeles?*

MK: When I was at Northwestern, I eventually became a theater major, thinking maybe I'd be an actor or director someday. And then a friend of mine got a part in a movie out in L.A., so I came out during spring break of my junior year and that led to an internship job. I ended up that summer as a production assistant on the movie, and that was my first glimpse of real show business. It was eye-opening because I saw the business in such a different light than in a university's theater or film department. Working in the film's production office I could see actors who were household names

worrying about where their next job would come from, I could see what people were being paid, and I could get a sense of the business and what it's really like to make a movie in Hollywood. I really took advantage of the opportunity to get coffee for people and talk to them and just hang out watching.

GB: *Were you still working as a PA when music was added to the film?*

MK: Oh yes, and when we got to the scoring stage and I saw the composer stand before an 80-piece orchestra, that was like finding a group of people speaking a language I didn't realize *I already spoke*. I just had such a cosmic connection to the entire process, and it made me realize this was my calling. I knew I had to be around *this* because this was where I belonged.

GB: *So where did you go from there?*

MK: Well, I went back to Northwestern and graduated, but then came back to L.A. to continue working for the same people who hired me on the film. Eventually, I left that job and, thanks to someone I had met, I went to work in a small recording studio.

GB: *What did you do while you were there?*

MK: Everything. I would work the mixing board on sessions, or go to TV sets and supervise recording, or even help actors fake playing musical instruments. And it was while I was doing that job that I was sitting in someone's office and picked up the annual film and TV music edition of the *Hollywood Reporter*. There was a directory of every film music department at studios and production companies along with names, addresses and phone numbers. So I wrote a letter to each person listed and asked if I might take them to lunch or come to their office and have a meeting. And I got exactly one response, and that was from an incredulous assistant at Fox who said they normally don't respond to letters like this, but Robert Kraft, who was then head of music at Fox, would like to meet me, and that was the biggest door that ever opened for me. I worked in the music department at Fox for many years before moving into my current position at Universal.

GB: *For people who think they might like to work in the film or TV music business, what kinds of jobs are generally available?*

MK: These days everything in a studio music department is very specialized. Taken together, the people in my department constitute a full-service, in-house music supervision resource for movies that get made at Universal Pictures. We are equipped to handle the music needs of any picture, big or small, expensive or inexpensive, that Universal makes. My department is broken up into a few groups. I have one group that manages and oversees all of our music licensing.

GB: *Do these people have to be lawyers?*

MK: No, but they do need to know how to negotiate licensing deals—they do it day in and day out, usually with the same small group of people. To

negotiate deals well, they need to understand what a piece of music is worth, which is a very unscientific task and one you learn from experience. And, because they negotiate with the same people over and over again, they need to have very good people skills. To show you how specialized things are, we even have one person who only negotiates licensing deals where music is used for marketing.

GB: *What other departments do you have?*

MK: We have our business affairs department. They negotiate principally composer deals, songwriter deals and soundtrack deals. We have a publishing group, which promotes and oversees the administration of Universal's catalogue of film and TV music, which includes tens of thousands of titles, some now a century old. For example, one person's full-time job is to cull our library of music for forgotten gems and songs from decades ago and promote them to other potential users. Then there is our creative/production department. These people work with filmmakers to help connect them with the right composers and songwriters. The bottom line is, our job is to help filmmakers realize their vision of the film and put it up on the screen ideally in synch with the studio's expectations of what that vision is as well.

GB: *I assume that, when it comes to film music, articulating a "vision" about what the music should be doing can be very difficult.*

MK: You bet, and so we try and bridge the gap between the filmmakers' vision and the studio's vision. And, of course, we work to keep everything running on time and on budget.

GB: *If you were hiring someone, what specifically would you be looking for?*

MK: First of all, when I meet someone, I want to know that they've done their homework. Today, thanks to the internet, there's no excuse for not knowing something, which is both a blessing and a curse. Now you can learn about the highly specialized facets within our business; you can learn that there's management, music labels, publishing, music departments at film studios, licensing, business affairs, production. But you better know it. I interviewed someone the other day, and in the time it took them to walk from the door of my office to the couch, they proved to me in casual conversation that they'd done their homework. Before their butt hit the couch I knew that this person was dialed in to what was going on in our business. When someone comes in having done their homework, who presents themselves with humility but with confidence, who understands the job requires that they be communicative and collaborative, that speaks volumes. That's how my department runs— we all work communicatively, collaboratively and with a solution-oriented sense of urgency. On top of all this, you want someone who is obviously enthusiastic and passionate about music.

GB: *What else might you say to someone who would like to work in film music?*

MK: This obviously isn't like becoming a doctor or lawyer where there's a systemized way to become a member of the profession. There are, however,

themes and constants that people's success stories in Hollywood have in common. Those include being tenacious and taking advantage of every opportunity and happy accident that comes your way, and being able to leverage each opportunity into the next one that presents itself. For example, by the time I interviewed with Robert Kaft for the Fox job, I could take all the things I'd done—being a PA on a movie, working in a record studio, working on TV shows—and tell Robert why I was really qualified to work in the film music department of Fox studios. And I am so fortunate that I get to come to work every day and do this. It's amazing to be part of a team that helps put music on to the screen—that helps make great films. Whether it's having a number one song with Pharrell Williams or working on *Les Miserables*, and everything else in between, it makes me the luckiest guy ever.

HAMILTON STERLING

Unlike others interviewed for this book, Hamilton Sterling knew early in life he wanted to be a filmmaker. At first he wanted to be a director. After college, however, the jobs he could find, which were hardly glamorous, required he perform a variety of different filmmaking tasks. Eventually, he found his way into what became a long and hugely successful career as a sound editor; to date Sterling has worked on more than 80 feature films, including *Stand and Deliver, Awakenings, Best in Show, Master and Commander, War of the Worlds, The Dark Knight, Men in Black 3, The Tree of Life* and *Fury*. He also wrote, produced and directed the festival film *Faith of Our Fathers*. His story demonstrates the importance of understanding different aspects of film, making the most of whatever jobs you can find by learning as much as possible, and always moving forward despite disappointment. And knowing a thing or two about jazz.

GB: *When you were in college, did you think you would be a filmmaker?*

HS: Yes, I wanted to be a director and a writer, but when I went to Arizona State University back in the late 1970s, there was no film school as there is now, so I majored in music. Still, I made *Generations,* a 16 mm, 54-minute science fiction film while I was there. It took me three years to do it because I financed it myself, but I managed to finish before I graduated.

GB: *Did you think that film would lead to other directing jobs?*

HS: Of course. [Laughing] When you're young you think you're going to show it to the world, and the world's going to say, "He's a *genius!*" That didn't exactly happen. Ultimately, the film was picked up by an international distributor with an office in a San Fernando Valley strip mall. [Laughing again] I think my film may have ended up on videotape in Spain.

GB: *So what did you do after college to earn a living?*

HS: I went up to the Bay Area hoping to find film work with one of the more cutting-edge film companies. George Lucas was up there with Industrial Light and Magic, Francis Ford Coppola was there with Zoetrope, but I never got into that universe, which was disappointing. So I ended up taking freelance jobs with a small local production company in Berkeley managed by two people. They ran the company as a collective, which meant I got to do a lot of different jobs, from sound to directing to editing to a whole lot of different things.

GB: *What did you direct for them?*

HS: A commercial for a local theater company. I also remember doing sound work on filmed legal depositions involving people who were dying of asbestosis. I would mic these people up and they'd be interviewed by a phalanx of lawyers. And I did picture editing on some industrial films—I really just bounced around trying to pick up as many jobs as possible.

GB: *Where did you go from there?*

HS: My wife got a job teaching at UCLA, so we moved down to Los Angeles. So then I beat the pavement in L.A. for six months carrying around the film that I made in college.

GB: *And where did you end up?*

HS: I eventually got hired by a company that made 16 mm industrial films. They made sales films, all sorts of different things, and I did directing for them, cinematography, sound work, picture editing, anything they needed. One of the people who worked for them did a lot of editing on Warren Miller ski films, and he hired me to do some picture editing. For about three years I just did whatever work I could get.

GB: *So how did you find your way into full-time sound editing?*

HS: I had worked as a picture assistant on a documentary about a jazz singer, and the picture editor saw my college film and said the sound was really good. So he introduced me to an up-and-coming sound supervisor who had just done an Alan Rudolph movie and was set to do another, *Trouble in Mind*, with Kris Kristofferson. That sound supervisor hired me to do sound effects editing on the film, so that was my first feature gig.

GB: *Obviously, that started you on a long and successful career. Any thoughts about what's specifically helped you succeed and become so good at sound editing?*

HS: First of all, let me say I love cinema. If you grow up loving all the different kinds of cinema, and if you're interested in directing, you're going to break scenes down and learn the intentions of the writer and director and actors. That ability, to know what everyone's intentions and emotions are in every scene, really helps. Also, my musical background helped as well. I had played jazz bass professionally from the age of 16, and I'm sure my training in rhythm and melody and harmony really worked for me when it came to understanding sound. In terms of continuing to be able to work all these years, you need tenacity and to pay great attention to detail so the work can be as good as possible.

GB: *Speaking of detail, how many separate sound effects are there in big productions like* Men in Black 3 *or* The Dark Knight?

HS: Thousands upon thousands. When you see films like those for the first time without any sound effects, it can seem daunting knowing how many different effects will have to be created for the film.

GB: *Of those thousands upon thousands, what percentage are you creating yourself as opposed to using pre-existing sound effects?*

HS: It really depends on the film. One of the most enjoyable things about the work is getting outside of the editing room to make field recordings. I always like to go record something new and interesting to put into a movie. As a matter of fact, I was just up in the Canadian Rockies on vacation and the wind was howling through the cracks of this 1914 lodge, [laughing] and so of course I take my recorders everywhere, even on vacation much to my wife's horror, and I was up at two o'clock in the morning recording the sound.

GB: *What was the strangest sound effect you ever created or recorded?*

HS: I have a garden rake—it has prongs that have a nice vibration to them, so I recorded the rake with a contact mic at a high sample rate, and then was able to pitch the garden rake's twangs down. The twangs became so vibrant and gigantic I used them in *Men in Black 3* as part of the Saturn V gantry shaking.

GB: *We were hearing a garden rake?*

HS: [Laughing] You were hearing a garden rake.

GB: *What is the biggest change in the business you've seen over your 30 years doing sound?*

HS: When the world was analog, many more people were required to physically do the work. Since the world became digital, enormous films can now be done with only a handful of people, and often are. For example, I just saw a huge science fiction film, which listed only two sound effects people in the credits. To those of us who started in the 1980s, it's shocking to have only two people doing sound effects on a huge sound design movie. Also, because of globalization and the internet, companies can now farm out sound work to the lowest possible wage earners they can find on the planet and get a fairly decent job done, thanks to all the available digital sound effects libraries. All of which is to say it's becoming harder and harder for sound editors to get feature work.

GB: *Given this, how important is it to network with as many people as you can?*

HS: It's extremely important, and it's something I probably could have done a bit better. That may sound surprising given the work I've been able to do, but most sound editors are somewhat retiring. We're not part of the giant production crew; usually, we're in a room alone. Of course, one's willingness to work tirelessly in the editing room makes you a better sound editor, but it's very important to network and form good personal relationships.

DANA LUSTIG

Dana Lustig grew up in Israel and came to America when she was 23 years old. When she arrived, she knew no one in the business and had no money. Despite all that, she has somehow managed to produce a remarkable 18 movies and direct 5 of them. She has learned to successfully navigate the world of independent filmmaking, and her success demonstrates the power of love and passion for your work, as well as the benefits of knowing a few teamsters along the way.

GB: *When you were growing up in Israel, did you want to be in the film business?*

DL: Yes, very much so. When I was 10 I started a puppet theater and began telling stories. I got all the neighborhood kids to join, so it was my first attempt at not only storytelling but also production. It was so empowering really, giving me the feeling that I could create something with others and people would come and laugh. Later, I wanted to be an actress, so I took a lot of acting classes and even joined a theater group. I met some of the best Israeli writers and directors, and that's when I decided I wanted to be a storyteller. So today I write and produce and direct and sometimes act, all jobs that require you to be a storyteller.

GB: *Why did you come to America?*

DL: I always loved American movies, and thanks to all my acting and production work I did in Israel, I managed to get accepted into the American Film Institute's producing program. And that was so important for me because, first, the AFI's whole focus was storytelling and making movies hands on, which just made me feel so connected to the program, and second, I was able to create a real network for myself, which was an incredible way to get to meet a whole group of people who were more or less on the same level as I was. And, as it turned out, the first few movies I made were all made in collaboration with fellow students.

GB: *Once you graduated, what did you do to earn a living?*

DL: I started as a PA, grip and video editor and then a production manager on low-budget films. So, I managed to scrape by while I learned about all the different jobs people do on movies, always thinking about how I would produce my first film.

GB: *How did that happen—how did you get your first film off the ground?*

DL: Well, the film itself focused on a particular equity waiver theater. The film's director, Jeff Seymour, owned the theater, and he said he'd like to make a movie someday. So we started talking about what kind of movie we'd like to make and we followed the oldest advice in the book, which is write about what you know. So he wrote a script surrounding his theater. Then, to finance the movie, we sent letters to all the subscribers of the theater, and some of those people were happy to send us checks—some smaller, some larger—and we managed to raise almost $200,000.

GB: *Did you have any idea that sending those letters would actually work?*

DL: None at all. We just tried it.

GB: *What have been the budgets of the films you've produced?*

DL: They've ranged from $100,000 to $5 million, though now I'm producing a $10 million film.

GB: *What are the ways you've gone about raising money?*

DL: Every movie is different. Each project has its own demands that require different approaches. Foreign sales have been a prime way to raise funds, but also private equity when the equity player has a special passion for some aspect of the film, such as the director, or actor, or the story itself. And this is another reason why networks are so important, because you never know when someone in your network may have a special passion for some aspect of a project you're trying to produce.

GB: *Most people trying to make a low-budget film may not have access to wealthy people. What advice do you have for them?*

DL: In truth, I don't know where all those wealthy people are either. I don't have a pool of rich people just waiting to give money. So what I always say is first bring something of value to the project before you approach investors. Attach a great actor, or find a free location or a producer with a reputation—anything that will make the project more tangible and attractive for investors. So, for instance, for my directorial debut, before I ever approached anyone for financing, I made the project so attractive to financiers that it was pretty easy to set up.

GB: *How did you do that?*

DL: While I was working on my second movie as a producer, I was chatting with our teamsters and they mentioned they had great connections in Las Vegas and knew Debbie Reynolds' son who owned a hotel there, and if I ever wanted to shoot a movie in Vegas they could help set it up. So with another AFI alum writer, Annette Goliti Gutierrez, we came up with an idea for a film that mostly took place in Vegas. With the help of the teamsters, we then took a road trip and pitched it to Debbie Reynolds' son, and he loved it. He said he couldn't invest in the movie, but he could let us shoot in his mother's Las Vegas hotel, and that the whole cast and crew could also stay there and eat there for free. He also mentioned that his mom might be in the movie if we wrote a part for her. So suddenly we had a free location, free food and, theoretically, Debbie Reynolds. With that, my then-business partner Ram Bergman and I were able to go to the foreign sales company we worked with on our first two movies, and they invested in the movie about $250,000 and we became 50-50 partners on the film. We also wrote a role for Debbie Reynolds, which got us the caché to get the rest of the cast, such as John Corbet, Illeana Douglas and Paulina Porizkova.

GB: *Besides bringing something of value to the project, what other lessons did you learn back in the early days of your career?*

DL: The most important thing as a producer is to have content. I realized that without content, you have nothing to sell. Your first job is to find a great

script or a book, an article in the paper or even an interesting unique personal story which can be turned into a script. I also learned the value of networking—go to plays, go to seminars, meet people in the industry or people that are interested in the arts. The more people you know, the more people you'll have access to. But more importantly, study and work in all areas of filmmaking, no matter what you want to do as a filmmaker. I would encourage everyone to study acting, screenwriting, editing, go to seminars, keep updated with the new gear and technical advancements. The more you know the more tools you have to go out there and make your first movie. Also work on pitching and making the person you're pitching to just as enthusiastic about the project as you are. And never be too afraid to ask questions of everyone. I learned so much about the deal-making side of the business by asking so many questions of the attorney who helped on my first project.

GB: *Tell me how you managed to start directing films?*

DL: The first film I directed was *Wedding Bell Blues*—the film set in Las Vegas. My writing partner and I wrote the story, which was based on a lot of our own experiences as young single women. By the time I got to the set I was ready to direct, because I had so much experience in production all around I just felt so at home. Today, in a way, it's easier to direct films—I mean it's never easy to make a film, but in the digital era the tools to make a low-budget movie are so much more accessible that there are no excuses for not making your movie.

GB: *What advice do you have about finding distribution?*

DL: If you are passionate about your first project, it will likely have some artistic value, which will help you, hopefully, to get the film into some great festivals and be exposed, reviewed and maybe seen by distributors. There is also the option of trying to raise a little bit of money and four-walling your movie. Showing your movie in a theater even for only a week can be a good thing—you can hire a publicist and get reviewed in the *L.A. Times* or *New York Times*, and even if it's a bad review, it puts you "on the map," which will make people that much more willing to talk to you. Suddenly you're a player because you managed to get it done, and now you go make your next one.

GB: *Name three or four skills or character traits you think independent filmmakers need to have to be successful.*

DL: You need endless love and passion for what you do. Then, you need to have great content, so you need to be able to recognize good stories, good material, which means you have to read a lot of scripts, books, articles and so on. You must know how to pitch it and how to get people excited about it. You need to know how to communicate your vision to all the creative talent making the movie, including your actors, so I highly recommend that young filmmakers take acting classes. You need to know what filmmakers do, so being on sets is very important, too. [Laughing] I know how to cater.

GB: *Has it been difficult going from one independent film to another, always worrying about raising money?*

DL: I live an insane life. It doesn't make sense to live the life I live. There's no security. I don't know where the next paycheck will come from. But I can't do anything else. The problem is, I don't love anything else as much as I love making movies.

GB: *You must have faced rejection from financiers. Has that been difficult to handle?*

DL: I deal with rejection all the time. Some people will like your projects and movies and others won't. You can't satisfy everyone, so when you know that and accept it, you can handle rejection. As long as you believe in your own projects, love what you're doing, have patience and don't give up, you'll manage to keep making movies. I love telling stories and I always have. I'll probably die doing this.

MAUREEN TUNNEY

Maureen Tunney has produced television commercials for more than 20 years. While she has produced many commercials that aired nationally for Fortune 500 companies, it's not her success that makes her story so remarkable. Instead, it's these two facts: Ms. Tunney never thought about producing *anything* until she was 35 years old, and for the vast majority of her career she has worked as a freelance producer. Her story demonstrates how someone with just a few connections, a talent for managing operations, the willingness to work hard and the ability to persevere can literally, one day, invent a producing career.

GB: *When did you first become interested in the film industry?*

MT: I grew up in Los Angles so I suppose it's always been part of my DNA. I did get involved in acting for a while, both during and after college, but the funny thing is, I didn't want to live in L.A., so I moved away, did a variety of jobs and acted in community theater. Then I met an actor who I eventually married, and moved back to L.A.

GB: *How then did you get started in production?*

MT: We were a two-actor family, which is something I don't recommend [laughing], and one of our friends asked one day if I wanted to come work as a production assistant on a Natalie Cole video. And I thought, okay, I'll try it out. And I went out there and walked onto the set and suddenly I realized *this* made sense to me.

GB: *What about it made sense?*

MT: I had been involved in lots of different jobs—non-entertainment jobs—that involved logistics and planning and organizing people. For example, in my early twenties, I had been the director of an international camp. I was in charge of a group of people and I had to organize the logistics, manage the

money and the schedules and so on. Back then I thought I would end up running a parks and recreation department in Oregon, but now I realized these skills would transfer nicely to the film business.

GB: *Obviously, you never thought about being a producer back in college.*

MT: No, never.

GB: *Then how old were you when you began your producing career?*

MT: I was 35.

GB: *Do you know anyone who got into the game as late as you did?*

MT: No, no one. Most everyone I know got in during their mid-twenties.

GB: *So what happened after the Natalie Cole shoot?*

MT: The woman who was the executive producer on that job was looking for someone to be an in-house coordinator. We started talking as the Natalie Cole shoot was wrapping, and I ended up working for her for two years. So, just like everything else in this town, it's about circumstance and timing and taking advantage of what comes your way.

GB: *What were you doing during those two years?*

MT: Really, getting my feet wet. We were putting together music videos and some Japanese commercials, and she would hand me a list of things to get done—calling equipment houses, getting permits, making sure the necessary people were on hold for the production dates—and that's how I learned the basics of production.

GB: *After those two years, what did you do next?*

MT: I actually took a year off to get married and have my first child, and when I came back, I came back by producing Japanese television commercials. I had made calls to as many people as I knew, and it turns out there was a real surge of Japanese production companies shooting commercials in America. So, through my connections and by making my own contacts I would get hired by these companies on a freelance basis. I would do research for them, put crews on hold, put locations on hold, arrange for transportation, arrange for food—basically production-manage each project. I would then be with the crew through the entire shoot and make sure everything got done properly.

GB: *How long would you have to prep the shoot?*

MT: Back then you could get up to a month—especially when a job had celebrities involved. And this is something I've always liked about producing commercials—you can end up handling one or two projects a month, which means you're always doing something new and different.

GB: *How long did you freelance for these production companies?*

MT: About seven years.

GB: *And what came next?*

MT: Well, when the Japanese yen took a dive these companies stopped coming to America to shoot, so I had to reinvent myself again. Once again I made calls and knocked on doors and sent out resumes. I would offer to come in as a coordinator, take a step down if it would get me in the

door. Eventually, I was picked up by a New York-based production company with heavy-hitter feature film directors who would do commercials in their spare time. I freelanced exclusively for them, first as a production manager, then later as a producer. They were so busy—they just kept me going from job to job to job.

GB: *Do you still primarily work for this company?*

MT: No, they lost a major client and were in the midst of merging with another company, and I needed to keep working. So, once again, I had to get back out and knock on doors and say, "Hello, here I am." Now I work for several different companies as a freelance commercial producer.

GB: *What do you like best about the job?*

MT: I really like that every project is different. I enjoy casting, location scouting and the variety each job has to offer. It can be stressful to keep everyone happy with ever-shrinking budgets, but I've had enough experience now that it is easier to manage my stress level and keep things in perspective. I've really learned how not to get upset when something happens, because I've learned getting upset just makes things worse. So, I go directly into problem-solving mode because that's really my forte—just give me the problem and I'll deal with it.

GB: *Do you see this as a field that young producers can get involved in?*

MT: It's tough but it's absolutely doable. If someone graduates from college and wants to be in the commercial business, there are still opportunities, especially in L.A. or New York, and now there's so much work in other parts of the country and the world, you can get started elsewhere. For example, because of the tax credits in Louisiana, there's lots of opportunity in that particular state.

GB: *What is the "average" production budget for a commercial?*

MT: Budgets really vary, but I'm currently working on a project budgeted at $350,000, and that's somewhere in the middle. On the other hand, if you have 200 extras on your shoot, and that happens, and you have a four-day shooting schedule, the budget can be $1 million.

GB: *Last question: What percentage of commercial producers are women? Is it a field where women have an equal chance?*

MT: Absolutely yes. I would say there's a 50-50 split between men and women producers, so I would encourage women to get involved if this is what they want to do.

Index

215, 223, 224n11, 246, 260n55; gross proceeds, 214, 216–17; in independent filmmaking, 269, 271, 273, 275n8; negative cost deductions, 218; net proceeds, 214, 217–18; net profits calculations examples, 219; the potential value of, 213; for rights owners, 234; *see also* negotiation

programming: as a means of retaining and attracting television subscribers 202; advertising as a source of financing television, 200–1; changes in following the breakdown of anti-trust laws, 138, 189n15; diversity and originality in television, 134, 174; independently produced, 125, 126n14, 269; the original mandate for public service in, 121, 125; the production of by networks, cable, and internet corporations, 199, 204; the seasonal patterns of early television, 181; television hours, 199; television licensing of, 199, 202; violence in television, 109n40

property: intellectual 9–10, 17, 77, 81n12, 83–6; and moral rights, 84–6; in option/purchase agreements, 227–39, 240, 244, 258n17; private and invasion of privacy, 103–4, 112nn79–82; TRIPS (Trade-Related Aspects of Intellectual Property Rights), 84; World Intellectual Property Organization (WIPO), 77, 83

public *see* audience

public figures: the *Gertz v. Robert Welch* (1974) case 111nn68–9; libel and slander standards applied to, 101–2; malice against, 102, 104–5; the *New York Times v. Sullivan* (1964) case, 101

public interest 121–5, 146–50

publicity: name and likeness misappropriation 103, 105; name and likeness used in, 113n89, 249–51; the right of, 106, 238; services owed by filmmakers, 244, 248

radio: as a free access medium 94, 107n17; as a medium of public access, 51n79; as a medium of public performance, 28, 58, 59, 65–6, 66n6; as an advertising medium, 192, 193, 194; broadcasting, 65,

92, 119–20, 133; commercial as an impetus for creation of the FCC, 119; conglomerate ownership of, 135–46; the early years of, 55, 115, 119, 122, 126n7, 127–8, 132–5; indecent speech on, 91–3, 107n20; independent stations, 124; the internet versus, 94; and legal liability, 108–9n38; music publishers, 63; ownership rules, 122, 124; royalties payments for recordings aired, 68nn26–9

ratings system: MPAA film 98–9, 110n52, 110nn49–50, 110nn54–55, 247–8, 257, 268; Nielsen television, 200–1, 207n27, 207n30; *see also* violence

RCA (Radio Corporation of America) 130–1, 134, 140, 146

Reagan, Ronald: the acting career of 130, 135; the pro-business presidency of, 123–4, 125, 135, 137–8, 150n7; the SGA union activities of, 135–6, 158–9

reality TV 88–9, 160, 189n16, 269

reasonable person: the as a legal guideline for behavior 104, 108n30, 110n63, 111n73, 111–12n75, 112n81, 238; the response of the to violence in entertainment, 94–6; the response of to obscenity, 90–1; and the zone of privacy, 103–4

Redbox 148, 193, 270, 275n12

rentals: of films by private viewers 28, 169n11, 192, 193, 196–7; of films by theaters, 194–6, 206n10, 206n13, 215

residuals: the 1985 strike for a filmmaker share of videocassette profits 159; the 2007–2008 strike for an adjustment to the home video rate, 159–60; the damage to filmmaker by piracy, 163; for foreign use of television programs, 169n9; formulas, 159, 160, 169n7, 169n11; the influence of film credits on, 157; the negotiation of by unions on behalf of filmmakers, 155, 157–61; for television writers, 159

revenues: as a basis for calculation of film residuals 158, 159; as a basis for the power of film studios, 172; as a basis for the power of television networks, 172; as a motivating factor of vertical and

horizontal business integration, 117, 118; as the basis for profit participations calculations, 213, 214–15; cable TV carriage fees, 201–2; for copyright owners, 31–2; Defined Gross, 215–16, 217, 224n7, 224n16, 224n20, 225n22, 275n13; distribution and marketing as the basis for generating, 191, 194–5, 196, 199–200, 270; downstream or ancillary film, 195–7, 247–8, 251; earned by cable channels, 148, 201–2; examples of filmmaking expenses and, 218–23, 273–4; film revenues as a small percentage of conglomerate, 141–2; future versus film production and distribution costs, 191; gross proceeds, 216–17; the impact of piracy on entertainment, 2–3; in independent filmmaking, 265–8, 270–4; the influence of on contingent compensation, 234; the influence of on filmmaker budgets, 177; the interconnection of revenue streams within entertainment conglomerates, 192–4; via licensing, 32, 197; the music publisher share of, 63–4; net proceeds, 217–18, 218–23; the offsetting benefits of from hit films, 206n23; profit participations, 213–15, 224n11; sharing as a source of conflict between filmmakers and studios, 197; studio from film home video sales, 71, 80n3, 159, 196–7; studio from internet showings of old films, 159–60; studio from television broadcasts of old films, 159, 197; subscriptions as a source of for internet companies, 202; subscriptions as a source of for pay TV channels, 202; syndication as a source of, 203–4; television commercials as a source of, 200–1, 203; from television shows, 202–4; from theater ticket sales, 195, 205n3, 206n14; theater versus downstream, 195; YouTube's advertising, 143, 151n10, 204; *see also* expenses

right of publicity 106, 238

RKO (Radio-Keith-Orpheum) 108–9n38, 123, 128, 130–1, 150n1, 223n3

Ross, Stephen 137, 139